Digital Transformation i
Cultural and Creative In

This research-based book investigates the effects of digital transformation on the cultural and creative sectors. Through cases and examples, it examines how artists and art institutions are facing the challenges posed by digital transformation, highlighting both positive and negative effects of the phenomenon.

With contributions from an international range of scholars, the book examines how digital transformation is changing the way in which the arts are produced and consumed. As relative late adopters of digital technologies, the arts organizations are shown to be struggling to adapt as issues of authenticity, legitimacy, control, trust, and co-creation arise.

Leveraging a variety of research approaches, the book identifies managerial implications to render a collection that is valuable reading for scholars involved with arts and culture management, the creative industries, and digital transformation more broadly.

Marta Massi is Assistant Professor, Brandon University, Canada.

Marilena Vecco is Professor of Entrepreneurship at Burgundy School of Business, France.

Yi Lin is Professor of Arts Management at the School of Arts and Director of the National Centre for Research into Intercultural Communication of Arts at Peking University, China.

Routledge Research in the Creative and Cultural Industries
Series Editor: Ruth Rentschler

This series brings together book-length original research in cultural and creative industries from a range of perspectives. Charting developments in contemporary cultural and creative industries thinking around the world, the series aims to shape the research agenda to reflect the expanding significance of the creative sector in a globalised world.

Managing Organisational Success in the Arts
Edited by David Stevenson

Music Business Careers
Career Duality in the Creative Industries
Cheryl Slay Carr

Racial and Ethnic Diversity in the Performing Arts Workforce
Tobie S. Stein

Understanding Audience Engagement in the Contemporary Arts
Stephanie E. Pitts, Sarah M. Price

Access, Diversity, Equity and Inclusion in Cultural Organizations
Insights from the Careers of Executive Opera Managers of Color in the US
Antonio C. Cuyler

Digital Transformation in the Cultural and Creative Industries
Production, Consumption and Entrepreneurship in the Digital and Sharing Economy
Edited by Marta Massi, Marilena Vecco and Yi Lin

For more information about this series, please visit: https://www.routledge.com

Digital Transformation in the Cultural and Creative Industries

Production, Consumption and Entrepreneurship in the Digital and Sharing Economy

Edited by
Marta Massi,
Marilena Vecco and
Yi Lin

Routledge
Taylor & Francis Group
LONDON AND NEW YORK

First published 2021
by Routledge
2 Park Square, Milton Park, Abingdon, Oxon OX14 4RN

and by Routledge
52 Vanderbilt Avenue, New York, NY 10017

Routledge is an imprint of the Taylor & Francis Group, an informa business

© 2021 selection and editorial matter, Marta Massi, Marilena
Vecco and Yi Lin; individual chapters, the contributors

The right of Marta Massi, Marilena Vecco and Yi Lin to be
identified as the authors of the editorial material, and of the authors
for their individual chapters, has been asserted in accordance with
sections 77 and 78 of the Copyright, Designs and Patents Act 1988.

British Library Cataloguing-in-Publication Data
A catalogue record for this book is available from the British Library

Library of Congress Cataloging-in-Publication Data
A catalog record has been requested for this book

ISBN: 978-0-367-35115-1 (hbk)
ISBN: 978-0-429-32985-2 (ebk)

Typeset in Sabon
by codeMantra

Contents

Contributors

William J. Byrnes is Professor Emeritus of Arts Administration at Southern Utah University (SUU); has extensive experience in arts management; and was a professor, Arts Dean, and Associate Provost at SUU from 2004 to 2017. He taught and mentored arts and theater management students for over 25 years. He has produced over 150 arts events and productions over the last 40-plus years. His textbook *Management and the Arts* is under revision, and the sixth edition will be published in the spring of 2021. His most recent book project was co-editing the *Routledge Companion to Arts Management*, published in 2019. William also worked as a manager and professor at Oberlin College and Florida State University earlier in his career. He is a Fellow and Past-President of USITT and has served on the boards of USITT, the ESTA Foundation, and the Utah Shakespeare Festival.

Antonella Carù is Professor of Marketing at Bocconi University, Milan, where she is also the Dean of the Graduate School. She is a faculty member at the SDA Bocconi School of Management. Her research focuses on consumer behaviour and marketing in contexts pertaining to the arts, services marketing, the experiential perspective in consumption and marketing. Member of the International Journal of Arts Management editorial board, she has published on her research topics in books and in prestigious national and international journals.

François Colbert is among the top scholars in arts marketing, having published close to 200 works and being one of the most cited authors in his discipline. He is holder of the Carmelle and Rémi Marcoux Chair in Arts Management at HEC Montréal and an international speaker. He currently is coordinator of the joint Master of Management in International Arts Management (HEC, SMU, Bocconi). He is Founding Editor and Editor-in-Chief of the *International Journal of Arts Management* and founding president and co-chair of the scientific committee of the International Conference on Arts and Cultural Management (AIMAC). He has been UNESCO Chair in Cultural Management from 2012 to 2018. He is also the author of *Marketing Culture and the Arts*, published in 15 languages. In May 2002, he was awarded the Order of Canada for

his many achievements and for his unique contributions in developing the field of Arts Management. He was made Fellow of the Royal Society of Canada in 2005.

Manuel Cuadrado-García is Associate Professor of Marketing at the University of Valencia, Spain. His main research interests are arts marketing and consumer behavior, including gender and diversity issues. His research has been published in highly prestigious journals and international books. Member of the AIMAC Scientific Committee and the International Journal of Arts Management editorial board, he has hosted international academic conferences, is engaged in different master's and PhD programs in cultural management, and collaborates with several arts organizations and projects.

Elena Di Raddo is Associate Professor of History of Contemporary Art at the Catholic University in Milan. She is Director of the Master "Designing Culture" (Almed, Catholic University and Polythecnic) and a member of the Steering Committee of the Research Center for Italian Abstraction (CRA.IT). She holds courses in Contemporary Art History and Economics & Management of Cultural Heritage courses. Her special interest areas include paintings of the late 19th and early 20th centuries, European Abstract Art and Italian/European art of the 1960s and 1970s, and the relationship between art and the new technologies. She has been a scientific consultant for museums and managed several events. She writes for news magazine, magazines, and art journals.

Mariagrazia Fanchi is Full Professor in Film and Media studies at the Università Cattolica del Sacro Cuore of Milan, where she is also head of the Postgraduate School of Media, Communication and Arts. Her field of research is focused on cinema and media audiences, gender, and cultural and creative industries analyzed in historical and synchronic perspectives. Among her recent publications are *Feminine Spectrum. Notes for a History of Italian Women at the Movies* (2019); *For Many But Not for All. Italian Film History and the Circumstantial Value of Audience Studies* (2019); *iGen Cinema. Moving Image Consumption and Production by Post-Millennials* (eds with A. Schneider e W. Strauven) (2018); *I nuovi Cinema Paradiso* (with A. Bourlot) (2017); and *Tutto cambia. Nulla cambia. Il cinema come impresa e come mercato* (2017).

B. Kathleen Gallagher is Assistant Professor in the division of Arts Management and Arts Entrepreneurship at Southern Methodist University. She teaches undergraduate and graduate-level courses in cultural policy and arts management. Dr. Gallagher's work advances understanding of the function and benefits of the arts as community assets. Her work has analyzed the impact of ecological conditions and public policies on the sustainability of arts and culture organizations in different settings. She is currently conducting research focused on arts organizations located in small cities and

rural settings. Her work is published or forthcoming in the *Policy Studies Journal, Film Finance: Theories – Practices – Futures*, and *The Routledge Companion to Arts Marketing*. Dr. Gallagher has presented research and participated in conferences in Australia, Canada, France, Ireland, Italy, Japan, and the United States, including the annual conferences of AIMAC, ARNOVA, ACEI, ISTR, Social Theory, Politics, and the Arts.

Grant Hall is Lecturer at the University of South Australia Business School in the Arts and Cultural Management program. He has over 25 years' experience working in the arts sector, as a musician, arts manager, business owner, consultant, and educator. From Adelaide, Australia, Grant has also lived and worked in Vietnam, Northern Ireland, and Canada. His professional aim is to learn about the transformative power of the arts and then share that knowledge with others. Grant's research interests include transformational learning and the arts, innovation, digital nomadism, and Burning Man culture. A Fellow of the Adelaide Festival Centre, he has presented his ideas at universities and conferences internationally.

Lala Hu is Assistant Professor of Marketing at the Catholic University of Milan, Italy. She teaches Marketing, Marketing Management, and International Marketing. She has been a Visiting Scholar at several universities worldwide, including King's College London, Kellogg School of Management (Northwestern University, USA), Tongji University (Shanghai), and UIBE Beijing. Her research interests include international marketing and cross-cultural marketing. She has published scholarly articles in peer-reviewed journals and book chapters. In 2020, she published the book *International Digital Marketing in China. Regional Characteristics and Global Challenges* (Palgrave Macmillan).

Yi Lin is Professor of Arts Management at the School of Arts and Director of the National Centre for Research into Intercultural Communication of Arts at Peking University, China. Her research interests cover arts management, marketing, and intercultural communication of arts. She is Director of the National Centre for Research into Intercultural Communication of Arts; Executive President of China Arts Administration Education Association; Chairperson and Specialist of the International Advisory Board for Promotion of Chinese Arts and Culture, Confucius Institute Headquarters; and Inspector and Board Member of the Asia Theatre Education Centre. One of her monographs written in English, *An Innovative Methodology for Analysing Finance and Policy in China*, won the "National Arts, Humanities and Social Sciences Research Excellent Achievements Award," which is the top prize for research achievements in Arts, Humanities, and Social Sciences in China. Another monograph, *The Cross-Cultural Communication of Chinese Opera*, has been regarded as the first book of systematic analysis on this issue in China.

Giada Mainolfi has a Degree in Business Administration from University of Salerno and a PhD in Marketing and Communication from University of Salerno. Since 2019, she has been an Associate Professor of Management and the Scientific Director of the Research Centre on Made in Italy (MA-DEINT) at the Faculty of Economics, University of International Studies of Rome, Italy. Her research areas of interest include international marketing strategies, with a special focus on country image, luxury sector, and emerging markets.

Marta Massi is Assistant Professor of Marketing at Brandon University, Canada. She has been a visiting scholar at Deakin University, Australia, and McGill University, Canada. Her research interests include country-of-origin, branding, and arts and culture marketing. Her work has been published in national and international journals, including the *Journal of Strategic Marketing*, the *Journal of Business & Industrial Marketing*, and the *Journal of Consumer Affairs*.

Piergiacomo Mion Dalle Carbonare is a Faculty Junior Lecturer at SDA Bocconi School of Management and PhD Candidate in Marketing at the University of Valencia. He graduated from the FSU (MA), where he obtained a BA in Economics and Management, and SDA Bocconi School of Management, where he obtained a master's in public administration. Piergiacomo has conducted research in performance measurement, social impact evaluation, and branding for arts and cultural organizations. He teaches courses on place branding, territorial marketing, and cultural policies. His research interests are mainly in management of cultural institutions. In the academic year 2018–2019, he was a visiting PhD student at SMU Dallas.

Lorenzo Mizzau is Senior Assistant Professor at the University of Genoa, Italy, and Adjunct Professor at Università Cattolica, Milan, Italy. He is interested in the management of cultural industries, in the role of context in organizational practices (particularly applying spatial perspectives), and in the dynamics of creative work. He has published, among others, in the *International Journal of Arts Management*, the *Journal of Economic Geography, Urban Studies, and Human Relations*.

Juan D. Montoro-Pons is Associate Professor of Applied Economics at the University of Valencia, Spain. His main research interests in the field of the Economics and Management of arts and culture include live and digital participation, the digitization of the cultural industries, information spillovers and cultural consumption, and indirect measurements of quality in the cultural sectors. He currently serves as member of the board of the International Music Business Research Association (http://www.imbra.eu).

Luigi Nasta is a post-doc researcher in Management at Luiss University. He holds a Ph.D. in Management from Luiss University and he is a researcher of the Luiss Creative Business Center (business unit of Luiss Business School for education and research on the creative industries). He was a visiting researcher in the ARC Centre of Excellence for Creative Industries and Innovation (CCI) at Queensland University of Technology. He is a lecturer at Luiss Business School for Economics of Strategy, Strategy, Business Modelling and Planning and at Luiss University for Public Management. He is author of several publications on topics ranging from project-based organization to knowledge management for creative organizations.

Trilce Navarrete is a specialist in the economic and historic aspects of digital heritage. She is currently Lecturer in Cultural Economics at Erasmus University. Her research merges theories of economics, heritage, and information science to support understanding of the changes in digital heritage production, distribution, and consumption brought by the adoption of digital technology. Navarrete is advisor at the European Group of Museum Statistics (EGMUS), board member of the International Committee of Documentation of the International Council of Museums (CIDOC), and regular guest lecturer at various Museology programs worldwide. She has contributed to the creation of the European statistics for digital heritage (ENUMERATE), has served as advisor for the creation and evaluation of (national) digital infrastructures, and has collaborated in several European-funded research projects. Navarrete was responsible for the first national account of the economic and historic development of digital Dutch museums. She holds a PhD from the University of Amsterdam.

Mirko Olivieri is a PhD candidate in Communication, Markets and Society at IULM University of Milan, Italy. He is member of the Digital Humanities Lab (ALMED Post-Graduate School) at the Catholic University of Milan. His research interests lie in the field of marketing communication, social media, and digital reputation management.

Maria Carmela Ostillio is director of the "Brand Management" course for the Master of Science in Marketing Management at Bocconi University (Milan) and Associate Professor of Practice and Core Faculty Member at SDA Bocconi School of Management (Milan). At SDA Bocconi, she is also in charge of the Brand Academy. Her studies and research are focused on Brand Management, Brand Strategy and Architecture, and Brand Communication and Storytelling. Her recent studies are focused on Sport Brand Management, Brand Authenticity and Heritage in Luxury and Upmarket Industries, Brand Experience, and Personal Branding. She has published on these topics in books and various national and international journals.

Chiara Piancatelli is a Faculty Lecturer at SDA Bocconi School of Management, Milan. Her research activities focus on Digital Marketing, Innovation in Communication and Marketing, and Big Data Marketing. She worked as a visiting research associate at Deakin University, Australia, where she conducted research on the impact of digital technology on consumer behavior within the arts sector. Chiara works as a research associate at Centrimark at the Cattolica University, Milan, where she teaches the course on Arts Marketing.

Luca Pirolo is Associate Professor at Luiss Guido Carli University. In 2015, he got the National Eligibility as Associate Professor in Management. He teaches Management at the BA program and Creative Industries and Business Model Innovation at the Master of Science program, delivered by the Department of Business and Management. At Luiss Business School, he is the Director of Luiss Creative Business Center, an active competence center created to investigate the management of creativity, with a focus on art, television, music, cinema, fashion, and luxury industries. He is also the director of some master programs (namely, Master of Art, Master in Media Entertainment, and Master of Fashion and Luxury Management).

Ruth Rentschler is an experienced scholar who has published widely in the creative industries with a focus on diversity and social inclusion. Her most recent co-authored monograph (with Rajeev Kamineni), on *Entrepreneurial Indian Movie Producers*, has been published by Routledge UK in May 2020. She has a keen interest in nonprofit boards and currently sits on the board of the renowned Australian Dance Theatre.

Ludovico Solima is Full Professor of Business Management and holder of the chair in Management of Cultural Organizations at the University of Campania "Luigi Vanvitelli," Department of Economics. He is member of the Board of Directors of the "Università degli Studi di Napoli L'Orientale" and scientific advisor to the Ente Pio Monte della Misericordia, the Valenzi Foundation, the Alessandro Scarlatti Association, and the Civita Association. Since June 2018, he has been member of the Steering Committee of the scientific journal *Economia della Cultura*. For more than 20 years, he has been coordinator of working groups in theoretical studies and field research on behalf of public and private institutions, in particular on issues such as museum marketing, visitor behavior, new technologies applied to the cultural sector, accountability and strategic planning, cultural attractors, and local development.

Andrej Srakar is Assistant Professor at the School of Economics and Business, University of Ljubljana, Slovenia. Andrej is Editor-in-chief of the *Review of Economics and Economic Methodology* (REEM) and Co-Editor of the Book Series on *Cultural Economics & the Creative*

Economy, published by Palgrave Macmillan. He has published, among others, in the *Journal of Cultural Economics, Cultural Trends, International Journal of Arts Management, International Journal of Cultural Policy, Poetics, European Planning Studies*, and the *Journal of Knowledge Management*, and in monographs published by De Gruyter (2015; 2019; 2020), Springer Verlag (2017), Edward Elgar (2018), Routledge (2018), and Sage (2020). His main research interests include cultural economics, mathematical statistics, mathematics (probability, complex and functional analysis), macroeconomics, and economics of ageing. He is co-author of research reports for the European Commission, the European Parliament, and the World Health Organization. He is also a member of scientific program committees of two most recent conferences (Lille 2021, Melbourne 2018) of the Association for Cultural Economics International (ACEI).

Matteo Tarantino is Assistant Professor at the Università Cattolica del Sacro Cuore of Milan, where he lectures on the sociology of digital technologies. His research interests focus on the intersection between data, society, and culture. Among his recent publications are *Navigating the Green Datascape: Some Challenges in Automating Environmental Data Procurement for Disclosure Efforts in China* (2019), *Uncertainty in the Air: Communicating Urban Air Pollution* (2019), and *Il Tecno Dragone: L'Immaginario Tecnologico Cinese Ieri, Oggi e Domani* (2020, in Italian).

Alex Turrini has been Director of the SMU Meadows Division of Arts Management and Arts Entrepreneurship as well as visiting professor of arts management and cultural policy at SMU Meadows and Cox School of Business. Tenured as Associate Professor in arts policy and management at Bocconi University, he carried forward several research, training, and consulting projects with different national and international public sector organizations involved in the arts. His research activities center on public policies and management in the arts and cultural sector, arts collecting behavior, and inter-organizational networks in the arts.

Marilena Vecco is Professor in Entrepreneurship at Burgundy Business School, Dijon (France), and Associated to the Carmelle and Rémi Marcoux Chair in Arts Management HEC Montréal (Canada). Her research focuses on cultural entrepreneurship and management, with a special focus on cultural heritage (tangible and intangible) and art markets. Marilena has over 17 years of academic and professional experience as a researcher, lecturer, and consultant for different international organizations (OECD, Centre for Entrepreneurship, SMEs and Local Development, World Bank, and the European Commission). She is the author of several books, book chapters, and articles published on different journals.

Raman Voranau is a Master's by Research student at the University of South Australia, UniSA Business. He was engaged in arts administration within public museums, not-for-profit organizations, and an event agency in Belarus. Inspired by professional experience, his current study focuses on how cultural leisure experiences impact the subjective well-being of video game industry workers. He has published several articles and book chapters.

Foreword

As one of those people who may, on some occasions, be disparagingly referred to as a "digital immigrant," I have tried to embrace the ideas, values, and practices in this new land where I reside. Of course, not being a native of the culture, there are knowledge gaps and the occasional digital equivalent of making a social blunder that I try to remedy expeditiously. I have also had to be more adaptive living in both a digital and an analog world. If nothing else, it has given me more resilience. These ruminations are to alert the reader to the fact that, when my colleague Dr. Marta Massi asked if I would be willing to write this foreword, my concerns about being a digital immigrant surfaced again. However, after reading the diverse range of topics covered by the contributors to this excellent new addition to the Routledge Research in the Creative and Cultural Industries series, I feel a great deal more confident navigating the landscape of digital transformation in the arts.

The transition to the digital world by arts and cultural organizations has involved much more than acquiring computers and software. It has been a bumpy ride and is, in fact, still going on. At times, it is difficult to get our bearings while trying to anticipate where we are headed on this journey. The adaptive capacity of cultural organizations is being tested as digital transformation becomes more deeply embedded in the broader culture. Varying degrees of disequilibrium can be caused by new technology, and it can also create tensions that are manifested through resistance to change, which, in turn, has an impact on the adaptive capacity of the organization.[1]

Digital Transformation in the Cultural and Creative Industries examines adaptive capacity and the impact of technology from the perspective of artists, the art world, arts managers, digital workers, cultural and heritage organizations, audiences, and patrons. The multidisciplinary approach will be of great value to readers searching for information and insights about how technology is altering the ways in which we experience and interact with the creative industries.

For example, Chapter 2 explores the impact on visitors attending a digital, experiential exhibition in Milan, Italy, of Modigliani's work. The exhibit design used images, music, and narrative to place the viewer in a

"Parisienne context." Chapter 6 is "the first analysis to estimate the causal effects of investments in the digital transformation of cultural heritage at an international level." The adaptive struggles of the music industry to the digital world are meticulously presented in Chapter 8. And Chapter 13 presents fascinating findings on the transformative power of digital technology on digital workers at the Burning Man festival. Other chapters help us gain insights into how digital technology can democratize cultural consumption and the role that digital technologies and social media play in marketing and communications. Crowdsourcing projects using digital transformation in the heritage sector are also examined as a way to engage the public and to fundraise.

Digital Transformation in the Cultural and Creative Industries is a resource that scholars, researchers, and arts managers will want to reference during these unsettling times. It is also a very timely book. Arts managers saw how critical it was to be able to employ digital technology in 2020 during the pandemic. COVID-19 created massive disruptions across the creative industries. However, there were organizations able to connect to their audiences, patrons, and the general public, in part because they were digitally capable. Online exhibitions, streaming video performances, and engaging social media content helped to keep artists, cultural organizations, and audiences connected.[2,3] Arts organizations will need to accelerate their evolutionary processes and become more digitally adaptive as a result of the pandemic. This digital immigrant will be following these change processes closely and is optimistic that the cultural and creative sectors will innovatively respond.

William J. Byrnes
Management and the Arts
April 2020

Notes

1 Eichholz, J. C. (2017). *Adaptive change: How organizations can thrive in a changing world* (2nd ed., pp. 26–35). London: LID Publishing, Ltd.
2 U.K.'s National Theatre Goes Online After Coronavirus Closure. *Variety*, March 26, 2020. https://variety.com/2020/biz/news/u-k-s-national-theatre-goes-online-after-coronavirus-closure-1203546270/
3 Using Scenarios to Plan Your Museum's COVID-19 (Coronavirus) Response, American Alliance of Museums (AAM), March 13, 2020. https://www.aam-us.org/2020/03/13/using-scenarios-to-plan-your-museums-covid-19-coronavirus-response/. Accessed March 26, 2020.

1 Digital transformation in the cultural and creative sectors

Marta Massi, Marilena Vecco, and Yi Lin

Introduction

Digital transformation processes—now occurring in many sectors, including hospitality and mobility—are also influencing the way that art is traded and consumed (Camurri & Volpe, 2018) and pushing arts organizations to re-envision their business practices and models (Newman, 2010; Chaney, 2012; Lee & Lee, 2018). Digital transformation has contributed to making art consumption more interactive, dynamic, and democratic. The effects of digital transformation have been particularly disruptive in many arts industries, including music, print, and film, decimating entire sectors of the arts industry (Newman, 2010). This shift is even more evident in the arts sector where the technological and digital revolutions have gradually corroded the aura of originals or prototypes threatening the notion of authenticity (Benjamin, 2008). At the same time, online media allow artists to remove barriers and show their authentic self to their supporters (Samdanis, 2016).

The advent of the novel coronavirus (COVID-19) has inexorably affected arts organizations such as museums, theaters, and galleries. Most of them have switched to digital, offering virtual visits, concerts, and performances online, increasing worldwide access to creative activities, which might otherwise be out of reach.

In a context of progressive disintermediation of the art market, organizations decouple their structures and land on the Internet to conform to the norms of their changing institutional environment, to gain legitimacy in the eyes of and build trust among constituents (Meyer & Rowan, 1977). At the same time, new organizations come up that take advantage of digital transformation and disintermediation: for example, online platforms that act as institutional entrepreneurs (Battilana et al., 2009).

This book deals with the transformational process and the critical changes—brought about by the advent of digital transformation—that are leading arts, cultural, and creativity-based organizations to re-invent/revisit their traditional business models and are pushing artists to revise and adapt their way of creating and communicating their artworks. In the sharing economy's era, organizations are increasingly disintermediating

their activities. Instead of using traditional distribution channels, that is, intermediaries such as wholesaler or agents, they may now deal with every customer directly via the Internet. Therefore, digital transformation leads not only to "a new form of goods and services distribution" but also to a completely novel reconfiguration of production and consumption processes (Guignard, 2014, p. 43). By initiating a dialectic dynamic of "integration/ disintegration of activities" on the one side and one of "disintermediation/ re-intermediation" (Jallat & Capek, 2001; Guignard, 2014) on the other one, digital transformation is introducing new evolving paradigms that threaten to disrupt the art world (Guignard, 2014, p. 43).

The disruptive power of digital transformation

Digital transformation has the potential to alter the established mechanisms of the art world, by redefining the roles of producers, consumers, and cultural intermediaries (O'Connor, 2013). Empowered by digital transformation, consumers may now concretely turn into prosumers (Toffler, 1980; Ritzer, 2014) as they can interact directly to exchange and co-create art-based products and services based on a collaborative consumption perspective. In this way, a process of "Uberization" (Daidj, 2019) takes place in the arts world and increasingly, many services are offered that empower consumers to take an active role in the delivery process. Meanwhile, new cultural intermediaries emerge in the creative economy that are not necessarily "institution-based" (O'Connor, 2013).

The platform logic that characterizes an increasing number of sectors is expanding to other fields, which are not traditionally related to the sharing economy, including crafts, music, fashion, and film (Geissinger et al., 2018). This development is also evident in the arts world, where many organizations, such as museums and art galleries, are getting increasingly involved in a new digital transformation process (Samdanis, 2016). This is an evolution that has allowed them a presence on the web with an interface that is more engaging for customers. According to Benghozi and Lyubareva (2014) the Internet has become a new alternative environment where arts and creativity can be consumed, discussed, known, and purchased. Online platforms, such as Artsy, ArtStack, and Artpassport, that allow users to purchase, share, and create personal exhibits with artworks, are just few examples of how digital transformation is redefining how arts and cultural products and services are created, distributed, and consumed. This raises the question whether art should be a possession or an experience to be enjoyed by users, as individuals increasingly prefer "affordable and meaningful experiences over ownership" (Leeds Davis, 2017, online resource).

Although online trading of artwork is not a completely new phenomenon since many websites came up in the 1990s as a consequence of the "dot.com boom" (Adam, 2014, p. 121; Lee & Lee, 2018), digital transformation processes are now occurring more often than ever in the arts and cultural field,

where "online art entrepreneurs create value through digital networks that bypass intermediaries linking producers directly to consumers" (Samdanis, 2016, p. 4).

The impact of digital transformation on the arts

The impact of digital technology has affected the way artists produce their artworks. Digital transformation opened up new spaces and possibilities for art creation, leading the way for novel and innovative artistic genres and techniques, including net art, digital installation art, and virtual reality. Furthermore, digital transformation has provided artists with new tools to communicate with their fun base and to promote their artworks. For some artists, such as Ai Weiwei, and especially contemporary art and street art artists, such as Bernulia @bernulia, Tanaka_tatsuya @tanaka_tatsuya, and Beccaclason @beccaclason, Instagram represents the main platform through which they promote or sell their artworks, do cultural branding, communicate to fans, and experiment new media-based art forms "that push the boundaries of contemporary art and museum collections" (Samdanis, 2016, p. 2).

The "Uberization" (Daidj, 2019) of markets is something that all cultural and creative industries, including the arts, need to be conscious of, and be ready to respond to in this new economy. The main key to understanding this metamorphosis/change is the recognition of the integration/disintegration and disintermediation/re-intermediation dialectic processes that many of the sharing economy platforms deliver. Consequently, new roles and functions of the art organizations involved in the digital transformation process will be created.

On the one hand, the art world is not avoiding the digital transformation as increasingly art galleries and artists exhibit their artworks on their websites (Henning, 2006; Taşkıran, 2019), while art dealers found in the Internet new and alternative opportunities for making profit and meeting prospect customers (Velthuis, 2014; Lee & Lee, 2018). Meanwhile, artists are increasingly using social media such as Instagram or Facebook to release information on their exhibitions (Fletcher & Lee, 2012) and personal blogs for branding themselves and their artwork, and for "inducing transactions by making direct contacts with prospective buyers" (Lee & Lee, 2018, p. 3). Furthermore, new apps such as Magnus and ArtPassport are bringing contemporary art closer to people in an attempt to democratize and "demystify the art world" (Fetherstonhaugh, Founder of ArtPassport, cited in Doshi, 2018).

On the other hand, digital transformation has made artists, galleries, art dealers, and other art intermediaries "all very anxious these days" as an increasing number of innovative apps and algorithms have been introduced, which threaten to change the rules of the art market game (Kamer, 2016). Recently, the Department for Digital, Media, Culture and Sport (DCMS)

has issued guidelines to instruct UK arts institutions on how to "harness the potential of digital technology" in order to relate to a more and more active and engaged audience (Furness, 2018).

Disintermediation processes can offer to art collectors the opportunity to be involved in socialization processes that are important for them as well. Especially art collectors who would like to be part of an artistic project as partners of institutions such as galleries (as opposed to mere service or fund providers) could find in disintermediation and decoupling new opportunities for socialization (Riché et al., 2016). In this vein, social media allow arts organizations such as museums to communicate with their audiences; however, "this socialising trend is still in their infancy within the art world" (Enhuber, 2015, p. 121).

In addition, the advent of digital transformation has boosted entrepreneurship in the art market, "empowering agents to create value in the art market through the development of online platforms and new business models" (Samdanis, 2016, p. 3; Lee & Lee, 2018). Thus, the phenomenon of disintermediation, occurring in several sectors, is also extremely timely and strategic within the arts context; and particularly relevant for the segment of art collectors, who usually develop "a private and intimate relationship with the artwork" (Riché et al., 2016, p. 37). Art-tech platforms and apps allow these collectors and art lovers to sell art among them, skipping the art gallery step (e.g., ART Please), to get the artworks' name and price without asking experts (e.g., Magnus), to rent artworks online (e.g., Rise Art), and to get information on which art to buy/sell/liquidate based on market forces (e.g., Artrank).

Surprisingly, however, studies on digital art platforms are scant both in mainstream and in arts marketing field (Lee & Lee, 2018). At present, there are no books dealing exhaustively with the phenomenon of digital transformation in the arts. This book aims to cover this gap by offering a critical contribution to the debate on digital transformation from the stance of the actors involved and based on a multidisciplinary perspective. Additionally, to show how the theory turns into practice, this book proposes research on and the analysis of cases showing how arts organizations are dealing with digital transformation in the age of the sharing economy. This book collects some of the leading scholars and specialists in the field to provide both empirical and conceptual contributions. It guides the reader through the state of the art and possible perspectives of research and development in this specific area.

Purpose and objectives of the book

Through cases and examples, the authors examine how artists and art institutions, such as museums, and the creative industries are facing the challenge posed by digital transformation in the age of the sharing economy. Specifically, this book examines how digital technology can lead to

institutional turbulence and change the way arts and creativity are produced and consumed. The authors investigate how arts and creativity-based organizations are addressing such profound technological shifts, as issues of authenticity, legitimacy, control, trust, and co-creation arise whenever digital disintermediation processes occur. The book clearly identifies the main managerial implications that arts and culture administrators need to be conscious of to take advantage of digital transformation strategically as they enter a more dynamic era of the art and creativity production and consumption.

In particular, the book aims to:

1 delve into the phenomenon of digital transformation and sharing economy in the cultural and creative sectors, looking at it from a multidisciplinary perspective—characterized by dialectic dynamics between the managerial and the artistic lens—and taking into account the stance of the diverse stakeholders involved;
2 outline and analyze successful cases of arts organizations to show how the theory is turned into practice;
3 employ a multidisciplinary perspective and a variety of research methods, both quantitative and qualitative to explore the phenomena at study;
4 provide practitioners with an enhanced understanding of the phenomenon of digital transformation in the art and come up with implications and recommendations for arts managers; bring together and build a community of international art scholars and managers to investigate the phenomenon of digital transformation in the art.

The phenomenon of digital transformation in the art is dealt with by showing concrete cases of organizations that used digital technology strategically. The presentation of the cases is supported by data collected both directly and indirectly, that is, interviews, surveys, and secondary data.

Conclusion and introduction to the chapters

The book is organized as follows. Chapters 2, 3, 4, and 5 deal with new digital technologies in the museum context. Digital transformation has entered museums, with the introduction of tools, including gamification, augmented reality, and apps, which make art more democratic and much closer to users (Jarrier & Bourgeon-Renault, 2012). These chapters will show how museums are increasingly embracing digital transformation for "the display, promotion and conservation of their collections" and for providing their visitors with "a unique experience" (Samdanis, 2016, p. 2). Digital transformation allows museums to reach new audiences, as it democratizes access to art by making art collections available without limitations of time, money, or location (Enhuber, 2015). The implementation of

digital technology in museums favors an active customer engagement with art, thereby fostering art education (Enhuber, 2015). In particular, Chapter 2 presents the results of an ethnographic study conducted at MUDEC, the Museum of Cultures based in Milan, Italy, an institution that has particularly embraced digital transformation. Chapter 3 explains the phenomenon of gamification applied to art, while Chapter 4 makes the case for gaming as a means of audience development in a museum. Chapter 5 addresses digital transformation issues from the perspective of tour guides.

Digital transformation has also affected the management of cultural heritage. 3D acquisition and modeling technologies have been defined ideal for the recording of heritage sites (Guidi et al., 2009; Corns & Shaw 2009). This technology allows for generating "digital simulacrum of a real artifact, and the availability of digital tools for manipulating, exploring, comparing and explaining a virtual object," thus greatly increasing "the comprehension and the valorization of monuments" (Guidi & Russo, 2011, p. 71). Further, digital technology turns users into active content creators, thus empowering them as cocreators of value (Prahalad & Ramaswamy, 2004). For instance, projects such as Cyark (cyark.org), 3D Icons (http://3dicons-project.eu/), and Scottish Ten (scottishten.org) that digitally record, archive, and share cultural heritage are examples of the application of such technology. Projects such as Curious Travellers, the Million Image Database, Heritage Together, and Share Our Cultural Heritage take a step further in that they are not only aimed at the documentation of archaeological sites and monuments but also employ crowdsourced data (Dhonju et al., 2018). Other projects, such as Rekrei (Massi & D'Angelo, 2020), take advantage of photogrammetry, an innovative technology that allows to create a 3D model by using two-dimensional images of the same object taken from different angles (Remondino, 2011). Chapters 6 and 7 delve into digital transformation applied to heritage conservation.

The music industry has been strongly influenced by the technological changes brought about by digital transformation. Chapter 8 investigates how the digital evolution has benefited the musical world, facilitating the production of musical products and allowing a wider distribution. This chapter also shows how the innovations introduced have substantially changed the structure of the music industry, producing a series of notable changes from an economic perspective.

Performing arts organizations have represented for many years an important way for individuals and communities to connect, be entertained, and have important conversations. Yet audience expectations have been changing rapidly, and place-independent access to information and entertainment has become common place (CAPACOA, 2018). Chapter 9 aims to understand how digital innovation is affecting performing arts organizations in the context of live concerts.

Digital transformation has led to a real revolution in the film industry, determining the definitive abandonment of the film: a necessary change

that also had a reflection on film production, distribution, and consumption. By removing the physical number of copies, and eliminating the cost of printing logistics and delivery, the benefits and advantages of digital transformation have affected the whole industry as well as the consumer. The latter can take advantage of an enrichment of the schedule that completes the cinematographic offer also with a series of alternative, or "additional" contents, such as live events—concerts, operas, sports, didactics, and a more organized and complete schedule of films. Chapter 10 deals with the disruptive effects of digital transformation in the context of gender issues, while Chapter 11 shows how fashion and luxury sectors have fully adopted digital transformation. The increase in multi-channel and personalized services shows that, from an organizational point of view, many brands have overcome the historical gap between e-commerce channels and physical stores. Numerous brands, including Burberry, Louis Vuitton, Dior, Tod's, Valentino, and Prada, have introduced personalized shopping services, such as personal shoppers available via messages, telephone, or e-mail, as sales assistants who create personal relationships with customers via e-mail, the possibility of making an appointment in a store, and offer tailor-made services for tailored clothes.

Finally, Chapters 12, 13, and 14 analyze with how digital tools can be applied in art organizations to pursue different purposes. Chapter 12 examines the role of social media in the museum context. Even if the visual art world seems to be still reluctant to a full digital adaptation that characterized all the other sectors, a growing number of museums extensively apply social media and digital technology to their daily work and exhibitions, making art accessible to everyone anytime and anywhere. Chapter 13 focuses on digital workers in the context of a cultural festival, and Chapter 14 examines how digital transformation impacted donor management and fundraising in the arts.

References

Adam, G. (2014). *Big bucks: The explosion of the art market in the 21st century.* Farnham: Lund Humphries.

Antoncic, B., & Hisrich, R. D. (2001). Intrapreneurship: Construct refinement and cross-cultural validation. *Journal of Business Venturing, 16*(5), 495–527.

Battilana, J., Leca, B., & Boxenbaum, E. (2009). How actors change institutions: Towards a theory of institutional entrepreneurship. *Academy of Management Annals, 31*(1), 65–107.

Benghozi, P. J., & Lyubareva, I. (2014). When organizations in the cultural industries seek new business models: A case study of the French Online Press. *International Journal of Arts Management, 16*(3), 6–19.

Camurri, A., & Volpe, G. (2016). The intersection of art and technology. *IEEE MultiMedia, 23*(1), 10–17.

Chaney, D. (2012). The music industry in the digital age: Consumer participation in value creation. *International Journal of Arts Management, 15*(1), 245–249.

Corns, A., & Shaw, R. (2009). High resolution 3-dimensional documentation of archaeological crowdfunding campaigns? An Empirical analysis on Italian context. *Journal of Cultural Heritage*, 10(1), 72–77.

Daidj, N. (2019). Uberization (or uberification) of the economy. In M. Khosrow-Pour (Ed.), *Advanced methodologies and technologies in digital marketing and entrepreneurship* (pp. 116–128). IGI Global.

Dhonju, H., Xiao, W., Mills, J., & Sarhosis, V. (2018). Share our cultural heritage (SOCH): Worldwide 3D heritage reconstruction and visualization via web and mobile GIS. *ISPRS International Journal of Geo-Information*, 7(9), 1–16.

Doshi, A. (2018). ArtPassport: A digitalized and democratized experience of art. Retrieved 7 June 2020 from https://mastersofmedia.hum.uva.nl/blog/2018/09/23/artpassport-a-digitalized-and-democratized-experience-of-art/

Enhuber, E. (2015). Art, space and technology: how the digitisation and digitalisation of art space affect the consumption of art: A critical approach. *Digital Creativity*, 26(2), 121–137.

Furness, H. (2018). Art galleries 'must embrace digital technology' as the battle against phones is lost. *The Telegraph*. Retrieved 7 June 2020 from https://www.telegraph.co.uk/news/2018/03/07/art-galleries-must-embrace-digital-technology-battle-against/ on 01/01/2019.

Geissinger, A., Laurell, C., Sandström, C., Eriksson, K., & Nykvist, R. (2018). Digital Entrepreneurship and field conditions for institutional change-investigating the enabling of cities. *Technological Forecasting and Social Change*, 6, 2–10.

Guidi, G., & Russo, M. (2011). Reality-based and reconstructive models: digital media for cultural heritage valorization. *SCIRES-IT-SCIentific RESearch and Information Technology*, 1(2), 71–86.

Guidi, G., Russo, M., Ercoli, S., Remondino, F., Rizzi, A., & Menna, F. (2009). A multi-resolution methodology for the 3D modeling of large and complex archeological areas. *International Journal of Architectural Computing*, 7(1), 39–55.

Guignard, T. (2014). Digital intermediaries and cultural industries: the developing influence of distribution platforms. *Journal of Media Critiques*, 1(3), 43–54.

Jarrier, E., & Bourgeon-Renault, D. (2012). Impact of mediation devices on the museum visit experience and on visitors' behavioural intentions. *International Journal of Arts Management*, 15(1), 18–29.

Kamer, N. (2016). *7 Art apps that terrify artist: The seven art apps best suited to changing the art world forever*. GQ, October 28, 2016. Retrieved 7 June 2020 from https://www.gq-magazine.co.uk/article/best-art-apps on 01/01/2019.

Lee, J. W., & Lee, S. H. (2019). User participation and valuation in digital art platforms: The case of Saatchi Art. *European Journal of Marketing*, 53(6), 1125–1151.

Leeds Davis, B. (2017). *How has the sharing economy affected the art industry?* Retrieved 7 June 2020 from https://deemly.co/blog/how-has-the-sharing-economy-affected-the-art-industry/

Massi, M., & D'Angelo, A. (2020). Reversing heritage destruction through digital technology: The Rekrei project. In Seychell, D. & Dingli, A. (Eds.) *Rediscovering heritage through technology* (pp. 109–122). Cham: Springer.

Meyer, J. W., & Rowan, B. (1977). Institutionalized organizations: Formal structure as myth and ceremony. *American Journal of Sociology*, 83(2), 340–363.

Moreau, F. (2013). The disruptive nature of digitization: The case of the recorded music industry. *International Journal of Arts Management*, 15(2), 320–343.

Newman, B. (2010). Inventing the future of the arts: seven digital trends that present challenges and opportunities for success in the cultural sector. *20under40: Re-Inventing the Arts and Arts Education for the 21st Century, 15*(2), 3–19.

O'Connor, J. (2015). Intermediaries and imaginaries in the cultural and creative industries. *Regional Studies, 49*(3), 374–387.

Prahalad, C. K., & Ramaswamy, V. (2004). *The future of competition: Co-creating unique value with customers.* Cambridge, MA: Harvard Business School Press.

Remondino, F. (2011). Heritage recording and 3D modeling with photogrammetry and 3D scanning. *Remote Sensing, 3*(6), 1104–1138.

Riché, C., Vidal, M., & Moureau, N. (2016). Les Valeurs de Consommation des Grands Collectionneurs d'art. Etude des Représentations Médiatiques. *Revue Management and Avenir, 87,* 35–54.

Ritzer, G. (2014). Prosumption: Evolution, revolution, or eternal return of the same?. *Journal of Consumer Culture, 14*(1), 3–24.

Samdanis, M. (2016). Art and information technologies. In J. Hackforth-Jones & I. Robertson (Eds.), *Art business today: 20 key topics* (pp. 164–172). London: Lund Humphries.

Samdanis, M., & Lee, S. H. (2018). Uncertainty, strategic sensemaking and organisational failure in the art market: What went wrong with LVMH's investment in Phillips auctioneers? *Journal of Business Research, 98*(May), 475–488.

Toffler, A. (1980). *The rise of the prosumer. The third wave.* New York: Morrow.

Velthuis, O. (2014). The impact of globalisation on the contemporary art market. In A. M. Dempster (Ed.), *Risk and uncertainty in the art world* (pp. 87–108). London: Bloomsbury.

Part I
Museums

2 The impact of technology on visitor immersion in art exhibitions

Evidence from the Modigliani Art Experience exhibition

Antonella Carù, Piergiacomo Mion Dalle Carbonare, Maria Carmela Ostillio, and Chiara Piancatelli

Introduction

The digital transformation process now occurring in many sectors has influenced the way in which art is consumed and has contributed to making arts consumption more interactive and dynamic (Giannini & Bowen, 2019). In the light of increasing technological developments in the 21st century, cultural production and consumption patterns have been diversified and cultural spaces have transformed (Karayilanoglu, 2019). Digital technologies have changed how visitors interact and engage with their surroundings and a growing number of museums and art galleries extensively apply digital technology (Bowen, Giannini, Ara, Lomas & Siefring, 2019) and social media (Karayilanoglu, 2019) to their daily work and exhibitions.

Traditionally, museums have placed emphasis on preserving artifacts, collections, and relationships with artists (Kolb, 2013). However, the growing market competitiveness has led these institutions to consider the relationship with their visitors as a critical element of success.

Many contributions underlined the relevance of a marketing approach as a museum's relevant strategic issue (McLean, 1995a, b; Kotler & Kotler, 2000; Caldwell, 2000), but nowadays, most research concerns the so-called "experience economy" (Pine & Gilmore, 1998; Schmitt, 1999; Roussou & Katifori, 2018). There has been an increasing adoption of the notion of "user experience" by cultural institutions, such as museums, which compete with other venues for visitors' recreational time.

In the attempt to broaden the offer and attract new audiences, museums' managers have been trying to develop enjoyable customer experiences through relevant marketing strategies (Rentschler & Hede, 2009), "embracing the design of experiences for their visitors; that is, holistic, meaningful, personally encountered events or stories emerging from the dialogue of a person with her or his world through action" (Roussou & Katifori, 2018, p. 2). This mesh of psychological, social, and physiological qualities requires

a particular emphasis on emotions. Visitors should feel at ease and not frustrated, anxious, or disoriented during their museum visit (Goulding, 2000) by the creation of mindful activities, involvement and engagement, inner reflection and imagination, and variation of stimuli. Successful institutions challenge themselves with innovative approaches to enhance the visitor experience. For these approaches, based on experiential marketing (Schmitt, 1999) and experiential platform (Addis, 2005), increasing attention is paid to the role of digital technologies (Marty, 2008; De Blas, Bourgeon-Renault & Jarrier, 2015; Roussou & Katifori, 2018). These have been considered an effective tool to add value to the cultural experience and to stimulate curiosity in museum visitors too (Collin-Lachaud & Passebois, 2008; Roussou & Katifori, 2018). Thus, digital technologies become facilitators of the visitors' immersion in the artistic contexts (Bowen et al., 2019).

In recent years, some interest has been paid to the immersive exhibitions created thanks to digital technologies that allow the creation of an environment designed to encourage consumers' immersion, making them live a unique and engaging experience (Karayilanoglu, 2019). The commercial success of several of these digital immersive exhibitions makes it interesting to further investigate and understand the experience lived by consumers in such contexts: described as a way of presenting physical artifacts in a digital way (Dumitrescu, Lepadatu & Ciurea, 2014).

To this end, the aim of this chapter is to analyze the relevance of immersion in the artistic and cultural contexts with a specific focus on visitors' experience in the immersive exhibitions, mediated by digital technologies.

The first part of the chapter presents some conceptual issues related to the literature on postmodern consumption experiences, focusing on the concept of immersion as a way for consumers to escape their ordinary life routines. The chapter then focuses on the digital technology-driven immersive exhibitions by the integration of digital tools/media and physical artifacts, connected or disconnected to the original site, describing how various exhibitions can enhance the visitor experience and immersion. This classification introduces the subsequent study of the Modigliani Art Experience exhibition. The second part of the chapter presents an exploratory study using an introspection-based research methodology conducted on the Modigliani Art Experience exhibition held at the MUDEC Museum in Milan with the aim of understanding the consumer experience by the characteristics of the immersion process. The final part of the chapter is dedicated to an initial reflection on the impact of these experiential settings on visitor experience and on how arts managers can navigate the emerging era of digital in the museum setting.

Consumption experience, immersion, and escape

In today's society, the consumption experience has become increasingly important as a consequence of the transformation of the role of consumption in

postmodern society (Firat & Dholakia, 1998; Maclaran, 2009). Throughout the 21st century, several art museums have changed their main objective according to technological developments, socio-cultural changes, and expanded in line with contemporary social needs, which has led them to define new scopes and goals. The primary goal is to be inclusive of all segments of society (Karayilanoglu, 2019).

Such visitors don't employ a utilitarian approach and seek a functional dimension in their purchase, but rather a holistic dimension (O'Connor & Wynne, 2017). They are more interested in experiences where to immerse themselves: "Life is to be produced and created, in effect, constructed through multiple experiences in which the consumer immerses" (Firat & Dholakia, 1998, p. 96). It is widely acknowledged that today's consumers seek immersion in a variety of experiences ranging from a hyper-real (Goulding, Shankar & Elliott, 2002) to a brand-related environment (Roussou & Katifori, 2018).

Consumers strive to escape their everyday lives by immersing themselves in experiential contexts with specific boundaries, since this allows them to break with (and step outside of) their daily lives, bringing them into a separate alternative world (Firat & Dholakia, 1998; Silva, Duarte, Machado & Martins, 2019) where all the usual worries and hardships they face disappear.

While Holbrook and Hirschman's (1982) seminal work shows that consumers look for sensory-emotional arousal and escape from reality, other studies show that consumers constantly pursue forms of escapism from everyday life through shopping (Babin, Darden & Griffin, 1994) or extraordinary experiences (Canniford & Shankar, 2013). Individuals want to escape routine. Consumer research has shown that individuals who live in unsatisfactory or frustrating situations try to change the status quo to enhance (De Groot, 1998; Budge & Burness, 2018) or escape their reality through consumption (Budge & Burness, 2018).

The need to escape may refer not only to the market and family, as historically considered, but also to work life as a specific area from which individuals want to escape (Scott, Cayla & Cova, 2017). Many jobs put pressure on individuals, limiting their creativity and resembling factory assembly lines (Crawford, 2009). Organizational life has become a rigid structure that puts pressure on individuals (Cederström & Fleming, 2012) who are seeking flexibility and detachment (Bardhi & Eckhardt, 2017).

Consumer immersion in experiential contexts allows them to step outside their daily lives in a defined space where they do not need to pay attention to threats to safety (Carù & Cova, 2006), can experience multiple identities (Budge & Burness, 2018) and develop an alternative self (Belk & Costa, 1998). Therefore, the consumers' final aim is not to experience a specific, defined mode, but to find their way through different ones.

The debate on escapism has also addressed the role of technology: from traditional television, that has represented the ultimate form of escapism since the 1960s (Kubey, 1986) to virtual experiences. Some authors have focused

on the risks of addiction to virtual experiences in youth (e.g. Blinka & Smahel, 2011), while others (e.g. Calleja, 2010) attempt to understand the impact of virtual experiences and escapism in consumers' lives. Given the pervasive role of technology and digital transformation in our daily lives, researchers identify digital virtual consumption as compulsive (Kozinets, 2008) and self-gratifying (Denegri-Knott & Molesworth, 2010). Digital consumption is a typical context for liquid consumption (Bardhi & Eckhardt, 2017) where consumers' selves can be extended, moving easily among multiple identities (Belk, 2014).

The influence of immersive technologies on the museum experience

The importance of technology for museums is highlighted by the number of studies that have dealt with the topic from various perspectives (Collin-Lachaud & Passebois, 2008; Jarrier & Bourgeon-Renault, 2012; Dumitrescu et al., 2014). Considering the degree of development and diffusion of digital culture, researchers in the field of information and computing have highlighted the importance for museums in dealing with the digital revolution in order to maintain their influence in modern society (Giannini, 2019): challenging the traditional approaches and paradigms, rethinking exhibitions merging physical and digital culture (Giannini & Bowen, 2019). This challenge had an important impact on the management of the relationship with visitors. Visitors, if provided with technological devices together with their increasing digital competences, may play an increasingly active role in the creation of their own experience (Budge & Burness, 2018).

Among the various studies, some have analyzed the transformation of digital devices throughout the customer journey, highlighting how visitors can manifest different reactions toward technological devices: resonance (complete adhesion to the devices), submersion (becoming emotionally steeped in the experience, with no distancing), critical distancing, banalization, and rejection. Only with resonance does the visitor become wholly involved in appropriating the experience, which is facilitated by interactive mediation (Jarrier & Bourgeon-Renault, 2012).

Visitors contribute to the museum environment thanks to technological devices; for example, the everyday use of smartphones with high-quality built-in cameras has led to an increase in museum visitors' use of these devices to document and share their museum experiences (Weilenmann, Hillman & Jungselius, 2013). Other mediation devices, such as digital screens, are also useful in history museums since they can provide the contextual elements needed to experience the past (Pallud & Monod, 2010). Museum websites function as a virtual stage that can integrate the experience. These are also similar to "internet presence" sites (Hoffman, Novak & Chatterjee, 1995) designed to promote the institution and attract visitors to the physical museum.

An exploratory study on the use of immersive technologies in museums showed a positive impact of such technologies on the customer experience in general (Collin-Lachaud & Passebois, 2008). This study identifies six sources of value that are affected by immersive technologies (i.e., function, cognition, affectivity and sensoriality, play, escapism, and social). The two primary sources of value are cognitive and emotional. Two values with different objectives, cognitive more concerned with the learning outcome, and emotional more concerned with the hedonic element of the experience. These results show that the use of digital technologies in a cultural context can enhance the learning outcome while stimulating emotions and the senses. The study identifies a negative impact of immersive technologies on the social aspect, which is in contrast with the more traditional characteristic of the cultural experience, identified as an enabler of social connections and interactions (Debenedetti, 2001; Pulh, 2002).

Immersive technologies are also identified as a tool to speed up the escape from reality. Traditional art and culture activities seem to take more time to allow the visitor to feel immersed in the experience, and technology is considered a facilitator of this process. When considering the functional value of immersive technologies, the results are contradictory: on the one hand, such technologies support the operation and efficiency of processes in terms of visitor flows and level of comfort; on the other hand, at same time, they can limit the experience in terms of freedom of movement and accessibility. These aspects reduce the value of the experience. Immersive technologies support a high level of cognitive value for consumers, facilitating the transfer of information and enhancing the educational purpose of the experience (more information and easier to grasp).

Lastly, immersive technologies provide emotional and play value. The use of technology allows visitors to stimulate their senses (hearing and sight) and emotions as well as the sensorial experience. At the same time, such experiences provide a strong value of play that increases the level of the experience.

In an effort to provide consumers with valuable experiences, arts and culture institutions have introduced a new approach to cultural consumption mediated by technology; the digital exhibitions that aim to represent and present physical heritage artifacts in a digital way, facilitating their access (Dumitrescu et al., 2014) thanks to the use of images, music, projections, and emotional and sensorial stimuli. Considering that in these new concepts of exhibitions there is an important increase of the digital component against the physical one, it appears interesting to investigate how consumer immersion develops in such contexts and how this has an impact on the customer experience.

Immersive exhibitions

In the arts and cultural world, a number of trends can be recognized that have an impact on museum experience design. A first evident shift saw

the museums move from collection-focused to visitor-focused management, and from a mission driven by preservation and accessibility to one offering meaningful engagements with the collection and rewarding learning experiences for their public (Vermeeren, Calvi & Sabiescu, 2018). Furthermore, museums and cultural institutions have invested in digital transformation of their collection and activities in order to support search and discovery by users. On the other hand, virtual or digital exhibitions can offer alternative experiences to the "real one" and open up other opportunities for visitors—far from a place or a site—that include education and learning, different type of content, as well as support for active and immersive participation by visitors. These considerations have led the authors to describe some of the major experiential exhibitions, between 2011 and 2019, with the objective of organizing the immersive exhibitions landscape. The technological or digital modes or media have not been considered.

The first dimension of the immersive exhibitions categorization (Table 2.1) takes into consideration the degree of the exhibit's connection with the place, the site where they are held: although virtual art exhibitions have similar characteristics in terms of the use of technologies and multimedia, they can be categorized based on the proximity to where they are performed and some critical elements that characterize these immersive spaces. The second dimension instead looks at the level of integration between the physical and digital aspects. One of the first and most famous experiential art exhibitions is "Van Gogh Alive," an experiential exhibition created by Grande Exhibitions and initially conceived in a site-specific venue—Arles, France—where the artist lived and worked, which evoked a strong connection with the artist himself. Since its launch in 2011, Van Gogh Alive has been the most visited experiential exhibition, with more than eight million visitors and activities in 100 cities around the world.

Since then, many similar experiences have been promoted and organized globally, promoting experiential exhibitions linked to renowned artists, such as Klimt, Da Vinci, Monet, and Modigliani, among others. At first sight, these experiences may seem similar to the original; however, they can be differentiated based on the value of the connection to the place where they are held as well as on a series of elements that characterize this type of exhibition (Figure 2.1).

Degree of connection with the original site

The first type is the site-specific exhibit. An example is the Ara Pacis Museum in Rome, characterized by a strong connection with the place where the experience takes place. In this case, the opportunity to experience through virtual reality the "Ara as it was" takes place on the very site where the original site is located. The experience, however, is different from other immersive exhibitions, as it concerns a specific site and occurs independently, leaving the visitor fully detached from the external.

A second typology includes those experiences that take place in proximity to the real heritage. Some instances are the Giudizio Universale in Rome

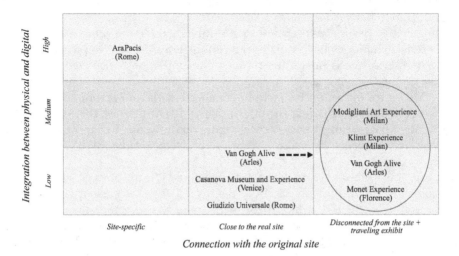

Figure 2.1 Typologies of immersive exhibitions.
Source: Authors' elaboration.

and Casanova Museum in Venice. The Giudizio Universale is an experiential show taking place across from the Vatican Museums and aims to tell the story of Michelangelo and the Sistine Chapel, with live performances and images projected at 270°. The Casanova Museum conveys the history of Giacomo Casanova by mixing real heritage (his original apparel) with technology (music and images) to generate a real Venetian atmosphere. The Museum, located in Venice, includes an introduction to the main places around the city that concerned Casanova's life. In this second typology we can also include exhibitions that have been conceived with a strong connection to the place and have become a traveling exhibit, replicated around the world, losing the strong connection with the place of origin. An example is the exhibition Van Gogh Alive, which was conceived in Arles but subsequently became a traveling exhibit (see Figure 2.1).

In contrast, traveling experiential exhibitions that have no connection with the original site where they were conceived represent the third and last typology. These exhibitions lack a site-specific connection and can be replicated almost anywhere. Examples include the Modigliani Art Experience and the Klimt Experience in Milan, and the Monet Experience in Florence. These exhibitions were replicated in other cities and different spaces.

Level and nature of integration between the physical and digital aspects

With the second dimension, the authors took into consideration the role of digital transformation in each of these typologies of a new type of museum experience that gradually emerged in the course of time. As shown

in Figure 2.1, traveling experiential exhibitions may have a low or medium integration between the physical and digital. In fact, this depends upon the presence of original artifacts in such exhibitions. On the other hand, site-specific exhibitions have a high degree of integration between physical and digital. Lastly, it is interesting to note how exhibitions organized close to the original site have a low integration between physical and digital.

Museum experiences began to be enhanced by the integration of interactive and digital media that encourage visitors to engage with the content on exhibit, to experiment with the techniques on show, and to appropriate the visiting experience by making it meaningful and memorable (Vermeeren et al., 2018).

Several studies have analyzed the impact and effectiveness of such technologies (Tallon & Walker, 2008; Bautista, 2013; Vermeeren, Calvi, Sabiescu, Trocchianesi et al., 2018), with some showing that these can be effective in stimulating sensory and aesthetic experiences in museum visitors (Jarrier & Bourgeon-Renault, 2012) as well as engaging and educating them (Alelis, Bobrowicz & Ang, 2015).

The crossover between virtual and physical integrations in exhibitions is particularly interesting, as it places the focus on the physical artifacts and simultaneously on digital capabilities specifically created around the personalized user vision and experience. These exhibitions may have some advantages, such as the relative ease to add new components or change existing ones in the form of adding new elements, updating, and reusing existing ones, or adding new educational components. Technologies are considered facilitators of the visitors' immersion in the artistic contexts (Bowen et al., 2019).

The presented categorization can be considered an interesting tool in describing how various experiential exhibitions have given more space to visitor agency and creative intention, reaching out to models in which visitors are involved as consultants or partners in co-designing museum experiences or even museum exhibitions.

The case of Modigliani Art Experience

The Modigliani Art Experience was held at MUDEC Museum in Milan from 20 June to 4 November 2018. Founded in 2014, MUDEC is a museum dedicated to interdisciplinary research of the cultures of the world and focuses on the relationship of these cultures within the landscape of Milan. MUDEC aims to acknowledge the impact and presence of foreign communities in Milan and describes itself as a meeting place for cultures and communities. MUDEC can count on a building in the design district of Milan which houses 17,000 square meters of space for the collection, exhibitions, and various educational and community activities. In addition to its unique function and role within the dense network of Milanese museums, MUDEC has a unique governance structure with both public and

private management between the Milan City Council and 24 ORE Cultura (MUDEC, 2019). Milan City Council is responsible for the management, preservation, and promotion of cultural assets as well as supervision of Forum of Cultures activities, while 24 ORE Cultura is responsible for the organization of exhibitions and additional services. This museum is an interesting context because, being relatively recent, the museum managers have been struggling to define a specific identity for the brand given its hybrid nature (both public and private).

The Modigliani Art Experience is an example of how digital technologies are used to enhance the museum experience. It is the second exhibition of this kind hosted at MUDEC; the first was the Klimt Arts Experience that saw a record number of 103.181 visitors. The experiential exhibition incorporates most of the digital technologies seen in large-scale contemporary art museums:

> "Modigliani Art Experience" is a fascinating narrative, represented through images, music, sounds and suggestions that will recreate in front of the visitor the universe of Amedeo Modigliani painter and sculptor, allowing the projection in the Parisienne context where Modì - the tragic artist by definition -was a main character.
>
> (MUDEC, 2018)

Research context and methodology

The Modigliani Art Experience was not a site-specific exhibition (based on the Immersive Exhibitions' categorization presented), but it included some original Modigliani artworks. The Modigliani Art Experience is a traveling exhibition of the renowned artist with an interesting but troubled life, whose works were influenced by the social and historical context in Italy and in France. Being a fully digital experiential exhibition, it was selected as the research context as it represents an opportunity to investigate the experience lived by visitors in such settings and the state of immersion they experienced.

The exhibition adopted a multisensory approach to accompany visitors in their journey of discovery of Modigliani's artistic style: the influence that Primitivism, African, Egyptian, and Cycladic sculpture is combined with the artist's Bohemian life. The multimedia approach and immersive feel of the MUDEC exhibition were enhanced by the two rooms bookending the visit.

The entrance room displayed masterpieces of 20th-century African art from the MUDEC collection alongside three Modigliani portraits from the Museo del Novecento di Milano, enabling visitors to make a direct comparison between the works and to appreciate the influence that these models of Primitivism had on the genius's work. The exhibition ended with an Infinity room where visitors were confronted with some of the artist's most iconic works appearing in a continuous play of refractions and splintered images

alongside a more classic account of the artist's life and the historical, social, and cultural context in which he produced his work.

The research had the aim of understanding of participants subjective experience during the exhibition and was based on the analysis of their introspective reports in agreement with Richardson (1999), "although agreeing that we can never know anything about a subjective experience as such, it is possible to search for an intermediate solution by arguing that we can at least study the reports that are made" (p. 470). Although close to the category that Wallendorf and Brucks (1993) described as "guided introspection," this type of retrospective introspection differs in that the subject's report is compiled in the absence of a researcher. The reports were based on a preparatory phase, during which the participants were asked to attend the exhibition and pay attention to their feelings, emotions, and thoughts during their experience, then write down an introspective report, free in length and open-ended, within a couple of days of the visit and send it via email to the authors.

The study involved ten people: three of the authors of this chapter, students attending a course at Bocconi University or participating in a program delivered by SDA Bocconi School of Management, who were invited to attend the exhibition on a voluntary basis. The age range of the participants was between 22 and 58 years. All participants were already familiar with Modigliani and had attended at least one traditional exhibition of the artist in their life. The merger of horizons recommended by Thompson for the reports' interpretation (1997) was facilitated by the three researchers involved, who followed an auto-ethnographic approach, which according to Reed-Danahay (1997) can reduce the gap between the text and the text's interpretation framework.

A thematic and structural inter-textual and an intra-textual analysis was conducted on the introspective reports, in order to assess the process of immersion and the role of various digital stimuli offered during the exhibition. We identified the realization of a state of immersion through a textual breakdown based on the presence of verbs and verbal locutions making explicit reference to feelings of pleasure and enjoyment of the exhibition and claims which show an individual's escape from his/her current environment as a result of specific emotions and feelings. In this context, we attempted to identify which kind of situations and stimuli were more important to achieve a state of immersion.

Results

Through the analysis of introspective reports, we were able to identify seven elements that have influenced visitor experience as well as their state of immersion. The seven elements are the following and will be discussed below: enjoyment and frustration; space and time fluidification; holistic storytelling about the artist; the power of music; voices, words, images for

comprehension and self-reflection. Questionable role of physical space and misalignment of expectations also emerged.

Enjoyment and frustration

Out of the ten participants, six enjoyed the exhibition—two of them lived a fully immersive experience (Informant 7 and 10); the others (Informant 3, 4, 6 and 8) alternated moments of immersion—three declared that the experience could have been better (Informant 1, 2 and 9), and one (Informant 5) found it to be boring.

Some extremely positive comments came from people who enjoyed the exhibition and were able to live a full immersion: "The emotions transferred by this exhibition are unique" (Informant 7), while frustration emerged in absence of enjoyment and immersion: "I did not find the exhibition particularly exciting nor immersive; the soundtrack was monotonous and I found the exhibition a boring one" (Informant 5).

It is important to highlight that some reports appeared to be poor in content, not due to the lack of commitment and enthusiasm of participants, but the difficulty in expressing emotions for this specific exhibition. A possible explanation may be the exhibition's limited ability to involve and surprise visitors. Nevertheless, some relevant elements, both positive and negative, regarding the impact on the immersion, emerged.

Space and time fluidification

The accounts of informants, who enjoyed the exhibition the most, recognize that digital technologies facilitate the immersion by speeding up and smoothening it: "In a few seconds we were able to go from modern and fast Milan to the 20th century of Modigliani" (Informant 8)

Holistic storytelling about the artist

Some elements were particularly relevant for the immersion: the historical context, the artistic production, the artist's life and influences. All these elements emerged as critical for learning and for the experience, in contrast with other types of artistic exhibitions where these references are not easy to grasp and understand. Participants appreciated the opportunity of being able to look at the broader picture and not only at the single masterpiece or artist: "The opportunity to understand the artist in a specific historical context" (Informant 7) and "Getting to know what happened in the world during Modigliani's works helped in reading its artistic production" (Informant 4)

These elements were facilitated and coherent with technology- and experience-driven tools, such as the use of words, music, images, and the construction of physical spaces.

The power of music

The participants identified music as an important facilitator of the experience: "The music facilitated the listening and learning" (Informant 10) and "The projections of the images followed the rhythm of the music" (Informant 3). Music also served to generate emotions, mainly positive, during the experiences: "The music was relaxing and helped me follow the story" (Informant 6).

In a few cases—and, in particular, before entering in the main room—the impact of music was negative: "I could hear the music from outside and I became annoyed" (Informant 1).

Voices, words, images for comprehension and self-reflection

Voices, words, and images were also identified as facilitators of the experience that allowed visitors to discover details about the artist and the artistic production, enabling an instant comparison with other forms of art that have influenced the artistic productions and their emotional impact: "The voice of the speaker that makes me more seduced by the voice than by the setting" (Informant 8) and "Images of masterpieces that are connected with the evolution of the life of Modigliani" (Informant 7).

The ability of digital technology to enhance critical thinking, self-awareness, and historical and/or artistic connections emerged from the introspective accounts. In some cases, visitors declared that the exhibition allowed them to look into their lives and personal development. In two cases, visitors highlighted the opportunity to compare the innovative impact of Modigliani (as well as other artists) with that of digital technologies today, drawing a connection between innovation capacity and creativity: "Thanks to the exhibition, I was able to reflect on my life and my personal growth" (Informant 4) and "It made me think how many times I had to make choices" (Informant 8).

In some cases, however, this self-reflection had an overriding effect on the integration with the exhibition. Some participants found the speed with which the various elements of the story followed one another annoying, and in fact alternated moments of attention with moments of abandonment of the thread of the exhibition, taking refuge in their own thoughts, often connected to individual stimuli—particularly music or moments in the artist's life—evoking experiences lived: "When La Traviata starts playing, the music dominates over images and words, and it drives my emotions" (Informant 1) and "In the end the projections started over, but I stayed there anyway, immersed in my thoughts" (Informant 7).

In these cases, irritation toward the abundant images and words accentuated the tendency to abstract from the exhibition and follow other thoughts: the setting simply became the background from which to abstract, an occasion to escape into themselves.

Questionable role of physical space

In terms of the physical space, visitors had various opinions. On the one hand, perceived as dark and uncomfortable, dispersive, and on the other, the physical space represented a place where living her/his own experience, with limited integration with others: "I was not sure where to sit in order to experience the exhibition at its best" (Informant 9); "A large room with benches, perhaps there should have been rotating chairs" (Informant 6); "I was able to fully immerse myself thanks to the lights, images and music" (Informant 3) and "Each person was able to have their own experience, despite everyone being together" (Informant 4).

The distinctiveness of the physical space allowed visitors to interact while experiencing the exhibition itself: "I was standing but when I saw that everybody was sitting on the ground I decided to do so" (Informant 4).

Interesting to note is that the dimension of the community was rarely highlighted. The exhibition allowed visitors to share information and exchange views after participation while living it in autonomy: "I will speak about it with my friends and invite them to come to the exhibition" (Informant 6). Important elements that emerged on the physical space were the noise and smell at the beginning of the exhibition as well as a dark and very formal corridor: "In the first aisle there was a smell of pizza and popcorn, together with noise caused by plates" (Informant 2) and "A long aisle with displays full of words and very static" (Informant 1).

These elements clashed with the idea of an experience declared not only in the title of the exhibition but also at the ticket counter. Lastly, an element of the physical space that generated interest in some of the visitors was the similarity between the experience and a cinema: "In the end it felt like participating in a movie more than an art exhibition, or perhaps a mix of the two" (Informant 1).

Misalignment of expectations

In some cases, the expectations were in contrast to the real experience, generating confusion in the visitor's mind. In this context, in two cases, the visitors did not know that the experiential model included only very few originals and was based on the sum of music, images, and lights to stimulate visitors: "When we go to an exhibition, we expect to buy the ticket and see works of arts" (Informant 5) and "The experience was good, but I missed seeing first-hand the real works of art" (Informant 6).

Discussion and managerial implications

Based on the analysis of the different typologies of digital exhibitions and the qualitative research conducted on the Modigliani Art Experience, our work contributes to understanding the experience lived by consumers

and identify which kind of situations and stimuli were more important to achieve a state of immersion in those contexts.

Digital technologies facilitated the immersive experience generating new knowledge, critical thinking, and the reminiscence of past knowledge and experiences. In fact, our research shows that thanks to the immersive context, the majority of visitors experienced a furthering of their knowledge on Modigliani, but above all on the social and historical context in which he worked. Moreover, the experience allowed recalling other similar experiences and previous knowledge about the artist and the social context. In some cases, the copious stimuli inhibited immersion and led to a limited appreciation or escape from the exhibition.

The present research brings some contributions to the discussion on the impact of technologies on the experience in museums and cultural institutions. In line with previous research (Collin-Lachaud & Passebois, 2008), our results confirmed that technology facilitates the cognitive and emotional values of the experience; the presence of references and the ability of consumers to identify them are fundamental to facilitate a state of immersion (Carù & Cova, 2006); however the access to stimuli can inhibit immersion, leading visitors to distance themselves from the setting.

A pivotal element to be highlighted is the critical role of technologies in enhancing further knowledge of the artist, his life, and the historical background in which he lived. Knowledge of these elements was appreciated by visitors and brought added value to experience. In practical terms, more traditional exhibitions may consider the involvement and adoption of digital technologies in supporting visitor learning, thus achieving their institutional objectives. Better knowledge of the historical context, together with the life of the artist, may lead to a better understanding of the artist's production.

A second element that emerged from the analysis is related to the impact of technology on the emotions. Specifically, images and music served as facilitators and generators of emotions. The emotions generated were both positive and negative. The use of music and images in some cases generated negative emotions, putting pressure on the visitor to move from the introductory room to the main room. The lack of a clear distinction in physical spaces and the allocation of the spaces themselves, together with the smell and the noise, generated negative emotions in visitors and affected their experience.

The social value of the experience is less strong and clearly identifiable. If, on the one hand, museums are places where social connections and activities occur, immersive exhibitions, through escapism, seem to have a bigger impact at an individual level. The context and characteristics of this exhibition, however, generated two types of socially related aspects: the opportunity to speak about the exhibition and invite friends to attend, and the effects of other people on the individual's behavior (most people were sitting on the floor, and individuals were influenced by those already sitting, thus deciding to sit down).

A new and interesting element that emerged is related to introspective reflection. This type of exhibition, leveraging generation and acquisition of knowledge and information, creates a positive setting for visitors to relate the story of the artist and his life to that of their own. Digital technologies served as a medium for activating memories and connecting occurrences in people's lives to those of the artist. This generated emotions that facilitated the immersion process. At times, however, the abundance of stimuli led to introspection in a way that was totally unrelated to the exhibition.

The use of digital technologies can enhance the visitor experience, generating knowledge and emotions. Managers of more traditional exhibitions should take these elements into consideration to combine digital-driven and physical heritage, to support meeting the institutional objectives as well as generating visitor immersion.

Lastly, an important element that emerged from the research and that should be further investigated is related to the similarities between the movie experience and the experiential exhibitions. If, on one side, the role of the audience in a cinema has been identified as passive due to the limited opportunity to move around (Santese & Botti, 2012), in experiential exhibitions, visitors can move around and find their own space while interacting with other visitors. This element could be a new point of interest for research in the field of experiential exhibitions and the role of digital technologies in facilitating the experience of individuals, highlighting which elements of the movie experience could bring value to more traditional exhibition experiences.

Conclusion

Our work builds on a growing stream of research and practice that strives to enrich museum visits by digital means. The aim of the chapter is to unveil and discuss the elements that facilitated the immersion in experiential exhibitions through the use of digital technologies and how it contributes to providing an in-depth understanding of the evolution of marketing in the evolving and complex environment of the arts system. By analyzing the impact of digital technologies on visitor experience exhibitions, the chapter contributes by identifying new cues for the development of marketing in the arts and cultural organizations from a business standpoint.

This chapter opens some questions which may be answered in future research and studies on various typologies of immersive exhibitions with increasing success among the public. Specifically, the evaluation deployed with the Case of Modigliani at the MUDEC Museum of Milan provided insights into innovative user experiences in a museum context which is challenging the traditional way of arts consumption. Overall, visitors had a very positive response to the experience, indicating that more unconventional, for example, storytelling, approaches to engaging with cultural content may greatly contribute toward more compelling visiting experiences. However,

it is important to highlight some limitations of the study. The first one being related to the characteristics of the exhibition, country-specific (in Italy): opening up to a more international context would be useful. Moreover, it would be interesting to investigate the visitors' experience in various kinds of digital immersive exhibitions, analyzing the integration between physical and digital. Lastly, an issue which requires further research is related to the difficulties encountered in obtaining in-depth individual accounts—some reports appeared to be poor in content—as well as the need for a more gender-balanced pool of informants.

This chapter should be considered an exploratory study and further research should be done on the topic. A follow-up project is already underway with the objective of researching the emotive potential of interactive storytelling experiences that resonate with visitors, informed by the lessons learned from this evaluation and the considerations presented in this chapter. Further analysis of immersive exhibitions should be conducted to deepen the understanding of the impact of digital technology on the visitor experience and to highlight the main implications for museums and exhibition marketing. These insights on new visitor experiences through technology with arts and cultural organizations can inform current thinking as well as approaches and practices in museums. Additional research should be carried out in other digital immersive exhibitions, to examine whether the difficulty in expressing emotions and memories are related to the specific exhibition or may be generalized due to the peculiarities of such immersive exhibitions, which, on one side, facilitate the immersion but, on the other, inhibit the peculiarities which characterize memorable experiences (Csikszentmihalyi, 1997). One final but very relevant theme that future research should consider is the impact that immersive exhibitions have on the diffusion of arts and culture in our society.

References

Addis, M. (2005). New technologies and cultural consumption–edutainment is born! *European Journal of Marketing, 39*(7/8), 729–736.

Alelis, G., Bobrowicz, A., & Yang, C. S. (2015). Comparison of engagement and emotional responses of older and younger adults interacting with 3D cultural heritage artefacts on personal devices. *Behaviour and Information Technology, 34*(11), 1064–1078.

Babin, B. J., Darden, W. R., & Griffin, M. (1994). Work and/or fun: Measuring hedonic and utilitarian shopping value. *Journal of Consumer Research, 20*(4), 644–656.

Bardhi, F., & Eckhardt, G. M. (2017). Liquid consumption. *Journal of Consumer Research, 44*(3), 582–597.

Bautista, S. S. (2013). *Museums in the digital age: Changing meanings of place, community, and culture.* Lanham, MD: AltaMira Press. Belk, R. (2014). Digital consumption and the extended self. *Journal of Marketing Management, 30*(11–12), 1101–1118.

Blinka, L., & Smahel, D. (2011). Addiction to online role-playing games. In K. S. Young & C. N. de Abreu (Eds.), *Internet addiction: A handbook and guide to evaluation and treatment* (pp. 73–90). Hoboken, NJ: Blackwell-Wiley.

Bowen, J. P., Giannini, T., Ara, R., Lomas, A., & Siefring, J. (2019). Digital art, culture and heritage: New constructs and consciousness. In *Proceedings of EVA London 2019 (EVA 2019)*.

Budge, K., & Burness, A. (2018). Museum objects and Instagram: Agency and communication in digital engagement. *Continuum, 32*(2), 137–150.

Caldwell, N. G. (2000). The emergence of museum brands. *International Journal of Arts Management, 2*(3), 28–34.

Canniford, R., & Shankar, A. (2013). Purifying practices: How consumers assemble romantic experiences of nature. *Journal of Consumer Research, 39*(5), 1051–1069.

Carù, A., & Cova, B. (2006). How to facilitate immersion in a consumption experience: Appropriation operations and service elements. *Journal of Consumer Behaviour: An International Research Review, 5*(1), 4–14.

Cederström, C., & Fleming, P. (2012). *Dead man working*. London: Zero.

Collin-Lachaud, I., & Passebois, J. (2008). Do immersive technologies add value to the museumgoing experience? An exploratory study conducted at France's Paléosite. *International Journal of Arts Management, 11*(1), 60–71.

Csikszentmihalyi, M. (1997). *Finding flow*. New York: Perseus Book.

De Blas, M. D. M., Bourgeon-Renault, D., & Jarrier, E. (2015). Can interactive mediation tools bridge the identity gap between the public and the art museum? *International Journal of Arts Management, 18*(1), 52–64.

De Groot, G. J. (1998). *Student protest: The Sixties and after*. London: Longman.

Debenedetti, S. (2001). *Rôle et impact de l'accompagnement du visiteur du lieu culturel: le cas de la sortie au musée d'art* (Doctoral dissertation in Sicences de Gestion). Université Paris Dauphine, Paris.

Denegri-Knott, J., & Molesworth, M. (2010). Concepts and practices of digital virtual consumption. *Consumption, Markets and Culture, 13*(2), 109–132.

Dumitrescu, G., Lepadatu, C., & Ciurea, C. (2014). Creating virtual exhibitions for educational and cultural development. *Informatica Economica, 18*(1), 102–110.

Firat, A. F., & Dholakia, N. (1998). *Consuming people: From political economy to theatres of Consumption*. London: Routledge.

Giannini, T. (2019). *Museums and digital culture*. Cham: Springer.

Giannini, T., & Bowen, J. P. (2019). Digital culture. In T. Giannini & P. B. Bowen (Eds.), *Museum and digital culture* (pp. 3–26). Cham: Springer.

Goulding, C. (2000). The museum environment and the visitor experience. *European Journal of Marketing, 34*(3/4), 261–278.

Goulding, C., Shankar, A., & Elliott, R. (2002). Working weeks, rave weekends: Identity fragmentation and the emergence of new communities. *Consumption, Markets and Culture, 5*(4), 261–284.

Hoffman, D. L., Novak, T. P., & Chatterjee, P. (1995). Commercial scenarios for the web: Opportunities and challenges. *Journal of Computer-Mediated Communication, 1*(3), JCMC136.

Holbrook, M. B., & Hirschman, E. C. (1982). The experiential aspects of consumption: Consumer fantasies, feelings, and fun. *Journal of Consumer Research, 9*(2), 132–140.

Jarrier, E., & Bourgeon-Renault, D. (2012). Impact of mediation devices on the museum visit experience and on visitors' behavioural intentions. *International Journal of Arts Management, 15*(1), 18–29.

Karayilanoğlu, G. (2019). Digital transformation in contemporary art museums with the example of Barcelona museum of contemporary art. In *Proceedings book digital transformation in contemporary art museums with the example.*

Kolb, B. M. (2013). *Marketing for cultural organizations: New strategies for attracting audiences.* London: Routledge.

Kotler, N., & Kotler, P. (2000). Can museums be all things to all people? Missions, goals, and marketing's role. *Museum Management and Curatorship, 18*(3), 271–287.

Kozinets, R. V. (2008). Technology/ideology: How ideological fields influence consumers' technology narratives. *Journal of Consumer Research, 34*(6), 865–881.

Kubey, R. W. (1986). Television use in everyday life: Coping with unstructured time. *Journal of Communication, 36*(3), 108–123.

Maclaran, P. (2009). *Postmodernism and Beyond.* In E. Parsons & P. Maclaran (Eds.), *Contemporary issues in marketing and consumer research* (pp. 37–54). London: Elsevier and Butterworth-Heinemann.

Marty, P. F. (2008). Museum websites and museum visitors: Digital museum resources and their use. *Museum Management and Curatorship, 23*(1), 81–99.

McLean, F. (1995a). A marketing revolution in museums? *Journal of Marketing Management, 11*(6), 601–616.

McLean, F. (1995b). Future directions for marketing in museums. *International Journal of Cultural Policy, 1*(2), 355–368.

MUDEC. (2018). The Modigliani art experience. Retrieved 10 May 2020 from http://www.mudec.it/eng/modigliani-art-experience/.

MUDEC. (2019). The museum. Retrieved 10 May 2020 from http://www.mudec.it/eng/museum.

O'Connor, J., & Wynne, D. (2017). *From the margins to the centre: Cultural production and consumption in the post-industrial city.* Abingdon: Routledge.

Pallud, J., & Monod, E. (2010). User experience of museum technologies: The phenomenological scales. *European Journal of Information Systems, 19*(5), 562–580.

Pine, B. J., & Gilmore, J. H. (1998). Welcome to the experience economy. *Harvard Business Review, 76,* 97–105.

Pulh, M. (2002). *La valorisation de l'expérience de consommation d'activités culturelles: le cas des festivals d'arts de la rue.* (Doctoral dissertation). Dijon.

Rentschler, R., & Hede, A. M. (2009). *Museum marketing.* New York: Routledge.

Richardson, A. (1999). Subjective experience: Its conceptual status, method of investigation, and psychological significance. *The Journal of Psychology, 133*(5), 469–485.

Roussou, M., & Katifori, A. (2018). Flow, staging, wayfinding, personalization: Evaluating user experience with mobile museum narratives. *Multimodal Technologies and Interaction, 2*(2), 32.

Santese, N., & Botti, S. (2012). *Il comportamento d'acquisto dello spettatore cinematografico.* Management delle istituzioni culturali, Milan: Egea.

Schmitt, B. (1999). Experiential marketing. *Journal of Marketing Management, 15*(1–3), 53–67.

Scott, R., Cayla, J., & Cova, B. (2017). Selling pain to the saturated self. *Journal of Consumer Research, 44*(1), 22–43.

Silva, S. C., Duarte, P., Machado, J. C., & Martins, C. (2019). Cause-related marketing in online environment: The role of brand-cause fit, perceived value, and trust. *International Review on Public and Nonprofit Marketing, 17,* 1–23.

Tallon, L., & Walker, K. (2008). *Digital technology and the museum experience: Handheld guides and other media*. Lanham, MD: AltaMira Press.

Vermeeren, A., Calvi, L., & Sabiescu, A. (Eds.). (2018). *Museum experience design: Crowds, ecosystems and novel technologies*. Cham: Springer.

Vermeeren, A. P., Calvi, L., Sabiescu, A., Trocchianesi, R., Stuedahl, D., Giaccardi, E., & Radice, S. (2018). Future museum experience design: Crowds, ecosystems and novel technologies. In A. Vermeeren, L. Calvi, & A. Sabiescu (Eds.), *Museum experience design* (pp. 1–16). Cham: Springer.

Wallendorf, M., & Brucks, M. (1993). Introspection in consumer research: Implementation and implications. *Journal of Consumer Research, 20*(3), 339–359.

Weilenmann, A., Hillman, T., & Jungselius, B. (2013, April). Instagram at the museum: Communicating the museum experience through social photo sharing. In *Proceedings of the SIGCHI conference on human factors in computing systems* (pp. 1843–1852). ACM, Paris, France.

3 From the artwork to the museum

Gamification as an instrument of art

Elena Di Raddo

Introduction

For some time now, the museum has not only been a dusty space used primarily for the conservation and exhibition of works of art; it has also been a venue for promotion, communication and entertainment, hosting meetings with the aim of encouraging social and cultural enrichment. This new function of museums and museum sites has led to the proliferation of tools for welcoming and entertaining the public through the dynamism of the activities connected to these spaces.

In recent years, the use of new technologies has become widespread with the aim of making the simple visit a real 'experience' when observing collections and in museum didactics. Such changes have become salient not only in museums of ancient and contemporary art but also at archaeological sites. The use of the dynamics of play in this field has proven to be an extremely effective tool, not only for children but also for adults. This is also demonstrated by the large number of publications dedicated both in a broader sense to the role of entertainment in the museum visit (Connolly et al., 2012) and to the specific application of 'Serious Games' as a new way of visiting such spaces (Paliokas & Sylaiou, 2016). A recent study (Kristianto et al., 2018) shows that 'gamification' can improve learning in museums as it motivates people to memorize content through the stimulation of emotions and curiosity while also helping to give them a clear indication of what to learn during the visit.

This chapter intends to address the more topical theme of gamification and the spread of gaming as a vehicle for both disseminating information and enhancing the attractive functions of the museum and its collections. In addressing these issues, this chapter demonstrates how the very nature of the work of contemporary art welcomes gaming as a form of artistic expression and has done so in the history of art (at least on the part of the avant-garde). The interactive and relational nature of games, the presence of rules and the implicit activation of the attention of the players/users are all aspects that have aroused the interest of art when, particularly with the avant-garde, it has untied itself from its traditional representative function to access the speculative and interpretative dimension.

Moreover, with the explosion of new technologies in the last 30 years, a real artistic current recognized as 'Game Art' was born. This development has led to the creation of works of art born from the comparison with video games, in conjunction with the presence of video games themselves being conceived with artistic purposes and even displayed in museums. After a brief excursus on historical cases of artists (from Duchamp to Cage) who have faced the dynamics of game, the first part of the chapter dwells on the distinction between game art and Game Art, highlighting how the second category includes artists who may also engage in traditional artistic means (e.g., painting, sculpture or installation) and put game at the centre of their work as well as artists who make real video games, the latter of whom do so with artistic finality and in this case can be included in the so-called Media Art.

In the second part of the chapter, the investigation extends to the use of games in the education and enjoyment of the museum and its collections. This phenomenon that has exploded in recent years has been defined as 'Edutainment', a term that combines 'education' with 'entertainment'. Learning by playing is the imperative of many museums both for the educational sections and for the marketing purposes, as the promotion of new methodologies that favour a happy visiting experience inevitably has the consequence of attracting more visitors.

The investigation of the use of the mechanisms of game from the point of view of art and the more functional nature of the use of game as a commercial, educational and promotional tool in the museum (Edutainment) are therefore the great macro-areas towards which we want to focus our attention. We wish to do this in order to show how these uses are actually complementary aspects, or two sides of the same coin, because they simultaneously reveal the attractive and educational potentials of game through the mechanisms of sensory and emotional involvement.

Thanks to the introduction of gamification in the museum, or through the didactics within a museum or its activities, such as exhibitions, it is possible to obtain greater interaction with visitors, leading them to transform from merely passive consumers into integral parts of artistic fruition/consumption.

Theoretical background

Before reviewing the different cultural fields in which the playful aspect of contemporary artistic culture is rejected, it is better to consider the possible definitions of the word 'gamification'. In the view of André Bouchard (2013):

> Gamification is the process of turning something into a game [...] it is the process of turning a development campaign, an education program, and/or a marketing promotion into a game or a process with game dynamics such as a contest, sweepstakes, or a scavenger hunt. The process of gamification adds one or more game mechanics into a scenario.

> The game layer that is created from the game mechanics can engage patrons who engage with it, a game play experience which can last from a few seconds to, potentially, months or even years of game play.
>
> (s.p.)

According to this definition, as with most of the more wide-reaching ones, gamification refers to the process of applying game elements and game-design techniques in non-game contexts, and, in this case, the non-game contexts are museum visits (Deterding et al., 2011). These applications would act on two levels: in a narrower sense, there would be some movement from the space of video games to other non-verbal digital areas (for example, such a case could involve the adoption of video games in social networks or in some commercial sites); in a broader sense, there could be some movement from gaming to non-verbal social practices (e.g., educational, wealthness or corporate training). These two levels are, however, in a reciprocal relationship since there is some continuity between digital media experience and real experience. In any case, the aim would be to increase the involvement and motivation of users to carry out certain practices. At the basis of the motivation of this encroachment of game into other areas, most of the definitions formulated so far identify a demand dictated by the laws of the market. Commercial purposes would therefore be the driving force behind the spread of the word 'gamification' as expressed in a 2010 article in *Fortune* (Lev-Ram, 2010) that uses this term (already introduced in 2004) for the first time to underline the possibility of applying the mechanisms of video game, in particular those developed by the company Zynga, for the development of marketing. More precisely, the new commercial opportunities offered by the dissemination of digital games have acted as a flywheel for the term, thus contributing in a decisive way to its euphoric connotations (McGonigal, 2011). These definitions, however, as Ruggero Eugeni (2012) has pointed out, are not entirely satisfactory. Rejecting these definitions, Eugeni takes a sociosemiotic approach to the term, arguing that 'they ignore (or pretend to ignore) that between playful and non-playful activities there has always been a complex and culturally regulated negotiation (as the classical reflection on games, from Huizinga to Caillois to Bateson has always stressed)' (Eugeni et al., 2015, p. 51). The very idea of marketing is in fact implicit in the activation of situations that can be traced back to games: campaigns, competitors, winning market shares, production awards and so on. 'It is not therefore a matter of announcing the advent of gamification', he continues,

> but of recognising that there are social processes of "framing" that qualify some practices as playful. In this sense, many mechanisms that gamification theorists consider to be proper to the game (accumulation of points and skills, achievement of objectives, etc.) are in themselves

"neutral" rules for the determination of collective processes, which can eventually be played.

(Eugeni et al., 2015, p. 51)

The phenomena belonging to games, therefore, are in reality present in the social system. In fact, the artists, often preconditions of many cultural and social phenomena, have understood this. Adherents to situationism have proposed replacing the rules of a new game with the dominant ones of capital. The current definitions of gamification are therefore interesting as 'social discourses'; in other words,

> they define the processes of framing social practices in a playful way. Analyzed in this key, these definitions reveal an important phenomenon: many aspects of everyday life (from interaction to financial transactions, from the purchase of goods to learning practices and so on) are currently considered playful or ludic because and to the extent that the processes that implicitly regulate their development are exhibited, represented, and staged. In other words, the playful character derives from the pervasive and euphoric display of devices that regulate the experience.
>
> (Eugeni, 2012, p. 152)

From this point of view, Eugeni concludes that it is no coincidence that 'the commercial sphere has functioned as a flywheel for the success of the term: gamification is one of the mechanisms that, in exhibiting contemporary media and non-media hyper-consumption practices, makes its diffusion sustainable' (Eugeni, 2012, p. 152).

Considering this broad and multifaceted definition of gamification, it is also possible to understand how gamification could have crept into other cultural areas that are not characterized (at least in the first instance) by commercial purposes. In the field of contemporary art, which is what we want to specifically investigate here, the process of 'gamification' can be seen from at least two points of view. First, it can be seen in artistic production, and in this sense can be understood as both a 'means' and an 'object' of investigation by artists at the same time. Second, it can be viewed as an educational 'vehicle' within the fruition of art, in either museums or exhibitions. In this second case, we can use the recently born term of 'edutainment'.

Gamification of art and culture

A game by its very nature generally involves interaction between several people, and it is this characteristic that has often been used by artists who have a relational vocation, that is, who are not content to show their work

to the public but intend to involve them in the process in emotional, intellectual and physical ways.

A recent and significant example of this 'use' of game dynamics in the artistic field is represented by the installation of the Italian Pavilion at the 58th Venice Biennale (2019). Milovan Farronato, the curator, designed a labyrinth in which the works were to be sought out by the visitors. The exhibition path led to a sort of game, in which one was to aim at discovering the works which were not immediately visible but, for example, instead announced by sound or music, evoked by small cracks in the exhibition structure or, finally, hidden behind a veil. However, as is the very nature of the labyrinth, the aim of the spatial mechanism was not only for viewers to find something, as happens, for example, in the labyrinths of neoclassical gardens, but also to experience an encounter with the unknown, with something that may just appear from one moment to the next. All of these aspects belong to the dimension of the game. This is what we can also observe, for example, in some works of art with a spatial characteristic conceived in the 1960s by artists who wanted to involve the public, such as the Italian Piero Manzoni or England's Ralph Rumney, Robyn Denny and Richard Smith, who imagined art exhibitions inspired by the labyrinth. Manzoni designed the *Placentarium* in the early 1960s, which the artist himself describes in this way:

> [It is] a kind of labyrinth composed of several cells (environ 60) controlled by an electronic brain. The 'subject', that is the spectator himself (his psychic structure). According to his reactions he will be directed autonomously rather towards one itinerary than another, an itinerary that will solicit in him different sensations, according to the unconscious choice that he will make. For some it will be banal, for others it will trigger upsetting reactions. For example, while in one cell he will be expelled, in another he will not be able to find a way out, while in the meantime the ceiling will be lowered threatening to crush him. And when he is close to finding the solution to get out, a voice will insult him and mock him by obstructing him.
>
> (Celant, 1989, p. 262)

The labyrinth is, as can be seen from this description, a futuristic space conceived according to the same criteria that in more recent years will be used for the creation of video games.

Place, on the other hand, is the title of a space created in 1959 at the Institute of Contemporary Art (ICA) in London by a group of painters from the Royal College of Art.[1] It was an exhibition-labyrinth, a 'unité d'ambiance', which immersed the viewer along a path full of obstacles made up of large-format paintings, which were also presented at an angle to the floor. Explicitly inspired by the concept of a game, the environmental installation was intended to investigate visitors' behaviour. In the space saturated with

paint, circulation was bound by certain rules and dictated by the path. Viewers could follow a path following a single colour of their choice between red, green, white and black. The viewers thus became an active part of the work, and the work works could not disregard the surrounding physical and psychic environment. It was to all intents and purposes a work strongly influenced by Guy Debord's Situationist thinking. Game in this specific kind of cultural context is conceived as a system of rules aimed at provoking a playful experience for the player, regardless of the result to be achieved. This is a democratic conception of game, inspired by chess, in which players are aware of their role and not pawns manipulated by capitalist society. Game is in fact intended for Situationists as a metaphor for the world of work. We read in the first issue of the *International Situationist*, the press release of Debord's movement:

> play - the permanent experimentation of new playfulness - does not appear in any way outside the ethics, the question of the meaning of life. The only success one can conceive in the game is the immediate success of its atmosphere, and the constant increase of its powers.[2]

Game, therefore, is not at all foreign to art, starting, at least, from the avant-garde (it is enough to remember the value of the game of chess for Marcel Duchamp) and up to the neo-avant-garde, but today it has considerably expanded its presence in the world of art and in that of society, especially among the young with whom art itself continually interacts. With the spread of new technologies, the game has also changed its face and has become one of the most extensive areas in which digitization, computer science and social work are applied. Video games, emerging as a simple pastime in the now-distant era of *Pong* (1972), have become a tool capable of ludicrously conveying contents in the fields of education and strategic marketing; it has even become a means with which to do scientific research. One can just think, for example, of the valuable application of the video game *Foldit*, the innovative online puzzle which has made an important contribution to research on HIV treatment.

Game as an artistic tool: the art perspective

The essentially 'social' nature of games and, therefore, of 'gamification' goes back to at least the avant-garde in the artistic field, especially among those artists who, following the example of Marcel Duchamp, have opened the sphere of art to everyday life. There could be many examples of its earlier manifestations, but, thinking about the role that new technologies have at the origins of this phenomenon, we can cite a famous performance by John Cage. Protagonist of Fluxus, the postwar movement that programmatically wanted to establish a relationship between art and society by investigating mass communication, Cage conceived a performative action in the form of

participation in some very popular television programs such as *I've Got a Secret* in the United States in 1960 and *Lascia o raddoppia* by Mike Bongiorno in Italy in 1959. Presenting himself as an expert in mushrooms for Mike Bongiorno's quiz, he created a short circuit with the normal rhythms and themes of the popular TV game, proposing a Fluxus concert entitled *Sounds of Venice* made of silences and sounds caused by using common objects such as boiling pots and water being poured from a watering can. The aim of this performative art form was to 'educate' the public, creeping into the medium itself and making them aware of the power of television in the information system. In this work, there are already all of the elements that have been found in the works of New Media Art since the 1990s.

In the field of New Media Art, an artistic form already having been extensively discussed because it is young and resistant to the more traditional definitions of a 'work of art', a creative vein inspired by video games has developed in recent decades. The video game itself is considered as an art form by several scholars who have been studying it from a cultural perspective since the beginning of the 21st century. In 2006, Matteo Bittanti summarized these interventions starting with the definition formulated by Henry Jenkins, Director of the Comparative Media Studies program at MIT in Boston. According to Jenkins (2005) 'Video games represent a new lively art, specific to the digital age, just as previous art forms have characterized the mechanical age' (p. 313). Also, Steven Poole in *Trigger Happy* (Poole, 2000) has argued that the very development of video games represents an art that transcends traditional categories, and James Paul Gee (Gee, 2006) has suggested that in order to properly understand the artistic status of video games, it is essential to develop new interpretative methodologies that go beyond those adopted for other forms of creativity such as literature or cinema.

In accepting these definitions that Matteo Bittanti introduces, however, a distinction between game artists and Game Artists emerges. In Bittanti's perspective (2006), while the former are generally programmers and web designers who make video games for commercial purposes, the latter make works of Art Games, 'videogames specifically developed for artistic, i.e. non-commercial purposes' (p. 316). The latter are generally characterized by contents that have in themselves political, social or historical aspects and whose purpose is not, therefore, strictly and only playful. To better highlight the difference between commercial video games and Art Games, Bittanti relies on Kristine Ploug's definition (Ploug, 2005), according to which some games are created specifically as art projects; therefore, it is the intentionality of the author or curator to define the scope of the game. Moreover, Bittanti concludes that it is always possible to include some commercial video games in the category of Art Games, such as *ICO* by Funito Ueda (2001), *Electroplankton* by Toshio Iwaii (2005), *Rez* by Tetsuya Mizuguchi or *Okami* by Clover Studio (2006), where the boundaries between the space of art and that of a game are extremely blurred.

That video games are a medium that arouses great interest from an artistic point of view is also demonstrated by a third approach to the art/video game relationship that is represented by Game Art – or video game art – in which it is possible to include 'any artifact in which digital games have played a crucial role in the creation, production and/or exhibition of the artifact itself' (Bittanti, 2005, p. 317). Game Art is not necessarily a technological art form, but it aims at reflecting critically on the language, role and status of video games in contemporary society because it exploits both the linguistic logic – aesthetic and interactive – and the 'power' of penetration and enjoyment within society, especially among young people. These works reveal the communicative potential of the video game, the bearer of a subliminal message that directly reaches the player/spectator in a physical way.

Are video games an art form?

To understand the complexity of the relationship between art and video games, it is therefore appropriate to use a different category from the tradition art history instead of the one of 'visual culture', adopting the theory that W. J. T. Mitchell, since *Picture Theory* (1994), defines as the 'pictorial turn', or the notion of a medium linked to the birth of new media and to the postmodern era. This image, mediated precisely by technology, is not purely visual but comprised of a certain complexity of fruition that involves not only sight but also a cultural and textual superstructure, 'rather, a postlinguistic, postsemiotic rediscovery of the picture as a complex interplay between visuality, apparatus, discourse, bodies, and figurality.' (Mitchell, 1992, p. 91). In this definition, we can also include what has been happening in the art of the last 20 years, as dominated by the poetics that Nicolas Bourriaud has defined as 'post-production', i.e., the reworking of images, themes or stories from different fields focused on the cultural, the social or current affairs.

Among the positive aspects of this adoption, it seems to me that there is also a new harmony between theory and artistic practice that arises. In fact, as Kevin McManus (2013) observes,

> The crisis of modernism in the aftermath of the official birth of video games, combined with the advantage of not having to account to the world of "high" culture, allows the new medium to freely enjoy its technological progress, living in a short time its own personal "renaissance", with the invention of perspective, its own realism, and all those phenomena of approaching real space that sooner or later have characterized the history of almost all visual or audio-visual arts, in that virtuosity that means hiding the material limits of the medium, overcoming them and building a new reality.
>
> (p. 63)

Therefore, game art does not abandon the field of art but shows a freer attitude that remains, however, alienated, with some strong characters of the 20th-century artistic gesture. I will give just three examples in this regard. First, we see a return of the poetics of the object trouvé. By adopting the principles of open source, game artists tend to appropriate found material, collaborate with other artists and make their work available to others on a share-and-share-alike basis. An example of this approach is Cory Arcangel's *Super Mario Clouds* (2002). To create this animation, the artist hacked into *Super Mario Bros* (1983), a classic video game that he entirely deleted except for the clouds. In this work, there are references to the history of art such as the clouds in Constable's work, but also to a work by Raushenberg called *Erased de Kooning Drawing* (1953), in which the artist also deleted on a composition by de Kooning to create a new work, thus unhinging the concept of authorship and authenticity of the traditional work of art.

Secondly, we are witnessing a return to the poetics of scenographic painting, that is, to a conception of pictorial space as a potential container for semi-developed or even undeveloped events. The artists imagine fantastic scenarios that meet the needs of a new narrative that remains enclosed in a parallel world, endowed, to all intents and purposes, with its own shared rules. The landscapes are often united by an imaginary rife with apocalyptic and futuristic tones, in which danger and confrontation loom over the events and lives of human or humanoid beings. In a sense, such images update the sublime dimension of romantic painting. The scenographic structure of the works of painters such as David Kaspar Friedrich and William Turner can be seen in the speed painting scenarios of Sebastien Larroude (aka 'rainart'), in the futuristic cities of Nicolas Ferrand (aka VIAG) or in the industrial architecture of Joel Dos Reis Viegas (aka 'féérik'). The feeling of danger inherent in the poetics of the sublime is here replaced by the unknown future of man, threatened but at the same time attracted by other worlds, hostile and at the same time fascinated by their grandeur and power. This is similar to the way in which the monumental and technological industrial architecture of Joel Dos Reis Viegas (aka 'féérik') seems to derive directly from the industrial landscapes of River Rouge painted by the precisionists Charles Scheeler and Charles Demuth.

A visual element that these young artists share with romantic painting is also represented by the way they interpret the spatiality of their work. Ernst Gombrich speaks of 'ambiguities of the third dimension' – based in art on the application of Renaissance perspective – which calls into question the viewers and their perceptive capacity. According to this definition, one can approach the works of some artists such as Stephan Barontieri (alias Thierry Doizon), who sets his stories within apocalyptic visions in which archaeological finds of lost civilizations appear, generally in a bird's-eye view, or Martiniere in *Metropolis 1* which displays the destruction of the metropolis with the fall of its symbols: from the skyscraper wounded by gashes, to the signs of the collapsed star system. Bruno Gentile, in turn, invents fantastic

architecture of Piranesian memory in which suggestions of buildings of the past (Mesopotamian or Aztec) and current architectural elements (architraves, viaducts, bridges and road junctions) are combined. The past, in this sense, is also experienced in the technological images conceived by these artists with the nostalgia of which the 19th-century pictorial vision is permeated. Video game often use the filter of history and literature, which transmit to posterity the values and virtues, or the mystical and epic sense of the landscape, rather than the pure sense of drama or contemporary reality. In art game creations, past and future coexist through a thread that flies over the present.

Finally, a third example is the return of a consciously critical attitude on the part of game artists. Even when the video game is closer to the contemporary life, it interprets political or social themes through the mediation of history or literature. The approach is in this sense very different from that of contemporary art, which today is closer to a documentary language. *Long March: Restart* (2010) by Feng Mangbo, for example, is a large installation in which the player and his avatar act on the same level and with similar dimensions within the game. The visitor is then involved with great realism in a game that is a revisitation of a political and military event that really happened: the retreat of the Red Army, marching for 10,000 kilometres, which began in October of 1934 and with which the revolutionary forces led by Mao Zedong gave birth to a new communist republic. The political and social content of the game is also underlined in the action of the guerrillas who ironically fight at the launch of Coca-Cola cans. The political content is even more explicit in *The Intruder* (1999) by Natalie Bookchin, which is both a work of Game Art and a work of Net Art, or *Velvet Strike* (2002) by Anne-Marie Schleiner, Brody Condon and Joan Leandre. *The Intruder* is an interactive web project that looks like a game, but it is actually a critical commentary on computer games and patriarchy. It is based on a 1966 story by Jorge Luis Borges entitled *The Intruder*, a dark history of prostitution, fraternal jealousy and violence against women. Two brothers fall in love with the same woman, divide and sell her in a brothel and then kill her and reconcile with each other. In this case, the silhouette of a woman takes the place of the Pong ball and is bounced around like an inanimate object. Combining literature and games, Bookchin builds a bridge between high art and low culture, questioning the difference between them, which is itself a type of levelling typical of New Media Art. In *Velvet Strike*, instead, Schleiner, Leandre and Condon act within *Counter Strike* (1999), a popular computer game on the net in which players are engaged in urban battles involving (and therefore connecting) both international artists and the usual Counter Strike players, many of whom criticized the intervention given that the characters on the screen often acted in a non-violent way instead of fighting, thus destabilizing the very logic of the game.

In conclusion, video games can be read as an art form especially when it aims beyond simply entertainment to serving as a vehicle for conceptual,

political or cultural messages. Museum institutions have long understood this by opening their exhibition spaces to this form of young creativity that remains in tune with technological innovations. The mechanisms of game, and video game specifically, are now also used in educational activities in museums to encourage greater visitor involvement and ease of learning through play and entertainment. In fact, since 1964, Herbert Marshall McLuhan argued that 'those who distinguish between entertainment and education perhaps do not know that education must be fun, and entertainment must be educational' (p. 28).

Edutainment

Another aspect of the 'gamification' phenomenon concerns the application field of museum didactics. To define it, one can use the term 'edutainment' formed through the union of education and entertainment. The term 'edutainment' was coined in 1973 by Bob Heyman, producer of documentaries for *National Geographic*, who illustrated an alternative way to experience cultural heritage based on the principle that, without entertainment, there is no learning. Educational entertainment, therefore, aims to educate and inform while promoting the discovery of new things and the development of practical skills. At the same time, such engagement is meant to improve relational behaviour. Through learning by doing and active participation in the enjoyment of content, traditional learning needs become part of a new system in which play and entertainment become useful means to the educational path. Therefore, more and more dynamic and effective innovative forms have been developed in all social and institutional fields which allow for the total and active involvement of the user.

In recent years, museums and their educational departments have adapted to the demands of a public no longer satisfied with a passive museum visit alone. This public is increasingly looking for active participation. The implementation of gamification in various contexts has been proven to be an effective method to motivate people to do things which they may have no desire to do (Burke, 2014). In addition to the classic guided tours of the collections, more interactive methods have therefore been added, such as the presence of computers and digital panels that allow visitors to learn more about the contents they are viewing, or immersive tools that virtually recreate objects and sites from the past with the construction of digitized environments within the museum's exhibition path. Multimedia and digitization are in fact among the best sectors in which edutainment acts, as it tends to relate a dynamic approach to educational processes through sensory stimuli. In this sense, there are several new media that are intended to be used as educational tools, from the use of social and augmented reality to immersive environments.

The Museo Civico degli Eremitani of Padua, for example, instituted the *Wiegand Room* in 2013 to allow for an in-depth examination of a visit to

Giotto's Scrovegni Chapel. Inside, the visitor follows cognitive paths by actively intervening through virtual reality. The purpose of this virtual museum is to provide reading instructions and satisfy curiosities by promoting a complete understanding of Giotto's painting.

The impact of new media and digitization on people's daily lives has also led to a new way of experiencing the museum. By introducing new technologies into the museum, one seeks a closer connection with one's audience and the experience of the visit. In fact, technologies democratically bring the museum closer to people's real life, just as they do with social networks. The artistic experiences of the 1960s and 1970s were pioneering, encouraging the playful involvement of the public in exhibitions and performances. To the examples cited above in the Situationist and Fluxus fields, one can certainly add the happenings initiated by Alan Kaprow in 1959 that invited the public to observe or perform actions conceived by the artist. The happenings contributed to the break of the elitist 'aura' of the work of art or exhibition space, previously reserved for the few, by encouraging a more direct contact between art and life. The major artistic experiences of the following years moved in the same direction, from those of Optical Art and Kinetic Art to the processional works of art. For instance, on the occasion of the Third Biennial of Paris in 1963, the artists of the Groupe de Recherche d'Art Visuel (GRAV) disseminated a document in which the elimination of distances between spectator and work was made explicit:

> We want to involve the viewer, free him from inhibitions, relax him.
> We want him to participate.
> We want him to be at the centre of a situation that can make it work and transform.
> We want him to be aware of his participation.
> We want him to orient himself towards an interaction with other viewers. (...)
> FORBIDDEN NOT TO PARTICIPATE
> FORBIDDEN NOT TOUCH
> FORBIDDEN NOT TO BREAK.

(GRAV, 1986)

These are of course words which echo the famously ironic and provocative work of Marcel Duchamp in *Prière de toucher* (1947).

Examples of the concretization of these ideas can be seen in those years and soon after in many environmental works, where game often plays a primary role in the artistic experience, as in Pino Pascali's environmental sculptures, for example. Pascali was an Italian artist who in a certain sense ludicised the serious matrix of American Minimal Art through a new, more organic morphology of geometric shapes. Such developments can also be seen in the video installations of Bruce Nauman's 'Video Corridor' series

made in 1970, which induce the observer to enter narrow corridors while being filmed by a camera that transmits their image to a monitor at the end of the path.

Recently, new technologies have been used in museums with the same purpose: to bring the viewers to the centre of the work, making their co-star of an experience. As has been done by artists, museums also use different innovative means to provoke amazement and enjoyment in an increasingly involved audience through both physical and conceptual means. Accordingly,

> The secret ingredient that makes gamification a truly special experience is fun. Fun is a consequence of brain adaptation to pattern recognition - that is, it is a consequence of learning. The traditional belief is that fun only promotes learning, but fun actually plays an essential role in learning.
>
> (Barkova et al., 2018)

It has long been understood that the museum's task is not only to conserve cultural heritage but also to enhance it. Interestingly, museums have found in edutainment[3] the most suitable formula for this purpose by involving the public in visiting their collections and exhibitions. The concept of edutainment is very broad and encompasses many different aspects of artistic engagement, including, for example, didactics for children; events organized within the institution, such as concerts and meetings; and the use of new technologies that allow for the innovative fruition of the works through customisable paths. The objectives of these programmes are to broaden the audience of all age groups and to increase the loyalty of visitors.

Of course, the playful aspect should not take over the primary vocation of the museum, which is that of providing a space for heritage education. As Cecilia De Carli (2003) writes, 'beyond any spectacularization and spread of the strategy of the event and the possible multiplication of its attractions, the real resources of the museum are the real and symbolic heritage that the works represent and education' (p. 104). The two aspects of dynamism, also playful, of the museum, and learning, must coexist and feed on each other. In accordance with this view, the Ministers of Culture of the European Union, through the *Work Plan for Culture 2015–2018*,[4] have defined the priority of promoting access to culture by focusing on technical innovation and the concept of 'Audience Development', which is

> understood not as numerical growth of the public, but as a diversification strategy that stimulates and involves potential and new audiences through innovation and change in project formats, in the logic of mediation and participation, in listening and communication tools, in the conscious use of digital technologies.
>
> (Barrella, 2017, p. 8)

Culture and entertainment can therefore be combined for the purpose of learning through programmes modulated according to the interests of different audiences, and digital technologies can promote this union.

Applications and social networks for museums

Museums use social networks such as Instagram, Twitter and Facebook not only as a marketing strategy but also as places that provide users with the opportunity to by creating stories and exchanging experiences. As discussed above, games and informal learning techniques are increasingly used in museums as educational tools (Beale, 2011; Sanchez & Pierroux, 2015). Games can be very effective in improving learning and content preservation, as the Invisible Studio was able to see in March of 2016 when it launched the educational game *Escape Tours* with Art in the City (Boiano et al., 2016). Based on the experiences in the Escape Rooms, in which spectators had to answer questions to get out, they added some useful clues to the classic guided tours. The authorized guide actually helps individuals to solve the enigmas of the Escape Room by including some small details in the explanations. The same company has also developed other game experiences, called *Adventours*, which are based on the use of WhatsApp or Facebook Messenger. To make visitors curious before entering the museum, the human guide, from inside the building, or a chatbot in the case of Facebook Messenger, poses cultural questions to individual visitors to find the answers to within the museum path, so that puzzles are consequently solved together. The use of the chatbot system is also widespread in Milan in museum houses, where virtual characters often guide the visitors.

The development of applications (or apps) has also led to huge success in recent years at attracting the interest of the public. In particular, we can mention the great success of Google Arts & Culture, launched in February of 2011 and which now reports more than five million downloads. The app collects information and images of works of art in very high resolution (7 gigapixels) and allows viewers to observe works with extreme precision as they virtually visit museums and galleries around the world. In addition, the app also allows viewers to create a personal virtual gallery with their favourite works, share them with friends and create a network based on common passions. The app produced by Google therefore allows viewers to overcome spatial barriers, learn more about art and share cultural information by creating an experience that was not possible before. The virtual experience, of course, does not replace the real one, but it certainly adds to it by allowing for more knowledge to be shared of the works and places of art.

Video games and museums

A very interesting development in museum edutainment is also represented by the introduction of video games into the museum, not only in the

form of a real work of art, as seen above, but also in fruitive and edu-cational mechanisms. Most of the critical literature on video games is in agreement in attributing the value of this form of mediation with the public not so much to 'narration' as to interactivity in terms of the physical, visual and emotional involvement of the players. This is an enormously important factor in considering the new ways available of enjoying culture. In the fru-ition of culture, the public and, more specifically, the visitor or the tourist seek the involvement, the experience and in this sense the world of gam-ing (and by extension the world of video games); the encounters between gaming and digital technology offer themselves as a privileged place of this relationship.

Through the use of apps, which are accessible directly from a museum's website or downloadable on mobile devices, museums offer playful experiences within their space by combining the app with the concept of a video game. In fact, the integration of a video game system allows for knowledge to be ob-tained through 'learning by doing' with the active participation in the available experience. In the gaming sessions, the user can decide which moves to make and which directions to take, obviously within the limits of the hypothesis for-mulated by the game developer, and in this way, the experience becomes more compelling. In fact, Italy is one of the most active countries on this side of the intersection between the gaming industry and the cultural sector.

Among the most significant examples of such integration is that of the National Archaeological Museum of Naples, which produced *Father and Son*, an application that can be downloaded on mobile devices that takes the museum 'outside' its walls. *Father and Son* is a narrative game, con-ceived by the collective TuoMuseo, with the same criteria of a 2D video game. Essentially, the game invites one to explore the spaces and works of the museum's collection. With almost four million downloads worldwide, this application has allowed the museum to bolster knowledge of its already important collections and attract potential visitors to the museum. Appli-cations that use a similar language are *Firenze Game*, designed to bring tourists in unknown places to the major art of traditional city tours, or *Past for Future* made in collaboration with Mibac and the National Archaeolog-ical Museum of Taranto, which combines gaming experiences with cinema. The technological playfulness thus contributes to making the viewing of a city, a museum or an exhibition unique and personal; it makes the spaces of culture less dusty without affecting the cultural component, which re-mains, of course, the most important aspect.

Among the most innovative and interesting systems in the realization of new experiences of the fruition of art and museum places is the application of augmented reality, an immersive form of technology that allows one to amplify the visit of the places by taking the visitor, through technology, di-rectly into the past. Among the softwares that have anticipated augmented reality, we must mention *Second Life*, the website produced in 2003 that, at the height of its success before the triumph of social networks, had more

than a million users. Through a virtual avatar, the user could act within a 'second life', assuming another identity and conducting business as he pleases. This game, unlike more traditional ones, did not have a final goal; a player's purpose was simply to escape from everyday reality and live in a parallel world. In the same way, by wearing specific devices such as 3D glasses, a visitor to a museum or archaeological site has the opportunity to have first-hand experiences of these locations of the past; the narrative is therefore replaced by a direct and therefore more engaging experience that promotes attention and understanding. Among the first archaeological sites to be so equipped in Italy is the Brixia Archaeological Park of Brescia, which has seen its visitors multiply (from 3,000 in August of 2012 to 38,000 in 2015). The glasses provided to visitors are equipped with a camera that recognizes what the visitor sees when moving in space; therefore, the virtual image of the original environments, reconstructed on the basis of the information that emerged from the studies and excavation campaigns, is recreated in front of the users' eyes together with the real vision. While observing the archaeological remains of the amphitheatre, the visitor can also see its original form and even the activities that took place in it in Roman times.

In this sense, the worldwide explosion of multimedia-immersive exhibitions dedicated to the life and works of the most famous protagonists of art history is also worth mentioning in this speech. These are exhibitions in which the work, the artefact, disappears completely and is instead replaced by high-resolution images. The aim of the experiential path is to enchant the public, involving them emotionally and psychically in a sort of journey within painting, which, fundamentally deprived of the material component, is something different from the actual work of art. The 'loss of aura' of the work of art as theorized by Walter Benjamin at the dawn of the photographic and cinematographic revolution is complete in these cases; the work is transformed into a pure vehicle of optical illusions. It is for this reason that such exhibitions are generally appreciated by a public not accustomed to frequenting museums and instead more taken by places of pure entertainment in a Disney key. The multisensory journey through lights, colours and sounds is completely totalized for the visitor with the declared aim of helping facilitate understanding of the artist's life and work. The result is often very far from a true understanding of the real nature of art. It is therefore very difficult to include these experiential exhibitions in the cultural sphere precisely because the playful aspect often prevails over the cultural one.

Ultimately, edutainment achieves its goal of promoting learning while having fun, only if the content is conveyed accurately and pure fun or marketing does not completely take over.

Conclusion

This chapter has reviewed the concept of gamification in the context of art and culture. It has been shown, through the description of some significant

examples, that, in the history of art, the concept of game has not had a secondary role, especially in research characterized by a conceptual matrix and addressed to the emotional and physical involvement of the public. It is precisely this same peculiar aspect of a game that is used in modern museum applications to involve the public in a more conscious and entertaining visit to the collections. The game 'works' when players are aware that they are involved in a system, regulated precisely by rules and strategies that lead to a final result. Such games, therefore, have a strategic role in both artistic production and the enjoyment of art, not only because they contribute to 'lightening' the sometimes rather complex message of the work of art through physical and psychological involvement, but also because they are based on a method that requires the acceptance of rules, both on an individual and a social level.

The fruition of art is never, or should never be, a 'distracted' fruition. Unlike watching cinema, for example, which McLuhan referred to as the 'distracted medium', when visiting an art collection, an exhibition or an art city, visitors must be accompanied and guided so that they can truly understand and become aware of what they are looking at. Art was born with a didactic function; the medieval masters knew this when they painted the stories of the Bible on the walls of cathedrals as if they were the smallest mountain churches.

The manager of a museum or other institution, public or private, can therefore count not only on new technologies, but also on playful strategies to involve the public of any age in contemplation, but above all in understanding art. This is precisely because, as when one is participating in a game, the enjoyment of art can be unconscious but never distracted. Museums and other institutions can therefore take advantage of these new forms of playful learning, but they must also adapt their structures and train their staff to use the technological means necessary to keep up with the times. They should therefore organize specialized departments that have not only educational but also technical skills so that they can continuously adapt and update the ways in which the museum is used.

Notes

1 An in-depth study of this environmental exhibition has been published by Èric De Chassey, Place: A Constructed Abstract Situation in the Urban Cultural Continuum of the 1960s, *October* 120 (2007), pp. 24–52.
2 See Contribution a une definition situationniste du jeu, *Internationale Situationniste* 1 (June 1958), p. 10.
3 The term was coined in 1973 by Bob Heyman, a documentary producer for *National Geographic*, to describe an alternative way to experience Cultural Heritage by following the principle that without fun, there is no learning.
4 The plan is considered a strategic instrument setting priorities and defining concrete actions to address the increasing shift to digital technologies, globalization and growing societal diversity in the area of cultural policy. The Work Plan, adopted on 27 November 2018, sets out the following five priorities for European

cooperation in cultural policy-making: Sustainability in cultural heritage; Cohesion and well-being; An ecosystem supporting artists, cultural and creative professionals and European content; Gender equality; International cultural relations. https://ec.europa.eu/culture/news/2014/2711-work-plan-culture_en.

References

Barkova, O., Pysarevska, N., Allenin, O., Hamotsky, S., Gordienko, N., Vladyslav Sarnatskyi, Ovcharenko, V., Tkachenko, M., Gordienko, Y., & Stirenko, S. (2018). Gamification for education of the digitally native generation by means of virtual reality, augmented reality, machine learning, and brain-computing interfaces in museums. *Uncommon Culture*, 7(1/2), 86–101. https://arxiv.org/abs/1806.07842.

Barrella, N. (2017). Musei e tecnologie Human centered: qualche riflessione sullo stato dell arte. *RISE Rivista Internazionale di Studi Europei, IV*, 8.

Beale, K. (Ed.). (2011). *Museums at play—Games, interaction and learning*. Edinburgh: MuseumsEtc.

Bittanti, M. (2006). Game art, (d)instructions for use. In M. Bittanti & D. Quaranta (Eds.), *Gamescenes. Art in the age of videogames* (7–14). Milan: Johan & Levi.

Boiano, S., Cuomo, P., & Gaia, G. (2016). Real-time messaging platforms for storytelling and gamification in museums: A case history in Milan. https://www.scienceopen.com/hosted-document?doi=10.14236/ewic/EVA2016.60

Bouchard, A. (2013). *Gamification in the arts. When and how to use layers enhance development and marketing*. www.technologyinthearts.org.

Burke, B. (2014). *Gamify: How gamification motivates people to do extraordinary things*. Brookline, MA: Bibliomotion.

Celant, G. (1989). *Piero Manzoni. General catalogue*, vol. 1. Milano: Prearo editore.

Connolly, T. M., Boyle, E. A., MacArthur, E., Hainey, T., & Boyle, J. M. (2012). A systematic literature review of the empirical evidence on computer games and serious games. *Computers & Education*, 59(2), 661–686.

De Carli, C. (Ed.). (2003). *"Education through art". I musei d'arte contemporanea e i servizi educativi tra storia e progetto*. Milan: Mazzotta.

De Chassey, È. (2007). Place: A constructed abstract situation in the urban cultural continuum of the 1960s. *October, 120*, 24–52.

Deterding, S., Dixon, D., Khaled, R., & Nackle, L. (2011). From game design elements to gamefulness: Defining 'gamification'. In *International academic MindTrek conference: Envisioning future media environments*. New York: ACM.

Eugeni, R. (2012). *The fate of the Epos. Racconto e forme epiche nell'era della narrazione transmediale*. In F. Zecca (Ed.), *Il cinema della convergenza. Industria, racconto, pubblico* (pp. 151–164). Udine-Milano: Mimesis.

Eugeni, R., & Di Raddo, E. (2015). Videogame, art and gamification. In A. Catolfi & F. Giordano (Eds.), *L'immagine videoludica. Cinema and digital media towards gamification*. Santa Maria Capua a Vetere (Caserta): Ipermedium libri.

Gee, J. P. (2006). Why game studies now? Video games: A new art form. *Games & Culture*, 1(1), 58–61.

GRAV (Groupe Recherche d'art visuelle). (1986). *Assez de mystifications*. In F. Morellet (Ed.), *Réinstallations, exhibition catalogue*. Paris: Centre Pompidou.

Jenkins, H. (2005). Games, the new lively art. In J. Goldstein & J. Raessens (Eds.), *Handbook of computer game studies* (pp. 175–192). Cambridge, MA: MIT Press.

Kristianto, K., Dela, K., & Santoso, H. (2018). Implementation of gamification to improve learning in museum. *Journal of Engineering and Science Research*, 2(1), 71–76.

Lev-Ram, M. (2011). Four directions enterprise tech will take in 2011. *Fortune*. Retrieved 10 May 2020 from http://tech.fortune.cnn.com/2010/12/31/four-directions-enterprise-tech-will-take-in-2011/.

McGonigal, J. (2011). *Reality is broken. Why games make us better and how they can change the world*. London: The Penguin Press.

McLuhan, M. H. (1964). *Understanding media*. New York: McGraw-Hill.

McManus, K. (2013). Due dimensioni e mezza. Elementi metalinguistici nei giochi "paper". In E. Di Raddo & M. Salvador (Eds.), Play the aesthetics. Video game between art and media, Comunicazioni Sociali. *Rivista di media, spettacolo e studi culturali, Anno XXXV, new series, 2* (pp. 231–238). Milan: Vita e Pensiero.

Mitchell, W.J.T. (1992). The Pictorial Turn. *Artforum*, 30 (7), 89–94.

Paliokas, I., & Sylaiou, S. (2016). The use of serious games in museum visits and exhibitions: A systematic mapping study. In *2016 8th International conference on games and virtual worlds for serious applications (VS-GAMES)*. IEEE, Barcelona, Spain.

Ploug, C. (2005). Art games. An introduction. *Artificial.dk*, 1 December 2005. http://www.artificial.dk/articles/artgamesintro.htm.

Poole, S. (2000). *Trigger happy: Videogames and the entertainment revolution*. New York: Arcade Books.

Sanchez, E., & Pierroux, P. (2015). Gamifying the museum: A case for teaching for games based learning. In *Conference: 9th European conference on games based learning (ECGBL 2015)*, Steinkjer, Norway. https://www.researchgate.net/publication/279845368_Gamifying_the_Museum_A_Case_for_Teaching_for_Games_Based_Learning.

4 Museums and the digital revolution

Gaming as an audience development tool

Ludovico Solima

Museums and the digital revolution: gaming as an audience development tool

Until a few years ago, Italian museums were characterized by a low propensity to introduce significant managerial innovations and a poor attitude toward using the possibilities offered by the ongoing digital revolution, both online and through social media. Although there was a growing adoption of online media, most of the time such approaches were superficial, almost as if they represented a mere digital translation of what was normally done in an analog format. Thus, all too often, the design and subsequent management of the museum's website or its social profiles ended up being very simplified, sometimes even going so far as to follow the layout of a printed guide to the museum.

In this rather static, albeit evolving, scenario, the National Archaeological Museum of Naples (MANN) has distinguished itself for having launched a very innovative project a few years ago, especially when compared to the other "autonomous museums." It should in fact be remembered that, in 2014, the system of Italian state museums was affected by a significant reform, which greatly expanded the decision-making power of the new directors of the 30 major museums in Italy. Among other things, this reform, for example, allowed the directors of these museums to open a bank account and to be able to manage the funds they could generate through ordinary management activities with relative autonomy. Unlike in the past, the possibility for museums to manage their financial resources autonomously has therefore been a prerequisite for experimenting with new ideas and starting new projects.

This greater degree of decision-making autonomy led the MANN, first of all, to create a corporate planning tool—the *Strategic Plan 2016–2019* (MANN, 2017)—in which the museum management outlined its mission and vision, thus identifying "in cascade" the consequent strategic (in qualitative terms) and operational (quantitative) objectives to be achieved during the period considered.

The strategic plan identifies the key values for the MANN and, among these, an accessibility requirement, on the basis of which the full enjoyment of the museum must be guaranteed to all the different categories of the

public, regardless of nationality, age group, and/or amount of income. This reflects the general idea that if museums are considered institutions for all, that does not necessarily mean that in reality they have turned out to be museums accessible by all.

More specifically, it should be noted that there are "weak categories," such as visitors with physical disabilities, who often encounter significant difficulties in visiting a museum or parts of it, due to the existence of architectural barriers. It is certainly true that, also in Italy, much has been done to reduce the presence of such barriers, but on the other hand it should also be noted that physical disability does not end with motor disability, but it should also be extended to include visual impairment (for blind or visually impaired visitors) and hearing disabilities (for deaf visitors). Furthermore, it should be remembered that physical accessibility is only one of the factors to be considered, since accessibility has three additional dimensions: economic, cognitive, and digital (Solima, 2017).

Now, at least in the Italian experience, most of the time these "weak categories" remain on the margins of the museum's observation perspective, with the result that, all too often, such visitors do not have the possibility to enjoy a museum and its permanent collections, as well as its cultural activities, such as exhibitions, meetings, or conferences.

In this chapter, we will consider the MANN experience, which has recently created a video game, Father and Son, in order to improve the accessibility of the museum and to experiment with new forms of audience development. After illustrating the characteristics of the video game and its logical structure, a brief analysis of the literature on the use of mobile devices in museums for educational purposes is developed; the expected objectives of the project and the results actually achieved are then illustrated, with comments on the main metrics of the video game three years after its launch. A further in-depth analysis is then conducted, using the sentiment analysis technique, on the reviews that users have published on Google's app store as a result of their personal gaming experience.

The research method is based on a qualitative exploratory study: the method used has consisted of crossing the information currently known on gaming and digital devices used in museums with the experience of the MANN, in order to identify the requirements of such solutions for enhancing museum attractiveness and to verify the possibility of using a video game as an audience development tool.

The MANN experience

Having placed at the center of its programming decisions the goal of maximum museum accessibility for its various audiences, the MANN, in 2016, launched the Father and Son project, which aimed to experiment with a new expressive form of digital communication, believed to be able to reach a significant portion of the museum's potential demand.

Figure 4.1 The logical scheme of the App.

Father and Son is in fact a video game set in the city of Naples and in the halls of the MANN, in which the story of the relationship between a father and a son takes place. Michael, the young protagonist of the story, finds himself searching for traces of his father's life through the exploration of museum spaces in which his father had studied and worked all his life.

The video game is characterized by a preeminent narrative dimension, which supports and accompanies Michael's journey in a pathway that is not only physical—through the streets of Naples and some rooms of the museum—but also and above all interior: the pain for the loss of an until then distant and little understood father is in fact diluted by the emotions and feelings of universal value that the protagonist feels during this journey.

The overall design of the video game has a very simple logical structure, centered on the presence of three areas of play that correspond to three thematic nuclei of the museum's permanent collections, which specifically characterize the cultural offerings of the MANN: the Farnese, Egyptian, and Roman collections.

As shown in Figure 4.1, to reach the end of the video game, the player must necessarily pass through each of these thematic areas, to which he or she has access through a "time jump" mechanism, which projects the player into the different historical periods of reference, lowering him or her into situations of choice in which it is necessary to decide how the protagonist should behave. This results in a new and different conception of *story-telling*, defined as "*story-doing*", in which the player is given a relevant role in the choice of the path to follow in order to reach the end of the story.

One of the most innovative aspects of this project is represented by the fact that, until the game's appearance, no museum in the world had made a video game and made it available through an app, downloadable for free from the two main digital stores, in Apple and Android versions.

This was therefore an innovative and audacious choice, because the decisions made by the directors of Italian state museums are subject to the verification activities of various control bodies, which could well have censured a museum investment that had completely uncertain returns.

In the absence of similar experiences, which could serve as reference points, at the time the project was launched it was in fact completely impossible to make even a vague forecast on the number of expected downloads and on the returns that such a project could generate.

From this point of view, it should be noted that a leading role in this circumstance was played by the director of the MANN, archaeologist Paolo Giulierini, who in fact personally took the risk of censorship by the museum's control bodies and, together with Ludovico Solima (creator of the project) and Fabio Viola (coordinator of the work team), contributed to the definition of the video game's objectives and its main narrative trajectories, based on the principles of engagement designed (Viola & Idone Cassone, 2017).

This risk was also increased by the fact that, as already mentioned, even for larger museums, the use of apps in the form of a video game was completely unknown at the time. In fact, video games have occasionally become part of the permanent collections of some museums (as in the case of the Australian Centre for the Moving Image or MoMA in the United States) (Modena, 2019), because they are considered real works of art (Goodlander & Mansfield, 2013; Izzo, 2017) or as expressions of life and culture in modernity (Muriel & Crawford, 2018). Only rarely, however, have video games been considered as real communication tools.

As observed by Yiannoutsou et al. (2009), the use of mobile devices for educational purposes in museums has typically involved three different areas: (a) the transmission of information useful to improve the visitor's learning process; (b) the enhancement of the levels of interaction between visitors and museum collections (as is the case for the Exploratorium in San Francisco); and (c) the creation of situations in which the user, typically of school age, is called upon to assume a role and to achieve some pedagogical objectives (as in the case of "MUSEX," developed by the National Museum of Emerging Science and Innovation in Japan). In all three cases considered, therefore, the use of mobile devices takes place within the museum's spaces, due to the more general aim of improving the overall visitor experience (Paliokas & Sylaiou, 2016), increasing visitor involvement, and stimulating mutual interaction with other visitors (Schroyen et al., 2008).

In the case of Father and Son, the initial setting of the project was actually to create a video game to be used during the museum visit experience. It was only during the design phase of the narrative structure that this approach gave way to the idea of creating an app that could instead be used completely regardless of a user visit, with the very intention of improving the MANN's accessibility and looking for an increase in its audience, as contemplated in the above-mentioned strategic plan of the museum.

The concept of this experimentation was therefore to "take the museum outside the museum" in the belief that some tools—particularly digital ones—are able to amplify the museum's capacity for dialogue and interaction both in a spatial (beyond its physical perimeter) and a temporal sense (not only during the visit experience but also before or after it).

The choice made by the MANN was therefore to address not only the museum's current visitors, but potentially the entire audience of video game users—estimated to be around two billion people worldwide—in a way that was completely independent of their physical location.

This choice was accompanied by the decision to significantly limit the amount of additional information on the permanent collections and/or services offered by the museum to the visitor, which generally constitutes the predominant content of the app developed by museums at the national and international level.

Expected objectives and results achieved

The educational potential of the video game has therefore been placed in the background, placing other strategic objectives of the MANN in a barycentric position, in terms of image, loyalty, visibility, accessibility, and attractiveness of the museum (Figure 4.2).

More specifically, with the Father and Son project the museum intended to pursue these aims (Solima, 2018):

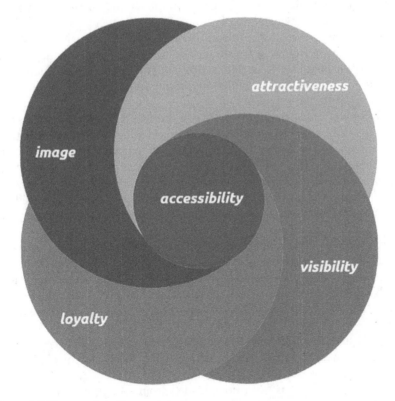

Figure 4.2 Expected results.

- Strengthening and improving the overall *image* of the MANN. In the collective imaginary, museums are often perceived as boring places, because they are considered mainly oriented to the conservation of their heritage, and therefore scarcely sensitive to the needs of their audience and not inclined to adopt innovative paths in the enhancement of their collections. The creation of the video game could therefore contribute significantly to modifying this perception in favor of the museum, bringing benefits in terms of image and differentiation of its cultural offerings.
- Increasing *loyalty* towards the MANN, through the creation of an emotional bond with the museum, in consideration of the fact that some of its main works in the video game become the access points to relive its historical, social, and human settings. Within this perspective, the museum can therefore be seen as a "digital portal" through which to overcome spatial and temporal barriers and access a multiplicity of historical contexts and characters from ancient times.
- Improving the *visibility* of the MANN. As the number of downloads increases, the museum's presence on the web improves, also thanks to articles and reviews in traditional and digital media, reports of the video game on Apple and Google stores made by the same administrators of these platforms, and user comments and the related word-of-mouth effect they generate.
- Increasing the level of *accessibility* of the MANN, considering the fact that the video game uses a simple and unconventional language, which makes it possible to develop a different way of communication by the museum, more fluid and more engaging, which makes it more accessible for different categories of users.
- Improving the *attraction capacity* of the MANN. In this respect, there is an unlocking mechanism within the video game to access additional contents of the game, which is linked to the physical presence of the visitor in the museum. This mechanism can represent a stimulus to go physically to the museum, further to the already significant motivation of the user to see in person the real-life settings, inside and outside the museum, that are digitally reconstructed as the background to the game.

With respect to these objectives, the results achieved have gone beyond all expectations, in the sense that the video game, since its release online in April 2017, has generated unexpected effects, primarily in terms of communication, which have evidenced its success at the international level. In fact, about three years after its launch, it is possible to register the following achievements:

- By September 2020, the total number of downloads had exceeded four million in 97 countries worldwide; of these, 75% of downloads were for the Android version and 25% for the iOS one. In the previous six months, the video game has been downloaded from Google's store more than 52,000 times, with a monthly average of about 18,000 downloads.

- In the Android version, the country of origin for the largest number of downloads is India (10%), followed by Brazil and the United States (both 8%), Russia (7%), Indonesia (6%), and Italy (about 5%). In the iOS version, China takes the lead (43%), followed by the United States and Italy (both 7%), Russia (5%), and Canada (4%).
- The launch trailer on YouTube has exceeded 819,000 views; the two main "walkthroughs" of the video game have been seen in total about 50,000 times.
- The number of newspapers worldwide, both paper and digital, in which discussions of the video game have appeared is just under 700.
- More than 920,000 hours have been spent inside the video game.
- The rating of the app, in both stores, is higher than 4.5 (out of 5.0 maximum); in the case of the Android version, 83% of the ratings are five-star ratings.
- On the Android store, more than 16,000 reviews have been written.
- The number of check-ins at the museum has exceeded 32,000.
- Finally, as far as the socio-demographic profile of users is concerned, there is a slight prevalence of men (57%) over women; and a majority of users (54%) are over 35 years of age, compared to 46% who are below the age of 35.

These results deserve some comment. First of all, it should be noted that the total number of downloads (more than four million) recorded in the period April 2017–September 2020 is truly extraordinary, considering that the MANN did not make any promotional investment following a press conference presentation at the museum. It should also be noted that, during the same period, the total number of visitors to the museum was around 1.8 million, that is, just under half the number of digital users.

The geography of downloads puts Italy in the top positions, but still with a relative weight (about 6%) much lower than it was reasonable to expect for a product promoted by an Italian museum, made by an "indy" (i.e., independent) producer and initially released only in Italian and English. Only in November 2017 there were translations for making the video game available in five additional languages (French, Spanish, Portuguese, Russian, and Chinese).

To date, the number of views on YouTube has exceeded 800,000, to which must be added the 50,000 or so views of the two main "walkthroughs" made by users. Therefore, word-of-mouth promotion must be contributing to the popularity, considering the number of articles, even at the international level, which have reported and commented on the game.

The rating of the app is particularly high. In the Android version it is slightly higher than 4.5 stars, which is equal or higher than the rating for some of the most popular Google apps, such as Gmail (4.4), Maps (4.3), YouTube (4.5), Photo (4.5), and Google Arts & Culture (4.5).

The distribution of players by age is worth further reflection. The fact that the average age of users was, in about 54% of cases, over 35 shows

that the audience profile is quite different from what is often thought to be prevalent for video game users. This represents not a platoon of millennials but a user base consisting largely of adults, who have also expressed a particularly high appreciation for the game.

Sentiment analysis

The number of reviews, more than 16,000, is a very relevant result, considering that internet users typically assign only a star rating to an app, without providing further commentary. It should also be noted that these reviews constitute a set of information of great interest, also from a scientific point of view; in most cases they comprise not just simple evaluations but quite specific comments, from which it is possible to draw useful indications and insight.

The scientific literature, on this specific aspect, is still at an early stage, but there is a general convergence on the idea that the evaluation of comments—made through so-called sentiment analysis (Jadav et al., 2017; Lee et al., 2017)—can provide information of great interest, useful in the first place to the app developers (Guzman & Maalej, 2014) but also, as in this case, to those who commissioned the video game (the MANN).

From a first analysis of these comments, conducted following a qualitative approach, it is possible to draw some initial indications, distinguishing three macro aggregations (Solima, 2018):

- The first group includes comments that give a more or less articulated evaluation on the video game as a whole or on some of its features (graphics, music, plot, etc.); in addition to numerous appreciations for the quality of the realization, the comments that highlight the communicative and pedagogical values of the video game, as well as the stimulus to visit the museum and/or the city that hosts it, are quite widespread. On this last point, it should be recalled that the game includes a mechanism to access additional content (additional music, costumes, etc.) on site; that check-in mechanism has been used by more than 32,000 museum visitors.
- The second group collects comments that contain specific requests. For example, these requests include longer game times and the creation of a second episode or a further extension of the first one; however, there are numerous suggestions on the content to be provided in subsequent episodes or on features to be implemented.
- The last aggregate includes comments that express the feelings felt by players thanks to the experience of the game. This aggregate is probably the most touching, because it includes comments that appear very personal, in which the cognitive and emotional dimensions take over. These comments reveal, in other words, how even a video game is able to touch some very intimate and personal "strings" of the players,

creating a special bond with the museum that can also guide further decisions to visit it and stimulate, in a more general sense, the willingness to consume culture in other museums or in places that offer appropriate cultural offerings.

Because of these successful results, and also to take into consideration the recurring and pressing requests of many players, the director of the museum has decided to realize a new episode of the game, scheduled for the end of 2020. In addition, the first episode has been translated into other languages, Japanese and German, as well as into the Neapolitan dialect, to highlight the deep territorial roots of the MANN. Finally, a local company has been commissioned to transpose the video game into a real theatrical performance, which is expected to take place hopefully in 2020, in the same museum settings that are the background of the video game.

Conclusion

The context in which museums are currently working is characterized by an intrinsic dynamism, in which changes in the scenario and the alteration of established rules and balances have become constitutive features of the ongoing digital revolution.

Museums must therefore adapt to these changes, seeking new forms of audience development and new ways of communicating with their existing and potential audiences. In particular, regarding the latter, which by their nature are more difficult to reach, innovative approaches must be identified, also by exploiting the new options made available by technology.

The experience of the MANN, with the project of the video game Father and Son, has been an undoubted success, to which it is possible to refer, however, not only along the same path—that is, through the use of gaming—but rather by introducing more flexibility into the decision-making system of the museum, through a cautious and controlled propensity to risk. In a context that evolves and changes unexpectedly, therefore, it is necessary to have the strength and the courage to progressively change the way museums are managed, even along lesser known roads. The digital revolution currently underway not only endorses (and often rewards) such behaviors but also makes them a necessary condition for reacting to the changes expressed by the external context every day.

References

Goodlander, G., & Mansfield, M. (2013). Press start: Videogames in an art museum. *Journal of Interactive Humanities, 1*(1), 37–41.
Guzman, E., & Maalej W. (2014). How do users like this feature? A fine-grained sentiment analysis of app reviews. In *2014 IEEE 22nd international requirements engineering conference (RE)*.

Izzo, F. (2017). Gaming and museum. *Journal of US-China Public Administration*, *14*(1), 57–62.

Jadav, S., Tanawala, B., & Guadani, H. (2017). Sentiment analysis: A review. *International Journal of Advance Engineering and research Development*, *4*(5), 957–962.

Lee, L. S., Lee, S. H., & Hwang, H. S. (2017). A study of evaluating of game review data using multiple regression. *International Journal of Innovation, Management and Technology*, *8*(2), 95–99.

Modena, E. (2019). Musei nei videogiochi. Videogiochi nei musei. *Pianob. Artieculturevisive*, *1*(4), 83–105.

Muriel, D., & Crawford, G. (2018). *Videogames as culture. Considering the role and importance of videogames in contemporary society.* London: Routledge.

Museo Archeologico Nazionale di Napoli. (2017). *Piano Strategico 2016–2019.* Napoli: Typescript.

Paliokas, I., & Sylaiou, S. (2016). The use of serious games in museum visits and exhibitions: A systematic mapping study. In *8th international conference on games and virtual worlds for serious applications.* Barcelona: IEEE.

Schroyen, J., Gabriëls, K., Luyten, K., Teunkens, D., Robert, K., Coninx, K., Flerackers, E., & Manshoven, E. (2008). Training social learning skills by collaborative mobile gaming in museums. In *Proceedings of the international conference on advances in computer entertainment technology, ACE 2008,* Yokohama, Japan, 3–5 December 2008.

Solima, L. (2017). Museums, accessibility and audience development. In M. Cerquetti (Ed.), *Bridging theories, strategies and practices in valuing cultural heritage* (pp. 225–240). Macerata: Edizioni Università di Macerata.

Solima, L. (2018). Il gaming per i musei. L'esperienza del Mann. *Economia della Cultura*, *3*(28), 275–290.

Viola F., Idone Cassone V. (2017). *L'arte del coinvolgimento.* Milano: Hoepli Editore.

Yiannoutsou, N., Papadimitrioua, I., Komisa, V., & Avourisb, N. (2009). Playing with museum exhibits: Designing educational games mediated by mobile technology. In *8th international conference on interaction design and children.*

5 The changing face of museum tour guides

How to raise audience interest and engagement through digital technology

Luca Pirolo and Luigi Nasta

Introduction

In recent years, innovation, especially if driven by digital transformation, has become a topic of significant interest among museums and has dominated the discussion in many museum conferences, workshops, and seminars. This is certainly because innovations, if correctly applied, can help museums in achieving their organizational mission in a more effective and efficient way by increasing the audience interest and engagement. Worldwide, an increasing number of new initiatives show the importance of introducing new digital technologies in improving the visitor's journey experience. Despite the growing attention paid by the international literature to this phenomenon, less research has been devoted to investigating the challenges faced by those people covering very traditional roles in the cultural field and, specifically, in museums. Therefore, this chapter aims to propose a conceptual model for understanding how museums can help tour guides in the process of redefining and/or developing their competencies in a renovated scenario driven by technological innovations.

In short, the research question is addressed to investigate on how digital technologies, adopted by museums, reshape the very traditional role of tour guides.

The chapter starts off by introducing the concepts of information systems and information and communications technology (ICT) as antecedents of the digital transformation process occurred in the last years. This is followed by the description of the innovation processes normally carried out by museums. Then, it proceeds with the representation of the technology acceptance model (TAM) revisited by explaining the role of the tour guides. Finally, a conceptual overview of the main drivers exploitable by museums to help tour guides developing technologically related competencies is provided.

From information systems (IS) to information and communications technology (ICT)

The information system (IS) can be defined as a set of people, machines, and procedures that allow an organization to have the necessary information in

the right place at the right time (O'Brien & Marakas, 2006). The information systems do not exhaust themselves in the adopted technologies, but, rather, it must be interpreted based on a socio-technical perspective. The same people who make up an organization represent important and fundamental vehicles for transmitting information, not only through their words, but also through the behaviors adopted. A broader definition of IS includes all those elements that allow an organizational actor to purchase inputs, implement processing activities and transmit output (Laudon & Laudon, 2011). Input acquisition involves the research and the collection of data and information, and, in turn, the output activity indicates the transfer of results of the processing actions that the organization has carried out. As far as a service firm is concerned, information systems help in collecting inputs to be used in order to provide the final service for clients.

Depending on the extension of the concept, the term information system is often used with reference to different meanings that are affected by the conception that the scholar manifests with respect to the company and the business economy. Among the multiple authors, those more oriented to deepen the organizational themes have framed the IS along the typical variables of the organizational structure, specifically between the functioning mechanisms (Piccoli & Ives, 2005; Thompson, 2017). According to these authors, the IS is considered an operating mechanism that must be designed and maintained in harmony with the organizational structure, so that the whole responds to the strategies and aims of the company.

Despite the most widespread definitions in the literature (Kohli & Devaraj, 2003; Laudon & Laudon 2011), it is possible to identify some common traits (Schryen, 2013):

- The systemic logic, that is the idea of the IS as a set of elements or variables that are mutually interdependent, even if heterogeneous;
- The intermediate result generated by the IS, which is the production of information, information flows, and the sharing of knowledge elements that go beyond company boundaries;
- The purposes of the IS to support decision-making processes, control, and more general management activities.

Therefore, we can define the corporate IS as the set of elements, interdependent among them, which generates information flows to support internal decision-makers, at various points and at various organizational levels, and outside the company borders, including customers or, in the case of museums, visitors.

This broad definition shows that IS does not only embrace technologies, but all those mechanisms, including social ones through which data and information are acquired, processed, and transmitted. Thus, it can be understood as the set of all data representations and processing activities (formal and informal) in the context of an organizational structure and in its relations with the external environment (De Haes & Van Grembergen, 2009).

IS can be divided in informal and formal according to the mechanisms used to transfer data and information. Gossip, word of mouth, conversations between colleagues as well as tacit knowledge are typical expressions of informal information systems in which there is no official and pre-established agreement on what information is, on how it should be processed and stored. Nonetheless, information sharing among final users, as well as exchanges in opinions and judgments, constitutes a precious source of data for an effective and efficient IS. In fact, informal information systems are clearly necessary for the activities of sense making, decision-making, knowledge-making, and coordination of an organization. Formal information systems, on the other hand, are those that derive from a conscious and explicit choice of the organizational actor regarding the definition of the data, the procedures, and the rules to be followed for their elaboration and transmission, and the actions to implement.

Even though there are no theoretical limits to the amount of information that can be stored on paper information systems, in practice, people have always been sought for technologies that can support larger volumes of data and facilitate the transmission and the storage. The term information technology (IT) means all the tools connected to the elaboration of symbols, be they words, images, or sounds (Thong & Yap, 1995). With the term computer-based information systems, we mean the formal ISs that make use of a specific IT that is the computers which allow electronic data processing (Onn & Sorooshian, 2013). This is especially true in some contexts, such as the cultural one, in which information is provided not only on a written basis but in a consistent way using images or symbols.

Before proceeding with the analysis that technologies have had on the organizational structure, it is necessary to distinguish what is meant by IT and ICT: while the first term refers to all the means and tools connected to the processing of symbols, the latter concerns all physical tools and software that allow the transfer of data from one physical location to another. In this sense, ICT embraces tools and logical applications that allow the combination of data calculation and storage capabilities specific to computers with data transmission and information capabilities characteristic of telecommunications media (Bolici & Giustiniano, 2013).

In recent years, new information and telecommunication technologies are playing an increasingly important role in the economic development of the most advanced countries and in the formation of renovated social behaviors. The shift from an economy based on the flow of materials to an economy focused on the flow of information has led to a change in the role of information technologies. In fact, from automation tools for the pursuit of better economies in the processing of internal data, they are now considered according to a logic of integrated information management (Cameron & Green, 2019). This change goes in parallel with technological innovations and with the progressive increase in the complexity of the environment in which companies operate. In this context of strong instability

for companies, the role of ICT is to promote the integration of various business processes and to foster the connection of companies with the external world. This represents a significant change in the way of running a business. Nevertheless, while most firms have already understood the importance of including technology innovations in their processes and activities, a more serious delay concerns public or semi-public institutions. Without getting into the details and the reasons of this delay, what is of primary concern are the opportunities available for those subjects who will decide to move along this path.

With reference to museums, it is easy to underline how technological innovations can have a positive impact from both a managerial and a social point of view. Even though the implementation of these strategies requires specific and, in some cases, significant investments, higher incomes can result by the attraction of new visitors encouraged by modern technologies. At the same time, the social and cultural purpose of a museum can take advantage of them since scientific information, if described in a new attractive and interactive way, is easier to assimilate, increasing the desire of the community to participate into museums' activities.

Nonetheless, in analyzing the effects of the introduction of new technologies in the fruition of museums' services, it is important to estimate the impact on the organization and human resources. In fact, as already underlined, new technologies can be used by museums to improve their edutainment purpose and increase the quality of the services offered to their visitors, but, to fully reach these outcomes, the organizational structure must be changed to be more effective and, most of all, all people working within and outside the boundaries of the museum (e.g., internal staff and external tour guides) have to adapt their mindset and their way of working to innovation.

Technology, organization, and human resources

Investments in information technologies cannot be studied as punctual phenomenon of simple acquisition of standards and devices, but they must be considered as inputs that give rise to long and complex processes of organizational change to be studied with a dynamic perspective. Additionally, the rapid development of ICT makes it difficult to identify regularities or prescriptions that can preserve a lasting validity in time. In other words, ICTs develop in such rapid and sometimes unforeseeable way as to render vain any attempt of a theoretical schematization (Checkland & Holwell , 1998). Another element of complexity is to be found in the number and the diversity of the perspectives according to which the analysis of the impact of ICT on business economics has been developed in the literature (Stowell & West, 1995). Despite these different studies, there is a general agreement about the fact that in an economic environment, characterized by

permanent and rapid technological evolution, successful organizations are those able to adapt their processes and activities to change.

With their multi-dimensional display languages, museums represent an inexhaustible educational resource and have long been holding a key function in education. Indeed, based on the definition provided by ICOM (the International Council of Museums), the museum is

> a permanent, non-profit institution, open to the public, at the service of society and its development, which carries out researches, acquires, preserves and, above all, exposes the testimonies of humanity and its environment for the purposes of study, education and delight.
>
> (Sandahl, 2019)

Considering these recent evolutions, the museum educational purpose must consider the introduction of new technologies in the educational field. Multi-media applications are increasingly playing a leading role within the communication and dissemination tools used in museums to help visitors to learn about and understand cultural artifacts: touch screens of different sizes, digital audio guides, interactive installations, virtual and augmented reality solutions, and portable devices are increasingly widespread, also due to the reduction of their costs. Compared to traditional communication tools (captions and textual panels, organized tour guides, etc.), new technologies offer the possibility of expanding the ways of visiting and the information to be offered to the public in terms of quantity and quality. In addition to texts and images, museums can propose videos, sounds, and interactive routes in a simple, fast, personalized, and effective way. For this reason, the use of new technologies as an integral element in the production of museums' cultural offer represents a topic that has, since the 1990s, been gaining increasing attention within the literature of cultural economics and museum management (Falk & Dierking, 2016; Fonseca et al., 2018; Camarero, Garrido & Vicente, 2019).

The management of a museum calls for different tools to cope with a traditional trade-off. Matter of fact, museums have to manage both economic inefficiencies, linked to limited resources and the difficulty of self-financing, and the difficult relationship with the audience, which struggles with understanding the work but which, despite this, increasingly requires engaging and stimulating experiences (Pine II & Gilmore, 2014). In this context, the technological resources have aroused interest because they are considered able to respond to both problems in a complete way. From the management point of view, technology can provide greater efficiency in the coordination of processes and favor the development of new activities capable of generating economic returns. From the customers' point of view, it is possible to assist them through a more direct contact with the heritage and to provide them with more appealing ways of enjoying it.

Museums, like any other organizations, must handle the change dictated by new technologies to be able to improve the performances obtained and reach a competitive advantage. For this reason, museums, over the years, have taken steps to adopt new technologies capable of improving certain aspects relating to their organization, to the management of communication toward their audience, and to the use of the cultural artifacts they manage.

In a nutshell, museum's innovation has been defined as the creation of new and improved products, processes, or business models through which museums can satisfy their social and cultural mission more effectively (Camarero & Garrido, 2012). Several studies, which analyzed the impact of innovation on cultural organizations, distinguished between (i) technological innovations, as those linked to the adoption of modern technologies embedded to products, services, or production processes for products or services, and (ii) organizational innovations, as those linked to changes in museums' management approaches.

Technological innovations in museum

Augmented reality, virtual reality, chatbots, and video games are now increasingly entering museums, exhibitions, and places of exposure. Innovating, when dealing with culture, always means renewing the spirit of the object in question and rewriting, to a certain extent, its meaning. The digital adoption in museums and art places thus, if well exploited, can increase both the concrete value of the heritage in question and the perceived value of the experience within it. Moreover, innovation in museums has relevant advantages such as the opportunity to provide a truly visitor-centered approach, a very marked experiential dimension, often even a greater level of understanding. However, in order to be truly functional, the introduction of technology into places of culture should be the result of a strategic vision: its role must be able to bring the user closer to the object of art. For this reason, a competition between the stimuli provided should not exist— museums must avoid the overload of solicitations toward the visitor—and the possible presence of hi-tech devices must be functional to the visit experience. In other words, it must add something to it and not be free. There is not successful strategy but focusing on quality: the technology in museums and other places of culture must be invisible and unobtrusive, which means—to give two practical examples—that if a museum uses augmented reality headsets, these cannot be an obstacle to visitor or they cannot tire him/her while transporting them and, in the same way, the images recreated in rendering cannot show pixels or mash.

Different realities in different countries have found their way to innovation in museums. Some initiatives have had, above all, a markedly philosophical objective: to make the artistic-cultural experience more democratic and to convince even the targets with less familiarity with these environments to overcome prejudices and false beliefs, like the presumed

elitist character of the culture. To this strand belong initiatives such as the Google Art Project: thanks to the collaboration with hundreds of art institutes (such as the Musée d'Orsay in Paris, the Museum of Islamic Art in Qatar and, for Italy, excellences such as the Venaria Palace) and the most advanced imaging techniques, the works of art by over 6,000 international artists have been put online; Internet users can see them up close—literally, even zooming in on details—exactly how if they could enjoy virtual tours of entire sections of museums (Proctor, 2011).

The involvement, not only remotely but also and especially during the visit, seems to be the key word when it comes to innovation in museums. Anyone who deals with designing and optimizing the in-store experience knows that a pleasant environment and the right sensory stimuli can increase the time spent in the store and improve the perception itself as well as the memory of the brand experience. The same goes for a museum. For this reason, it should not be surprising that new technologies have been used by curators and museologists to create environments and an immersive storytelling. Among the others, it is worth mentioning "L'Ara com'era," a temporary project, still active, that, using 3D reconstructions and virtual videos, allows visitors to see the original appearance of the Ara Pacis and even witness to a sacrificial rite in Campo Marzio. Another noteworthy project is "Viaggi nell'antica Roma" in which, through two exciting and innovative multi-media shows, the objective is to recount and revive the history of the Forum of Caesar and the Forum of Augustus. Thanks to special audio systems with headphones and accompanied by the voice of Piero Angela, a very famous Italian science communicator, and the vision of magnificent films and projections that reconstruct the two places as they appeared in ancient Rome, viewers are able to enjoy an exciting and at the same time rich of information representation of great historical and scientific rigor (Natale & Piccininno, 2018).

Organizational innovations in museums

The explosion of the digital universe and the emergence of new opportunities related to data-driven innovations represent two phenomena of general scope that do not impact only on profit-making organizations. The technological evolution changes the reference context also for the institutions appointed to the conservation and enhancement of the historical, artistic, and cultural heritage with possible consequences also in terms of redefining their own function and mission.

The role of museums is increasingly turning from the collection, cataloguing, preservation, and exposure to the public of objects to the co-creation with visitors of an increasingly interactive and personalized experience. The "paternalistic" view, under which the museum must provide its visitors with an interpretation of what they see, is accompanied (and sometimes replaced) by the possibility for the visitor to build a path, an interpretation and a

personal meaning starting from the information that is associated with each object in an exhibition. Information concerning the acquisition of the object, evidence about the context of its creation, the network of relations that link it to other works, and so on can support visitors in the co-creation of their own experience. Much of this information is normally contained in museum information archives. Making it available to visitors in a structured way, functional to manipulate and interpret them, is a way to enrich visitors' experience, enabling co-creation of value through a digital experience.

For these reasons, using artificial intelligence (AI) in the museum could be useful for several purposes, such as a better organization of catalogues and collections as well as to guarantee continuity and coherence among collections of different bodies. Indeed, for an AI algorithm it is extremely simple to recognize recurrent visual or chromatic elements, associate them with a current or an artistic expression and thus create more consistent collections and catalogues. This is what the Norwegian National Museum has tried to do: using machine learning and neural networks, it has added meta-data to the paintings in the collections that could prove to be very functional, especially for those who study them.

Similarly, the digital transformation of works, usually used for documentation and archiving purposes, might change the entire museum model. Examples which are relevant to mention are: "Opera Omnia - Raffaello" and "Van Gogh, Starry Night." The exhibition "Opera Omnia - Raffaello" gives a unique opportunity to view and admire under one roof 35 life-size digital reproductions of the original paintings of the Great Renaissance Master Raffaello Sanzio, which are displayed in various museums across Europe. Likewise, the Atelier des Lumières, a digital art center in Paris, has recently launched a new exhibition called Van Gogh, Starry Night—a visual and musical installation, honoring the works on Vincent Van Gogh. The exhibition features some of the artist's most famous works projected onto the art center's walls by over a hundred projectors accompanied by the music composed by Luca Longobardi.

Even more interesting is the example of The International Museum of Women (integrated in the Global Fund for Women since 2014), a fully virtual museum that organizes virtual exhibitions of works created by women. Around the museum there is a community of 10,000 artists participating in online exhibitions and with whom the 600,000 visitors per year of the museum can interact directly (Offen & Colton, 2007). The virtualization of the museum, obtained through the complete digital transformation of the works and exhibitions, has made it possible to reach a high number of visitors and has allowed the creation of a "participated museum," not only because of the large number of people who follow its activities on social networks but, above all, because it is based on a user-generated content model rather than on a museum-curated model (see Table 5.1)

These examples allow us to understand that organizational planning cannot ignore the opportunities offered by ICT. The development and

Table 5.1 Innovation in museums

	Technology	Benefits
Technological innovations		
Google Art Project	Imaging techniques	Remote access to art
L'Ara com'era	Augmented reality	Immersive experience
Viaggi nell'antica Roma	Virtual reality	Immersive experience
Organizational innovations		
Norwegian National Museum	Artificial intelligence	Create consistent collections and catalogues
Opera Omnia - Raffaello	Digital reproductions	Digitalization of works
Van Gogh, Starry Night	Visual and musical installation	Digitalization of works
The International Museum of Women	User-generated content	Remote access fully digitalized

Source: Authors' elaboration.

diffusion according to criteria of effectiveness and efficiency of the ICTs in a business context cannot disregard an adequate consideration of the organizational variables, both from the point of view of the systemic coherence and from that of the management of the process of the associated organizational change. As Ciborra (1996) states, technology can lead to labyrinthine paths, to emerging strategies, to differentiated learning, and therefore to unexpected behaviors; it is ambiguous.

The acceptance of technology

If technology can lead to unforeseen behaviors and results, how do people in museums cope with the advances in information technologies? Is the direction of change unique, or is there the possibility of intervening to make it more like a "desirable" direction? A substantial part of the debate in the 1980s until the mid-1990s revolved around two opposite positions. On the one hand, the thesis summarized in the *upskilling* term; from the other hand the thesis summarized in the term *deskilling* (Braverman, 1998).

In the first case, we observe an "optimistic" view of the scenarios that arise from the relationship between man, work, and technology; a vision according to which technology would increasingly be configured as a support and assistance to man for decision-making problems, integrating in a complementary way with typically human skills and abilities, and thus enhancing them. The term upskilling evokes the increase and expansion of skills and knowledge, decision-making autonomy, and flexibility. In the second case, technological development is interpreted as a way to support

the tendency toward the return, consolidation, or new introduction of Tayloristic solutions and that as a whole would manifest itself both in quantitative terms, that is in the substitution of work with automation, and in qualitative terms, that is by disqualifying the work itself to mere assistance and support of the technical tools.

TAM represents one of the most widely used tools in the analysis and understanding of the reasons why individuals choose to use or not a given technology, in both their work and the private sphere. For years, it has been a reference scheme that has, as its purpose, the study of the processes of use of information technologies, aiming to foresee the adoption of specific applications by classes of users. TAM is one of the most influential extensions of the theory of reasoned action (TRA) proposed by Fishbein and Ajzen (1975). Developed by Fred Davis, Richard Bagozzi, and Warshaw in 1989, it replaces many of the measures of the attitude of the TRA. It was formalized with the aim of providing a good tool for forecasting the use of computer applications depending on different classes of users. According to the Davis and Bagozzi model, the use of a computer system is influenced by two elements, in turn determined by a series of external variables:

- Perceived usefulness, or the degree of a person's belief about the fact that the use of a specific system increases the level of his work performance.
- The perceived ease of use, that is, the degree of a person's belief about the fact that the use of a specific system is devoid of effort.

Therefore, according to this theory, people would tend to choose whether or not to use a system based on their beliefs in relation to the fact that it is able to help them in completing their tasks, then perform their work better, and that it is not too much difficult to use.

As shown in Figure 5.1, the attitude toward using (A), as already modeled by the TRA, had a direct effect on the behavioral intention (BI), and is determined by the perceived usefulness (U) and the ease of use (E).

In short, TAM suggests that it cannot easily induce users to use a system if users themselves are not actually intent on using it in the first place.

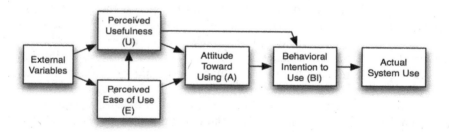

Figure 5.1 Technology acceptance model (TAM).
Source: Davis, Bagozzi and Warshaw (1989, p. 985).

In fact, many designers have believed for a long time that the barrier to technological acceptance was represented by the low usability and comprehensibility of information systems. This resulted in the improvement of the interface and usability as the key to success for technological acceptance. However, TAM shows that although the ease-of-use is a very important factor, the utility of the system becomes a second key factor to be taken into consideration. To facilitate the adoption process, it is then possible to act on the computer system improving its usefulness and ease of use, and/or intervening to modify users' attitudes toward this system. Attitudes, in turn, can change if users perceive that the system will allow them to work better or to be productive with equal perceived usefulness (U) efforts and that the system will be simple to use (E). Adequate communication and marketing plans, training activities to develop suitable knowledge and skills, documentations, practical demonstrations, and user support/involvement are simple variables that can influence these perceptions.

Thus, museums and, more generally, cultural institutions are facing a double challenge: it is not enough to attract visitors; they also need to find a way to communicate their heritage with a different approach, which makes it closer to the needs of knowledge and experience of citizens and tourists. To address this critical issue, cultural institutions must equip themselves with new, hybrid figures that become "digital" interpreters of the heritage, that is, people who know the cultural inheritance as well as the customs and traditions, but at the same time they are able to assess the opportunities offered by the digital. Those people are identified in the tour guides who constitute a bridge between the cultural organizations, which own and manage a given cultural asset, and the audience that should develop a more prominent attitude toward the technological innovations implemented by the museums, in order to fully understand the benefits offered by them.

The role of the tour guide in the acceptance of technology by the museums' visitors

As previously mentioned, one of the most socially and culturally useful professional figures for the precious role of mediation and for the dissemination of knowledge that it carries out in both historical and artistic contexts is that of the so-called tour guide. Today this figure is incomprehensibly relegated to the margins of cultural heritage enhancement activities and, consequently, considered to be the lowest rung of the scale, now very crowded by the operators of the sector. The origin, however, is linked to an ancient tradition, which has fueled the trend of artistic literature related to the evolution of travel, routes, and destinations, from the medieval pilgrimage to the 18th-century grand tour. The tour guide is among the most fascinating and ancient professions in the world. At the beginning of the 18th century in Europe, this figure was known by the nickname of Cicero, most likely due to the comparison with the eloquence of the Latin orator Marco Tullio

Cicerone. The birth and history of the tour guide is to be rediscovered in the history of travel. In the Greek world, for example, when one had to visit a city characterized by important artistic and architectural testimonies and places full of history, it was addressed to the Priests who, being more educated and prepared, could narrate events, legends, and meanings of a place. In the Middle Ages, the pilgrims who walked toward the sanctuaries and places of worship had with them local guides able to let religious travelers know the right directions, spiritual itineraries, news, and events related to history and rituals. The figure of the tour guide, for some time, was also associated with the role of the chaperone; it was in the past planned by mercantile law and found a first legal definition in the 14th century.

The complexity that has arisen in the figure and in the role of the tour guide with the evolution of the concept of cultural heritage is reflected in its current and specific requirements. The traditional competencies associated to the tour guide professionalism are the knowledge of one or more foreign languages, an in-depth acquaintance of the works of art and of the archaeological heritage, and an appropriate cognition of natural beauties and environmental resources. Considering this, it is obvious that tour guides cannot be improvised. A solid theoretical foundation and a long practical experience are indispensable requirements for the practice of the profession. The task of the tour guides is to offer each type of audience an approach to cultural good suited to their level of knowledge and interests. This is not easy if you do not have the means to attract the interest and attention of the group, especially if you refer to foreign tourists. Thus, the profession of the guide needs a solid cultural preparation, accompanied by a disposition to the social relationship. Indeed, the quality of the service depends largely on the ability to adapt the cultural offer based on who you are facing and based on what the users' expectations are.

Developing a meaningful relationship with the customer is an extremely relevant condition in a service economy that has developed into an "experience economy": the passive approach of the customer to the "connection" is replaced by the active approach of "getting in touch" (Pera, 2017). The desire of tourists to engage in more intense relationships with the local tourist destinations is growing. It is the expression of the desire to experiment the "authentic" tourist site, to go beyond the destination stage and get involved in its background (Sharpley, 2018). Persuasive stories told by good tourism storytellers can engage tourists both intellectually and emotionally with the destination, and to make the tourist visit personal, relevant, and meaningful for them (Tung & Ritchie, 2011).

Additionally, to the prerequisites imposed by the experience economy, the position of tour guides is challenged by technological evolutions in two main ways. First, travelers have become tourism storytellers themselves. Thanks to all the—mostly online—user-generated content applications and social networks, tourists have become co-creators of the (content of) destination imaginaries. Second, technological devices have become major

carriers of tourism stories. Therefore, giving the strong connection that tour guides have with both cultural organizations and visitors, they represent the most appropriate subject to favor the acceptance of this renovated scenario by visitors.

As a matter of fact, technological innovations may impact the visitors' attitude in two directions. On the one hand, new technologies can lead to a less participation in the activities organized by cultural organizations. Indeed, the resulting experience might be considered less engaging than that one offered by a tourist guide. While a guide offers a human face, electronic devices, for example, tend to make the experience more individual. Nevertheless, the visit of a museum is often an activity that requires a social interaction. On the other hand, visitors might appreciate the introduction of modern technologies in museums since they might consider them useful for people with disabilities, for the construction of a more personalized visit (e.g., they do not require the presence of the visitor at pre-agreed times), or for the improvement of the visiting experience (e.g., through the choice of the language or the amount of time to be dedicated to each art manufacturer, by selecting specific contents).

Through their skills and knowledge and by virtue of their role as intermediaries in the process of fruition of cultural assets, tour guides can help visitors to develop a positive attitude toward the acceptance of technologies implemented in cultural organizations. Recalling the sensemaking perspective developed by Hill and Levenhagen (1995), tour guides might reinforce the positive attitude of those visitors who already have a more prominent behavior toward technology with respect to the benefits provided by technological innovation. Similarly, tour guides might change the attitude of those who present a more adverse attitude toward technology with respect to the benefits provided by technological innovation. As shown in Figure 5.2 through the assistance of the tour guides, visitors might embrace the sensemaking process in order to build a more positive attitude

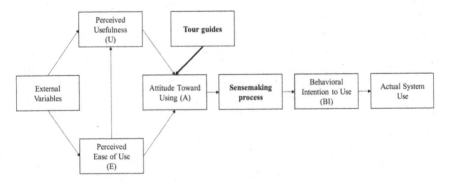

Figure 5.2 The role of tour guides in the acceptance of technology process by visitors.
Source: Authors' elaboration.

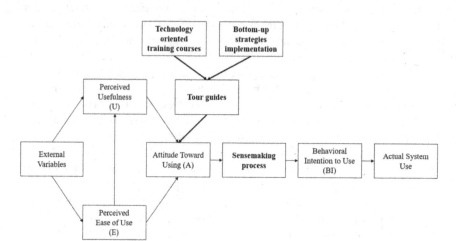

Figure 5.3 The tools to support tour guides role's redefinition and competencies development.
Source: Authors' elaboration.

toward technology, develop a behavioral intention to explore innovative museums, and join and enjoy the exhibitions which adopt the most innovative technologies.

Thus, to favor the usage of ICTs and to encourage the enjoyment and enhancement of cultural heritage, policy makers and managers of cultural institutions should consider how a redefinition of the traditional roles and models in the cultural setting is possible. Since digital transformation is non-reversible and is indeed becoming more and more pervasive, public and private actors should devote respectable attention to the enactment of change through the engagement of more proactive roles as change agents.

To move along this unstoppable path, organizations should act on the main drivers able to redefine the role and the competencies that tour guides should develop to operate in a renovated scenario driven by technological innovations. As shown in Figure 5.3, museums and, more generally, cultural organizations should provide technology-oriented training courses as well as implement bottom-up strategies to help tour guides in their role redefinition and improve their competencies and skills in the process of favoring technology acceptance by visitors.

Technology-oriented training courses

Usually, the professional figures who work in the cultural heritage have been trained on disciplinary skills (history, art history, archaeology, architecture, restoration, etc.) and on the typical functions of the sector (cataloguing, archiving and implementation of protection interventions and of enhancement).

However, the role of staff in museums has altered following changes in the organization of work and increasing market orientation. Thus, the education and training systems are going through a phase of profound and turbulent renewal and there are no targeted training paths. We try to put more attention on the development of autonomous behavioral modalities and on the passage from the know-how to the problem-solving attitude. Training programs should aim to enrich the wealth of possible knowledge, developing know-how, enhancing existing skills, and promoting and supporting change processes.

Training geared to new technologies is possible, but it requires an effort that goes beyond the traditional educational paths. Most innovative museums might develop courses dedicated to the training of professionals in the sector with objectives defined in terms of knowledge, capacity for analysis and interpretation, development of skills, abilities, and methodological strategies to facilitate the manipulation and integration of new technologies to support the artistic products. In doing so, it is possible to intervene on the attitude of those who work in the museum sector so that they can develop skills and competencies that might help them to proactively face the change driven by technology.

Additionally, through the implementation of innovative training courses, museums could take advantage of a new business opportunity allowing also other people outside the organization to join the courses provided. This prospect would guarantee additional revenues and a fresh form of financing for the activities traditionally carried out.

Bottom-up strategies implementation

The bottom-up approach is realized by rediscovering the work that people perform as agents and active promoters of the change. Museums, in promoting cultural or audience-oriented strategies to disseminate knowledge, must rely on the active participation of workers and the public. Indeed, museums should promote the interaction between these actors, since through mutual influence processes, they can contribute to the enhancement of cultural heritage. On the other side, cultural heritage represents a resource that can stimulate intervention, commitment, and the proactive participation of individuals and groups involved to create public, social, and cultural value for the communities that benefit from it. Along this perspective, a bottom-up strategy implementation should prevail. Consequently, the strategy emerges and is realized "from the bottom": tour guides and visitors influence the path of creation of cultural and social value in museums. Specifically, the public tends to "do the job" by supporting the activity of tour guides in actively participating to contribute to organizational performance in the context of the museum experience. In an economy and a society increasingly oriented toward communication, relationship, and sharing, companies and institutions should pay attention to the quality of the human factor and the dynamics that develop in the increasingly interactive relationship between

worker and customer. Today, human communities also progress in virtue of what they have been in the past. Furthermore, it is the task of educational institutions, public and private, and of society to form and educate individuals and communities to the value of history, traditions, and customs that are handed down to us through objects to learn to build the future. In particular, investing in human capital and in the formation of relational skills makes the worker a "protagonist" and "creator" in the realization of strategic objectives by building relationships with the public and the visitors involved, committed to the enhancement of the cultural resources, which they take on the role of co-workers actively participating in organizational performance and creating value oriented toward social and cultural well-being for the human development of communities.

Conclusions

Digital transformation is a growing trend in museums that changes the entire concept of experiencing the cultural heritage. Technology and culture run parallel. Advances in one area help push the progression of the other. They each evolve over time and change the way people interact with them.

Museums are seen as a staple when people think about culture. They hold significant amounts of information about a particular city or country, including its history, society evolution, notable people, and much more. Museums have always been a major destination for understanding more about where people are and the impact that culture has had on them all. With recent advances affecting museums, it is worth examining the way people could interact with museums of the future.

The main mission of a museum has always been to guarantee the management, conservation, and access to a collection of works of art, balancing two specific needs, potentially fighting against each other: the preservation and the valorization of cultural assets. Nowadays, the digital transformation affecting the museums allows to meet these needs in different, faster, and more advanced ways. Through this chapter, we identified the main types of innovation that museums are implementing in their business models by distinguishing between technological and organizational innovation. However, this application seems to be hampered by physical and motivational barriers that play a central role in the effective use of these technologies in support of the cultural experience. Above all, technology is not seen as a negative element that can impact the beauty and essence of the artistic product. On the contrary, if correctly used by the organization, it can be considered a useful support to increase audience engagement. But to be an effective tool, new technologies must be first accepted by those who represent a bridge between the cultural product and the public: the tour guides. Only by encouraging the development of their technological skills and, consequently, their degree of acceptance of new technologies, museums can fully benefit from the advantages deriving from innovation.

For this reason, cultural organizations should provide technology-oriented training courses as well as implement bottom-up strategies to help tour guides in their role redefinition and improve their competencies and skills in the process of favoring technology acceptance by visitors.

Future studies should then be aimed at identifying how museums could effectively implement these tools by conducting some empirical research. For instance, through interviews or surveys, researchers could identify the main opportunities and difficulties that museums encounter in the implementation of programs and procedures aimed at supporting/facilitating the development of technologically relevant skills for tour guides.

References

Bolici, F., & Giustiniano, L. (2013). *Design science and eTrust: designing organizational artifacts as nexus of social and technical interactions.* Berlin and Heidelberg: Organizational Change and Information Systems.

Braverman, H. (1998). *Labor and monopoly capital: The degradation of work in the twentieth century.* New York: Monthly Review Press.

Camarero, C., & Garrido, M. J. (2012). Fostering innovation in cultural contexts: Market orientation, service orientation, and innovations in museums. *Journal of Service Research, 15*(1), 39–58.

Camarero, C., Garrido, M. J., & Vicente, E. (2019). Does it pay off for museums to foster creativity? The complementary effect of innovative visitor experiences. *Journal of Travel & Tourism Marketing, 36*(2), 144–158.

Cameron, E., & Green, M. (2019). *Making sense of change management: A complete guide to the models, tools and techniques of organizational change.* London: Kogan Page Publishers.

Checkland, P., & Holwell, S. (1998). *Information, systems and information systems: Making sense of the field.* Chichester: John Wiley & Sons, Inc.

Ciborra, C. U. (1996). The platform organization: Recombining strategies, structures, and surprises. *Organization Science, 7*(2), 103–118.

Davis, F. D., Bagozzi, R. P., & Warshaw, P. R. (1989). User acceptance of computer technology: a comparison of two theoretical models. *Management Science, 35*(8), 982–1003.

De Haes, S., & Van Grembergen, W. (2009). An exploratory study into IT governance implementations and its impact on business/IT alignment. *Information Systems Management, 26*(2), 123–137.

Falk, J. H., & Dierking, L. D. (2016). *The museum experience revisited.* New York: Routledge.

Fishbein, M., & Ajzen, I. (1975). *Intention and behavior: An introduction to theory and research.* Boston, MA: Addition-Wesley.

Fonseca, D., Navarro, I., de Renteria, I., Moreira, F., Ferrer, Á., & de Reina, O. (2018). Assessment of wearable virtual reality technology for visiting World Heritage buildings: an educational approach. *Journal of Educational Computing Research, 56*(6), 940–973.

Hill, R. C., & Levenhagen, M. (1995). Metaphors and mental models: Sensemaking and sense giving in innovative and entrepreneurial activities. *Journal of Management, 21*(6), 1057–1074.

Kohli, R., & Devaraj, S. (2003). Measuring information technology payoff: A meta-analysis of structural variables in firm-level empirical research. *Information Systems Research, 14*(2), 127–145.

Laudon, K. C., & Laudon, J. P. (2011). *Essentials of management information systems.* Upper Saddle River, NJ: Pearson.

Natale, M. T., & Piccininno, M. (2018). Italy: tourism and technological innovation: The spectacularization of cultural heritage in Rome and Cerveteri. *Uncommon Culture, 7*(1/2), 134–145.

O'Brien, J. A., & Marakas, G. M. (2006). *Management information systems.* London: McGraw-Hill Inc.

Offen, K., & Colton, E. L. (2007). The International Museum of Women. *Museum International, 59*(4), 19–25.

Onn, C. W., & Sorooshian, S. (2013). Mini literature analysis on information technology definition. *Information and Knowledge Management, 3*(2), 139–140.

Pera, R. (2017). Empowering the new traveller: Storytelling as a co-creative behavior in tourism. *Current Issues in Tourism, 20*(4), 331–338.

Piccoli, G., & Ives, B. (2005). IT-dependent strategic initiatives and sustained competitive advantage: A review and synthesis of the literature. *MIS Quarterly, 29*(4), 747–776.

Pine II, B., & H. Gilmore, J. (2014). A leader's guide to innovation in the experience economy. *Strategy & Leadership, 42*(1), 24–29.

Proctor, N. (2011). The Google art project: A new generation of museums on the web? *Curator: The Museum Journal, 54*(2), 215–221.

Sandahl, J. (2019). The museum definition as the backbone of ICOM. *Museum International, 71*(1–2), vi–9.

Schryen, G. (2013). Revisiting IS business value research: What we already know, what we still need to know, and how we can get there. *European Journal of Information Systems, 22*(2), 139–169.

Sharpley, R. (2018). *Tourism, tourists and society.* New York: Routledge.

Stowell, F., & West, D. (1995). *Client-led design: A systemic approach to information systems definition.* London: McGraw-Hill, Inc.

Thompson, J. D. (2017). *Organizations in action: Social science bases of administrative theory.* New York: Routledge.

Thong, J. Y., & Yap, C. S. (1995). CEO characteristics, organizational characteristics and information technology adoption in small businesses. *Omega, 23*(4), 429–442.

Tung, V. W. S., & Ritchie, J. B. (2011). Exploring the essence of memorable tourism experiences. *Annals of Tourism Research, 38*(4), 1367–1386.

Part II
Cultural heritage

6 Are investments in the digital transformation of cultural heritage effective? A program evaluation approach

Andrej Srakar and Marilena Vecco

Introduction and literature review

Culture is becoming increasingly a precondition of all kinds of economic and social value generation, a process driven by two concurrent streams of innovation: digital content production and digital connectivity (ViMM, 2018). It is critical to Europe's economy and society that the significance of digital cultural heritage is described and well understood, to ensure that this heritage benefits from necessary investment and sustained funding at the EU, national, regional, and local levels. Heritage organizations, particularly libraries, archives, and museums, are the keepers of most cultural and scientific content. They are generally non-profit organizations driven by goals related to providing access to collections in order to facilitate knowledge creation (Bakhshi & Throsby, 2012). Increasing and improving access to collections is an important driver for these organizations to adopt new technologies. Digitization and publication of collections online can potentially allow access to content across the globe and, as such, liberate this untapped knowledge potential (Borowiecki & Navarrete, 2017).

Since the 1990s, the European Commission has funded a number of projects to connect and give access to heritage materials in order to stimulate an innovative information society. Starting from the early 2000s, digitization of heritage collections became part of the key strategies that would contribute to the knowledge economy enabled by "unrestricted, sustainable and reliable digital access to Europe's cultural and scientific knowledge" (OCW, 2004; Navarrete, 2014a: 163). In 2007, a specific complementary Competitiveness and Innovation Program (CIP) was established to fund the Information and Communication Technologies Policy Support Programme (ICT-PSP). Most recently, the Horizon 2020 framework (running from 2014 to 2020) aims at creating a genuine single market for knowledge, research, and innovation.

All sectors benefit from the availability of creative content to innovate as content creation and diffusion fuel adoption of new ideas across all sectors, expanding beyond the creative industries (Lee & Rodríguez-Pose, 2014). It could be argued that a content-rich environment, fueled by collections

held in heritage organizations, supports the formation of what Lee and Rodríguez-Pose (2014) refer to as genuine breeding grounds, key to creative cities and fundamental to drive soft innovation in all sectors.

To date, however, there is little known about the extent to which heritage organizations are able to innovate, or at least to adopt digital technology and increase access to collections. A previous qualitative analysis using an older data set and focused only on Dutch museums finds a slow growth of digital collections and their publication due to a national policy that, although it focuses on innovation, fails to support organizational change or skill development (Navarrete, 2014b).

In general, digitization is a loosely defined term which describes the set of management and technical processes and activities by which material is selected, processed, converted from analog to digital format, described, stored, preserved, and distributed. In this sense, digitization is an example of a supply-chain activity—one which generates an output (a product) based on a managed input (raw materials), which is distributed and transacted with an end-user (Barata, 2004; Yakel, 2004). In the European cultural heritage sector, digital transformation has come to signify various activities through which physical (analog) cultural content, such as books, artifacts, records, and other cultural material, is translated into a digital form, described, and made accessible through digital channels such as the Internet (Saracevic, 2000). Some critical distinctions concerning the use of this concept is required. Although digital transformation refers to similar processes in museums, archives, and libraries, the basic conceptual model differs in each domain. Hence, while digital transformation of published material in libraries is best characterized as a form of conversion or replacement (converting essentially the same material and content from one display/storage format to another without a significant loss of its cultural value, meaning or significance), in the case of museums and archives it is better characterized as surrogacy (the creation of a digital image and metadata which records and represents the original object, record or document; see e.g. Stroeker and Vogels [2014]). The distinction is important because conversion is mass-scale, reproducible, and broadly lossless in the sense that the information content of the original is not fundamentally lost in the process. Surrogacy, on the other hand, is less amenable to mass-production workflows because of the inherent complexity and variability of the material. It is, however, important not to regard too strictly the distinctions between digitization in museums, archives, and libraries (particularly in the case of national institutions), given that the nature of the material they are managing is frequently the same.

Digitization of library collections, largely comprised of books that can be scanned, has generally taken place within universities and national libraries. Digitization of books has had a specific trajectory after Google launched the mass digitization program in 2004, the Google Library Project, which accounts by now for over 15 million digital books (Benhamou,

Table 6.1 Description of activities in the process of digitization

Activity	Description
Selection	Choosing material to be digitized
Preparation	Making objects and books ready to be digitized
Description	Cataloguing, description, indexing, and the creation of management information
Conservation	Care, handling, packaging, transport, and conservation of the material
Production of Intermediates	For example, microfilming and photography
Technological Infrastructure	Includes equipment (scanners, computers), software, and suitable space for Digitization
Quality Management	Error checking and correction
Conversion to master Digital formats	Scanning, digital photography, or audio and video encoding
Storage/maintenance	Storage and management of digital assets for use and preservation

Source: Adapted from Tanner (2006, in: Poole, 2010, pp. 14–15).

2015). Another related initiative is the Open-Access Text Archive project launched by the Internet Archive in 2007, responsible for scanning over 2.1 million books and for giving online access to over six million full-text books (https://archive.org/).

As with any other manufacturing or supply process, can the process of digitization expand or contract to include a variety of activities, depending on the nature of the sector analyzed? To create a meaningful and consistent approach to this inquiry, the authors of *MINERVA Digitization Cost Reduction Handbook* (Tanner, 2006) have defined the scope of digitization as including the activities, described in Table 6.1.

This chapter aims to estimate the economic effects of government-level investments in the digital transformation of cultural heritage in Slovenia. To develop the analysis, the second section presents the three different datasets and methods used. The third section introduces the results and discusses our methodological choices, while the final section presents the discussion of the findings and concludes.

Data and method

In this analysis we use data from three sources. In the multiplier analysis, we use data from the already prepared symmetric input-output table of the Statistical Office of Republic of Slovenia (SORS) from 2014 (latest year of publication available). For the estimation of macroeconomic effects, we use municipality-level data of Statistical Office of Republic of Slovenia, database SI-Stat, and data from the yearly reports of Ministry of Culture of Republic of Slovenia in years 2008–2017. The latter provide detailed

statistical assignment of the given funds for digital transformation of cultural heritage (budget line item: Digital transformation, available only for the studied years 2008–2017) to each organization to the municipality of its location. We exclude the funds provided to libraries, due to ambiguous reporting (some years have no data on this budget line item, while in many it is reported differently, either only for public libraries or also for other organizations). This provides us with a possibility to assign libraries as a control group in our analysis.

In the third part of the analysis we use data of ENUMERATE survey, in three waves, for years 2012, 2013, and 2015. ENUMERATE started in 2011 as an EC-funded project, led by Collections Trust in the UK. As of 2014, the project became part of Europeana v3 led by Collections Trust and the DEN Foundation in the Netherlands. The primary objective of ENUMERATE is to create a reliable baseline of statistical data about digitization, digital preservation, and online access to cultural heritage in Europe. The first ENUMERATE project brought about major improvements in the quality and availability of intelligence about digital heritage. Again, we also use data from the yearly reports of Ministry of Culture of Republic of Slovenia and assign libraries as control group.

Figure 6.1 shows the short illustration of sample used in our study. For Slovenia, the sample of organizations is represented by 56 organizations (classified into museums; archives; libraries; and other organizations[1]) for 2012, 57 for 2015, and 54 for 2015. A brief visualization of the distribution of those organization types is shown in Figure 6.1 (top right part of the figure).

According to the summary of the last Slovenian National Programme for Culture 2014–2017, the chapter on digitization envisages, besides the digitization and safe storage of content, the provision of on-line accessibility to all digital cultural content, with particular care devoted to content adapted to young users, cultural minorities, and other vulnerable groups. An optimal

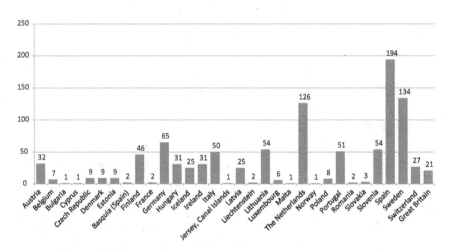

Figure 6.1 Number of participating organizations in ENUMERATE, 2015.
Source: Lesjak and Vodeb (2016, p. 87).

organization and free accessibility of digitized cultural content, created with public funds, is in the public interest, as in this way it serves educational, creative, research, and business purposes. In this context, we must not forget the issue of accessibility of work of contemporary authors, where the key challenge is to ensure adequate management and the protection of digital rights.

The following important measures and projects have been realized so far in Slovenia (Čopič & Srakar, 2015):

- In 2005, the Slovenian Music-Information Centre (SIGIC) in Ljubljana was established with an ambition to serve as a basic information center for accessing information on Slovenian musicians, music, musical heritage, and activities in this area. In 2007, a web portal with presentation of the Slovenian theatre SIGLEDAL was formed; since 2010, it has received acknowledgment and financial support from the ministry in charge of culture.

- In 2005 and 2006, a network of 15 multimedia centers in all statistical regions across Slovenia was established. Later, another four were included. A sum of 1.3 million EUR was invested in these centers, of which more than half of the amount was obtained from the European Structural Funds. Additionally, a separate accounting entry for financing activities connected to the regional cultural centers was planned, with the goal to increase the number of cultural institutions and their activities that are presented in individual regional Internet portals; to provide information on cultural themes, events, and activities in the regions; and to enable connection to the national cultural portal.

- The portal KAMRA—with the intention to include libraries, archives, museums, associations, local study centers, and multimedia centers—started in 2005 with ten Slovenian regional libraries. The portal is especially intended for knowledge of a specific geographical area and it therefore includes digital information created at the regional and local level.

- The National and University Library (NUK) developed the Internet portal "Digital Library of Slovenia" (d-Lib.si) and connected its digital content to the European Digital Library. It was placed on the Internet in 2006. It has the ambition to act as the national knowledge management portal and it offers free searches by source and access to digital content—magazines, books, manuscripts, maps, photographs, music, and handbooks. Access to the collection on the portal is free.

- The improvement of ICT equipment in public libraries is very much connected with the development of the Co-operative Online Bibliographic System and Services (COBISS), which functions as an integrated and shared bibliographic tool of the Slovenian library network where all kinds of libraries in the country cooperate and participate. Libraries are already changing into information nodes and digital content providers.

- The priority of digitizing cultural heritage suffers from a lack of coordination, although the need to set up an inventory of ongoing digitalization

projects has been recognized. The leading institutions are the national library and state archives, the first with digitized library materials, such as manuscripts, newspapers, and other periodicals as well as non-book materials, like postcards, pictures, graphic art, maps, and music (the biggest project of digitization is a collection of articles of older Slovenian authors which includes 100,000 scans), and the second with old archival documents of different public sources (the most extensive project is the scanning of the Emperor Francis Cadastre, which included 28,000 recordings or 2,800 recorded cadastral municipalities with 28,000 cadastral maps). National radio and television are expected to become another competence center for digital transformation of cultural heritage. However, digital transformation of radio-diffusion broadcasting presents a problem and Slovenia is in the last position of the European states in this area.

– A new portal Culture.si was set up by the Ministry of Culture in 2010. It is intended as a presentation of all relevant data in the field of culture in Slovenia to foreign visitors. It offers four major services: an up-to-date address book, logo, and logo banks for downloading and use according to their specific licenses, calendar of international events, and reference articles on Slovene culture.

– In the framework of European Capital of Culture 2012 a program module LIFETOUCH devoted to digital presentation and experimentation of the art events has been formed. The part of the Maribor 2012 cyber space, intended for the program section LifeTouch, should become a place, where a sort of media experiment is unravelling, and an experiment that connects and gathers contents related to the ECOC Maribor 2012 from other media sources. The second part of the program cycle LifeTouch was the publication of (auto) reflections.

Although the acceptance of three important legal documents for digital culture (in 2006 the Legal Deposit Act; and Protection of Documents and Archives and Archival Institutions Act and in 2007 the Cultural Heritage Protection Act) could be considered as the realization of the strategic documents, legislation is just an instrument like the strategic documents and not the end in themselves. These acts revise previous legislation or bring new legal foundations to libraries, archives, and museums for collecting, manipulating, preserving, and use of digitized and digitally produced publications and archival documents which are of long-term importance. In their regulative capacity, they offer important legal grounds for positive developments of the information society in these fields.

Assignment of the ministry funds to digitalize cultural heritage (excluding libraries) in Slovenia is presented in Table 6.2. The bulk of the funds was assigned to Ljubljana-based organizations and some other larger cities (Celje, Maribor, Koper, Ptuj, Nova Gorica).

Figure 6.2 presents basic descriptives for some of the main variables from ENUMERATE survey, shown only for Slovenian organizations

Table 6.2 Assignment of funds, ministry budget item line "digitalization" (libraries excluded), 2008–2017

Občina/leto	2008	2009	2010	2011	2012	2013	2014	2015	2016	2017
Ljubljana	253,454.92	516,766.22	465,818.84	515,166.44	475,263.87	401,690.30	364,446.00	288,812.00	265,407.78	262,086.78
Grosuplje	36,954.96									
Velike Lašče	4,920.00									
Vrhnika	24,780.00	20,600.00	23,000.01	15,099.97	9,600.00	9,500.00	7,779.97			
Celje	112,000.00	55,471.00	42,421.61	27,331.06	18,513.99	16,248.00	14,040.00	14,040.00	9,449.00	11,449.00
Maribor	76,000.00	51,854.98	39,462.57	34,865.12	22,485.99	18,552.00	17,280.00	20,280.00	14,811.00	17,091.00
Koper	41,500.00	48,670.00	25,236.77	22,542.00	11,207.01	9,276.00	18,639.97	8,640.00	5,670.00	7,046.00
Ptuj	41,500.00	43,716.95	196,236.77	190,542.00	157,916.25	158,076.00	108,640.00	108,640.00	105,670.00	97,046.00
Kostanjevica na Krki		49,600.00	40,000.00	9,999.98						
Murska Sobota		12,750.00	932.80	4,000.06						
Slovenj Gradec		18,600.00	3,932.80	4,000.06						
Kranj		3,000.00	932.80	2,000.03						
Nova Gorica		16,200.02	19,582.83	6,417.00	7,766.25	4,668.00	4,320.00	4,320.00	2,835.00	3,523.00
Škofja Loka		1,000.00	932.80	2,000.03				6,500.00		6,500.00
Kamnik		1,100.00	932.80	2,000.03						
Idrija		2,000.00	932.80	2,000.03						
Ivančna Gorica		14,600.00		1,800.00	1,800.00	7,225.00	6,399.97			

(Continued)

Občina/leto	2008	2009	2010	2011	2012	2013	2014	2015	2016	2017
Velenje		700.00	932.80	2,000.03						
Radovljica		1,600.00	932.80	2,000.03						
Postojna		800.00	932.80	2,000.03						
Piran		9,000.00	932.80	4,000.06						
Ajdovščina		9,000.00		2,000.03						
Brežice		800.00	932.80	2,000.03						
Tolmin		4,000.00	932.80	2,000.03						
Moravče		2,400.00								
Zagorje ob Savi		680.00								
Metlika			932.80	2,000.03						
Novo mesto			932.80	2,000.03						
Kočevje			932.80	2,000.03						
Trbovlje			932.80	2,000.03						
Jesenice				2,000.03						

Source: Ministry of Culture of Republic of Slovenia, own elaboration.

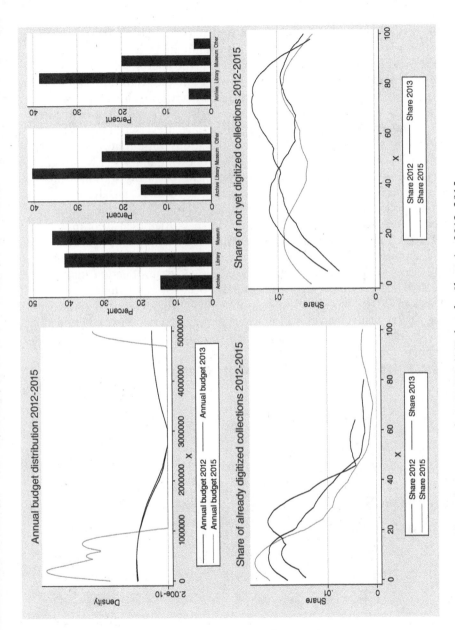

Figure 6.2 Visualization of basic descriptives of ENUMERATE data for Slovenia, 2012–2015.
Source: Own elaboration.

participating in the study. Organizational budget is clearly bimodal, with one peak in the bottom part of the distribution, and one for organizations with budget, larger than 4,000,000 EUR. We avoid distributional problems of this variable by using non-parametric corrections in our models. While in 2012, there were slightly more museums than libraries participating in the survey, in 2013 and 2015, libraries predominated over museums, with archives lagging back in all studied waves of the survey. The variable of share of already digitized collections has the longest "right tail" for year 2015, i.e. in this year there were more organizations with almost completely digitized collection than in, respectively, 2013 and 2012 (with the latter having the least share of such organizations). Reversely, in 2015 there was the lowest number and share of organizations with almost no collections not yet digitized, with 2013 and 2012 following in respective order.

Figure 6.3 shows the total volume of investments in the digital transformation of cultural heritage over the studied period 2008–2017. The dynamics of the funds follow the general budgetary trends in public budget for culture in Slovenia (analyzed in detail in Srakar, 2015): they reach their peak in years 2009–2011 and drop ever since, with stabilization only in years after 2015.

Our empirical strategy follows two strands. In the first we present a simple input-output-based multiplier analysis, using production multipliers, calculated previously in studies of Srakar (2015) and Črnigoj, Bartolj, and Srakar (2018). Based on the multidisciplinary character of investments in the digital transformation of cultural heritage (being on the bound of cultural and compute-related investments), two possibilities of sectorial multipliers are used: either sector "Creative, arts, entertainment, library, archive, museum, other cultural services; gambling and betting services"

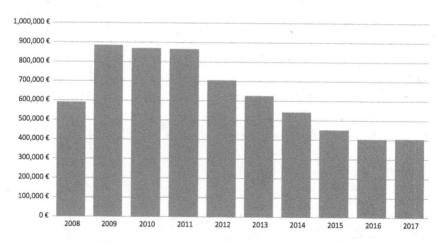

Figure 6.3 Investments in digitalization of cultural heritage, Ministry of Culture, 2008–2017.

Source: own calculations based on Ministry of Culture's data.

or "Computer programming, consultancy and related services; Information services." Additionally, we use as third possibility, a simple linear combination of the two. The two multipliers in year 2014 amount to 1.4162 (first sector) and 1.5280 (second sector).

In the second strand we use models of dose and response continuous treatment assignment (Hirano & Imbens, 2004; Bia & Mattei, 2008; Cerulli, 2012), described shortly below to derive causal estimates of the ministry investments and based that we have continuous treatment in the form of a specific amount assigned in specific year.

In many socioeconomic and epidemiological contexts, interventions take the form of a continuous exposure to a certain type of treatment. From a program evaluation perspective, indeed, what is relevant in many settings is not only the binary treatment status but also the level of exposure (or dose) provided by a public agency. Compared with similar models—and in particular the one proposed by Hirano and Imbens (2004)—this model does not need a full normality assumption, and it is well suited when many individuals have a treatment level of 0. Moreover, it may account for treatment endogeneity by exploiting an instrumental-variables (IV) estimation in a continuous treatment context.

Consider a policy program where a binary treatment is assigned not randomly (i.e., according to a structural rule). The program provides a different "level" of treatment (or dose t) to treated—ranging from 0 (absence of treatment) to 100 (maximum treatment level).

Two groups of units are thus formed:

i untreated, whose level of treatment (or "dose") is zero, and
ii treated, whose level of treatment is greater than zero.

We are interested in estimating the causal effect of the treatment variable t on an outcome y by assuming that treated and untreated units may respond differently to observable confounders (x). The objective is to estimate a dose-response function of y on t.

Suppose we have two exclusive outcomes, when a unit is treated, y_1, and when the same unit is untreated, y_0. w is the treatment indicator, taking value 1 for treated and 0 for untreated units, $g_1(x)$ and $g_0(x)$ are the unit responses to the vector of confounding variables x when the unit is treated and untreated, μ_1 and μ_0 are two scalars, e_1 and e_0 two random variables with zero unconditional mean and constant variance, and $h(t)$ is the response function to the level of treatment t.

We can define the Dose-Response-Function simply by averaging $ATE(x, t)$ on x:

$$ATE(t, w) = E_x\{ATE(x, t, w)\} =$$
$$w \cdot \left[ATET + \left(h(t) - \bar{h}_{t>0} \right) \right] + (1-w) \cdot ATENT \qquad (1)$$

and

$$ATE(x,\ t,\ w) = w \cdot \left[ATET + (x_{t>0} - \bar{x}_{t>0})\delta + (h(t) - \bar{h}_{t>0}) \right] + (1-w) \cdot$$
$$\left[ATENT + (x_{t=0} - \bar{x}_{t=0})\delta \right] \qquad (2)$$

$$ATET = \mu + \bar{x}_{t>0}\delta + \bar{h}_{t>0} \qquad (3)$$
$$ATENT = \mu + \bar{x}_{t=0}\delta \qquad (4)$$

Under previous definitions and assumptions, the baseline random-coefficient regression can be obtained (Wooldridge, 1997, 2003):

$$y_i = \mu_0 + w_i \cdot ATE + x_i\delta_0 + w_i \cdot (x_i - \bar{x})\delta + w_i \cdot \{h(t_i) - \bar{h}\} + \eta_i \qquad (5)$$

Where $\eta_i = e_{0i} + w(e_{1i} - e_{0i})$.

Equation 5 provides the baseline regression for estimating the basic parameters (μ_0, μ_1, δ_0, δ_1, ATE) and then all the remaining ATEs.

Results

In the first part of the analysis, we apply simple production multiplier analysis to the volume of Ministry's funds assigned to the digital transformation of cultural heritage. The results are presented in Table 6.3, by years, for three different multiplier sectorial possibilities, noted before: whether the funds are assigned to sector "Creative, arts, entertainment, library, archive, museum, other cultural services; gambling and betting services" (Multiplier effects Culture), "Computer programming, consultancy and related services; Information services" (Multiplier effects Computing), or a simple linear combination of the two (Multiplier effects – average). As

Table 6.3 Results, multiplier analysis, 2008–2017

	Investments min cult	Multiplier effects culture	Multiplier effects computing	Multiplier effects—average
2008	591,110 €	837,129.81 €	903,215.90 €	870,172.85 €
2009	884,909 €	1,253,208.37 €	1,352,141.21 €	1,302,674.79 €
2010	869,684 €	1,231,646.76 €	1,328,877.46 €	1,280,262.11 €
2011	865,764 €	1,226,095.26 €	1,322,887.70 €	1,274,491.48 €
2012	704,553 €	997,788.47 €	1,076,557.53 €	1,037,173.00 €
2013	625,235 €	885,458.23 €	955,359.54 €	920,408.89 €
2014	541,546 €	766,937.32 €	827,482.15 €	797,209.73 €
2015	451,232 €	639,034.76 €	689,482.50 €	664,258.63 €
2016	403,843 €	571,922.15 €	617,071.77 €	594,496.96 €
2017	404,742 €	573,195.31 €	618,445.44 €	595,820.37 €
Total	6,342,619 €	8,982,416 €	9,691,521 €	9,336,969 €

Source: Authors' calculations.

noted above, the two multipliers in year 2014 amount to 1.4162 (first sector) and 1.5280 (second sector).

The results provided in Table 6.3 show that the yearly effect ranges from as high as approximately 1,350,000 EUR (second sector, 2009) to as low as approximately 570,000 EUR (first sector, 2017). In total, the economic (direct, indirect, and induced—see, e.g., ten Raa, 2006) effects of the investments in the digital transformation of cultural heritage range from about 9,000,000 EUR to about 9,700,000 EUR.

These results present only an *ex-ante* analysis, that is, the results show the effects that "should be there." To calculate the *ex-post*, that is, "actual" effects of investments in the digital transformation of cultural heritage, that is, our continuous treatment/dose, we estimate the above models using four outcome variables (all available on municipality level in SORS SI-Stat data): company incomes, employment (i.e., number of people in the labor force), number of tourist arrivals, and number of tourist overnight stays.

The results confirm significant effects of investments on employment, the effects are linear, strong, and robust. Furthermore, both treatment itself and level of treatment (Treat_W1) variables are positive and significant. The results are presented in Table 6.4 and Figure 6.4, respectively. For the other three outcome variables, neither treatment nor level of treatment is significant, meaning that the positive economic effect of investments in the digital transformation of cultural heritage is visible on the level of employment—as has been confirmed in the literature (Lesjak & Vodeb, 2016): digital transformation of cultural heritage brings demand for new employment spaces in different industries. It is interesting, though, that such an effect is (possibly still) visible also on the level of company incomes.

Table 6.5 presents the results of the analysis in terms of organizational effects. We model the effects on the annual budget of the organization (Ann-Budg), the dummy variable of having or not having a collection (HaveColl), whether an organization has digital collections or is currently involved in collection digitization activities (DigColl), level of already digitized collections (AlreadDig), and level of collections still needing digital transformation (NeedsDig).

As shown in Table 6.5, the effects of treatment are visible only for one outcome variable—level of already digitized collections. The effects are robust over different specifications of the model but, interestingly, do not depend on the investment size. As estimated by further basic treatment effects models (not including continuous treatment possibility), the average treatment effect amounts to 11.0891 percentage points, that is, for those institutions which received the treatment (investment in the digital transformation of cultural heritage), the share of already digitized collections has been raised by about 11 percentage points.

Table 6.4 Results of dose-response models, macro effects, 2008–2017

	Company incomes			Employment			Tourist arrivals			Tourist overnight stays		
	Coef.	tstat.	Sig.	Coef.	tstat.	Sig.	Coef.	tstat.	Sig.	Coef.	tstat.	Sig.
Constant	952.22	3.16	***	695.05	1.17		264.12	2.40	**	1160.73	0.74	
Treatment	2,263.14	0.97		7072.30	15.24	***	2,687.47	1.00		2,758.20	1.84	*
GDP_Regional	19.36	2.96	***	21.51	4.49	***	12.05	4.13	***	28.83	0.67	
NrEducated	76.51	2.49	**	60.24	1.62		56.02	1.34		106.02	2.15	**
MortalityRate	-17.96	-3.0	***	-17.96	-1.56		-31.97	-2.4	**	-27.12	-1.3	
Ws_GDPReg	85.43	3.29	***	70.60	3.92	***	31.06	2.31	**	96.72	6.08	***
Ws_NrEduc	-86.69	-0.7		-84.17	-0.37		-122.88	-0.3		-55.55	-0.6	
Ws_MortRate	-42.07	-1.5		-261.40	-2.61	***	-130.70	-3.3	***	-196.05	-3.3	***
Treat_W1	0.18	1.42		0.22	5.26	***	0.13	0.49		0.16	1.69	*
Nr. Obs.	2103			2103			2103			2103		
F stat	712.46	***		734.55	***		812.11	***		801.80	***	
Adj. R squared	0.5449			0.7363			0.6332			0.6259		
Root MSE	5,089.63			4,504.10			5,314.84			5,765.25		

Source: Own elaboration.
Note: The asterisks denote significance levels: ***1%; **5%; *10%.

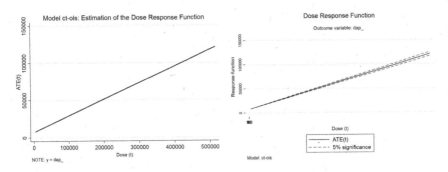

Figure 6.4 Dose-response model results, effects on employment, 2008–2017.
Source: Own elaboration.

Discussion and conclusion

This contribution estimates the economic effects of investments in the digital transformation of cultural heritage specifically focusing on the case of Slovenia. To assess the economic impact, we used treatment effect methodologies, where we estimated the effects of both the treatment itself and its level on different sets of outcome variables on the micro level of individual organizations and the macro level of municipalities. We were able to confirm a positive macroeconomic effect of investments in the digital transformation of cultural heritage on employment level, dependent also upon the investment size. Furthermore, we were able to confirm (and estimate) a sizeable effect of the investments on the share of already digitized collections. Interestingly, no other factor in these organizations seems to be affected by investments in the digital transformation which serves as a reason for concern. What is also interesting is that there was no visible effect on company incomes which would be logical based on the observed effect on employment—we attributed this to time lag; it is possible that the effect is still not visible yet, but it would be visible in larger time frame.

There are several limitations of the present chapter which provide possibilities for future work. First, we used only the results from one budget line item, for the reason of comparability over the years. It was precisely for this reason that we avoided including investments in the digital transformation of library collections, which allowed us to construct our comparison/control group. Methodologically speaking, we still have not provided account of some reverse causal and endogenous relationships in the model, including omitted variable bias. The models are of cross-sectional nature and longitudinal models (or time series cross section, in the case of ENUMERATE) would also be interesting to explore in the next future. Finally, due to missing data in different years of the survey, some questions in ENUMERATE

Table 6.5 Results of dose–response models, organizational effects, years 2012, 2013 and 2015

	AnnBudg			HaveColl			DigColl			AlreadDig			NeedsDig		
	Coef.	t stat	Sig.	Coef.	t stat	Sig.	Coef.	t stat	Sig.	Coef.	t stat	Sig.	Coef.	t stat	Sig.
Constant	28,33,663.00	1.61		0.90	13.62	***	1.04	7.23	***	18.44	1.01		99.15	4.18	***
Treatment	−6256.29	−0.0		−0.07	−1.34		−0.05	−0.57		20.29	2.15	**	−2.17	−0.17	
DumYear2	1,71,733.80	0.36		0.07	2.70	***	−0.06	−1.27		−4.11	−0.85		−3.40	−0.50	
DumYear3	−317559.60	−0.5		0.11	3.13	***	0.06	0.91		−9.14	−1.38		−4.74	−0.52	
AnnBudg				0.00	−0.29		0.00	1.07		0.00	−1.56		−0.00	−3.24	***
HaveColl	−429515.30	−0.3					−0.05	−0.31		8.77	0.57		2.27	0.11	
DigColl	9,71,147.40	1.07		−0.02	−0.31					10.10	4.09	***	−39.37	−3.16	***
AlreadDig	−13121.54	−1.6		0.00	0.57		0.00	1.09							
NeedsDig	−22065.82	−3.6	***	0.00	0.29		−0.00	−2.56	**						
Tw_1	−1.02	−0.3		0.00	2.14	**	0.00	0.78		0.00	−1.29		0.00	0.09	

Source: Own elaboration.
Note: The asterisks denote significance levels: ***1%; **5%; *10%.

were still not included among predictors, which could possibly be remedied in future data collecting and research.

Scientific contributions of this chapter nevertheless loom large. It is, as far as we are aware, the first analysis to estimate the causal effects of investments in the digital transformation of cultural heritage at an international level. Furthermore, such analyses are seldom, if ever, conducted within the cultural sector in general. This analysis could provide ground for policy usage as well as future development of the field of economic of cultural policy. For this reason, the methodology used and datasets identified at the Slovenian level could provide a cornerstone for similar work in other national contexts as well as at the international level. On a more practical and policy level, our findings confirm that positive effects of investments in the digital transformation of cultural heritage exist at both the macro and the micro level but are particularly heterogeneous on the micro level compared to the macro level, and many expected relationships and outcomes were not observed.

Economics and econometric studies in the analysis of cultural policy are still few to find. Many fields of empirical cultural policy research are still largely blank (Srakar, 2017): namely, the analysis of the effects of cultural policy measures. We do hope this contribution will also further stimulate direly needed work in this area—for both research and policy and practical reasons.

Note

1 Including: Audio-visual/broadcasting archive; Institution for monument care; Other type of institution.

References

Bakhshi, H., & Throsby, D. (2012). New technologies in cultural institutions: Theory, evidence and policy implications. *International Journal of Cultural Policy*, *18*(2), 205–222.

Barata, K. (2004). Archives in the digital age. *Journal of the Society of Archivists*, *25*(1), 63–70.

Benhamou, F. (2015). Fair use and fair competition for digitized cultural goods: The case of ebooks. *Journal of Cultural Economics*, *39*(2), 123–131.

Bia, M., & Mattei, A. (2008). A Stata package for the estimation of the dose-response function through adjustment for the generalized propensity score. *The Stata Journal*, *8*(3), 354–373.

Borowiecki, K. J., & Navarrete, T. (2017). Digitization of heritage collections as indicator of innovation. *Economics of Innovation and New Technology*, *26*(3), 227–246.

Cerulli, G. (2012). Ivtreatreg: A new STATA routine for estimating binary treatment models with heterogeneous response to treatment under observable and unobservable selection. CNR-Ceris Working Papers, No. 03/12. http://econpapers.repec.org/software/bocbocode/s457405.htm.

Čopič, V., & Srakar, A. (2015). Slovenia. In Council of Europe/ERICarts (Ed.), *Compendium of cultural policies and trend.* https://www.culturalpolicies.net/database/search-by-country/country-profile/?id=37 (Access: 27/09/2020).

Črnigoj, M., Bartolj, T., & Srakar, A. (2018). *Študija ekonomskih in družbenih učinkov planinskih poti in planinskih koč ter planinstva: Final Report.* Ljubljana: Inštitut za ekonomska raziskovanja.

Hirano, K., & Imbens, G. (2004). The propensity score with continuous treatments. In A. Gelman & X. L., Meng, (Eds.), *Applied Bayesian modeling and causal inference from incomplete-data perspectives* (pp. 73–84). New York: Wiley.

Lee, N., & Rodríguez-Pose, A. (2014). Innovation in creative cities: Evidence from British small firms. *Industry and Innovation, 21*(6), 494–512.

Navarrete, T. (2014a). *A history of digitization: Dutch museums.* (Ph.D. dissertation). University of Amsterdam, Amsterdam.

Navarrete, T. (2014b). Becoming digital: A Dutch heritage perspective. *The Journal of Arts Management, Law, and Society, 44*(3), 153–168.

OCW (Ministerie van Onderwijs, Cultuur en Wetenschap – Dutch Ministry of Culture). (2004). Strategies for a European area of digital cultural resources. Towards a Continuum of digital heritage. In *Conference report.* 15–16 September 2004. The Hague: OCW.

Saracevic, T. (2000). Digital library evaluation: Toward evolution of concepts. *Library Trends, 49*(2), 350–369.

Srakar, A. (2015). Financiranje kulture v Sloveniji in ekonomski učinki slovenske kulture v letih 1997–2014. *Likovne besede: revija za likovno umetnost,* Special Issue, 5–25.

Srakar, A. (2017). In need for a drastic change: on the "evidence-based" debates in cultural economics and cultural policy research. *Review of Economics and Economic Methodology, 2*(1), 45–62.

Stroeker, N., & Vogels, R. (2014). *Survey report on digitization in European cultural heriaga institutions 2014.* Zoetermeer: Panteia.

Tanner, S. (2006). *Handbook on cost reduction in digitisation.* Rome: MINERVA Plus Project.

ten Raa, T. (2006). *The economics of input-output analysis.* Cambridge: Cambridge University Press.

ViMM – Virtual Multimodal Museum. (2018). The ViMM Manifesto for digital cultural heritage—Introduction. https://www.vi-mm.eu/wp-content/uploads/2018/09/ViMM-Manifesto-for-digital-culture-heritage.pdf. (Access: 27/09/2020).

Yakel, E. (2004). Seeking information, seeking connections, seeking meaning: Genealogists and family historians. *Information Research, 10*(1), 205. http://InformationR.net/ir/10-1/paper205.html.

7 Crowdsourcing the digital transformation of heritage

Trilce Navarrete

Introduction

Crowdsourcing can be defined as the redistribution of the cost of developing new products and services beyond the firm to a crowd who provides finances, information, labor, or ideas resulting in marginal costs for the firm (Howe, 2008; Estelles-Arolas & Gonzales-Ladrón-De-Guevara, 2012). This chapter looks at crowdsourcing and heritage that has been converted into a digital media format for transmission through the Web with the help of the crowd.

The World Wide Web was envisioned as a global document reference system, where individuals could navigate via hyperlinks to access various text, images, audio, and video in increasingly complex forms (Berners-Lee et al., 1992). Website design has developed to facilitate consumer creation and distribution of multimedia content (Visser, 2014), while access to lower-cost mobile technology has facilitated the increase in online use to 72.7% of the global population (ITU, 2018). It could be argued that digital transformation enables democratization of consumption and production of content to anybody with a device that can access the Web. Enclosed consumption (e.g., via a subscription of email, telephony, television, virtual private networks, gaming, and many mobile applications accessed without a browser) is outside the scope of this chapter, which focuses on accessing the Internet content through the Web.

The original Web could have developed as a Peer-to-Peer network (P2P) but that required all users to be active editors and contributors. Instead, most consumers preferred the client-server model, which allows them to free-ride from the content produced by others (Kushner, 2016). Contributing to existing platforms represents a lower overall consumer's costs and so the Web 2.0 flourished, promising full democratization to consumers.

An explosion of projects followed which explored the production and distribution of content online involving the crowd, with strong network effects centralizing activity in a winner-takes-all model. Firms benefited from economies of scale, increasing the number of contributors, and from economies of scope, increasing the pool of ideas and general resources to develop

new products. New digital platforms emerged to facilitate the interaction of actors, with perhaps the best-known being Amazon's Mechanical Turk, a platform that serves as marketplace for initiators (crowdsourcees) to find workers to complete a task. Crowdsourcing became the term to refer to the outsourcing work to the virtual crowd (Estelles-Arolas & Gonzales-Ladrón-De-Guevara, 2012).

It can be argued that virtual work increases efficiency in the labor market by pairing actors, so that workers can participate from any location at any time, and that crowdsourcing may reduce brain drain (Cherry, 2011). However, few workers are paid, even though many receive some form of reward. The new technology has led to new dynamics in the use of resources calling for a revision of legislation: for instance, regarding virtual labor contracts and intellectual property rights. Something else that has changed is the ability to capture resources that used to be considered a public good, such as the knowledge about the world, and transforming them into commons triggering two social dilemmas: free-riding and sustainability (Bertacchini et al., 2012). This is the case of digital galleries, libraries, archives, and museums: the so-called GLAMs.

Digital technology facilitates the dissemination of heritage collections and public engagement. A sectoral goal, and no easy challenge, is to link digitized collections in meaningful structures across institutions and as part of the Web 3.0 network to position GLAMs prominently in the information economy (EC, 2011).[1] It has been estimated that 300 million objects from European heritage institutions have been digitized, representing 10% of the region's cultural heritage (Europeana, 2017). Identifying the provenance and context of heritage objects, for example, has not yet been automated and remains a high labor cost post. Crowdsourcing has attracted the attention of heritage institutions to advance this monumental task (Estermann, 2014). A few examples will be discussed in a later section. Engaging the public to advance the work of heritage institutions is not new to the adoption of digital technology. As example we can identify the Friends of the Museum association serving as financing crowd and donors providing the majority of the museums' collections. Digital technology has, indeed, increased the speed of information spread and the scope of potential participants. Using social media, the Prado Museum has asked the online crowd to identify the location depicted in a painting recently donated.[2] At the time of writing, the museum is analyzing the numerous suggestions and images for possible identification.

In this contribution, a series of digital heritage projects that make use of crowdsourcing are analyzed to argue that the most successful projects are characterized by strong (self-)governance and niche markets. Examples presented in this chapter suggest that greater engagement with the content can be found in all activities of heritage institutions, where the crowd supports the management, preservation, and development of a cultural good. For specific examples, socially constructed commons can be identified.

The remainder of the chapter is organized as follows: Section Two will review the literature on crowdsourcing, presenting characteristics that will serve to form a typology to discuss the emerging dynamics. Section Three will focus on the heritage sector, particularly the process of digitization of content, and examples will serve to populate the typology constructed. Section Four will close with policy implications.

Crowdsourcing background

Crowdsourcing has been adopted as distributed solution to various problems with attractive cost savings for firms. A very early form of crowdsourcing can be found in the 16th century's rewards issued to devise a system to determine the location of a ship in the Netherlands (Bell, 1947). Online, the initiator, or crowdsourcer, sets out a call to the crowd to take part in a project, with various forms of contracts, providing certain rules and expectations for instance to specify if the task is given to an individual or to the crowd (Berg et al., 2018) or regarding the ownership of the resulting product and intellectual capital generated (Wexler, 2010).

The crowdsourcing system is meant to distribute the risk involved when developing new products or services, and, therefore, the crowd may receive some form of payment. Payment for contributors of crowdsourcing varies and can be material or psychological (Wexler, 2010; Cherry, 2011). Individual ideas may involve a larger payment, while micro-tasks may be rewarded at a cent of a dollar per task (Hossain & Kauranen, 2015). Contributors may not always be paid in cash but may receive credit to purchase goods (Amazon's Mechanical Turk workers get paid in Amazon.com credit), virtual currency (common for videogames), or simply be given points to rank the level of achievement. In some cases, contributors participate in projects to gain experience, tap into a network, or receive career-enhancing visibility (Wexler, 2010).

Virtual labor has raised concerns regarding rights, safety, and payment of participants: for instance, to prevent discrimination based on age, gender, background, or location (Wexler, 2010; Cherry, 2011; Berg et al., 2018). Crowdsourced work is labor on demand, "temporary and very short-term," with extremely low wages if any (Ettlinger, 2016, p. 2170). Certain crowdsourcing platforms specifically market their outsourced labor to the global south, advertising the possibility to advance social responsibility goals for potential firm clients (Prpić et al., 2015). An example is Samasource, a platform that offers training to the crowd arguing that outsourced virtual labor is a way to increase digital literacy in the global south (Prpić et al., 2015). Regions with low labor costs may be more prone to virtual work for micro-tasks, for example, for the gaming industry to advance the level of a player in a videogame. As crowdsourcing projects become gamified, the division of work and leisure may blur rising issues of responsibilities, ownership, and benefits.

Other forms of crowdsourcing may involve local governments seeking to stimulate public participation and dialogue through crowdsourcing projects, also known as citizen sourcing. Governments can collect ideas to solve problems, to develop policies, to design service co-production, or for surveillance and monitoring, and can also collect images and other documenting information (Nam, 2011). Examples include tracking the spread of influenza through a mobile phone application (Ranard et al., 2013) and the United Nations MY World survey and e-discussion on the topic of environmental sustainability (Gellers, 2016).[3]

A form of crowdsourcing often analyzed by economists is crowdfunding, which involves the collection of funds from the crowd. The main benefit of crowdfunding is overcoming the geographic limitations to identify potential investors (Robertson & Wooster, 2015), while the greatest challenge is that of asymmetric information that prevents backers from supporting a given project (Belleflamme et al., 2019). In the United States, the passing of the Jumpstart Our Business Startups (JOBS) Act in 2012, also known as the Crowdfunding Act, has made possible the provision of securities so that funders, backers, or lenders can earn a positive financial result from their investment (Robertson & Wooster, 2015). Equity crowdfunding is rare, and most rewards take other forms of payment, such as royalty sharing or some form of non-pecuniary rewards (Mollick & Robb, 2016).

Crowdsourcing projects can be analyzed by the level of complexity of the given task, by the relation between the contributions, or by their model of management, as discussed below (see Table 7.1).

Complexity level of the tasks

Crowdsourcing involves the use of crowd labor to perform a specific task, which may require various levels of skill.[4] At the complex end of the spectrum, firms may want the crowd to generate new specific ideas, which may include answering scientific problems, in exchange for a financial reward.

Table 7.1 Matrix on crowdsourcing dimensions

Dimensions	Variables		
Level of complexity	High-complexity (project proposal)	Mid-range complexity	Low-complexity (minimal skill)
Relation between contributions	Filtered	Aggregated	
Management of the crowd	Centralized/ decentralized	Open/closed	Collaborative/ unknown participation

Source: own elaboration.

The crowd finances the project proposal and only the winners receive a compensation (Ettlinger, 2016). An example is the Innocentive website, a platform where seekers present a problem, evaluate solutions proposed by solvers, and choose the best option that receives an award, often financial, in exchange for the intellectual property of the crowdsourced idea.[5] Crowdsourcing new ideas is often coordinated through competition.

A mid-range skill task can be found in virtual call center services and some citizen science projects, which require some form of accountability by the participating individuals for the system to function. Firms may train contributors or may request a certain level of previous knowledge from participants. Citizen journalism can be considered another example of a mid-range skill task, particularly valuable to gather information from inaccessible areas (e.g., war zones), though not without concerns on the quality of the contributions (Hossain & Kauranen, 2015).

A crowdsourced task requiring minimal skills is the most prevalent. Micro-tasks are often low-skilled tasks and generally involve repetitive and easy activities, such as transcriptions, annotations, validation, and translations, often to be used for training algorithms (Hossain & Kauranen, 2015). Popularity contests of television shows can also be considered examples of aggregated low-skill contributions (Prpić et al., 2015).

There are crowdsourcing projects where the crowd is in fact not aware of their contribution This is the case of the CAPTCHA system used to discern humans from computers, giving Google about 83,000 hours of daily labor to support optical character recognition (OCR) and semantic links (for image identification) (Prpić et al., 2015). CAPTCHA stands for a Completely Automated Public Turning test to tell Computers and Humans Apart. It was adopted by Google to digitize books and newspapers, with variations in reCAPTCHA and later including image identification to train algorithm systems.

Aggregate and filtered content

In addition to the level of complexity of a task, and the distribution of the costs, crowdsourcing projects can be organized based on the relation between contributions to achieve the final goal. Some projects break up the process into small parts, such as micro-tasks and voting, which are later aggregated to create a final product (Prpić et al., 2015). A well-known example of this is the crowdsourcing Zooniverse platform,[6] where the crowd is asked to tag, match, classify, or identify characteristics of images and videos from large datasets generated by space telescopes or cameras in natural parks. The data collected is then aggregated and analyzed to develop new insights about galaxies or species behavior. The individual contributing members of the crowd do not need to interact, and the task started by one can be continued by another at any time. The platform Zooniverse also provides humanities content such as hand-written texts and asks the crowd to transcribe them, following the same principle.

A similar example is the Foldit project developed by the University of Washington. The crowd plays with protein molecular structures to identify images (e.g., density maps). Results are more accurate interpretations of protein structures than those from automated algorithms, and the crowd can process images faster than previous cryo-electron micrographs or X-ray crystallographs (Bkoep, 2019). The aggregated micro-tasks have served to publish a series of scientific papers by the university team, who kindly acknowledge the contributions of the Foldit players (estimated to surpass the 57,000).[7]

In contrast, crowdsourcing projects can rely on one individual to create a finished product, which may be then selected by the requesting firm and adopted for production. This is the case with many idea generation projects where firms outsource the creation of an innovation or the anticipation of predictions (Hossain & Kauranen, 2015). An example is NASA's $30,000 award to a solution for the prediction of solar flares (Nam, 2011).

Management of the crowd

Crowdsourcing projects can allow centralized or decentralized authority, open (e.g., interoperability, future reuse of the gathered information) or closed participation (e.g., anonymous participation, peer review), and a range of relationships (from unknown participation to full collaboration). Activities can be objective, as transcribing a text, or subjective, as voting for "the best of." Firms may request funds to finance a project, devise a tournament type crowdsourcing (giving a prize for the best idea), call for virtual labor (made up of a series of micro-tasks), or engage in an open collaboration (such as a wiki) (Prpić, Taeihagh & Melton, 2015).

Not all crowdsourcing projects are collaborations between crowdsourcee and crowdsourcer. Projects such as Google's CAPTCHA tap into the crowd to do a job without encounters or relationships between actors. Platforms such as del.icio.us or YouTube are not clear in their crowdsourcing nature, as the call, the benefits, the tasks, the nature of the participation, and the role of the initiator are not clearly identified (Estelles-Arolas & Gonzalez-Ladrón-De-Guevara, 2012). Such aggregators utilize the crowd's input, including content, behavior, and ratings, to prioritize content output without calling the crowd for a greater goal. Most crowdsourcing projects, however, do call the crowd.

Attracting the right crowd and aligning efforts to the project's goal is essential, though not as easy as one would think. Crowds respond to information about the firm or platform where the project takes place as well as to signals from other participating members of the crowd (Belleflamme et al., 2019). Breaking up problems into tasks doable for individuals outside of the firm requires sufficient organizational capacity from the firm in order to return usable results, which explains the emergence of specialized crowdsourcing platforms with a history of constructing crowds, offering paid services to intermediate coordination (Prpić et al., 2015).

Consistent and good quality participation from the crowd requires a clear central idea, as well as transparent governance structure. An important point is the ownership of the final product. An example of a jointly owned product is open source software (OSS), free to use and developed by a crowd generally driven by altruistic motivations, which often outperforms commercial products. Well-known examples include Linux, Mozilla Firefox, OpenOffice, and Ubuntu. OSS is dependent on the active crowd to assess, improve, and evaluate the software to increase its quality, and to keep it usable (Wexler, 2010).

Another example is the free online encyclopedia Wikipedia, with over 49 million articles (6 million of which are in English), edited by 200,000 contributors every month, available in 307 languages, and viewed by over 21 billion individuals across the world on a monthly basis.[8] The project is one of many products coordinated by the Wikimedia Foundation as part of a free knowledge infrastructure aiming at giving access to all the knowledge of the world.[9] It has become an important global information resource, a socially constructed common good (Hess, 2012).

Crowdsourcing and digital heritage

Many heritage institutions have a certain experience with crowds providing for finances, information, labor, or ideas in a small scale through the long history of working with volunteers. Adopting a crowdsourcing approach as we now know it involves a larger number of respondents at a much higher speed. For this, constraints to adopt a crowd approach include issues of validating contributions (Ridge, 2013) or the fear of undermining the authority of heritage experts who want to protect a certain exclusivity of the sector (Abbing, 2019). Further, while digital networked technology promises to facilitate referencing by linking to primary data (including heritage collections), the challenges of dealing with the nature of heritage data, characterized by being fuzzy, heterogeneous, uncertain, and interpretative, have not been solved (Blanke et al., 2012).

The issue of multiple objectives may also be identified. While for-profit firms may call the crowd to lower costs of production or reduce risk of product uncertainty as in the case of the creative industries (Dalla Chiesa & Handke, 2020), heritage institutions may seek to engage consumers. Heritage services are often driven by multiple goals, including the preservation and development of cultural heritage, advancing education, providing entertainment, or increasing welfare (Towse, 2019), all of which may be pursued during a crowdsourcing project. Similarly, consumers may want to engage with heritage content for various reasons. Participants in heritage crowdsourcing are motivated to take part in a history- and archaeology-related project; to learn about the subject; to connect with the institution; to develop skills, for fun, out of curiosity; to help out; to contribute to

knowledge production; and to learn more about a personal cultural background (related to identity forming) (Bonacchi et al., 2019).

Involving the crowd is inherent to intangible heritage and most forms of culture. In the visual arts, Spencer Turnick can serve as prime example of volunteers contributing as models for a group photograph, including the 18,000 nudes posing at Mexico City's central square.[10] A film example can be found in Peter Jackson's call of 20,000 volunteers to contribute to the sound of the org armies in the Lord of the Rings: Two Towers (Prpić et al., 2015). The fashion firm ModCloth has launched several crowdsourcing projects in exchange for discounted purchases, including calling the crowd to contribute images modeling clothes, to suggests clothes based on body types, to vote the best drafts to be produced as final designs, and to provide sketched ideas for new designs, which were in turn voted by the same crowd and adapted into the following season (Estelles-Arolas & Gonzalez-Ladrón-De-Guevara, 2012). Creative industries crowdsourcing regularly involve larger crowds for content generation, ratings, and new ideas, which do not compare to most heritage crowdsourcing projects, receiving support from a few hundred individuals and rarely surpassing the five thousand (Carletti et al., 2013).

An overview of projects in the heritage field that tap into the crowd using digital technologies has not yet been inventoried and has only recently attracted broad attention (for an overview of a selection of projects from the early 2010s, see Ria, 2014). A few projects with large consortia have been financed by public money in the last decade. Examples include 3D-ICONS, a three-year project for the documentation of archaeological monuments and historic buildings to feed Europeana;[11] The Scottish Ten, a project to document five international heritage sites to help with their conservation and management;[12] or the Million Image Database, a repository of heritage images to document the past and to explore the use of 3D imagery.[13]

Crowdsourcing projects specific to advance digital collections of heritage institutions, the GLAMs, have emerged to explore alternative sources of labor, and sometimes funds, for the digitization production process. A recent European survey estimated that museums spend a yearly median €10,000 (mean €111,000) in digital activities and allocate an average of five paid staff and two volunteers toward digital collection activities. Management (e.g., licenses, online services) make up about 40% of the structural costs, digital preservation and archiving make up about 35% of the costs, and the rest is allocated toward user outreach, usage analysis, and editorial work. Eighty-nine percent of the budget is internally generated, and so far, it has been estimated that 31% of museum collections have been digitized (Nauta et al., 2017).

Invariably, availability of online collections increases their use, yet production and proper online publication remain a challenge. To give an example: one large city archive has 32 kilometers of materials, which would represent about 224 million scans (there are roughly 7,000 scans per meter). At an output of 10,000 scans per week, which is quite an impressive mass digitization process, it would take the archive 431 years to digitize

their entire collection. Digitization started in 2001 and continues to improve, speeding up the process to about two million scans per year, or 20,000 scans per week, or 30 scans per minute. This included 6,000 scans requested by 1,260 different consumers (scan on demand program). Since 2001, the archive has digitized six million scans (Holtman & Van Zeeland, 2019). However, digitized material can only be accessed when its contents can be searched for and identified; a digital image in itself is not enough. The city archive decided to call the crowd to support the identification of important information, such as dates, names, places, and type of document. With a grant of €150,000 from the Mondriaan Foundation, the Amsterdam City Archive collaborated with a software partner, Picturae, to develop the crowdsourcing software, which is currently used by many more heritage institutions to annotate digital collections. To ensure quality, every document data element is entered twice (SAA, 2013). The archive commissioned the creation of an online program called Many Hands (Vele Handen) to coordinate crowdsourced annotations and in the first 1.5 years, over 1.6 million objects were identified with name, birth place, and date of birth twice, representing a full-time staff working for a period of over 18 years (SAA, 2013).[14] While the onsite access to the archives has decreased by 66% in the past ten years, online access continues to increase (from zero to 18,000 yearly requests in the same period) (Duran, 2019).

Besides tapping into the crowd to advance the digitization of collections by providing financial resources or labor to enhance existing collections, crowdsourcing projects can support public engagement and can lead to developing new collections: for instance, to document history as a form of intangible heritage (Carletti et al., 2013). The main crowdsourcing forms in the heritage field are crowdfunding (acquiring funds to finance a project), idea generation projects (for new products and services), aggregated input projects (generally to speed digitization projects, some of which through micro-tasks), and open collaboration projects (for instance to populate a digital collection). We follow with a discussion of each with examples (summarized in Table 7.2).

Table 7.2 Typology of crowdsourcing in heritage projects

Type of project	Examples		
Crowdfunding projects	Hardware/software development	Production of digital surrogates	Sustainability (none found)
Idea generation projects	Reuse of collection	For product development (shop)	
Aggregated input projects	Classification, transcription, correction, revision	Curation, preservation	Ownership identification (orphan works)
Open collaboration projects	Development of a common resource	Individual/ institutional	Use of own/third-party platform

Source: own elaboration.

Crowdfunding projects

While heritage institutions increasingly engage in development campaigns, asking private patrons for financial support, projects inviting the crowd to co-finance digitization projects or the production of digital surrogates are extremely rare. Generally, crowds are asked to support the financing of capital projects, the acquisition, preservation, or exhibitions of collection objects, and the financing of events in museums but rarely a digital collection. A well-known portal for arts and culture crowdfunding is Kickstarter.

An example of co-financing hardware is the crowdfunding project to acquire 35 Oculus Rif 2 glasses to present a 3D video of the city of Horn in the 1650s. The Westfries museum developed a video and wanted to show it using advanced technology, calling the crowd through the Dutch cultural crowdfunding portal Voordekunst, receiving 112% of its €32,000 goal, backed by 317 donors.[15]

A notable crowdsourcing project for a digital collection is the call by the information and library services department of the ethnographic museum in Amsterdam. The museum called the crowd to raise €10,000 for the development of a search engine to access 355 photo albums and to develop a mobile phone application for the documentation of the collection. The museum received 13 crates with photo albums left in Java and Sumatra when Dutch-Indians moved to the Netherlands after the war. The majority found their owner family, but 355 personal photo albums remained unidentified. The museum developed a "Photo seeks family" project online to involve younger generations and to reach non-visitors who were asked to identify their family members' stories (KIT, 2013). The museum used Voordekunst and received 125% of the amount requested, financed by 232 crowd donors.[16]

A similar project was developed by the Amsterdam City Archive where the crowd was invited to co-finance the digitization of 38,463 photographs, including glass negatives. The project was launched in 2013 and, at the time of writing, it has digitized 12,000 photographs and received €34,500 of a goal of €50,000. The project has its own website, where it was possible to donate and where a special page acknowledges donors. The crowd is also invited to provide additional information to identify the photographs: for example, the individuals portrayed, the locations, or the dates. All the digitized collection is still available online.[17]

Idea generation projects

The use of digital collections for idea generation is not always crowdsourced, as online consumers are free to make use of the images for any purpose without collaborating with the museum institution. The Rijksmuseum in

Amsterdam has devised a crowdsourcing system for ideas on the reuse of collections through the bi-yearly Rijksstudio Award. The Rijksstudio is the portal of the Rijksmuseum online collection, which is the base for the idea generation. The 2020 prize amounts to €7,500, a Young Talent Award of €5,000 will be awarded, and the winner of the public vote will receive €25,000. At the time of writing, entries were still being evaluated by a jury of experts and the crowd was called to vote for a favorite. In addition to the prize, winners can become part of the goods sold at the museum's gift shop.[18]

Aggregated input projects

Most crowdsourcing projects ask the crowd to contribute to the classification, transcription, correction, revision, and documentation of collections to enrich metadata and contextualization. Perhaps the first effort to improve access to digitized collections through crowdsourcing is the Steve. museum, a collaboration initiated by the Metropolitan Museum of Art, the Guggenheim Museum, the Cleveland Museum of Art, and the Deventer Art Museum. It was launched in 2005 when museums were just broadly adopting the web to present collections online. The Steve.museum project asked the crowd to support classification of collections through tagging objects and in doing so develop a folksonomy. From the initial 30 objects that were given crowd terms, 80% of these were not found in the museum's documentation system but added on. The project required a new data model infrastructure to capture the crowd's contributions (Chun et al., 2006).[19] A more technically advanced semantic annotation project was Accurator, led by the Rijksmuseum, designed as niche-source to provide expert knowledge by the crowd. The bird experts identified 1,528 birds in 213 artworks in the collection (Jongma & Dijkshoorn, 2016).[20] The Accurator project was a collaboration with a consortium of Dutch researchers from the VU University, Delft University of Technology, Centre for Mathematics and Informatics, and three large museums—Rijksmuseum, Naturalis, and Sound and Vision (Jongma & Dijkshoorn, 2016). These are examples of innovative explorations to involve the crowd in collection annotation.

Crowdsourced tagging can serve other purposes. The Indianapolis Museum of Art aggregated tags into heatmaps to identify the most visible areas of an artwork (Carletti et al., 2013). Such a by-product of an initial tagging project may become more prevalent as the availability of data allows for new insights in consumer behavior online.

Crowdsourcing the curation of digital collections has proven quite successful to engage with the public. The crowd can support the selection, classification, and organization of an existing collection (Carletti et al., 2013). These can blend the digital and physical worlds, such as the Dutch Kröller-Müller museum project, first for adults and then for children, asking the

crowd to rank works. Those receiving greater votes were included in a physical exhibition (Schoemaker, 2010). Similarly, the Victoria and Albert Museum devised a voting system to rank its 140,000 digital images of the collection to appear in the Search the Collections page.[21]

A geographic-based crowdsourcing project of sounds was led by the British Library Sounds collection, which presented over 50,000 recordings from the library collection and invited the public to contribute their own sounds. A series of Sound Maps were created documenting accents (the crowd could read a children's story or a list of six words) and daily sounds at home, work, or play (over 2,000 recordings were received by 350 contributors).[22] A similar project collected 1001 Stories of Denmark, in a crowdsourcing effort initiated by the government meant to capture intangible heritage through geo tagging. At the time of writing, the project website was no longer functional, though recorded stories were accessible via the project's YouTube channel.[23]

A more challenging effort was led by EnDOW (Enhancing access to 20th-century cultural heritage through Distributed Orphan Works clearance). The crowd was called to support rights clearance of European digitized cultural heritage by identifying orphan works. The project was a response of the European Directive on orphan works that required institutions to perform diligent search before publishing collections online. The labor costs that such diligent search would require are prohibitable expensive for any cultural institution with a sizable collection. The crowd is instructed on how to search for a works potential right holder before labeling it as orphan (Borghi, Erickson & Favale, 2016).[24]

Open collaboration projects

There are crowdsourcing projects that invite the creation of a common resource. These tend to be larger projects with a strong crowd engagement, for long periods of time. One Dutch example is the whale stranding database,[25] launched in 2006 by the Naturalis Biodiversity Centre to merge the historic data housed at the museum, including the first documented case dating from 1255, and inviting the crowd to add current findings. The site provides basic fields to harmonize the documentation of the findings, including date, location, measurements, and an image when available. The site also provides basic clues to identify the various characteristics of the animals, to differentiate a whale from a dolphin for example (Naturalis, 2006). The site is currently an important resource where over 12,000 whale and dolphin strandings have been documented (513 entries in 2019), available for everybody to use free of charge. The natural history museum has in fact taken the role of coordinator of the newly formed common resource.

The Amsterdam museum intends to similarly serve as facilitator of a socially constructed commons of intangible heritage about the city of Amsterdam, starting with the Memory of East project in 2006, followed by

Centrum and West, and eventually to expand to South, South East and North neighborhoods of the city. The overarching Memory of Amsterdam project intends to collect, preserve, and make available the daily memories and stories of residents of the city. Selected content is regularly used for thematic exhibitions (AM, 2018). The crowd is similarly guided on how to generate content through a series of harmonizing fields, such as place, date, and keywords.[26]

An institutional crowdsourcing project of heritage content across Europe is Europeana, currently giving access to 50 million items. Though the project receives a yearly subsidy from the European Commission (over €6 million in 2018), this is largely allocated to cover staff and general operations (80% of the budget), as well as the development of the portal and regular meetings to coordinate the project (20%) (Europeana, 2018). Participating heritage institutions bear the costs of digitization of collections and ingestion into the national aggregator. Institutions receiving European grants are required to publish the digitized outcomes in the Europeana repository. The portal launched in 2007 and has evolved from earlier efforts to integrate heritage collections remotely across Europe (Navarrete, 2014).

Whereas the previous examples have a coordinating institution directing the crowdsourcing efforts, there are other examples where a platform is adopted as common storage of content, without clear curatorial guidelines. Such is the example of the Sketchfab platform, launched in 2011 for the publication of 3D, VR, and AR content. Museums can upload content, some have created a profile, though the majority of the content is uploaded by member of the crowd.[27] This portal gives access to the largest 3D, VR, and AR collection of heritage in the world (consumers do have to filter through all the non-heritage-related content!).

Conclusion and managerial implications

Digital technology has transformed the social perception of crowds as "collective intelligence that solves problems" (Wexler, 2010, p. 12) voluntarily, with important economic implications. Tapping into the crowd as a pool source of labor may crowd out payment for activities to trained individuals in an already distressed labor market; 66% of Dutch museum staff is currently non-paid volunteer or intern (NMV, 2018). In addition, a study of Swiss museums reported that involving the crowd to support digitization of collections was clearly seen to deliver greater risks than benefits (Estermann, 2013). On the other hand, there are four important positive outcomes.

First, the crowd can advance work that has been limited by the available resources to heritage institution. Particularly, regarding the digitization of collections, crowds can advance the identification of objects so that these are usable for any purpose. From one account, the crowd advanced in one and a half year what a full-time staff would have taken 18 years to do.

Second, the engagement with the institution and the content can lead to new forms of citizen participation: for instance, to create socially constructed commons. From the presented examples it can be argued that the digital repositories, freely accessible to all, are a valuable resource in the information economy. Individuals from every field, as well as machines, can benefit from quality, structured, diverse, reliable, and sustainable content.

As with any resource, a digital repository requires investment and maintenance for its sustainability (and growth). Conceptualizing the digital heritage repository as a socially constructed cultural commons may strengthen engagement with communities of users to sustain it. Stimulating reuse of objects in the digital heritage repository can be expected to support sustainability of the increasingly dynamic repositories, able to adapt to social changes and crowd contributions.

Third, crowdsourcing may improve the distribution of costs and benefits beyond political borders. Currently, many digital heritage projects are paid for by tax payers, yet online dissemination allows for consumption beyond the paying population. Crowdsourcing could provide input from a greater segment of the population, including those outside of the political district.

Crowdsourcing and niche-sourcing may favor popularity as network effects inevitably have strong dynamics. It is the role of policy makers to intervene and support greater diversity and equity in the access and development of heritage. Because heritage is socially defined and changes over time, it can be expected that priorities will change.

Last, engaging with crowdsourcing and digital heritage content would inevitably lead to a digital trail that may reveal trends in emerging forms of digital cultural consumption. So far, much of the digital content has been analyzed by private firms (such as the family of Google services), yet little knowledge has been shared with researchers, politicians, and the crowds. The explosion of content, particularly through social media, is simply not sustainable. Curating a socially constructed heritage commons may raise awareness of the terabytes needed to maintain our current digital consumption lifestyle.

Notes

1 The Web 1.0 is characterized by static document publication which evolved into the Web 2.0 when it allowed user contributions (such as likes, uploading of media, and writing content) and interactions (such as discussions and mashups). The Web 3.0 refers to the Semantic Web, where content is encoded to allow machines to understand it (such as a name, a date, or a place). Some envision the Web 4.0, or Symbiotic Web, to be characterized by a seamless relation between machines and humans through robotics (such as virtual assistants) and high personalization (such as context specific displays) (Aghaei et al., 2012).
2 The original call via Twitter is available at https://twitter.com/LuisCollantesR/status/1143170732450570240. The information about the painting with mystery location is available at https://www.museodelprado.es/coleccion/obra-de-arte/paisaje/07e8f75e-3622-4b48-ba3d-2fc1096e6c5a?searchMeta=agustin%20riancho.

3 Data from the project is available at http://data.myworld2015.org/.
4 For an overview of large crowdsourcing projects with a short description see Cherry (2011).
5 https://www.innocentive.com/
6 https://en.wikipedia.org/wiki/Zooniverse.
7 https://fold.it/portal/info/about.
8 All statistics from Wikipedia are available at https://en.wikipedia.org/wiki/Wikipedia:Statistics.
9 https://wikimediafoundation.org/.
10 https://www.spencertunick.com/.
11 http://3dicons-project.eu/.
12 https://www.engineshed.scot/about-us/the-scottish-ten/.
13 https://www.millionimage.org.uk/.
14 The projects can be found at https://velehanden.nl/.
15 A portion of the video is available at https://vimeo.com/105549924. The Crowdsourcing page is available at https://www.voordekunst.nl/projecten/2751-de-gouden-eeuw-vr-stap-in-1650.
16 The successfully closed crowdsourcing page is available at https://www.voordekunst.nl/projecten/578-foto-zoekt-familie-1.
17 http://redeenportret.nl/doneer.
18 The Rijksstudio is available at https://www.rijksmuseum.nl/en/rijksstudio.
19 A folksonomy was desired to allow non-experts to search and find objects in collections that would otherwise be hard to find in the authored expert information system. The name clearly differentiates the folk nature of the taxonomic classification. Terms were often simple descriptors, such as animal, archery, baroque, luxury, movement, nude, ornate, saddle, and woman to describe a 1620 silver "Diana and the Stag" by Joachim Friess, part of the Metropolitan Museum of Art (Chun et al., 2006).
20 The project website is available at http://accurator.nl/.
21 The dynamic web page displays a new set of objects based on the crowd's input (https://collections.vam.ac.uk/).
22 The crowdsourcing project took place in 2010, which is available together with the rest of the sound collection (https://sounds.bl.uk/Sound-Maps).
23 For a short overview of the project see https://www.youtube.com/watch?v=NFw2x20y6vo.
24 The project website is available at http://diligentsearch.eu/.
25 The project can be found at http://www.walvisstrandingen.nl/.
26 The project is available at https://geheugenvan.amsterdam/.
27 The British Museum, for example, opened a profile in 2014 and currently displays 257 models (see https://sketchfab.com/britishmuseum).

References

Abbing, H. (2019). *The changing social economy of art: Are the arts becoming less exclusive?* Cham: Palgrave Macmillan.

Aghaei, S. (2012). Evolution of the World Wide Web: From Web 1.0 to Web 4.0. *International Journal of Web & Semantic Technology*, 3(1), 1–10.

Amsterdam Museum. (2018). *Amsterdam Museum jaarverslag 2018*. Amsterdam: Amsterdam Museum. Available at https://www.amsterdammuseum.nl/over-ons/over-de-organisatie/jaarverslagen.

Bell, A. E. (1947). *Christian Huygens and the development of science in the seventeenth century*. New York: Longmans, Green & Co.

Belleflamme, P., Lambert, T., & Schwienbacher, A. (2019, August 9). *Crowdfunding dynamics*. Social Science Research Network. http://dx.doi.org/10.2139/ssrn.3259191.

Belleflamme, P., & Peitz, M. (2020). Ratings, reviews and recommendations. In R. Towse & T. Navarrete (Eds.), *A handbook of cultural economics* (3rd ed., pp. 466–474). Cheltenham: Edward Elgar.

Berg, J., Furrer, M., Harmon, E., Rani, U., & Six Silberman, M. (2018). *Digital labour platforms and the future of work: Towards decent work in the online world*. International Labour Office. https://www.ilo.org/wcmsp5/groups/public/---dgreports/---dcomm/---publ/documents/publication/wcms_645337.pdf

Berners-Lee, T., Cailliau, R., Groff, J.-F., & Pollermann, B. (1992). World-Wide Web: The information universe. *Electronic Networking: Research, Applications and Policy*, 2(1), 52–58.

Bertacchini, G., Marrelli, M., & Santagata, W. (2012). Defining cultural commons. In G. Bertacchini, M. Marrelli, & W. Santagata (Eds.), *Cultural commons* (pp. 3–18). Cheltenham: Edward Elgar.

bkoep. (2019, November 11). *The Foldit cryo-EM paper*. foldit. https://fold.it/portal/node/2008272

Blanke, T., Bodard, G., Bryant, M., Dunn, S., Hedges, M., Jackson, M., & Scott, D. (2012). Linked data for humanities research—The SPQR experiment. In *2012 6th IEEE international conference on digital ecosystems and technologies (DEST)*. IEEE. https://ieeexplore.ieee.org/document/6227932

Bonacchi, C., Bevan, A., Keinan-Schoonbaert, A., Pett, D., & Wexler, J. (2019). Participation in heritage crowdsourcing. *Museum Management and Curatorship*, 34(2), 166–182.

Bonancini, E. (2013). Stories on geographies: Geo-social tagging for co-creation of cultural value. *International Journal of Heritage in the Digital Era*, 2(2), 222–243.

Borghi, M., Erickson, K., & Favale, M. (2016). With enough eyeballs all searches are diligent: Mobilizing the crowd in copyright clearance for mass digitisation. *Chicago-Kent Journal of Intellectual Property*, 16(1), 135–164.

Carletti, L., McAuley, D., Price, D., Giannachi, G., & Benford, S. (2013). Digital humanities and crowdsourcing: An exploration. In N. Proctor & R. Cherry (Eds.), *MW2013: Museums and the Web 2013* (n.p.). Museums and the Web. https://mw2013.museumsandtheweb.com/paper/digital-humanities-and-crowdsourcing-an-exploration-4/

Cherry, M. (2011). A taxonomy of virtual work. *Georgia Law Review*, 45(4), 951–991.

Chun, S., Cherry, R., Hiwiller, D., Trant, J., & Wyman, B. (2006). Steve.museum: An ongoing experiment in social tagging, folksonomy, and museums. In J. Trant & D. Bearman (Eds.), *Museums and the web 2006: Proceedings* (n.p.). Archives & Museum Informatics. https://www.museumsandtheweb.com/mw2006/papers/wyman/wyman.html

Dalla Chiesa, C., & Handke, C. (2020) Crowdfunding. In R. Towse & T. Navarrete (Eds.), *Handbook of cultural economics* (3rd ed., pp. 158–167). Cheltenham: Edward Elgar.

Duran, C. (2019). *Analysis of the use of the collections at the Amsterdam City archives (1999–2018)*. Amsterdam: Stadsarchief Amsterdam. Internal report.

Estellés-Arolas, E., & González-Ladrón-De-Guevara, F. (2012). Towards an integrated crowdsourcing definition. *Journal of Information Science, 38*(2), 189–200.

Estermann, B. (2014). Diffusion of open data and crowdsourcing among heritage institutions: Results of a pilot survey in Switzerland. *Journal of Theoretical and Applied Electronic Commerce Research, 9*(3), 15–31.

Ettlinger, N. (2016). The governance of crowdsourcing: Rationalities of the new exploitation. *Environment and Planning A: Economy and Space, 48*(11), 2162–2180.

European Commission. (2011). *The new renaissance: Report of the 'Comité des Sages'.* https://ec.europa.eu/commission/presscorner/detail/en/IP_11_17

Europeana. (2017). *Europeana strategy 2020.* https://pro.europeana.eu/post/europeana-strategy

Europeana. (2018). *Annual report: A decade of democratising culture.* Published online 29 March 2019 at https://pro.europeana.eu/page/annual-report-2018-a-decade-of-democratising-culture.

Gellers, J. C. (2016). Crowdsourcing global governance: Sustainable development goals, civil society, and the pursuit of democratic legitimacy. *International Environmental Agreements: Politics, Law and Economics, 16*(3), 415–432. https://doi.org/10.1007/s10784-016-9322-0

Hess, C. (2012). Constructing a new research agenda for Cultural Commons. In G. Bertacchini, M. Marrelli, & W. Santagata (Eds.), *Cultural commons* (pp. 19–35). Cheltenham: Edward Elgar.

Hossain, M., & Kauranen, I. (2015). Crowdsourcing: A comprehensive literature review. *Strategic Outsourcing: An International Journal, 8*(1), 2–22.

Howe, J. (2008). *Crowdsourcing: Why the power of the crowd is driving the future of business.* New York: Three Rivers Press.

International Telecommunications Union. (2018). *Measuring the information society report* (Vol. 2). https://www.itu.int/en/ITU-D/Statistics/Documents/publications/misr2018/MISR-2018-Vol-2-E.pdf

Jongma, L., & Dijkshoorn, C. (2016). Accurator: Enriching collections with expert knowledge from the crowd. In D. Bearman & J. Trant (Eds.), *MW2016: Museums and the web 2016* (n.p.). Archives & Museum Informatics. https://www.museumsandtheweb.com/mw2006/papers/wyman/wyman.html

Koninklijk Instituut voor de Tropen. (2013). *KIT annual report 2012.* Amsterdam: KIT. Available at https://www.kit.nl/about-us/annual-report/.

Kushner, S. (2016). Read only: The persistence of lurking in Web 2.0. *First Monday, 21*(6), n.p.

Mollick, E., & Robb, A. (2016). Democratizing innovation and capital access: The role of crowdfunding. *California Management Review, 58*(2), 72–87.

Naturalis. (2006). *Annual report 2006.* Leiden: Naturalis Biodiversity Centre. https://www.naturalis.nl/over-ons/verantwoord-bestuur-anbi-informatie#state-search.

Nauta, G.-J., van den Heuvel, W., & Teunisse, S. (2017). *Europeana DSI 2—Access to digital resources of European heritage. D4.4. Report on ENUMERATE Core Survey 4.* Digitaal Erfgoed Nederland. https://pro.europeana.eu/files/Europeana_Professional/Projects/Project_list/ENUMERATE/deliverables/DSI2_Deliverable%20D4.4_Europeana_Report%20on%20ENUMERATE%20Core%20Survey%204.pdf

Navarrete, T. (2014). *A history of digitisation: Dutch museums.* (Doctoral dissertation, University of Amsterdam). https://hdl.handle.net/11245/1.433221

Nederlandse Museumvereniging. (2018). *Museumcijfers 2018.* https://www.museum vereniging.nl/media/museumcijfers_2018_def.pdf

Prpić, J., Shukla, P. P., Kietzmann, J. H., & McCarthy, I. P. (2015). How to work a crowd: Developing crowd capital through crowdsourcing. *Business Horizons, 58*(1), 77–85.

Prpić, J., Taeihagh, A., & Melton, J. (2015). The fundamentals of policy crowdsourcing. *Policy & Internet, 7*(3), 340–361.

Ranard, B. L., Ha, Y. P., Meisel, Z. F., Asch, D. A., Hill, S. S., Becker, L. B., Seymour, A. K., & Merchant, R. M. (2014). Crowdsourcing—Harnessing the masses to advance health and medicine, a systematic review. *Journal of General Internal Medicine, 29*(1), 187–203.

Ridge, M. (2013). From tagging to theorizing: Deepening engagement with cultural heritage through crowdsourcing. *Curator: The Museum Journal, 56*(4), 435–450.

Robertson, E., & Wooster, R. B. (2015, July 15). *Crowdfunding as a social movement: The determinants of success in Kickstarter campaigns.* Social Science Research Network. https://doi.org/10.2139/ssrn.2631320

Schoemaker, T. (2010, November). Kinderen kiezen kunst in museum Kröller-Müller. *NRC Handelsblad.* https://www.nrc.nl/nieuws/2010/11/26/kinderen-kiezen-kunst-in-museum-kroller-muller-11974501-a79233

Stadsarchief Amsterdam. (2013). *Open Archieven door Crowdsourcing:een project voor grootschalige archiefontsluiting.* Eindverslag voor het Mondriaan Fonds. Amsterdam: Sadsarchief Amsterdam. Internal report.

Towse, R. (2019). *A textbook of cultural economics.* Cambridge: Cambridge University Press.

Visser, J. (2014). Strategies for a heritage revival in the digital age. In L. Egberts & K. Bosma (Eds.). *Companion to European heritage revivals* (pp. 73–93). Cham: Springer.

Wexler, M. N. (2011). Reconfiguring the sociology of the crowd: Exploring crowdsourcing. *International Journal of Sociology and Social Policy, 31*(1/2), 6–20.

Part III

Creative industries

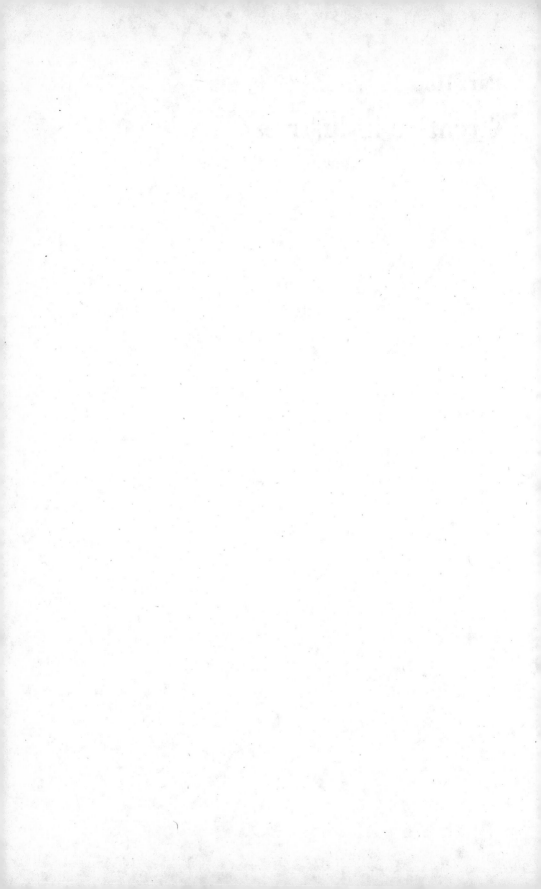

8 Digital music (r)evolution

Disruption through digital transformation in the music industry

Lorenzo Mizzau

Introduction

In recent times, the music industry has epitomized the profound changes that the cultural (Lampel et al., 2006; Hesmondhalgh, 2012), media (Picard, 2011) or copyright (Wikström, 2013) industries have gone through since digital technologies appeared. It has traversed the "high tide" of digital technology earlier than other cultural industries, and it was revolutionized by a disruption that was—for reasons that will be dealt with in this chapter—particularly deep and significant compared to what happened in other sectors of the economy. In effect, while, nowadays, it is common to talk about "digital transformation" (meaning a radical rethinking of customer relationships as well as internal organization), the music industry has faced the challenge posed by the de-materialization of analog, physical recordings,[1] being probably the *least digital* industry when the technology first came about. More generally, in a continuum between the Internet and electronic industries popularized by the rise and fall of the "dot.com bubble" at the beginning of the new millennium, and the non-digital industries, we may place the film, books, and music industries at the dusk of the 20th century much closer to the non-digital end (with media laying in the middle). Then something happened, and nothing was the same anymore.

This chapter responds to a gap lying at the intersection of literatures about disruptive technologies, cultural industries, and strategic and organizational change. Although the digital transformation of cultural industries started to capture the media and public attention since the early 2000s, scholarly studies about the phenomenon tended to focus on single, specific aspects of the matter. For example, economists have studied whether peer-to-peer file sharing was detrimental, neutral, or even beneficial to music sales (e.g., Oberholzer-Gee & Strumpf, 2016); law scholars have long debated the pros and cons of regulations such as the Digital Copyright Millennium Act (DCMA) and more generally of tighter control on content use to prevent misuse or piracy (e.g., Lessig, 2009); and marketing scholars have focused on consumers' reactions to music companies' choices (e.g., Vernik et al., 2011). However, comprehensive accounts of the "transformations

induced by the digital revolution in the value chain and organization of a specific CCI [Cultural and Creative Industry]" have been heretofore scant (Salvador et al., 2019, p. 6; see also Moreau, 2013).

Studying what happened to the first of the cultural industries experiencing the digital revolution is worth for the following reasons, which will also outline the research approach and methodology of this chapter. First, reconstructing how incumbent industry actors reacted to an innovation that was—as will be shown clearly below—largely developed outside of their control is a way to understand the typical features of those industries. In effect, as several theories in organization and management theory argue, a specific industry, due to socio-technical and evolutionary paths, carries on typical response patterns, routines of action and decision, and ways of deploying and using the resources at hand. Specifically, it will be argued that the peculiar way the actors of the music industry reacted to this epochal change depends on ingrained beliefs and assumptions about how to navigate changes that were developed in past events of disruption. It will also be shown how actors were, albeit difficultly, able to modify these response patterns along the way, and how they progressively learned to deal with digital transformation in different ways than those enacted in the early history of digital music. These are endeavors that will be taken on in the next section (where the basics of theories of incumbents' reaction to technological change will be outlined) and in the third section, which, by expanding on those theories, will detail what actually happened in the early (2000–2006) and middle (2007–2010) eras of the digital music history. In this central section, I will present evidence from first-hand material and secondary sources to frame the reconstruction of the events in those stages of development of the industry. The concluding section starts by summing up the lessons learned by industry actors along the way, and sketching out the ones that other cultural industries (prominently the movie/video content and the book/publishing industries) were able to apprehend and "interiorize"—which allowed these latter to react differently than the music industry to similar challenges posed by digital transformation. The chapter closes with an exploration of the challenges the cultural industries are still facing (and will face), pointing to the importance of completing a digital transformation "from the inside out."

Overall, the goal of this chapter is to explain how a disruptive innovation such as digital has been tackled by quite a peculiar industry—the recorded music industry. Due to ingrained beliefs and assumptions, the innovation was first ignored, then played down by incumbent actors, who tried to "fight the new" and its protagonists, and finally embraced, through a difficult process of acceptance and change in beliefs, organizational structures, and business models. The chapter analyzes such an evolution by paying attention to the difficulties actors faced, assuming their point of view and thus the respondence of their decisions and actions to their rationality, that is, the structure of goals and preferences they had developed over decades of development of the industry. Further, the chapter analyzes what were the

"triggers" of change that allowed industry actors to evolve their beliefs and actions in a direction that led to the current digital business models.

At a disadvantage with newness: incumbents' reactions to new technology

In a classic article, Hill and Rothaermel (2003) posited that incumbent firms are at a disadvantage in adopting new, exogenous technologies for three reasons: *strategic* (i.e., commitments to existing vs. new customer and supplier networks), *economic* (i.e., incentives), and *organizational* (i.e., capabilities, routines, and other structural sources of inertia; absorptive capacity and learning; power and politics; macro-cultural homogeneity[2] and institutional pressures). Drawing on this line of reasoning, scholars have extensively studied both failed and successful adoptions of new technologies in such sectors as the pharmaceutical, telecommunications, and photography devices industries (e.g., Huff & Huff, 2000; Tripsas & Gavetti, 2000; Kaplan, 2008).

Frames, particularly technological frames (Kaplan & Tripsas, 2008), have been proposed as a major source of inertia, because they tend to become "fixated" once developed, conditioning the interpretation of new environmental cues in a way that is consistent with the "internal schemata" of organizations. But where do frames come from in the first place? Gavetti and Tripsas's, based on Polaroid's historical case-study (2000), illustrate this point very well: the initial imprinting of a founder's view (in Polaroid's case, his belief in the "razor-blade" business model when reacting to the appearance of consumer digital photography devices) may be transmitted over time and progressively inscribed into the organization's systems, which could impede an organization to react to exogenous changes that are inconsistent with it. In particular, the study shows how the failure of Polaroid in entering the new market of consumer digital photography devices depended more on this widely held and difficult-to-abandon belief, than on the absence of actual technological capabilities within the company, which were instead available thanks to early investments made by the company in medical digital imaging.

Appetite for self-destruction or rational choice? The bumpy ride of the early and middle eras of digital music

So, what happened in the cultural industries? Products of the cultural industries are information goods (Shapiro & Varian, 1999), and the physical supports are simple duplications/reproductions of the original "master copy," which subsumes the real costs for producing a given title (Peitz & Waelbroeck, 2006). Actually, as it will be shown below, it was precisely the embeddedness of the basic cultural industries' business model in physical supports (Dowd, 2006)—revolving around single exemplars of physical

supports (e.g., CDs, DVDs, books) allowing discrete payment for each unit sold—to be so reassuring and ingrained in industries' "recipes" that it seemed impossible to abandon, thus delaying the adoption of digital technologies to their own despair (Currah, 2006; Knopper, 2009). Several contributions have shed light on the explanations why the cultural industries have been so inept to transition to the digital technology. The problem was that, when it eventually happened, it was led by other actors that had gained considerable power in the cultural industries value constellations. In the following section, these explanations will be analyzed based on the nature of the explanation advanced, according to the tripartite classification introduced in the previous section.

Strategic explanations

Regarding specifically the music industry, Moreau (2013) applied the conceptual model of *disruptive technologies* to analyze reactions of the major music labels to the appearance of digital music files. Disruptive technologies, especially in the first stages of their life, are often cheap (even free), grant lower margins rather than greater profits, underperform compared to incumbent technologies due to the necessity to fix flaws, are popular in niche markets that might not influence the larger ones, and are therefore not trusted (at least initially) by the more mainstream costumers (Moreau, 2013; Urbinati et al., 2019).

This was particularly the case when the MP3 technology was made available at first[3] as the quality of the audio was quite a bit lower if compared with the current recorded music industry technology—that is, the CDs. However, in a relatively short time, the digital music-based technology moved up on the "disruptive technology" curve, contributing to the general improvement of the digital music experience also thanks to progresses in broadband, portable devices (e.g., iPods), and compressing technologies. By 2003, it seemed that what was deemed (and at the time still was) a niche market could not be ignored anymore by the incumbents, which agreed to Apple's Steve Jobs's proposal to offer their catalogues for legally paid download on the "safe" iTunes platform. For example, paralleling the case of music, in the movie industry Currah (2006, p. 461) pointed out how physical

> retailers [...] are able to restrict the speed and extent to which the studios can embrace digital commodities and Internet distribution, which would lead to some degree of 'disintermediation' between studios, retailers and consumers: "The majors have to operate in the context of institutional restraints and existing matrices of deals. Changing the window for Internet distribution could provoke a backlash by big retailers, who may reduce the exposure of [a particular studio's] content in the store."
>
> [quote by interviewee:] (Senior Vice President, studio)

In the music industry, this element of strategic commitments made to other actors in the value chain related to the primary suppliers of musical content (i.e., artists and their representatives), intermediaries (e.g., publishers, independent producers, other actors of creative networks), and distributors (in particular, physical distributors). To further stress this point, a quotation by Al Smith, a Sony Music VP who became legendary to technology entrepreneurs as a "stonewaller" to digital technology, becomes illustrative. In an interview to Knopper (2009, p. 142), he admitted that

> it was not what the perception is - it was not ignorance. It was not being caught ... by something that was coming. It wasn't any sort of arrogance of maintaining the old way and preventing new things from happening [...] It's that the whole nature of the copyright business created issues that are impossible to overcome.

Converting all contracts with the artists and setting up new management systems apt to the digital "way of doing" were for sure factors that discouraged industry executives to champion the new technology, as it seemed to imply an overwhelming magnitude of change.

These accounts may be placed under the "strategic" rubric using Hill and Rotharmael's (2003) framework, as stickiness to existing consumers and suppliers blinded incumbents—the major music labels and movie studios—from seeing the opportunities or even necessity to turn to other segments by transitioning to digital.

Economic explanations

Scholars and analysts have also lent support to the explanation that relates to the (lack of) *incentives* to evolve toward digital technologies on the part of the incumbent music players. It can be declined in two main questions, that is, whether and how the incumbents (major labels) would have benefited (or lost) from the adoption vs. non-adoption of digital technology; and who specifically would have been interested/incentivized to embrace a change that—as was shown above—was quite huge and disrupting within the bureaucratic structures of the same organizations.

As to the first point, Elberse (2010) makes a very good point in proving that the de-bundling (i.e., switching from the "bundled" business model of CD from the "discrete-choice" model of digital music downloading, which rendered possible to select single songs from albums) was *rationally* not a good choice for the music industry executives. The possibility of cherry-picking only the "best songs" of an album by digital music consumers, coupled with the lower marginality on (digital) singles compared to that on (both physical and digital) albums, would normally have led to a decrease in sales (econometrically demonstrated by Elberse's model), which major music executives of course did not want. Of course, the flaw in this line of

reasoning is represented by the "cognitive trap" the managers incurred in, highlighted by industry observers such as Leonhard (2008) and Knopper (2009). The managers, in effect, framed the transition to digital as a loss compared with the previous (CD-based) situation, failing to acknowledge that things would have gotten worse because of exacerbated piracy, the migration to other forms of accessing music (e.g., web-radios) in the absence of a satisfying legal offer, and the (bad) agreement they would have been forced to strike with the new distributors when a legal offer was eventually devised through Apple's iTunes in 2003.

On the second point, an interesting question to reflect on is: who did *not* benefit (or believed would have not benefited) from the transition to the digital shift? Referring to the movie studio executives, but again paralleling what happened in music, Currah (2006, p. 459) stated that "they operate in large publicly traded companies, where they are expected to minimize risk and secure incremental revenue growth from mature markets, such as theatrical exhibition..., DVD sales and pay-television." As a studio president interviewed declared,

> As executives working for large public companies, we have a fiduciary responsibility to our shareholders to ... protect our assets from piracy..., maximize the value of our products in existing markets and minimize our exposure to risk, like investing in an unproven market such as the Internet, which could easily cannibalize our growth if mismanaged.

This reflects the point made above on the lack of incentives by incumbents to develop new, unproven markets to the detriment of current, profitable ones; but also introduces an element related to the interests of major executives within their companies. In fact, as upper echelons are normally older and highly tenured, and rewarded on the achievement of short-term results, they tend to exhibit a short-term attitude that favors conservative, rather than innovative, behaviors/decisions.[4]

Organizational explanations

As far as *capabilities* are concerned, it is first of all useful to distinguish between two concepts of capabilities. The first is the most intuitive one, covering the state of the technological and related (e.g., digital marketing skills and capabilities) necessary to navigate the digital revolution on the part of the major labels faced with this radically new (and disruptive) technology. The second way to intend capabilities is the one used in the organization and management literature (e.g., Dosi et al., 2000), which comprises an organization's knowledge, abilities, and competences, the capacity to absorb new knowledge and act accordingly, and the capabilities to change capabilities themselves (i.e., dynamic capabilities; Cohen & Levinthal, 1992; Zollo & Winter, 2000; Ambrosini et al., 2009).

In the case of the music industry facing digital technology, if we intend capabilities in the first sense, commentators agree that, while the typical major music executive was not a technology "champion," (not) possessing digital-related technological capabilities was not the decisive issue determining the industry conservative reaction to it. Contrary to conventional wisdom and self-justifying claims made later (like, for example, Universal's 1995-on chairman and CEO Doug Morris, who in 2007 declared that "there's no one in the record industry that's a technologist" [quoted in Knopper, 2009, p. 113]), music organizations actually *had* technology experts on their staff, such as, for example, Erin Yasgar, who headed Universal's first new media department beginning in 1998, leading a team of roughly 40 people working on possible technological developments (Knopper, 2009).

Moreover, the sheer competence problem could have been solved by acquiring firms and/or people from other firms, who already possessed the market, technical, and systems integration capabilities for making the digital music "machine" run within record labels. So, as in the Polaroid case, the sheer "technical capabilities" issue cannot explain the courses of action in that delicate moment of development of the digital music industry. Major labels' high-rank executives, such as the above-mentioned Doug Morris and Sony Music's Al Smith, deliberately chose not to pursue the digital business model, as well as inhibited the internal resources and both intra- and inter-industry collaborative efforts to develop innovative solutions (Goodman, 2010).

This account is further corroborated by observing that, when it was realized that not having a (legal) digital music offer was worse than not having it (i.e., circa 2003–2005), the major labels actually *did* modify their structures and people such that they could deploy digital capabilities. In Italy, industry sources interviewed by the author in 2009 confirmed that the "New Media VPs" appointed since 2004 were mostly managers acquired from outside the industry, especially from mobile telecommunications and the independent/start-up music sector (from those organizations that were "born digital" or that had an orientation toward new channels from before). For example, the New Media VP of Warner Music Group Italy in 2008 was taken from the local subsidiary of H3G (one of the largest mobile companies); her reports were two young employees, one coming from the mobile operator Vodafone, the other having previously worked for Vitaminic, a pioneering start-up that had created a subscription service for independent (i.e., unsigned) music bands in Italy and Europe as early as in 1998. Around the same years (2005–2006), Sony BMG Italy recruited a telecommunication engineer from a technology consultancy to appoint him as the Head of New Media; his chairman and CEO, prior to working for another major label, held an executive position at Vitaminic (Mizzau, 2011).

Regarding specifically the cognitions held by executives in the major labels (i.e., at the organizational level and, by means of socialization via industry

associations and institutionalization, at the industry level), a number of interesting evidences have emerged. Cognitions are shared representations of specific aspects of the (music) business, such as the business models (i.e., how to derive value from markets, who are the customers, what do they want, etc.), which are the relevant actors for the business and how should their relationships be governed (with governments, competitors, customers, suppliers, etc.), and other representations useful to understand the state of the business (e.g., stability and change, and factors thereof), to devise strategies, and to take actions aimed to maintain and develop the business itself.[5]

Box 8.1: Breaking the rules/1: EMI abandoning DRM-encrypted music files (Source: elaboration on Mizzau, 2011)

Gerd Leonhard was a quite visionary commentator in the early and middle ages of digital music. About DRM in particular, he proposed a cognitive explanation for the fixation of industry actors on formats that were limiting the possibility of "further piracy." In his 2008 collection of blog posts, he stated:

> Is DRM a question of belief systems? After countless conversations and debates over the past eight years, I have come to think that the DRM issue is largely a question of which reality one believes to be true – and we must address the solution as such, too. No research, no statistics, no hard facts, and no futurists will tell us conclusively whether the record companies should or should not use DRM when selling digital music.
>
> (Leohnard, 2008, p. 125)

He went on by highlighting the intertwining of representation and "reality," where by this latter term I mean—following Weick's argument on sensemaking—the practical consequences of "believing" and, so, enacting a given representation:

> Clearly the DRM question cannot be truly considered if kept separately from the drastic changes that are impacting all adjacent sectors of the record industry, such as music production, contracts, pricing, licensing, promotion, and marketing [...]. [M]y own conclusion is that eight years of badly implemented DRM have forced the major record labels into a detrimental fixed-pricing model for digital music, creating even more walled gardens and virtual monopolies such as iTunes.

But how were music labels able, then, to change these beliefs, and finally opt for an open, DRM-free file format?

Table 8.1 illustrates this cognitive change between 2000 and 2010.

What is striking is how the interpretation of the importance and necessity of DRM left space to the belief that offering DRM-free files was key to boosting customer satisfaction and thus sales in the digital world. How did this happen? The trigger was "pulled" by one of the major music labels' (EMI Music) CEO. On April 2, 2007, Eric Nicoli announced that the label would release most of its catalogue online with no copyright protection whatsoever. In his presentation, Nicoli talked about "interoperability" as "important to consumers" and key to "unlocking" and "energizing" the digital business (Southall, 2009). Given the frame-braking nature of the decision, as Knopper points out, "[t]he rest of the record business thought Eric Nicoli was nuts. And maybe he was. Or maybe he just had nothing to lose" (Knopper, 2009, p. 229). In terms of organizational inertia theories, the extreme financial crisis of the company and the resulting pressures were so compelling to lead EMI's CEO to take a decision which overcame the industry's widely held belief that DRM was a pillar of digital strategy, thus "liberating" the company from the normative pressure of the industry. When exposed to the consequences—which were positive, and not negative as held by the industry belief—the other actors, albeit shocked about Nicoli's move, were able to accommodate the new format relatively quickly, abandoning DRM in their turn within a few months.

For example, one crucial representation in the "middle age" of the digital music history was related to the copyright issue, specifically to whether and how Digital Rights Management (DRM) should be integrated into the legal digital music offer (see Box 8.1). A prominent observer of the digital revolution in the music industry framed this precisely as a cognitive issue: the shared belief regarding the use of Digital Rights Management for protecting the legal music files was that, in a digitalized (legal) business framework where control has been already "given away" to consumers, such tools were necessary to maintain a minimum level of "control" on consumers' behaviors regarding digital music (Leonhard, 2008). According to him, the assumptions on which the label executives based their decision of maintaining DRM (i.e., not offering their music in free, e.g., MP3 file formats) looked like the following one: "If we offer unprotected music, everybody would just share their music with everyone else, and nobody would ever make any payments, and that would be the end of it!" (Leonhard, 2008, p. 128). This far too pessimistic vision led to an even increased rigidity (i.e., decreased usability of legal digital music) in the face of a phenomenon where most cues from the market were signaling to act in the opposite direction (i.e., flexibility), as it was necessary to make a "step towards the customers" in order to regain credibility as suppliers (Gordon, 2005).

Box 8.1 offers a reconstruction of how the industry framed the issue, how much this framing was far from the representation of the problem by other actors, and of how the industry resolved this impasse (see also Table 8.1).

Another crucial event in the early history of digital music—a blocked attempt to convert the peer-to-peer music platform Napster into a licensed, legal music service by one of the majors—is recounted in Box 8.2.

Table 8.1 Evolution of major labels' DRM-related concepts, 2000–2010

Theme / Stage of digital music evolution	*2000–2005*	*2006–2007*	*2008–2010*
Role/function of DRM and relationship with broader strategy	DRM critical for the development of legitimate digital services. DRM as a response to the increase of digital piracy even after the launch of iTunes in 2003.	Repeatedly asserted necessity of DRM for any intellectual product in the digital era. • Accountability function for rights owners • Prevention measure for digital piracy No signal of a possible change in the sense of DRM removal.	2008: Semantically contradictory vision: concepts about DRM-free models offered 2007-on are presented along with the ones stating that DRM is a "key element of the digital business." 2009–2010: as DRM are almost completely abandoned, there is no discussion of their role and function.
Consequences of DRM	No treatment of the issue.	Untested belief that DRM-free formats would increase digital piracy. **Belief that digital piracy negatively affects sales.**	The DRM-free model led to: • Increased freedom of usage and enhanced consumer experience • Improving contractual power of labels on retailers (through, e.g., variable pricing) and increased competition in the digital retailing sector (beneficial for the labels) • **Increased digital sales** *No effect of DRM-free formats on digital piracy.*

Source: Mizzau (2011)

Box 8.2: Breaking the rules/2: the strange story of Napster's (failed) acquisition by Bertelsmann AG (Source: elaboration on Mizzau, 2011)

Napster was the name of probably the most important and iconic digital music services of all times. Founded in 1999 by a college dropout (Shawn Fanning) and backed by his uncle and subsequently other investors (including Hank Barry, a lawyer who became the company's CEO), it gained incredible traction, going from some thousands to over 60 million subscribers in less than two years. As such, the RIAA (Recording Industry Association of America) blamed Napster to be responsible for diffusing digital piracy, and sued the company in two famous court rulings.

From the point of view of this chapter, what is interesting is what happened between the two rulings, when Thomas Middelhoff, CEO of Bertelsmann AG—the German publishing company that owned one of the then-five major record labels, BMG (Bertelsmann Music Group)—showed a strong interest toward acquiring Napster with the idea of transforming it into a legal service. As industry experts reported, Middelhoff was

> impressed with Shawn Fanning's service. He immediately had visions of a peer-to-peer network in which customers would pay a $4.95 a month and get unlimited content over the internet ... Middelhoff excitedly returned to Germany and authorized his head of e-commerce ... to look partnering into the company.

> (Knopper, 2009, pp. 145–146)

According to market research conducted by Bertelsmann, if the 50% of Napster users (by that time, there were a huge 60 million) would have paid just 10$ a month for a legally refashioned Napster service, the company's ARPU (average revenue per user) would have been $30—about three times the industry ARPU at that time. Middelhoff publicized this study in a *Financial Times* interview, trying to convince the other major labels, and ultimately the whole music industry, to jump in what he sincerely believed the deal of the millennium (Goodman, 2010). Shortly after, Bertelsmann offered Napster a loan of $60 million, in exchange for a Bertelsmann's majority stake into the company. The deal was announced on October 31, 2000, when Bertelsmann-owned BMG was still involved, as member of the RIAA, in the appeal lawsuit copyright-infringement against Napster. In February 2001, a US Court of Appeals concurred with the previous decision, ruling that Napster was illegal and thus had to take down all the copyrighted content in the following days. While Napster's people tried to maintain the relationships with RIAA in the hope of striking a deal, RIAA was definitely unwilling to do it, based

on the fact that a victory in the court would have "eliminated" the digital piracy issue. Napster CEO Hank Barry lobbied Congress for a copyright law change to allow music file sharing, finding someone sympathetic with the cause, but ultimately coming up with nothing.

Internally, it is not clear if Middelhoff's behavior complied with the company's chains of command and policies; while he later claimed to have received support and consensus by BMG executives to go on with the Napster loan, BMG's head Strauss Zelnick recalls it the opposite way: Middelhoff went ahead alone, despite Zelnick's disapproval of a deal with an illegal business (Knopper, 2009). As a result, both BMG's CEO Strauss Zelnick and chairman Michael Dornemann resigned. Moreover, despite the controversy about the opportunity to go ahead with the acquisition of Napster, BMG's newly appointed CEO Konrad Hilbers asked for more money to continue to run Napster as a legal service (it is not clear if it would have become a copy-protected-file site, or a filtered site that assured that only non-copyrighted material could be exchanged—much like the YouTube takedown policy nowadays). As a consequence, Bertelsmann had become exposed by $95 million with a service that has been formally declared illegal by a US court. Eventually, Bertelsmann owners, the Mohn family, lost confidence in Middelhoff and fired him in July 2001 (Knopper, 2009). Some months later, in May 2002, Napster declared bankruptcy and officially went out of business. The famous software company Roxio bought the name and the famous logo and associated them for its music service, but the new Napster had nothing to do with the original (Gordon, 2005).

Elsewhere (Mizzau, 2011), I have defined the BMG-Napster "broken love story" as a clear attempt to overcome the industry ingrained assumptions and routinized pattern of action prescribing that every innovation, even those which could be potentially seized for restructuring the current business model at the advantage of the industry, should be blocked. Seen from this stance, the court ruling was clearly a victory for industry participants: having the main symbol of digital piracy shut down represented a clear "message to the folks" that copyright had to be taken seriously. However, from a strategic and organizational point of view, not acquiring Napster and not exploiting its visionary business model legally further testifies to the immaturity of the industry in leading the change spurred by digital. As Knopper argued,

> To an extent, the opposition [to Napster] from executives at the major labels was understandable. Napster was enabling and encouraging theft ... But label chiefs were so bogged down in the

file-sharing battleground that they refused to act on the digital future of the business. Many figured they would simply win in the courts and the CD-selling business would go back to normal. As a result, they wasted almost three critical years before agreeing to a functional, legal song-download service. ... In hindsight, after years of plummeting CD sales and industry-wide layoffs and artist-roster cuts, it's clear that making Napster official 2001 would have been a huge positive for the record business.

(Knopper, 2009, pp. 141–143)

Middelhoff's intuition, while probably beneficial for the industry, was rejected as inconsistent with the belief that Napster represented digital piracy. In other terms, converting Napster into a legal digital music service was thus not accepted by incumbent actors, which re-established the order by putting it out of service and playing down the efforts of the deviating actor within the industry itself[6].

Digital and music: an organizational synthesis

From what above, all in all, it seems that the major record labels have acted according to a "familiar" response pattern they already resorted to in the past, whenever faced with an (exogenous) change affecting the sector. Tschmuck (2008, p. 230), drawing on a cultural-institutionalist perspective, argues that, within industries, actors tend to behave according to a "cultural paradigm" which comprises "all values, norms, and action heuristics that form the basis for all agents' activities"; while not every participant necessarily shares them all constantly through time, "there are action routines and heuristics, which are not questioned, that principally determine the system of production, distribution, and reception." It is possible to argue that, with digital, industry actors made recourse to a pattern that—as they did during past periods of industry turmoil (both cultural, e.g., the Rock 'n' Roll revolution in 1950s, and technological, e.g., radio airplay of music in the 1920s[7])—consists of the stages shown in Figure 8.1.

Dowd (2006), from a neo-institutionalist perspective, offers an account consistent with this perspective examining the "embedded impact of technology" in the recorded music sector. He highlights that new technologies are never "just technologies," that is, they are not judged neutrally by actors that might be affected by their emergence. Thus, the sheer technical superiority of a given technology (e.g., the advantages digital music could bring to consumers and producers alike) does not automatically translate in adoption in an institutionalized sector, as every

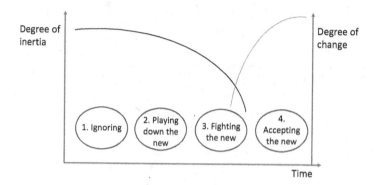

Figure 8.1 Stages of the pattern of reaction to the new by industry actors, with related levels of inertia and change.
Source: Author's own elaboration based on Tschmuck (2008)

technology is interpreted according to the role, position, and status of a given actor. He points out that the industry used the same pattern with two innovations before digital music. The first was broadcasting of re-corded music:

> Amid the economic turmoil of the 1920s and 1930s, recording person-nel drew conclusions about uses of their product. They concluded that record firms suffer when stations broadcast prerecorded music. This conclusion rested on what would later prove to be a flawed assumption: Consumers would not buy records when they could hear them for free on radio.
>
> (Dowd, 2006, p. 211)

The second was the rise of the CD as the dominant format since the early 1980s: while in 1979 sales began to stagnate, for a variety of reasons, the major labels blamed the introduction of the cassette tape: "they claimed that consumers were 'illegally' taping recordings rather than purchas-ing them" (p. 217). In both cases, the assumptions held by record mu-sic officials were proven wrong (i.e., radio airplay did not displace sales of recorded music, nor the cassette caused the end of the vinyl and CD markets). Instead, as the DRM case shows, the innovations were finally adopted, to the benefit of the whole system (see Box 8.1). These kinds of explanations concur with those examined above: for example, about the line of reasoning that led them to "fear" the digital downloading model because of de-bundling (Elberse, 2010), ultimately highlighting the com-plexity of decision-making in new situations. In Table 8.2, a synthesis of the main cognitions held, and actions taken by key players in each of the above illustrated stages, is presented.

Table 8.2 Example of cognitions and actions by industry actors for each stage of the pattern of reaction to the new

Stage of the reaction pattern	1 Ignoring the new	2 Playing down the relevance of the new for one's business	3 Fighting the new and its protagonists	4 Accepting the new
Examples of cognitions held and actions taken (time period)	• Failing to recognize the demand for (legitimate) digital music (1999–2003). • Failing to develop technical solutions on digital formats and platforms (1999–2003; 2004–2007).	• Belief in the "return of the CD" after some victories in courts against digital piracy (1999–2004). • Deliberate refusal to license content to legal digital services (2000–2005).	• Blocking BMG's acquisition of Napster (2001). • Legal actions (cease and desist orders) issued to platforms that included copyrighted music content (including YouTube); 2001–2008).	• Licensing deal with iTunes (2003) and other digital music stores (2004–). • Deal with telcos for delivering music content via mobile phones (2007–2009). • Deal with YouTube (2007) • Acquisition of stakes of Spotify by major music labels (2009-on).

Source: Author's own elaboration based on Mizzau (2011) and Tschmuck (2008).

Conclusions

Lessons learned: learning and unlearning

Mangematin et al. (2014) suggest that one of the main effects of digital technology has been a "disassembly" in these industries (i.e., "the shaking of existing business models of transaction and distribution" [p. 2]), followed by the "reassembly" of, for example, "new tools and architectures to interact with audiences and communities in [...] creative industries" (p. 2). From the analysis provided in this chapter, it can be concluded that the music industry has been a prime example of the complex impact of

digital technology on the creative industries. Complexity in this case has been due to factors such as the production and diffusion of the technology from actors external to the incumbents ruling the game, the decentralized nature of the evolution of the technology (influenced by a variety of actors in different positions), and the peculiar way of interpreting changes and (counter)acting them based on long-standing routines, heuristics, and patterns of collective actions, which hampered the industry-shaping capabilities of incumbents at the advantage of newcomers. One of the objectives of the chapter was precisely to explain the "rationality in the irrationality" shown by big actors in the industry—that is, the major music labels—when taking actions such as the unwillingness to collaborate with digital entrepreneurs for offering digital music in the early days; being forced to enter in an inconvenient deal with Apple to offer digital music; and a subsequent fixation with inflexible digital models that replicated the rigidities of the analogic world (i.e., offering DRM-locked music files instead of opting for more flexible formats).

From what above, one first contribution of this chapter regards pointing out the necessity of unlearn old, outdated recipes, and learn new ways to deal with changes introduced in the environment. Analyzing retrospectively the case of digital music, the metaphors of "unfreezing" and "unlearning" a previous cognitive or action path for enabling effective change (Argyris & Schön, 1978; Starbuck & Hedberg, 2001) are quite apt to describe what prominent actors in an institutionalized field needed to do before reconstructing a viable future for the industry. Along the journey, some of the actors lost their way and were profoundly restructured, or disappeared entirely (e.g., EMI Music). However, the insights from the digital music history suggest that overcoming inertia can be triggered by deviating from industry norms, despite the strong pressures to stick with the legitimate paths (what neo-institutional theory calls normative and cognitive sources of isomorphism). Actors could be forced to let go of ingrained ways-of-doing and to embark on a new path, first, prompted by an extreme performance decline (e.g., EMI abandoning DRMs in 2007); or, in a second instance, because the situation at hand is analyzed through "new lens," for example when new people, untied from the cognitive and normative pressures developed within the industry, are appointed to analyze the factors of performance declines and areas of improvement (e.g., the Maltby Capital investment fund officers when it took over EMI). The capacity to change beliefs and recipes within a "cognitive community" (Porac et al., 1989, 2011) stimulated by those triggers is testified by an evolution in the actions taken in the middle era of digital music (2006-on). Specifically, this comprised the change of attitude toward new technological players after the Napster experience (i.e., entering in a partnership with YouTube in 2007); opening up toward Internet providers and mobile companies along with the diffusion of broadband since years 2008–2009; and even acquiring (progressively bigger) stakes of the breaking-through streaming model

par excellence—Spotify. Thus, the change represented by the diffusion of digital technology in distribution and consumption of recorded music led to a change in actors' underlying beliefs and routinized cognitive models, patterns of actions, and macro-cultures; this, however, as in any paradigmatic shift, required a turnaround in the composition (i.e., people's backgrounds, organizational structures, contractual structures) of the industry itself (Tschmuck, 2008), which is now paralleled, albeit in specific ways, in the other major cultural industries.

A related observation regards precisely what other cultural industries learned from the mistakes and troubles of the music industry. For example, the digital video content industry (comprising the movie and TV series production actors, among others), while reacting in a similarly reticent way at the outset of digital transformation and diffusion of P2P sharing websites (e.g., Currah, 2006), was far quicker than music in devising deals with platforms and media companies (e.g., satellite TV operators such as Sky, or mobile telephone companies which now offer content "packages" along with their services) (see Salvador et al., 2019). However, in the publishing industry, characterized by an institutional structure which also varies widely in different national contexts, there are signals that massive issues with "disassembling" institutionalized and well-enshrined business models and ways-of-doing still remain, as demonstrated by the difficulties for many medium-sized publishers, in key markets (e.g., in Europe), to reconvert from books to e-books or audiobooks (e.g., Øiestad & Bugge, 2014). Even more compelling seems the hurdle faced by the periodic publishing and newspapers industries (e.g., Rothmann & Koch, 2014), where the relative openness of content, the substitution of traditional customers with "digital natives," and a general expectation of free content are pushing toward the non-sustainability of many brands and a concentration of both demand attention and supply investments (which are interdependent; see Elberse, 2014) on a few iconic franchises that only can drive advertising revenues.

The challenges ahead: digital transformation, or holding on to implementation

Drawing from the lessons learned by digital music, the prediction is that, while organizations in cultural industries should now have new, more opportunity-driven cognitive models regarding digital technology, the internal organization of these companies may represent the biggest issue for devising and implementing new strategies that lead to a successful navigation of the current environment. In other terms, there is evidence that, while the cultural industries may have "digested" digital as an opportunity to be caught, in these fields hard-to-change organizational cultures and institutional inertial forces (Blanc & Huault, 2014; Øiestad & Bugge, 2014) may continue to provoke inertia at the level of organizations. It is here (and now) that the matter of digital transformation, intended as a profound

internal change in the philosophy, structure, and culture of single organizations, becomes relevant. In this sense, Human Resource managers should play a key role along with other organizational constituents (such as board members, IT managers, and strategic marketing managers), insofar as it is their responsibility to implement people management policies that could instill such future-oriented digital vision (see Yeow et al., 2018).

In terms of strategy, firms, especially those with historical legacies in this industry, which—as we have seen—brings about a whole array of beliefs, preferred responses, and ways-of-doing—should complete the shift from a product- (and format-) to a service-based logic (i.e., "freemium" business models based on a mix of ad-based, free access to content and premium-quality subscriptions). Furthermore, organizations in the cultural industries should proceed in striking alliances and partnerships with key actors well positioned in the "last mile" between service and consumer, that is, those service operators that already have a contractual relationship with consumers (e.g., mobile and fixed-line telephones, TV services, and "grocery online platforms" such as Amazon). While the strategic direction is quite clear, the challenge continues to be implementation: it is here that, consistent with the theories of organizational inertia and change discussed above (and with organization theory in general: e.g., Cyert & March, 1963), the challenge is to be won or lost.

Notes

1 Most sources (e.g. Wikström, 2013) consider the music industry to be composed of three sub-sectors: recording, publishing, and live music. In this chapter, the focus is on the *recorded* music industry, that is, the field composed by those actors and processes who make it possible to have discrete audio "master recordings" to be played repeatedly and in any form. While the live music industry is generally deemed to be bigger and characterized by specific dynamics (although recently there are interesting deals with artists which cover recording, live, and management), the recorded music industry is the most historically stable industry, and the one that has traditionally "led" the music publishing industry since the invention of recording techniques (see Tschmuck, 2008).

2 According to Hill and Rothaermel (2003, p. 261), "macrocultural homogeneity in an industry—specifically, shared beliefs about customers, technologies, and the best way to compete in an industry" can be such a source. Scholars have also talked about industry recipes (Spender, 1989), scripts, shared beliefs, and frames (terms borrowed from the cognitivist stream in management and organization theory, herein "MOC"), which are, on the one side, factors of success and industry socialization of best practices, but in the face of external changes (technological or of other type) become "core rigidities" (Leonard-Barton, 1992) that actually place incumbents in an industry in a disadvantaged position to recognize, analyze, and take appropriate action in response to changes.

3 The technology was available from 1993, but the first websites aimed at exchanging music songs in that format appeared by the end of the 1990s, with Napster popping up in 1999 (Gordon, 2005).

4 This point relates to the composition of the workforce and their distribution in terms of age in the hierarchy of the organization. In the following paragraph, I

will return on this by referring to the recruitment of new personnel instigated by the crisis in major music companies.

5 I here adapt the use of the term "cognition(s)," based on foundational literature in the Managerial and Organizational Cognition stream (see Kaplan [2011] and Walsh [1995] as state-of-the-art and review papers).

6 In this sense, embracing a legal version of Napster was premature in that it would have meant skipping the scripted behavior of the stage "Fighting the new and its protagonists" as detailed in the following paragraph.

7 This paradigm is precisely the one that was challenged by the Rock 'n' Roll revolution.

References

Ambrosini, V., Bowman, C., & Collier, N. (2009). Dynamic capabilities: An exploration of how firms renew their resource base. *British Journal of Management*, *20*(S1), 9–24.

Argyris, C., & Schön, D. A. (1978). *Organizational learning*. Reading, MA: Addison-Wesley.

Blanc, A., & Huault, I. (2014). Against the digital revolution? Institutional maintenance and artefacts within the French recorded music industry. *Technological Forecasting and Social Change*, *83*, 10–23.

Cohen, W. M., & Levinthal, D. A. (1990). Absorptive capacity: A new perspective on learning and innovation. *Administrative Science Quarterly*, *35*(1), 128–152.

Currah, A. (2006). Hollywood versus the Internet: The media and entertainment industries in a digital and networked economy. *Journal of Economic Geography*, *6*(4), 439–468.

Cyert, R. M., & March, J. G. (1963). *A behavioral theory of the firm*. Englewood Cliffs, NJ: Prentice-Hall.

Dowd, T. (2006). From 78s to MP3s: The embedded impact of technology in the market for prerecorded music. In J. Lampel, J. Shamsie, & T. K. Lant (Eds.), *The Business of Culture* (205–226). Mahwah, NJ: LEA Associates.

Elberse, A. (2010). Bye-bye bundles: The unbundling of music in digital channels. *Journal of Marketing*, *74*(3), 107–123.

Elberse, A. (2014). *Why big hits—and big risks—are the future of the entertainment business*. London: Faber & Faber.

Goodman, F. (2010). *Fortune's fool. Edgar Bronfman Jr., Warner music, and an industry in crisis*. New York: Simon & Schuster.

Gordon, S. (2005). *The future of the music business: How to succeed with the new digital technologies*. San Francisco, CA: Backbeat Books.

Hesmondhalgh, D. (2012). *The cultural industries* (3rd ed.). London: Sage.

Hill, C. W., & Rothaermel, F. T. (2003). The performance of incumbent firms in the face of radical technological innovation. *Academy of Management Review*, *28*(2), 257–274.

Huff, A. S., & Huff, J. O. (2001). *When firms change direction. A cognitively-based theory of the firm*. Oxford: Oxford University Press.

Kaplan, S. (2008). Cognition, capabilities, and incentives: Assessing firm response to the fiber-optic revolution. *Academy of Management Journal*, *51*(4), 672–695.

Kaplan, S. (2011). Research in cognition and strategy: Reflections on two decades of progress and a look to the future. *Journal of Management Studies*, *48*(3), 665–695.

Kaplan, S., & Tripsas, M. (2008). Thinking about technology: Applying a cognitive lens to technical change. *Research Policy, 37*(5), 790–805.

Knopper, S. (2009). *Appetite for self-destruction: The spectacular crash of the record industry in the digital age.* New York: Simon and Schuster.

Lampel, J., Shamsie, J., & Lant, T. K. (2006). *The business of culture.* Mahwah, NJ: LEA Associates.

Leonard-Barton, D. (1992). Core capabilities and core rigidities: A paradox in managing new product development. *Strategic Management Journal, 13*(S1), 111–125.

Leonhard, G. (2008). *Music 2.0. Essays by Gerd Leohnard.* Retrieved 3 November 2017 from http://www.mediafuturist.com/

Lessig, L. (2009). *Remix: Making art and commerce thrive in a hybrid economy.* London: Penguin.

Mangematin, V., Sapsed, J., & Schüßler, E. (2014). Disassembly and reassembly: An introduction to the special issue on digital technology and creative industries. *Technological Forecasting and Social Change, 83,* 1–9.

Mizzau, L. (2011). *Strategy as a matter of beliefs: the recorded music industry reinventing itself by rethinking itself.* (Unpublished Doctoral Dissertation). University of Bologna, Bologna.

Moreau, F. (2013). The disruptive nature of digitization: The case of the recorded music industry. *International Journal of Arts Management, 15*(2), 18–31.

Oberholzer-Gee, F., & Strumpf, K. (2016). The effect of file sharing on record sales, revisited. *Information Economics and Policy, 37,* 61–66.

Øiestad, S., & Bugge, M. M. (2014). Digitisation of publishing: Exploration based on existing business models. *Technological Forecasting and Social Change, 83,* 54–65.

Peitz, M., & Waelbroeck, P. (2006). Piracy of digital products: A critical review of the theoretical literature. *Information Economics and Policy, 18*(4), 449–476.

Picard, R. G. (2011). *The economics and financing of media companies.* New York: Fordham University Press.

Porac, J. F., Thomas, H., & Baden-Fuller, C. (1989). Competitive groups as cognitive communities: The case of Scottish knitwear manufacturers. *Journal of Management Studies, 26*(4), 397–416.

Porac, J. F., Thomas, H., & Baden-Fuller, C. (2011). Competitive groups as cognitive communities: The case of Scottish knitwear manufacturers revisited. *Journal of Management Studies, 48*(3), 646–664.

Rothmann, W., & Koch, J. (2014). Creativity in strategic lock-ins: The newspaper industry and the digital revolution. *Technological Forecasting and Social Change, 83,* 66–83.

Salvador, E., Simon, J. P., & Benghozi, P. J. (2019). Facing disruption: The cinema value chain in the digital age. *International Journal of Arts Management, 22*(1), 25–40.

Shapiro, C., & Varian, H. R. (1999). *Information Rules.* Boston, MA: Harvard Business School Press.

Southall, B. (2009). *The rise and fall of EMI records.* London: Omnibus Press.

Spender, J. C. (1989). *Industry recipes.* Oxford: Basil Blackwell.

Starbuck, W.H., & Hedberg, B. (2001). How organizations learn from success and failure. In M. Dierkes, A. Bertoine Antal, J. Child, & I. Nonaka (Eds.),

Handbook of organizational learning and knowledge (pp. 327–50). Oxford: Oxford University Press.

Tripsas, M., & Gavetti, G. (2000). Capabilities, cognition, and inertia: Evidence from digital imaging. *Strategic Management Journal, 21*(10–11), 1147–1161.

Tschmuck, P. (2008). *Creativity and innovation in the music industry.* Berlin: Springer.

Urbinati, A., Chiaroni, D., Chiesa, V., Franzò, S., & Frattini, F. (2019). How incumbents manage waves of disruptive innovations: An exploratory analysis of the global music industry. *International Journal of Innovation and Technology Management, 16*(1), 1–18.

Vernik, D. A., Purohit, D., & Desai, P. S. (2011). Music downloads and the flip side of digital rights management. *Marketing Science, 30*(6), 1011–1027.

Walsh, J. P. (1995). Managerial and Organizational Cognition: Notes from a trip down memory lane. *Organization Science, 6*(3), 280–321.

Wikström, P. (2013). *The music industry: Music in the cloud.* London: Polity.

Yeow, A., Soh, C., & Hansen, R. (2018). Aligning with new digital strategy: A dynamic capabilities approach. *The Journal of Strategic Information Systems, 27*(1), 43–58.

Zollo, M., & Winter, S. (2002). Deliberate learning and the evolution of dynamic capabilities. *Organization Science, 13*(3), 339–351.

9 Digital participation and audience enlargement in classical and popular music in Spain

*Juan D. Montoro-Pons and
Manuel Cuadrado-García*

Introduction

Music has by far been the creative sector most affected by the impact of digital technologies. But what have digital technologies brought about? Among other things, the change in the way cultural products are produced and used, the role of intermediaries, the ability of consumers to produce contents building upon pre-existing ones or the increasing availability of niche genres and products to mention three. All this has had an impact in cultural participation, especially through the diversification of distribution channels for cultural artifacts (Hambersin, 2017), prompting the emergence of new alternative business models that aim at overcoming some of the barriers audiences face. A remarkable example in this regard is *My Opera Player*, a streaming platform launched by *Teatro Real* in Madrid on November 2019, which provides live performances but also to the back catalogue of the theater, which consists of opera and classical music. Similar platforms already exist for pop music concerts such as moshcam.com or evntlive.com.

When focusing on live music audiences, the foregoing discussion raises three main questions. First, in relation to the link between online and offline music engagement and whether they can be seen as complements or substitutes. Second, one might question the extent to which barriers to live participation are overcome through online participation. Finally, and with regard to the accessibility of culture, it is relevant to know whether online music participation expands beyond boundaries (including new audiences) or reproduces access inequalities to live culture. The aim of this study is to empirically address these three questions. To do so we analyze audience's engagement with music concerts through attendance (offline or live participation) and digital means (online participation). We split music participation into classical and popular as this will allow us to identify the structural constraints audiences face in highbrow and lowbrow manifestations. To this end, available data of a sample survey conducted in Spain in 2018/19 and representative of the population aged 15 and over is used.

The structure of the chapter is as follows. First, we briefly discuss the main topics highlighted in the literature on digital cultural participation. Second, we introduce and describe the dataset, a survey on cultural participation representative of the Spanish population over 15. Third, using the available

dataset, we explore the link between digital and live participation in popular and classical music and formulate alternative explanations for the observed behavior. These are tested using alternative bivariate probit specifications. We close by discussing the main findings and their practical implications.

Digital participation and audience engagement

While digital technologies display a significant impact in the cultural and creative economy that goes well beyond participation (see Peukert, 2019), it is nonetheless true that one of the most significant changes brought about the digitization of culture is the way in which cultural goods are used by audiences (Handke et al., 2017). This, in turn, has attracted the interest of the scholars who consistently have embraced digital audience development as a means of incorporating new public to cultural consumption.

This has been analyzed considering different cultural manifestations and different methodological approaches. Not surprisingly, popular music is the most analyzed creative sector. Mortimer et al. (2012) show that digital file-sharing increases the demand for live music, an effect they find to be asymmetric, as smaller acts benefit most from sampling. Aguiar (2017) finds that free streaming affects music purchasing. Bakhshi and Throsby (2014) test whether traditional theater attendance is expanded or cannibalized through the broadcasting in digital cinemas. Their findings support digital streaming to be a complement of live attendance, hence expanding the audience. Walmsley (2016) analyses the role of an online platform in engaging audiences to contemporary dance, where public participated in the selection of two projects. They show that by deepening the relations between artists, organizations, and audiences, digital tools may help in increasing attendance, and providing potential audiences with the competences needed to decode the performances, that is, increasing individual's cultural capital, hence reducing the barriers to participation.

Considering engagement across more than one specific cultural sector, Montoro-Pons et al. (2018) analyze the impact of online copyright-infringement on consumption in the cultural industries (music, films, and books) and find that this is related to the stage of digitization of the sector, that is, the development of alternative business models exploiting digital technologies. Montoro-Pons and Cuadrado-Garcia (2019) analyze highbrow online/offline consumption in Spain and conclude that digital audiences and live audiences overlap, hence the possibility of expanding audiences through digital consumption seems to be limited. This has been a rather common finding in the literature as De la Vega et al. (2019) confirm using the same dataset to focus on online and live consumption of highbrow performing arts. Their results pinpoint a complementarity between online/live consumers. Furthermore, individuals facing supply and price constraints in live consumption are more likely to consume online, which suggests that this channel caters for unsatisfied live demand. This, in

turn, brings into question the potential democratizing impact of digital culture, an issue that is discussed in Mihelj et al. (2019), who analyze offline/online museums and galleries attendance. They aim to investigate the link between the increase in audience engagement and the growth in household Internet access, the use of museums and gallery sites, and the diversity of the audience. They conclude that rather than incorporating new audiences, digital participation reproduces the existing ones.

To summarize, the ongoing interest in the literature on digital participation and the role it plays in enlarging live audiences and stimulating diversity to cultural access is far from being settled. While there are some consistent results across studies, the evidence so far is mixed. This chapter aims to shed some light by looking at the same basic cultural manifestation (music) from a highbrow/lowbrow perspective, which allows us to characterize the degree of complexity of the codes that users need to enjoy it and hence to observe the existence (or its lack thereof) of objective barriers to engagement for a unique set of individuals. To do so, we undertake a quantitative analysis on digital and live engagement in classical and popular music through the estimation of a bivariate binary dependent variable model.

The dataset

Our research draws on data from the Survey of Cultural Habits and Practices 2018–19 (SCHP18), a survey conducted by the Spanish Ministry of Culture and Sports and directed toward a sample of people aged 15 and over, with a theoretical sample size of roughly 16,500 units. Information was collected over one calendar year from March 2018 to February 2019.

The survey aims at evaluating cultural habits and practices of the Spanish population over time and analyzing specific aspects in cultural consumption as well as the channels through which audiences obtain specific cultural artifacts. The questionnaire covers several aspects related to cultural participation, both consumption and practice in heritage, museums, art galleries, music, performing arts, films and video, television, and video games, among others. It also provides information about attitudes toward and opinions on these activities and practices, cultural equipment in Spanish households, educational attainment, and other socio-demographics. For the purpose of this chapter, we draw on general respondent information and the specific module on music concerts attendance, split into classical and popular music. Furthermore, information on online participation for both types is also analyzed. We start by describing the main traits of music consumers.

Relative share of live music audiences

Figure 9.1 plots participation to classical and popular live music performances. It shows the answers to the question of the last time the survey-taker attended to a live music performance. It does indirectly provide a measure of respondents' frequency of participation, as these choose the appropriate attendance time-frame: in the last three months, in the last year,

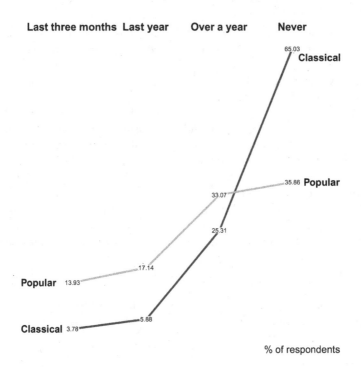

| Last three months | Last year | Over a year | Never |

65.03 Classical

35.86 **Popular**

33.07

25.31

17.14

Popular 13.93

Classical 3.78

5.88

% of respondents

Figure 9.1 Frequency of classical and popular live music participation.

over one year, never. Note that, unless otherwise indicated, survey weights are used throughout the chapter. Altogether, classical music has a restricted audience: 65% of individuals can be classified as non-participants. Furthermore, for empirical purposes, we will consider participation that takes place within the year. Therefore, roughly 9.4% of the Spanish population over 15 can be classified as audience of live classical music.

In comparison to classical music, popular music performances have a wider appeal. In this case the population can be broken down into three roughly equal-sized groups: 32% of the population actively participates in the year of reference; 35% are non-participants; finally, 33% of the population could be labeled as occasional attendees (frequency over one year). Interestingly, these results highlight the increasing relevance of live popular music. In a previous paper using the same dataset for the period of 2010–2011 (Montoro-Pons & Cuadrado-García, 2016), we analyzed the determinants of live attendance using and report a 12% attendance/25% occasional/47% non-participants breakdown. In just eight years, non-attendance has gone down by 12% (from 47% to 35%), while the participation rate has more than doubled.

Two questions emerge then when trying to understand live music attendance. First, what motivates audiences' participation? Second, what are the main barriers that individuals face that make them participate less or not at all?

Motives to live participation

As for the first query, namely, what drives attendance, Tables 9.1 and 9.2 show the distribution of motives that survey-takers mentioned when asked about motives of attendance. Note that respondents provide two different motives (first and second). Therefore, plots include the distribution for the first and second motives. From these, three observations stand out.

First, there is some common ground in highbrow and lowbrow audiences as, in terms of relevance, artists and the music itself are the two main attendance drivers for both classical and popular attenders. Notwithstanding the evidence, it is noteworthy that the distribution of motives is more concentrated in the latter case. The relevance of artists is key to understand pop concert-goer behavior: over 95% of respondents mention it as either first or second motive compared to less than 60% of classical music live attenders. On the other hand, music is equally relevant for both audiences, with roughly 65% of classical/pop concert-goers mentioning it as their first/ second motive.

Second, external influences are preferably originated in the inner circle (word of mouth by friends and relatives) for roughly 30% of classical music attendees and above 20% of pop concert-goers. Advertising has in both cases a relatively modest impact, while critical reviews show a marginal role.

Third, highbrow attendees' motives show a greater spread, which underlines a differential and more complex decision-making process. In this respect, live classical music attendee's motives are more evenly distributed and include more non-marginal drives, such as composer or conductor. This only points to the wider array of elements that could enter the highbrow cultural consumer assessment of a performance. On the contrary, the

Table 9.1 Classical music live audience: motivations

	First choice			Second choice		
	Freq	% Attend.	% Cum.	Freq	% Attend.	% Cum.
Artists	486	33.48	33.48	320	22.00	22.00
Music (score)	457	31.48	86.20	496	34.18	80.77
Family/friends opinions	182	12.51	98.71	227	15.59	96.36
Composer	144	9.94	48.78	173	11.91	40.53
Ads	86	5.94	54.72	88	6.06	46.59
Conductor	78	5.36	38.84	96	6.62	28.62
Opinions on social networks	8	0.58	99.29	14	0.93	97.29
Criticism	8	0.54	99.84	32	2.22	99.51
Awards	2	0.16	100.00	7	0.49	100.00

Table 9.2 Popular music live audience: motivations

	First choice			Second choice		
	Freq	*% Attend.*	*% Cum.*	*Freq*	*% Attend.*	*% Cum.*
Artists	3,076	66.06	66.06	1,455	31.25	31.25
Music (score)	1,025	22.01	88.07	2,202	47.29	78.54
Family/friends opinions	380	8.15	99.46	643	13.80	97.45
Ads	151	3.24	91.31	238	5.11	83.64
Opinions on social networks	12	0.26	99.71	55	1.17	98.62
Criticism	12	0.25	99.96	51	1.09	99.71
Awards	2	0.04	100.00	14	0.29	100.00

extraordinary clout that artists and music carry for popular music attendees makes other motives pale in comparison.

Barriers to live participation

On the other hand, Tables 9.3 and 9.4 show barriers to participation for both classical and popular live attendance. As with motives, respondents provide two different barriers (first and second). Looking at classical music, lack of interest stands out as the main barrier to attendance, which, in turn, can be equated to non-participation. Once this is accounted for, three barriers emerge as major obstacles to participation: time, price, and supply availability. Overall, 83% of the survey-takers choose any of these as their first or second barrier to attend more to classical music concerts. Indeed, this seems plausible as live participation is both time intensive and geographically predetermined. As for the former, attendees need not only to allocate time for cultural consumption but also the coincidence of an individual's time availability with the time slot when the show is programmed. Regarding geographical constraints, the concentration of supply in specific urban areas means that even if one has (time and financial) resources the spatial distribution of supply may make attendance non-feasible. Therefore, time and supply availability are active hurdles for most individuals. Add to that the existence of budget constraints, in this case a trait not necessarily specific of live performances, and we obtain a detailed depiction of the main restrictions individuals face.

The lowbrow nature of popular live music makes it more accessible to the general public and therefore makes lack of interest a less relevant barrier. Apart from this, the same live-specific barriers emerge (time, price, and supply restrictions) and in the same order as in the case of highbrow participation.

Table 9.3 Barriers to attendance: classical music

	First choice			Second choice		
	Freq	*% Total*	*% Cum.*	*Freq*	*% Total*	*% Cum.*
Lack of interest	6,688	43.27	43.27	6,110	39.54	39.54
Lack of time	2,963	19.17	62.45	3,342	21.62	61.16
Price	1,904	12.32	74.77	1,395	9.03	70.19
Supply restrictions	1,809	11.70	86.47	1,493	9.66	79.85
Caregiver	710	4.59	91.06	725	4.69	84.54
Prefer other means	428	2.77	93.83	433	2.80	87.34
Information	269	1.74	95.57	649	4.20	91.54
No one to go with	234	1.51	97.09	404	2.61	94.15
Accessibility	181	1.17	98.26	170	1.10	95.25
Difficult to understand	146	0.94	99.20	511	3.31	98.56
Difficult to get tickets	120	0.78	99.98	207	1.34	99.90
Only resale	3	0.02	100.00	15	0.10	100.00
Total	15,455	100.00		15,455	100.00	

Table 9.4 Barriers to attendance: popular music

	First choice			Second choice		
	Freq	*% Total*	*% Cum.*	*Freq*	*% Total*	*% Cum.*
Lack of time	4,117	26.64	26.64	4,164	26.95	26.95
Lack of interest	3,523	22.80	49.44	3,562	23.05	49.99
Price	3,255	21.06	70.50	2,247	14.54	64.53
Supply restrictions	2,318	15.00	85.50	2,249	14.56	79.09
Caregiver	886	5.73	91.23	894	5.79	84.87
Prefer other means	488	3.16	94.38	487	3.15	88.02
No one to go with	250	1.62	96.00	456	2.95	90.97
Information	192	1.24	97.24	597	3.87	94.84
Accessibility	185	1.20	98.44	195	1.26	96.10
Difficult to get tickets	165	1.07	99.51	370	2.39	98.49
Difficult to understand	71	0.46	99.97	220	1.43	99.92
Only resale	5	0.03	100.00	13	0.08	100.00
Total	15,455	100.00		15,455	100.00	

Overcoming live-attendance barriers through digital consumption

The coincidence of barriers for both highbrow and lowbrow live music engagement suggests audiences face similar attendance problems and, to enlarge them, similar strategies could be addressed. Specifically, it could be argued that digital consumption, inasmuch as it is unaffected by time and

geographical restrictions, could cater to the segments of the market mostly comprised of occasional and non-participants and, in so doing, raise participation. Additionally, and given that minimal technological requirements apply to the online consumption of classical and popular music concerts, digital participation may prove to be an inexpensive means of accessing cultural consumption (overcoming financial constraints) and an alternative way of taste formation, therefore enlarging audiences. Of course, one should also account for the possibility of digital consumption cannibalizing live participation.

The above discussion brings about some research questions regarding digital participation that this study aims to address. First, we pursue evidence regarding the composition of audiences brought about by digital participation. Specifically, we are interested in knowing whether it incorporates new cultural consumers (enlarging audiences) or it adds a new channel to current participants (deepening or increasing consumption of individuals that already participate). Second, and linked with the previous question, we examine the issue of whether online participation reproduces those barriers identified in live consumption or if, on the other hand, creates new ones. This, as suggested, is linked to the enlargement of audiences through digitization and its potential to lifting structural constraints enabling the incorporation of new consumers, not only as digital consumers, but also as live consumers through learning and taste shaping. Third, we aim at identifying under what circumstances digital consumption substitutes, that is, cannibalizes, live participation or, on the contrary, it complements it. Note that the three research specific goals we have spelled out are interwoven in that audience enlargement comes with effortless digital access and, possibly, the accumulation of competences and specific knowledge that leads to taste formation.

To understand the role of digital participation, we start by looking at Tables 9.5 and 9.6, which cross-tabulate live and digital participation for classical and popular music respectively. The latter is the binary answer to the question "Have you watched a music concert through the Internet in the last year?" Individuals answer twice (classical/popular) to this question.

From these, it is apparent that digital participation represents less than half of the audience of live music. Data show that 4.8% of the population engages in classical music online (Table 9.5), while 13.5% engage in popular music (Table 9.6). Compare these with offline participation rates of roughly 10% and 30% respectively, and one sees what could be deemed as a complementary contribution to the overall audience. However, it is true that one sees some marginal evidence of non-participants of live music accessing to music performances online: 2.3% for classical music and 5.7% for popular music. These shares could be considered net gains in terms of audience. Yet the pattern of participation shows that the probability of going digital increases as we move up in Tables 9.5 and 9.6, which means that the more frequent a live cultural consumer is, the more likely she is to use additional channels.

Table 9.5 Classical music: live and digital participation (row percentages)

Live	Digital	
	True	False
Last three months	20.1%	79.9%
Last year	13.3%	86.7%
Over a year	7.0%	93.0%
Never	2.3%	97.7%
Total	4.8%	95.2%

Table 9.6 Popular music: live and digital participation (row percentages)

Live	Digital	
	True	False
Last three months	26.3%	73.7%
Last year	20.5%	79.5%
Over a year	13.2%	86.8%
Never	5.7%	94.3%
Total	13.5%	86.5%

If we look now at the effect of digital consumption on live participation (Figure 9.2) we see that, in general, digital participation enhances both classical and popular live participation. In pop music, roughly 52% of digital audiences are also live audiences, compared to merely 27% of non-digital ones. This effect is even more intense in classical music: 31% of digital audiences are also live audiences, while only 8% of non-digital audiences are live participants. As a consequence, digital participation reduces the probability of live non-participation in all cases: only 15% of popular online music audiences and 32% of classical online audiences are only digital audiences. Furthermore, non-participation in the digital arena also increases the likelihood of non-participating live: 67% and 40% for classical and popular music respectively.

At this point, we acknowledge that the descriptive evidence is somehow mixed. We see that some individuals that do not attend live are attracted to online consumption, a finding that is consistent with an audience-enlargement effect. However, we also find that cultural consumers seem to have a propensity to participate through different channels, which pinpoints the reproduction of consumption patterns and barriers in the digital world.

Methodology

The foregoing descriptive findings are suggestive of a non-trivial relation between offline and online music concerts consumption. To identify it, a

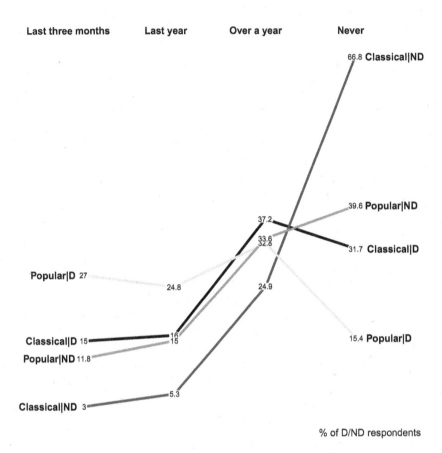

Figure 9.2 Frequency of live classical and popular music conditional on digital participation (D: digital; ND: non-digital).

bivariate probit model (Marra & Radice, 2017) using R is estimated (R Core Team, 2017). Specifically, we aim to single out: (1) the link between online and offline engagement and the extent to which distribution channels are complements or substitutes; (2) the barriers audiences face when consuming live/online music; (3) the contribution of online engagement to the democratization of culture by increasing the diversity of audiences.

Live and digital participation are simultaneously determined in a model that we separately estimate for each cultural manifestation. Let $Y_{i,j,k}$ a binary indicator for individual i whose value determines whether she participates in manifestation (classical/popular) through channel k (live/online). Then, we estimate the following specifications:

$$P(Y_{j,i}=1)=f(sociodemo_i, phisicalk_i, geo_i, digital_i) \qquad (1)$$

where two binary dependent variables (digital/live participation) are explained in terms of a set of covariates. These are classified as follows:

1 Socio-demographics (*sociodemo$_i$*). We include age, gender, labor-market, and family situation of the survey-taker. Expression (1) also includes the square of age to account for nonlinearities.
2 Educational attainment is measured as a set of dummy variables: secondary, vocational, and university. The reference value is an individual that has completed at least primary education (or possibly less).
3 Labor market position is a set of dummies that control for being employed, unemployed, student, househusband, retired, and other, with the reference value being disabled.
4 We include marital status (being married) and having children as two dummies. We also include the number of members of the household as a trait to describe family situation.
5 Household equipment (*phisicalk$_i$*) is included to control for the availability and variety of physical capital which, we assume, facilitates cultural consumption and participation. Furthermore, and given the survey does not include information about income, this will allow us to control for it. Here we use information about reading, music, and other audiovisual equipment as well as computer and other Internet-related hardware and online and TV subscriptions which a household has. Overall there are 39 variables describing a household's equipment that we reduce, using principal components analysis, to nine scores that account for over 50% of the total variance.
6 Geographical covariates (*geo$_i$*) are included in the model to control for supply and demand spatial structural traits, such as the geographical distribution of cultural supply and regional income differences to name two. To this end a dummy for each region in Spain is included. Furthermore, a variable controlling for the city of residence of the survey-taker (province capital; more than 50,000 inhabitants; less than 50,000 inhabitants) has also been included.
7 A measure of the digital expertise of the survey-taker (*internet$_i$*) has been included to account for the skills and competences needed to participate online. In this respect, two variables are included. First, we use a binary variable to account for whether the survey-taker uses the Internet on a regular basis at work. Second, we also control for the weekly number of hours the respondent uses the Internet at work.

Additionally, we control for the term when the survey-taker was interviewed. This is relevant as the supply of live performances exhibits a strong seasonal pattern. This is specially the case of popular music, in which big events (music festivals) are concentrated in the summer months (see Montoro-Pons & Cuadrado-García, 2016).

Table 9.7 provides a summary of the main explanatory variables used. Note that it provides the overall mean for the whole sample (or proportion

Table 9.7 Description of the sample

	Sample	Classical		Popular	
		Live	Digital	Live	Digital
Age	49.300	51.290	47.060	39.440	37.390
Female	0.515	0.533	0.435	0.489	0.435
Children	0.386	0.381	0.404	0.364	0.375
Married	0.573	0.619	0.568	0.485	0.454
number of household members	2.920	2.820	2.990	3.110	3.220
Primary or less	0.189	0.090	0.066	0.060	0.051
Secondary	0.287	0.176	0.192	0.244	0.287
Vocational	0.097	0.088	0.097	0.126	0.118
University	0.427	0.646	0.646	0.570	0.543
Disabled	0.009	0.005	0.007	0.004	0.004
Employed	0.493	0.515	0.516	0.614	0.558
Unemployed	0.105	0.082	0.105	0.108	0.141
Retired	0.224	0.256	0.189	0.068	0.049
Student	0.093	0.090	0.137	0.169	0.214
Househusband	0.064	0.042	0.034	0.026	0.023
Other	0.012	0.011	0.012	0.011	0.011
Province capital	0.417	0.509	0.476	0.436	0.447
>50,000 inhabitants	0.204	0.180	0.241	0.199	0.230
<50,000 inhabitants	0.379	0.312	0.283	0.365	0.323
Internet at work	0.430	0.600	0.650	0.660	0.690
Time Internet at work (hours/week)	5.970	8.850	9.710	9.560	10.100

for categorical variables) as well as the summaries across the categories of the dependent variables.

Estimation results

Estimation results are provided in Tables 9.8 and 9.9. These include coefficients and standard errors, the correlation between the residuals of both equations (theta) and a test on its significance, and two information criteria for model selection (AIC and BIC). Each table shows estimation results for three alternative digital/live consumption simultaneous equations models. Specifically, for each manifestation (classical or popular) the specifications included in the analysis are:

1 A seemingly unrelated regression (SUR) model 1. In it both dependent variables depend on the same set of regressors, with errors assumed to be correlated.
2 Two recursive models. In these, one of the dependent variables enters as explanatory variable; equations are, again, estimated jointly. In this case two specifications compete in the explanation of observed data: one in which digital participation explains live attendance (2); another where live participation explains digital participation (3).

We draw on information criteria to choose among the alternative specifications. In this regard, results using both AIC and BIC agree: for classical music participation a SUR model (i.e., model 1) is preferred, while for popular music the recursive one, with digital participation entering the live equation is favored (model 2). Unless otherwise indicated, we report and discuss the results of these.

Classical music

For live classical consumption, being female without children increases the likelihood of participation. Both are expected results: the gender effect in highbrow participation has been consistently reported, while the time-intensive nature of live participation implies that having children acts as a constraint. It has also been found that the number of members of the household has a negative impact on consumption, while being married has a non-significant statistical effect. Age is found to have an inverted U-shape effect (increasing impact and decreasing after) and its maximum effect is estimated at 76 years. These results contrast with those found for digital classical consumption: males are more likely to participate (effect is estimated positive) and having children does not significantly influence participation. As for age, the nonlinear effect persists but the maximum effect is estimated at 64 years. Overall, these indicate that different structural restrictions operate restrictions in the online/offline domain.

Education seems to matter in both live and digital consumption: increasing educational attainment is linked to a higher likelihood of participation. This effect could be linked to the impact of the stock of cultural capital an individual has, which can be indirectly measured through education (see Suarez-Fernández et al., 2019 for a discussion on this topic), and/or income, a measurement that is unavailable in the SCHP18. In this regard, we should mention that income is also captured through physical equipment (included in the model as the scores of the principal components analysis but not shown).

Labor market results provide clear outcomes. For live consumption no situation except student (marginally) and retired are significant. Both are positive, which is consistent with time availability as the likely explanation. On the other hand, no estimate is statistically significant in the case of digital consumption. Two additional covariates are found to increase the probability of live participation: using internet at work (probably an indirect measure of a work status) and living in a province capital, which decreases the likelihood of supply variety being an active restriction. As for digital participation, using Internet at work, living in a province capital, or a large city is found to have a positive impact on participation.

Finally, the estimated correlation between the unobserved heterogeneity of both live and digital participation is positive and significant across all specifications. This implies an underlying trait, a propensity to consume classical music by any means, which is not captured by the model.

Table 9.8 Bivariate probit estimation results. Dependent variables: live/digital classical music participation

	(1)		(2)		(3)	
	Live	*Digital*	*Live*	*Digital*	*Live*	*Digital*
Digital					-0.1943	
					0.5049	
Live			-0.1641			
			0.3704			
Male	-0.0764 *	0.1395 **	-0.0712 *	0.1388 **	-0.0769 *	0.1319 **
	0.0311	0.0387	0.0333	0.0387	0.0311	0.0442
Age	0.0383 **	0.0336 **	0.0388 **	0.0338 **	0.0382 **	0.0351 **
	0.0064	0.0083	0.0065	0.0084	0.0064	0.0091
Age2	-0.0003 **	-0.0003 **	-0.0003 **	-0.0003 **	-0.0003 **	-0.0003 **
	0.0001	0.0001	0.0001	0.0001	0.0001	0.0001
Children	-0.1282 **	-0.0262	-0.1278 **	-0.0252	-0.1266 **	-0.0342
	0.0430	0.0543	0.0428	0.0542	0.0431	0.0577
Married	0.0430	-0.0501	0.0407	-0.0487	0.0431	-0.0463
	0.0389	0.0495	0.0391	0.0495	0.0389	0.0499
Members	-0.0502 **	-0.0411 *	-0.0510 **	-0.0414 *	-0.0500 **	-0.0432 *
	0.0171	0.0202	0.0171	0.0202	0.0171	0.0207
eduSecondary	0.1211	0.1233	0.1221	0.1238	0.1204 *	0.1284 ***
	0.0574	0.0778	0.0571	0.0776	0.0573	0.0777
eduVocational	0.1367 ***	0.1630 ***	0.1387 ***	0.1646 ***	0.1369 ***	0.1666 ***
	0.0728	0.0941	0.0726	0.0939	0.0727	0.0931
eduUniversity	0.3853 ***	0.3268 **	0.3894 ***	0.3281 **	0.3853 ***	0.3424 **
	0.0574	0.0766	0.0578	0.0764	0.0573	0.0857
Employed	0.1069	-0.1714	0.1015	-0.1730	0.1082	-0.1619
	0.1971	0.2179	0.1962	0.2175	0.1969	0.2169

(*Continued*)

	(1)		(2)		(3)	
	Live	Digital	Live	Digital	Live	Digital
Unemployed	0.1960	0.0174	0.1951	0.0177	0.1970	0.0280
	0.2010	0.2223	0.1996	0.2219	0.2008	0.2214
Student	0.3833 ***	0.2141	0.3872 ***	0.2129	0.3815 ***	0.2306
	0.2119	0.2351	0.2105	0.2347	0.2117	0.2362
Househusband	0.2100	0.0288	0.2096	0.0286	0.2120	0.0381
	0.2053	0.2330	0.2040	0.2326	0.2052	0.2314
Retired	0.4003 *	0.1344	0.3999 *	0.1357	0.4015 *	0.1546
	0.1980	0.2220	0.1967	0.2215	0.1979	0.2257
Other	0.2575	0.0346	0.2565	0.0321	0.2623	0.0462
	0.2392	0.2719	0.2376	0.2716	0.2391	0.2702
internetWork	0.3392 **	0.2245 **	0.3423 **	0.2244 **	0.3387 **	0.2385 **
	0.0462	0.0551	0.0464	0.0550	0.0462	0.0659
timeInternetWork	-0.0003	0.0006	-0.0003	0.0007	-0.0003	0.0006
	0.0014	0.0017	0.0014	0.0017	0.0014	0.0017
Province capital	0.1058 **	0.1134 *	0.1075 **	0.1125 *	0.1059 **	0.1175 *
	0.0356	0.0457	0.0356	0.0457	0.0356	0.0461
>50000 inhabitants	-0.0062	0.1597 **	-0.0017	0.1590 **	-0.0057	0.1559 **
	0.0446	0.0535	0.0456	0.0534	0.0446	0.0540
Rho	0.3258		0.4066		0.4330	
H0:Rho=0	0.0000		0.0164		0.0344	
AIC	13,838.4		13,840.2		13,840.2	
BIC	14,595.3		14,604.8		14,604.8	

The table shows the SUR (1), and recursive (2 and 3) specifications.
*** p-value between 10% and 5%.
** p-value less than 1%.
* p-value less than 5%.

Popular music

For live popular consumption, we find that being male and unmarried without children are related to an increased likelihood of participation. As in the case of classical music the number of members of the household has a negative impact on consumption. Age is found to have an inverted U-shaped effect, but the estimates provide a maximum effect below the age-range of the survey, which points to a negative effect. These results are also found for digital consumers except for the age effect: now a clear nonlinear effect with a maximum effect estimated at 25 years.

Education is a relevant factor for live consumption as an increasing educational attainment is found to positively affect the likelihood of participation. However, in the case of digital participation only secondary education is found to be marginally significant.

An individual's position in the labor market also impacts asymmetrically live/digital consumption. As for the former, results indicate that being employed, unemployed, and student increases the probability of consumption. These apparently contradictory results can be explained when one considers the interplay of time availability (unemployed/students) and income (employed). For digital consumption, being student or unemployed (marginally) increases participation.

Live consumption is also positively affected by using Internet at work and living in a province capital. As for digital participation, also using Internet at work and living in a province capital or a large city are found to have a positive impact on participation.

As with classical music, the estimated correlation between the residuals of both live and digital participation is positive and significant across all specifications, which, again, has to be interpreted as an inclination toward popular music. What is specific about popular music is that a recursive model with digital consumption entering the live equation is preferred. The negative sign of this covariate implies a substitutive effect of digital participation on live consumption. We discuss these findings in the next section.

Discussion and conclusions

This chapter has studied live and digital music participation. In so doing, we have investigated what drives them, the barriers that consumers face, and the unobserved connections between online and offline consumption, making a distinction between highbrow and lowbrow participation. The findings provide some interesting insights into the topic.

First, results are mixed with regard to the elimination of barriers to live consumption in the digital realm. Time availability, consistently regarded as a relevant constraint for cultural participation in the literature, has been proxied through personal traits, specifically caring for children and an individual's labor market situation (being retired, student, or unemployed),

Table 9.9 Bivariate probit estimation results. Dependent variables: live/digital popular music participation

	(1) Live	(1) Digital	(2) Live	(2) Digital	(3) Live	(3) Digital
Digital			-0.9393 ** (0.2464)			
Live						-0.3135 (0.2995)
Male	0.0216 (0.0242)	0.1635 ** (0.0296)	0.0572 * (0.0257)	0.1662 ** (0.0291)	0.0210 (0.0242)	0.1617 ** (0.0293)
Age	0.0047 (0.0054)	0.0152 * (0.0074)	0.0047 (0.0053)	0.0148 * (0.0073)	0.0046 (0.0054)	0.0147 * (0.0074)
Age2	-0.0002 * (0.0001)	-0.0003 ** (0.0001)	-0.0002 * (0.0001)	-0.0003 ** (0.0001)	-0.0002 * (0.0001)	-0.0003 ** (0.0001)
Children	-0.1433 ** (0.0338)	0.0215 (0.0431)	-0.1270 ** (0.0337)	0.0254 (0.0424)	-0.1432 ** (0.0338)	0.0048 (0.0455)
Married	-0.0823 ** (0.0311)	-0.0977 * (0.0395)	-0.0954 ** (0.0302)	-0.0809 * (0.0394)	-0.0825 ** (0.0311)	-0.1049 ** (0.0394)
Members	-0.0561 ** (0.0125)	-0.0520 ** (0.0149)	-0.0639 ** (0.0121)	-0.0536 ** (0.0148)	-0.0559 ** (0.0124)	-0.0572 ** (0.0154)
eduSecondary	0.0177 (0.0448)	0.1220 * (0.0617)	0.0346 (0.0440)	0.1045 . (0.0606)	0.0180 (0.0448)	0.1183 . (0.0609)
eduVocational	0.1031 (0.0553)	0.0489 (0.0731)	0.0957 . (0.0536)	0.0429 (0.0715)	0.1052 . (0.0553)	0.0572 (0.0725)
eduUniversity	0.1573 ** (0.0458)	0.0570 (0.0627)	0.1450 ** (0.0447)	0.0444 (0.0613)	0.1579 ** (0.0458)	0.0712 ** (0.0633)

	(1) Live	(1) Digital	(2) Live	(2) Digital	(3) Live	(3) Digital
Employed	0.3229 * (0.1451)	0.1265 (0.1958)	0.3211 * (0.1405)	0.0984 * (0.1877)	0.3228 * (0.1450)	0.1578 (0.1955)
Unemployed	0.2976 * (0.1476)	0.3686 . (0.1980)	0.3569 * (0.1434)	0.3356 . (0.1902)	0.2972 * (0.1475)	0.3908 * (0.1962)
Student	0.2516 (0.1547)	0.3441 . (0.2049)	0.3106 * (0.1502)	0.3200 * (0.1969)	0.2493 (0.1546)	0.3604 (0.2026)
Househusband	0.1490 (0.1539)	0.1548 (0.2087)	0.1725 (0.1491)	0.1174 (0.2009)	0.1482 (0.1538)	0.1664 (0.2060)
Retired	0.2471 . (0.1497)	0.2057 (0.2042)	0.2662 . (0.1450)	0.1710 (0.1964)	0.2458 (0.1496)	0.2262 (0.2023)
Other	0.2502 (0.1795)	0.0767 (0.2372)	0.2463 (0.1738)	0.0493 (0.2291)	0.2486 (0.1794)	0.1003 (0.2350)
internetWork	0.1391 ** (0.0331)	0.1084 ** (0.0399)	0.1509 ** (0.0319)	0.1093 ** (0.0392)	0.1387 ** (0.0331)	0.1225 ** (0.0413)
timeInternetWork	0.0017 (0.0012)	0.0013 * (0.0013)	0.0020 . (0.0011)	0.0013 (0.0013)	0.0017 (0.0012)	0.0015 (0.0013)
Province capital	-0.0141 (0.0278)	0.0715 (0.0345)	-0.0001 (0.0273)	0.0595 . (0.0341)	-0.0136 (0.0278)	0.0681 * (0.0342)
>50,000 inhabitants	0.0139 * (0.0338)	0.1127 ** (0.0409)	0.0373 ** (0.0333)	0.1090 ** (0.0404)	0.0141 (0.0338)	0.1115 ** (0.0404)
Rho	0.1147		0.6412		0.3020	
H0:Rho=0	0.0000		0.0000		0.0424	
AIC	25,366.1		25,357.9		25,366.8	
BIC	26,123.0		26,122.5		26,131.4	

The table shows the SUR (1), and recursive (2 and 3) specifications.

that reflect an individual's time constraints. Some of them have been shown to significantly affect the probability of live participation: having children reduces it, while being retired or student increases it. The evidence supports the hypothesis of a relaxation of time restrictions when it comes to digital participation: care-giving, being a student, or being retired becomes non-significant. All in all, we see that online engagement allows the participation (both in classical and popular music) of individuals whose time constraints are active.

Another related issue is that of supply availability. We have already mentioned that the spatial concentration of supply of live events might play against participation, something that could be overcome through digital consumption. However, results suggest that this barrier is reproduced in the offline domain, with individuals in urban environments (province capitals and cities with more than 50,000 inhabitants) having a greater likelihood of participation.

An additional structural constraint we consider is that of an individual's cultural capital. Can digital consumption lead to sampling therefore breaking down barriers related to competences and codes individuals hold? Regretfully, and using education as a proxy, we see the reproduction of barriers in highbrow music consumption: more education is also linked to a higher probability of engagement, both online and offline. On the contrary, lowbrow consumption breaks this tendency: while education is key to explain live participation, digital consumption is less affected by it. Here the less demanding nature of the manifestation, and the skills needed to enjoy it, could explain the fact that less-educated individuals are not at a disadvantage when it comes to digital consumption. Nevertheless, it could be also argued that through education we also incorporate an indirect measurement for income as the survey we use does not explicitly include one. In this case, individuals overcome income barriers through digital participation. Most likely the estimate captures a mixture of both effects.

Across live manifestations (highbrow/lowbrow) gender plays a differential role. While the probability of classical music attendance is found to increase for females, that of popular music increases for males. However, men are more likely to participate in online consumption, be it highbrow and lowbrow. While the enhanced female participation of high-status cultural activities has been explained through socialization and labor-market determinants (see Christin, 2012), the observed asymmetry could be explained in terms of a digital divide. In this respect, the literature has identified the inequality in access or first-level divide, and the inequality of use, linked to skill and competences, of digital technologies or second-level divide (Hargittai, 2010; Mihelj et al., 2019). The evidence provided by SCHP18 is consistent with the hypothesis of the inequality of usage of digital technologies. Looking at the use of Internet for leisure, 22% of men, compared to roughly 27% of women, declared never using Internet for such a purpose. Furthermore, the average weekly use of Internet for leisure is 398 minutes

on for men compared to 334 for women. Consequently, findings are consistent with new barriers emerging in the digital realm that are linked to Internet usage.

This digital inequality is also present geographically. While 21% of those living in province capitals mention never using the Internet for leisure, this percentage increases to 27.4% for individuals living in smaller cities (less than 50,000 inhabitants). This could be a partial explanation of the results found: while digital consumption could allow to overcome the spatial barriers, the digital divide helps reproduce them.

Overall, we find a mixture of evidence: some live barriers are broken down while others are reproduced, which brings us to the question of whether digital consumption incorporates new audiences. The evidence is supportive of an increase in diversity: individuals facing time constraints, males (in classical music), and those with financial restrictions (popular music) are more likely to participate online. Regarding the relationship between live and digital engagement, two observations. First, we have found an innate tendency to participation, such that individuals that do participate live are also more likely to participate offline (and the other way around). This has been consistently estimated across the different models as an unobserved trait that could be linked with individual preferences toward classical/popular music. This suggests that, to a certain extent, live and digital audiences overlap. This overlap would be of individuals who engage online/offline, that is, consumption-deepening.

Second, and specific to popular music consumption, results point toward a cannibalizing effect of digital on live participation. We calculated the sample average treatment effect and found that digital participation reduces the probability of live participation by 22%. Nevertheless, it is worth mentioning that the correlation between unobserved components increases from 0.12 in the SUR model to 0.64 in the recursive model. This pinpoints the complexity of the decomposition of the total cross-effect. On the one hand, there is an indirect effect due to unobserved heterogeneity: we identify this component with preferences for popular music, which has a net positive effect on participation. Note that the SUR model underestimates this component (see Filippini et al., 2018). On the other hand, the recursive model includes a direct effect from digital to live participation, which is a substitution effect. Overall, the negative estimated direct effect offsets the positive effect that preferences have in increasing the probability of live participation. Note that, due to the nonlinearity of bivariate probit, the specific impact of digital on live participation depends on the values of the covariates.

All in all, this chapter sheds some light on live and digital participation in lowbrow/highbrow music and the possibility of enlarging audiences through digital participation. As we have shown, some but not all barriers to live participation are overcome through online consumption and, besides, it can bring about new ones related to skills and usage. In this sense, there is some

evidence consistent with live participation stimulating new audiences. It is true that the existence of underlying unobserved heterogeneity affecting both live and digital engagement suggests a propensity toward music, and hence the fact that to some individuals digital complements live engagement (and would not add diversity to audiences). However, it also implies that, if participation spills over from the digital to the live domain, online engagement, by allowing individuals to accumulate competences over time, could lead to increasing live attendance. In the case of popular music, however, the substitutive nature of live and digital consumption seems to put a limit to the strategy of enlarging the audiences through digital consumption.

References

Aguiar, L. (2017). Let the music play? Free streaming and its effects on digital music consumption. *Information Economics and Policy, 41*, 1–14.

Bakhshi, H., & Throsby, D. (2014). Digital complements or substitutes? A quasi-field experiment from the Royal National Theatre. *Journal of Cultural Economics, 38*(1), 1–8.

Christin, A. (2012). Gender and highbrow cultural participation in the United States. *Poetics, 40*(5), 423–443.

De la Vega, P., Suarez-Fernández, S., Boto-García, D., & Prieto-Rodríguez, J. (2019). Playing a play: Online and live performing arts consumers profiles and the role of supply constraints. *Journal of Cultural Economics, 44*, 425–450.

Filippini, M., Greene, W. H., Kumar, N., & Martinez-Cruz, A. L. (2018). A note on the different interpretation of the correlation parameters in the Bivariate Probit and the Recursive Bivariate Probit. *Economics Letters, 167*, 104–107.

Hambersin, M. (2017). Classical music: New proposals for new audiences. In V. M. Ateca-Amestoy, V., Ginsburgh, I., Mazza, J., O'Hagan, & J., Prieto-Rodriguez (Eds.), *Enhancing participation in the arts in the EU* (pp. 311–322). Cham: Springer.

Handke, C., Stepan, P., & Towse, R. (2017). Cultural economics, the internet and participation. In V. M. Ateca-Amestoy, V., Ginsburgh, I., Mazza, J., O'Hagan, & J., Prieto-Rodriguez (Eds.), *Enhancing participation in the arts in the EU* (pp. 295–310). Cham: Springer.

Hargittai, E. (2010). Digital na(t)ives? Variation in internet skills and uses among members of the "net generation". *Sociological Inquiry, 80*(1), 92–113.

Marra, G., & Radice, R. (2017). A joint regression modeling framework for analyzing bivariate binary data in R. *Dependence Modeling, 5*(1), 268–294.

Mihelj, S., Leguina, A., & Downey, J. (2019). Culture is digital: Cultural participation, diversity and the digital divide. *New Media & Society, 21*(7), 1465–1485.

Montoro-Pons, J. D., & Cuadrado-García, M. (2016). Unveiling latent demand in the cultural industries: An application to live music participation. *International Journal of Arts Management, 18*(3), 5–24.

Montoro-Pons, J. D., & Cuadrado-García, M. (2018). Copyright infringement and cultural participation. In S. C. Brown & T. J. Holt (Eds.), *Digital piracy: A global, multidisciplinary account* (pp. 146–174). New York: Routledge.

Montoro-Pons, J. D., & Cuadrado-García, M. (2019). Retos de la cultura de alto nivel para atraer nuevos públicos en el entorno digital (Challenges of high-brow culture to attract new audiences in the digital environment, in Spanish). *Observatorio Social de La Caixa.* https://observatoriosociallacaixa.org/-/retos-cultura-alto-nivel-captacion-publico.

Mortimer, J. H., Nosko, C., & Sorensen, A. (2012). Supply responses to digital distribution: Recorded music and live performances. *Information Economics and Policy*, *24*(1), 3–14.

Peukert, C. (2019). The next wave of digital technological change and the cultural industries. *Journal of Cultural Economics*, *43*(2), 189–210.

R Core Team. (2017). *R language definition*. Vienna: R Foundation for Statistical Computing. URL https://www.R-project.org/.

Suarez-Fernández, S., Prieto-Rodriguez, J., & Perez-Villadoniga, M. J. (2019). The changing role of education as we move from popular to highbrow culture. *Journal of Cultural Economics*, *44*, 189–212.

Walmsley, B. (2016). From arts marketing to audience enrichment: How digital engagement can deepen and democratize artistic exchange with audiences. *Poetics*, *58*, 66–78.

10 Has digital transformation impacted gender imbalance in Italian cinema? A data analysis of creative clusters 2004–2016

Mariagrazia Fanchi and Matteo Tarantino

Introduction

The history of the relationship between women and the cultural and media industries is marked by an inverse proportionality: the stronger the medium—from an economic, political, social, or cultural point of view—the weaker the numbers and relevance of the role of women in it, and vice versa.

Cinema is not an exception in this sense. We find women in key positions when the medium is fragile and undefined. As in other national cinemas, Italian silent film is populated with women directors, producers, and exhibitors (Bruno & Nadotti, 1988; Sossi, 2000; Morandini & Morandini, 2010) who are subsequently excluded or relegated to "service" roles, which provide silent and invisible support to male work, as soon as the medium is institutionalized and transforms into the great popular spectacle of the 20th century (Women Film Pioneers Project).

Within this framework, the profound changes taking place at the moment, in relation to digital transformation, could prove favorable to professional women. Although some scholars (Friedberg, 2000; Bellour, 2012) see digitization as a catastrophic event for cinema, going so far as to pronounce its "death" as a consequence, others look to the processes activated by the switch to digital technologies from a palingenetic viewpoint. For these scholars, digitization signals the remaking of cinema, capable of restoring the seventh art to its past glories, and placing it in the center of artistic, cultural, social, and even political and economic life (Rodowick, 2007; Iordanova & Cunningham, 2012; Hansen, 2012; Casetti, 2015).

For many scholars, therefore, post-digital transformation cinema functions as a horizon of opportunity, whose coordinates have been eloquently summarized by John Hartley, Wen Wen and Henry Siling Li (2015) with the phrase "everywhere, everything and everyone." Everywhere—that is, a cinema that can be made at any place, evading the centrality of Hollywood, and marked by the emergence of new "creative scenes" that bring previously undervalued models, values, and aesthetics with them (Lobato, 2012; Jedlowski, 2015). And a cinema that can be *viewed* anywhere, because it

is global (Lobato, 2019) and available on a range of channels and devices: diffused and pervasive, capable of redefining the contours of public space (Tryon, 2013; Casetti, 2015). Everything—that is, a remediated cinema (Tryon, 2009; Gaudreault & Marion, 2015) that assumes different forms and formats and enters into fluid relationships with other media vocabularies and expressive outlets, starting with the visual arts (De Rosa, 2012; Butler, 2019). Everyone—that is, an inclusive cinema, open to those usually excluded from the production process: women, young people, non-western filmmakers: postcolonial and intersectional through and through.

This chapter tests this third trajectory of change. It looks at the forms that the remaking process, triggered by the digital turn, has taken in the Italian film industry. More specifically, it tries to verify whether and how post-cinema—cinema that is the result of digitization (Ji-Hoon, 2009)— has been able to valorize women's creativity, to promote the entrance of women filmmakers and professionals into the field, and, finally, to transform creative networks.

To this aim, the chapter will examine a corpus of 3,542 Italian films that requested public funding between 2004 and 2016—the temporal arc of the digital switch-over in Italy. We will examine these works from the point of view of creative team composition and cluster structure as the "range of social synergies, networks and institutions that allow for knowledge, skill-sets, projects and evaluation processes to interact in a flexible, informal and largely efficient social production system" (Currid, 2007 quoted by Hartley et al., 2015, p. 122).

The general aim is to see whether digital transformation can offer opportunities for the renewal of cinema, beginning with the overcoming of the gender imbalance—an issue that famously extends well beyond the borders of Italy, and represents one of the main weak points for cinema and the media system, from a sociocultural but also an economic standpoint (Gledhill & Knight, 2015; EWA, 2016; Simone, 2019; European Audiovisual Observatory, 2019; Centre national du cinéma et de l'image animée, 2019; Ofcom, 2019).[1]

Research questions and methods

As mentioned, the research spans a period of 13 years, from 2004 to 2016. The timeframe coincides with that of cinema digital transformation in Italy. While the first fully digital films by established filmmakers (FEFs) were released a little earlier (the first was a little-known work by Nello Correale, *Sotto Gli Occhi di Tutti*, 2001), 2004 was marked by the release of major fully digital feature film with Davide Ferrario's *Dopo Mezzanotte*. On the distribution side, in 2004, the first fully digital theatre was unveiled, and by 2016 all 3,000+ Italian movie theatres adopted digital distribution and projection techniques (Greco, 2002; Casetti & Fanchi, 2006; MEDIASalles, 2019).

In this period, Italian cinema industry was regulated by the Urbani Law (DL 28/2004), which came into effect on January 22, 2004 and was

substituted by a new law on cinema and audiovisual media in 2017. The Urbani Law reformed the film sector by establishing specific criteria for the public financing of national cinema, with attention to the production and appreciation of *works of national cultural interest*. In the words of Article 2 of the Law, cultural interest films are defined as those that, "in addition to satisfying technical criteria, present significant cultural or artistic qualities, or exceptional entertainment qualities" (DL 28/2004).

Our corpus therefore includes the 3,542 works that requested funding under the rubric of "cultural interest" films during the period of the Urbani Law that is also the period of the Italian film industry switch-over.

The corpus functions, therefore, as an exemplary and useful cross section through which to investigate the digital transformation effects on women's cinema, and Italian audiovisual production more generally. The works we going to examine have three further characteristics. The first one is the relative *stability of the public funding system* during those 13 years. We remind readers that MiBACT (Ministry of Cultural Heritage, Cultural Activities and Tourism) is the main funding body for film and audiovisual works in Italy (Cucco & Manzoli, 2017). The timespan of the Urbani Law therefore allows us to operate within a system of opportunity that is relatively stable from the point of view of production support. As a result, we are better able to notice changes determined by digitization and its results on the media field and on the presence of women within it.

The second is linked to the specific funding scheme we have adopted as our point of entry for the observation of the composition and potential transformation of the creative clusters of "women's cinema." This funding scheme is addressed primarily to *production initiatives at their starting stages*, that is, not yet realized. Among the projects we studied there is therefore a significant number of works that never arrived to completion, as a result of failure to obtain public funding and/or lack of private funding.[2] This group of unfinished projects constitutes an underground universe of which we see no trace in lists of films requesting approval for distribution, or in the content which makes it to our screens, big and small. Such a hidden universe offers us a wider perspective on the Italian creative scene and its (often unrealized) potential for renewal.

The corpus presents a third and final peculiarity. The funding scheme we've chosen to look at provides support for a range of content: feature films, that is, FEFs; debut or second films, that is, production initiatives headed by filmmakers at the start of their careers (DF/SF); and short films.[3] It therefore provides a better view into the creative structures of the national film and audiovisual industry, allowing us to compare and contrast the productive clusters of audiovisual works of different sizes and formats.

This rich collection of data will be analyzed in order to answer four main questions. First of all, we want to *assess the percentage of women filmmakers* during the digital transformation process of Italian film industry. What is their level of seniority—how many are established filmmakers and, conversely, how

many are starting off their careers? Which formats do they tend to work in (feature length or short films) and what production frameworks do they feel more comfortable or appreciated in? The aim, as stated above, is to expand and flesh out already available data, by including in the census of women's cinema projects that were halted at the planning stage, as well as those formats that depart from the standard feature length, such as short films.[4]

Second, to what extent were women able to enter into dialogue with the production system during the process of digitization, starting with the criteria that regulate public financing? Similarly, to what extent are women able to comply with the logics of the system and gain benefits from it? Specifically, we looked at the rate at which films by women obtained state support and measured their projects' performance across different formats and production frameworks.

Regarding creative networks, we tried to reconstruct *cluster composition* and measure women's presence in above- and below-the-line professions. To this end, we introduced a further sub-group of 1,270 films from the data corpus: 459 FEFs (55% of the total FEFs considered); 547 DF/SFs (37%); and 264 shorts (21%). Narrowing down the corpus for this research question was rendered necessary by the lack of data on the composition of the creative clusters for many of the projects in the original corpus, especially when it came to unfinished projects.[5]

Finally, we considered the *shape taken by creative clusters headed by women*, their capacity to include new types of actors, different from those professionals who habitually recur on the creative scene. We also inquired into the level of their interlacing, that is, which and how many professionals, both men and women, are involved in more than one project and, therefore, to what extend do creative networks overlap or coincide. Finally, we investigated the type of relationships they establish with creative clusters headed by male directors.

To answer these questions, we looked at our film corpus from several points of view and using different methodological approaches. First, we looked at the films' *general information*: for each of the 3,542 projects, including FEFs, DF/SFs and shorts, we collected data on the year in which the request for funding was submitted, the title, director, declared production costs, funding approval/rejection, funding body, and acceptance of the funding by the production. Information was collected from the decision reports published by the Direzione Generale Cinema e Audiovisivo (DGCA) and indexed in the folder "Contributi a progetti di interesse culturale," available on the MiBACT website.[6]

Second, we looked at *professions*. For the 1,270 projects selected for the analysis of creative clusters, we acquired and analyzed data relating to the identities of the editor, scriptwriter, and producer as well as the technical crew, such as costume, visual effects, photography, music, sound, and makeup directors. This information was collected and analyzed using CENTRIC (CrEative NeTwoRks Information Cruncher), an online search

tool developed by the Digital Humanities Lab at ALMED—Postgraduate School in Media, Communications and Performance of the Catholic University of Milan. CENTRIC collects, indexes, and analyzes the general information, credits, cast and crew details, and markets (specifically in relation to streaming platforms) of films and other audiovisual works.

The third perspective is that of *relationships*. Information on above-the-line and below-the-line professions collected by CENTRIC were analyzed using the tools and categories of Social Network Analysis (Cattani & Ferriani, 2008; Paterson, Lee, Saha & Zoellner, 2015; Freeman, 2016; Holdaway, 2017; Montanari 2018), with the aim of identifying the network structures behind production initiatives headed by women. Specifically, the following were measured: the size of networks; the identity of nodes, that is, of professionals who constitute those networks; their relational gradient, that is, the number of other nodes they are in contact with or enter into relationships with; the stability of their bond, that is, the extent to which collaborations recur between one or more professionals over different projects, and therefore cluster density.

The favorite? Women in the Italian creative scene

As mentioned above, the choice of working on the wider corpus of projects that requested funding under the rubric of cultural interest films permits a longer view. Such a view looks beyond finished film products and allows us to observe what could have been, or what is potentially there in the national production system.

We will begin by providing some further details on the composition of the analyzed corpus. As mentioned above, the total of 3,542 projects is subdivided into 827 feature-length projects by established filmmakers (23.34%); 1,474 debut or second films (41.6%); and 1,241 shorts (35.02%) (Figure 10.1).[7]

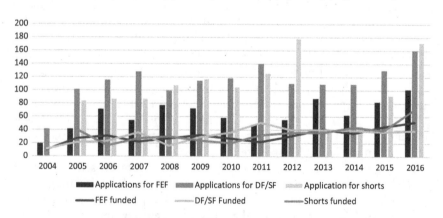

Figure 10.1 Number of applications and approved requests by category (FEF; DF/SF; Shorts) (2004–2016).

Source: Elaboration by the authors on ministerial data.

The majority of requests for funding are made by filmmakers at the start of their careers (DF/SF); small-caliber projects follow (shorts), while the smallest number of requests is made for feature-length FEFs.

Of these 3,542 requests, 1,235 (34.86%) received public funding. 402 FEFs, 418 DF/SFs, and 415 shorts enjoyed the benefits of being recognized as "works of cultural interest." Proportionately, the projects that received the most funding were those by established filmmakers: their requests were granted funding in 48.06% of cases. Shorts followed with a 33.44% success rate. Finally, debut and second features were the least successful, with a rate of 28.36%.[8]

The imbalance in favor of work by established filmmakers is further accentuated if we look at funding amounts. In the span of the 13 years considered here, 68.84% of funds for the support of cultural interest films (282 million euros) were allocated to projects by established auteurs; 28.02% to projects by new filmmakers (115 million euros); and 3.13% to shorts (13 million euros). The following chart shows the distribution of resources per year (Figure 10.2).[9]

On average, therefore, FEFs received a funding of around 701,000 euros; DF/SF about 274,000; while the average funding for shorts was 31,000 euros. In this context, *women occupy a doubly marginal position.*

First of all, the share of projects headed by women that apply for funding is significantly lower that than of projects headed by men: "women's" projects add up to 544, with an extra 42 projects directed by teams composed of at least one man and one woman (represented in the graph as "mixed"). Together, these two categories form just above 16% of the total number of applications (Figure 10.3).

Second, the rate of "women's" projects is *at its peak in the category of shorts* (21.59% of funding applications come from women or teams comprising at least one woman) and *at its lowest in the category of films by established filmmakers* (10.76%). Debut and second features directed by women that requested funding, in the 13 years considered here, add up to 15.53% (Figure 10.4).

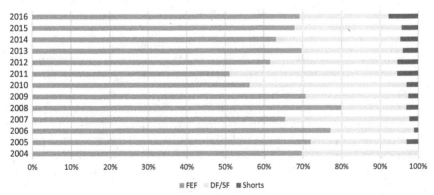

Figure 10.2 Share of funds according to format (films by established filmmakers; debut films/second films; shorts), per year.

Source: Elaboration by the authors on ministerial data.

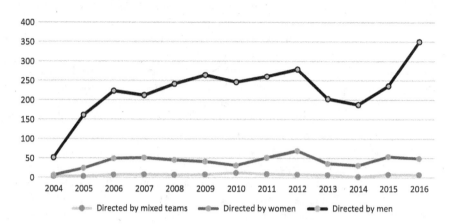

Figure 10.3 % rate of applications by women, men, and mixed teams, per year.

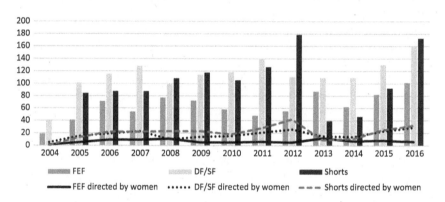

Figure 10.4 % rate of projects directed by women or teams comprising at least one woman, compared to the total number of applications (by women, men, and mixed teams), per year.

It becomes clear that women's presence in the national creative scene is limited. When they are present, they are often positioned in funding categories where resources are more contained (shorts) or where chances of selection are lower (DF/SF).

This imbalance is not made any better by the selection criteria. The absence, in the provisions of the Urbani Law, of arrangements that would balance out gender inequality and that would therefore guarantee greater support for those who are usually excluded (such as women filmmakers, especially if at the start of their careers), effectively reaffirms the imbalance observed in our analysis of funding applications.

Projects directed by women (or teams with at least one woman) that received funding are 45 in the FEF category; 64 in DF/SFs; and 86 in shorts. On the whole, then, the gender discrepancy is blatant: only 11.19% of

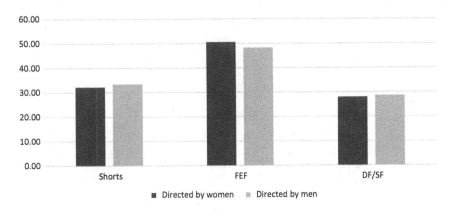

Figure 10.5 Percentage rate of funded projects directed by women (or mixed teams) and by men (or mixed teams) over the total number of funding applications by women (or mixed teams) and men (or mixed teams), divided by category.

funded FEFs; 15.31% of DF/SFs; and 20.72% of shorts are directed by women. The imbalance is reduced if we compare the rate at which "women's" projects are selected for funding from among the pool of requests by women to the equivalent rate for projects directed by men. In this case, the percentage of projects headed by women that receive funding remains lower than that of men in the category of shorts and DF/SFs but by a very small margin (32.09% of shorts directed by women accede to funding, as opposed to 33.40% of shorts directed by men; 27.95% of DF/SFs headed by women, as opposed to 28.58% headed by men) (Figure 10.5).

When it comes to established women filmmakers, instead, they are marginally more successful at obtaining funding that their male colleagues: 50.56% of their funding requests are approved, as opposed to 48.25% of requests by men. Nevertheless, when it comes to the size of the funding allocated, the balance is once again reversed. Projects by established women filmmakers receive, on average, smaller sums than those given to feature film projects directed by men: 655,000 euros, compared to 706,000 euros (Figure 10.6).

Our analysis of funding applications under the rubric of cultural interest films and the financial support they receive permits us to give an answer to our first two research questions: what is the presence of women on the national creative scene, and to what extent are they able to tune into the logics of the production system, starting with the criteria that regulate public funding?

The data we have illustrated thus far confirm what the literature indicates (Mascherini, 2009; Barca, 2018; EWA, 2018; Italian Research Council; Fanchi, forthcoming): women directors' presence on the creative scene

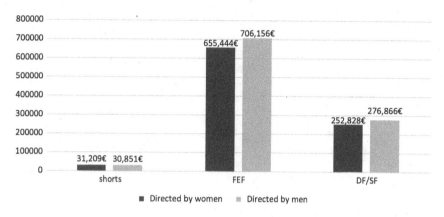

Figure 10.6 Average funding given to projects directed by women (or teams with at least one woman) and men (or teams with at least one man), by category.

is small to very small. When they are present, as we'll see in later sections, they tend to occupy marginal positions within the system. They are not very present in big productions (FEFs), where they are at a disadvantage in terms of both the number of projects funded and the sums they receive. Their presence is felt more in the new generation of filmmakers (DF/SFs) and smaller formats (shorts), but their percentages remain significantly lower than those of their male colleagues.

The extent to which they are in a position to take advantage of state support and adjust to the logics of production appears lower, too. This issue would require further fleshing out, based on an in-depth analysis of the points system used to evaluate the funding applications. An analysis of the macro- and micro-entries in the various sections of the application forms would help reveal the strong and weak points of women's productions.[10] Even so, it remains unequivocally the case that women filmmakers, especially those breaking out into the creative scene, receive less funding than their male colleagues, both on the whole and in proportion to the number of requests made by them.

We might add that the quality of the production plan, and the fame and reputation of the professionals involved, are important criteria that allow projects to maximize yield during the funding application process. We will return to this point in the conclusion. On the one hand, such criteria serve as forms of guarantee for the state's investment (reducing the risk of project failure). But on the other, they tend to exclude professionals who are starting their careers, ossifying the creative scene and providing a further obstacle to redressing its gender imbalance.

The overall trend in the 13 years considered confirms this interpretation. The data curve of applications and financed projects by women does not show significant changes. The small indication of growth in the number of applications in the categories of shorts and DF/SFs starting in 2014 seems

more like a small irregularity, not unlike ones that have appeared in the past, than a sign of consistent improvement.

Despite the opportunities offered by digitization (lower production costs; greater possibilities for the circulation of audiovisual products; and, therefore, market growth and increasing demand for audiovisual contents), the number of female directors involved in the Italian film industry remains dramatically low.

Since women's presence on the creative scene remains weak, are we to conclude that they are unable to make their mark on the digitized production system? To answer this question, we have to refocus the analysis on the level of individual professions and the relationship between professionals.

Women and creative networks

Within the corpus of 1,270 works we used as the basis for our analysis of creative networks,[11] the 167 projects headed by women indicate a first unequivocal fact: films directed by women engage more women.[12]

This is true when it comes to the central roles of editor, screenwriter, and producer, which were occupied by women 47.7% of the time for women's projects, compared to 23.2% for men's projects (Figures 10.7 and 10.8). It is still true, but less so, for technical roles (costumes, visual effects, photography, music, sound, makeup), where women were employed 41.03% of the time in women's projects and 33.97% in men's projects (Figures 10.7 and 10.8).

When it comes to the main professions (which, for the purposes of this article, we consider to be those of director, editor, producer, and screenwriter), the tendency of women directors to give space to women professionals emerges particularly strongly in relation to the role of screenwriter. In

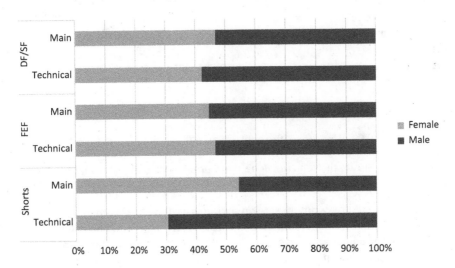

Figure 10.7 % rate of women and men in main and technical roles; projects directed by women.

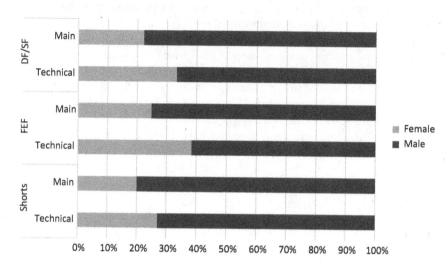

Figure 10.8 % rate of women and men in main and technical roles; projects directed by men.

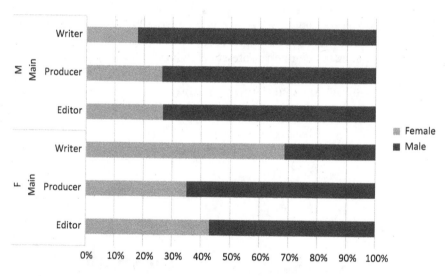

Figure 10.9 % rate of women among main professions (editor, producer, screenwriter). Projects directed by women ("F") vs. projects directed by men ("M").

projects directed by women, screenwriting is assigned to women in 68.59% of cases, compared to 17.83% in projects directed by men. The discrepancy is smaller for editor and producer roles. About the latter, it should be borne in mind that a filmmaker does not exert a direct influence on the choice of the producer; however, it is still noteworthy that in the creative clusters managed by women there is a higher percentage (even if only slightly) of women in the producer roles (Figure 10.9).

This interesting fact can be read in a twofold way. In one sense, the lesser predominance of women editors and producers in films directed by women confirms the tendency to recruit men in roles that are perceived to require technical skills (editor) and leadership (producer). This fact also emerges in the analysis of below-the-line roles, as we will see later. Regarding projects directed by men, the scarce occurrence of women screenwriters betrays men's difficulty to share "authorial" space with a woman. This is further confirmed by the very small number of collective projects, especially projects where the role of director is shared between men and women (1% of the total).

When it comes to technical roles, differences are less stark. In general, women tend to employ more women even in roles traditionally considered male, such as director of photography (in women's projects, 19.86% of directors of photography are women, compared to 5.2% in men's projects). Conversely, women appear slightly less attached to the stereotype of the woman costume designer (77.22% in women's projects, compared to 81.12% in men's) (Figure 10.10).

The gender composition of creative networks requires one last observation. If we compare the categories of production—shorts, feature films by established filmmakers, debut and second features—we notice a substantial homogeneity in gender composition. As women's bargaining power grows—from the production of shorts to debut and second features, and up to films produced as established filmmakers—the rate of women professionals employed does not grow with it, especially in the main roles. We can hypothesize that the institutionalization of production initiatives brings with it at least a partial compliance with consolidated practices, including the tendency to turn predominantly to male professionals.

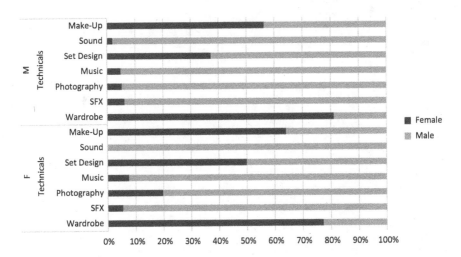

Figure 10.10 % rate of women in technical roles. Projects directed by women ("F") vs. projects directed by men ("M").

To sum up, although the digital transformation of the film industry has supposedly put *everyone* in a position to express their talent, as Hartley suggests (Hartley et al., 2015), the production system and practices remain tied to pre-digital models, heavily conditioned by patriarchal logics.

"Women's" and "men's" creative clusters

In this section, we attempt one last dive into creative network structures— or creative clusters, to use the term with which John Hartley defines the new base unit of the cultural industries. Creative clusters, according to Hartley, are systems of relation that activate around a production initiative, which depends on them for the production of value, both economic and cultural (Hartley et al., 2013, 2015).

Figure 10.11 shows the creative networks of shorts directed by women or teams comprising at least one woman director. The points (nodes) represent different actors involved in the production, in both above- and below-the-line roles, as described in the previous section. From a methodological

Figure 10.11 Creative clusters: shorts directed by women.

point of view, it's important to note that we included only natural, not legal persons (such as ministries, companies, and other bodies).[13]

To help the reader navigate the graphs, we note that, the larger the diameter of a node or the name of a professional, the bigger the number of relations it activates, both within one production initiative and between different productions. Similarly, the thicker the line that connects a node to other nodes, the greater the frequency with which that professional collaborates with other professionals. For example, editors Aline Hervé and Ilaria Fraioli have been involved in more projects and have collaborated with a great number of professionals; and producer Marta Donzelli has participated in the production of an important number of shorts directed by women.

Below, we compare the patterns of creative networks headed by women with those headed by men (Figure 10.12), in the category of short films.

The first thing to note—apart from the impressive difference in scale between the two networks, men's creative cluster hosting a far greater number of productions—is that the two networks trace two different production structures, that is, two different layouts of relations. In the case of women's productions, single clusters (which, in our visualization, are deprived

Figure 10.12 Creative clusters: shorts directed by men.

of the organizations that would function as dominant connectors, such as the Ministry of Culture or the Italian national television company) tend to take a constellation-like form. Every production initiative generates its own network of relations, which tends to exhaust itself with that one production. With the couple of exceptions noted above, these are therefore extemporaneous initiatives which do not seem able to replicate themselves (as evinced by the fine lines that link the different professionals/nodes). Nor are they able to generate further production initiatives and establish synergies and exchanges, as demonstrated by the isolated character of each group of relations.

The structure of production initiatives when it comes to shorts directed by men appears similar to the women's model at the edges of the graph. The central zone, however, demonstrates a stable core of relations (marked by the thicker lines) that acts as a sort of spinal cord for the production system. Men's productions therefore show a greater tendency to replicate themselves and create synergies. These are not extemporaneous initiatives. They show a continuity that manifests itself in the many groups of professionals involved (nodes and micro-networks that appear along the main "spinal cord") and that sketches an embryonic production system (the future national creative scene?).

Comparing the creative clusters in the production of shorts to those of DF/SFs and FEFs allows us to make some further observations. The bigger a project, in terms of duration and financial commitment, the more the creative networks tend to restrict themselves and collect around a smaller system of professionals. In terms of social network analysis, network density[14] can grow to twice that of shorts, for both men's and women's FEFs. The constellation-like structure morphs into an archipelago in the case of DF/SFs (Figure 10.13) and a peninsula-like model in the case of FEFs (Figure 10.14). In other words, networks progressively become more stable.

At the same time, the rising centrality of male nodes becomes noticeable: producers Gregorio Paonessa and Rocco Messere are examples of this when it comes to DF/SFs directed by women (Figure 10.13). Composer Pasquale Catalano and visual effects director Fabio Traversari are similar examples in the case of FEFs directed by women (Figure 10.14).

As mentioned in the previous section, in order to obtain public funding a film must have a "solid" cast and crew and involve professionals with experience. The CVs of the "artistic team" and the "technical team" are fundamental in the evaluation of projects and therefore decisive when it comes to obtaining funding (see footnote 15). This explains the presence of many male professionals in the creative clusters headed by women: they bring prestige and evaluation points.

At the same time, some nodes representing women professionals are present throughout the three categories of production, maintaining their centrality across the spectrum of film production. Examples of this are producer Marta Donzelli and costume designer Sabrina Beretta. These nodes tend to belong to technical roles.

Figure 10.13 Creative clusters: DF/SFs directed by women.

To further examine the composition and structure of creative clusters and help standardize them in the face of the great variety of size and structure of our corpus, we developed a metric called gender degree score, or *gd-score* (Table 10.1).

This metric ranks the first 15 nodes of each network by number of connections (i.e. those professionals entertaining the highest number of collaborations) and assigns them with a score proportional to their position (position 1 is worth 15 points, position 2 14 points, and so on). It then calculates the total sum of points by gender. The results (Table 10.1) show that women involved in creative clusters exercise most of their influence on the network of shorts directed by women (with a gd-score of 60). After that, the influence of women starts rapidly decreasing, reaching its lowest in the category of DF/SFs directed by men (with a gd-score of 0). The gd-score confirms the data previously illustrated, demonstrating women's clearly minoritarian role in almost all networks from the point of view of

Figure 10.14 Creative clusters: FEFs directed by women.

Table 10.1 Gd-score of the position of each gender in the first 15 nodes for every network's connections

	gd-Score /100	ATL/100
FEF		
F		
Female	16	3
Male	84	28
M		
Female	3	3
Male	98	23
DF/SF		
F		
Female	39	24
Male	61	47
M		
Male	100	34
Shorts		
F		
Female	60	45
Male	40	35
M		
Female	11	11
Male	89	53

influence. This dynamic is also reflected in the distribution of power. The rate of women in main professional roles is, on average, inferior to that of men in terms of their gd-score. This imbalance grows along with the size of the production as we move from shorts to feature films (and from smaller to bigger budgets).

In conclusion, the creative clusters of the 1,270 films analyzed show some main tendencies. First of all, "women's cinema" is inclined to construct slightly more cohesive, but less structured networks without centers of power that would be in a position to exercise influence outside the network. In other words, their clusters don't replicate themselves. What we notice, rather, is a small number of subjects who work in more than one projects. Moreover, women professionals tend to remain in weak positions both within "women's cinema" and (most of all) within "men's cinema" and there are a lot of women "meteors" who only work on a single project in the 13-year timeframe. Finally, when they are more imbricated in the production system, women professionals exercise more influence in technical, rather than main, roles (such as editor or producer) in both men's and women's cinema.

Conclusions

This multi-faceted exploration of the Italian cinema industry switch-over period aimed to determine whether digitization has been able to change the rules of the game, fostering a more inclusive production system—one able to accommodate the ways in which women operate on the contemporary creative scene. In other words, we asked whether digital transformation empowered Italian women directors in terms of influence on production structures, and ability to introduce innovations in production, values, and aesthetics. The answer is ambivalent.

On the one hand, women have shown an ability to create somewhat idiosyncratic creative networks. Women's creative networks appear less interpolated, but also more internally cohesive. They also appear to attract more woman professionals and, in this sense, they work toward the overcoming of the gender gap, which would spur a range of positive consequences for the totality of the production system and for the development of more ecological—that is, socially, culturally, and politically sustainable—representations, stories, and social models.[15]

At the same time, it is unclear how much of this is related to the specifics of digital transformation. As we have seen, the consolidation of the digital transformation of the industry did not translate into visible trends concerning gender diversity; the industry did not land in 2016 far away from where it took off in the early 2000s. Women directors are still too few, as are women who occupy the main roles in creative networks (editors, producers, screenwriters). Their influence appears limited by all metrics, as does their ability to enter definitively into the system, to make film and audiovisual media their profession, and to acquire the credibility that guarantees, in the eyes of evaluators, a project's sustainability, especially when it comes to big budgets.

The implications of this imbalance can be felt on many levels. In cultural and symbolic terms, these manifest in the construction of poor and weak discursive habitats. In economic terms, they influence the competitiveness of the national film and audiovisual industry. To exclude women (or to provide arguments for their self-exclusion) means to fatally undermine the ability of Italian cinema to renew itself, to change its old models, in accordance with the new structures of the creative industries (Hartley et al., 2015; Lobato, 2015; Smith & Telang, 2016).

This is not just a question of numbers. The small number of women in creative networks is a problem, but so is the limited range of positions they hold within them. Strengthening the ability of women's production clusters to connect with professionals outside them and with the wider Italian production system is one of the objectives we need to strive for in order to redress the imbalance emerging from the contemporary Italian cinematic and creative scene. The fragility of women's creativity in the post-digitized Italian audiovisual system requires bold structural interventions: from the elimination of sexist discourse, the rethinking of professional imaginaries, to policy reforms.

The New Regulations for Cinema and Audiovisual (Law 220/2016), active from January 2017, may be a step in this direction. The Regulations include in the selection criteria for public funding compensative measures aimed at containing and reducing the gender gap. Their impact on production practices and their ability to fulfil the promise of digital transformation of an open, inclusive cinema industry will be verifiable in a few years' time.

What we can say at this stage is that digital transformation and the related transformations of the value chain of the cinema industry—a change so deep it spurred some commentators to speak of "death of cinema," as we have seen—appears to have been insufficient to eradicate the segregationist logics of Italian cinema. In our opinion, this requires an intensification of legislative intervention and the development of system of care enabling women's creative scene to consolidate itself without losing its attributes, and to propose itself as a viable alternative approach.

Notes

1 Both authors contributed to the development of the idea and arguments in this article. Mariagrazia Fanchi composed Sections 1 and 2; Matteo Tarantino composed Section 4, managed the data collection and analysis and developed the database. The two authors contributed equally to the introduction, conclusion, and Section 3

2 Previous research on "cultural interest" projects, and specifically on feature-length films in the period 2004–2015, suggests that 38% of projects by established filmmakers are never realized, while that number rises to 64.84% in the case of projects without funding and is proportionally higher for projects directed by women (a total of 50% compared to 37.53% for films directed by men) (Fanchi, 2020).

3 The cultural interest film funding scheme also includes provisions for the development of scripts. Such projects were not taken into consideration for this research. The decision was made so as to keep the corpus and, by extension, the creative clusters examined here, relatively analogous, even if different in their dimensions.

4 Ideally, an extension of this research would require a comparative analysis of the presence of women directors in other sub-sectors of audiovisual production, such as television and streaming content. Such an analysis was recently conducted on the corpus of works that obtained public funding in the context of Law 220/2016 (Università Cattolica del Sacro Cuore and CLAS, 2019).

5 The reader should keep in mind that over 60% of debut and second feature films never see the light of day. A further obstacle was presented by changes in film project titles and in other basic information filed by MiBACT and available in the funding results reports. Due to such discrepancies, we sometimes had to verify data and intervene when additions or corrections were needed.

6 Every project's general information sheet was amended with supplementary information on any subsequent requests for funding, any changes in the data registered by MiBACT (such as a change of the film title) and on the realization (or not) of the project.

7 To assess the trends of requests over time, keep in mind that funding in support of shorts came into effect in 2005.

8 This imbalance in favor of feature films by established auteurs is further demonstrated by the smaller number of requests and the criteria used for selection.

These criteria require not only an evaluation of artistic qualities but also of the soundness of the production plan.

9 The reader should bear in mind that the projects were indexed using the date of the first submission of a request for funding, and that funding, even if allocated subsequently, is associated with that date. The sums per year might therefore not correspond to the annual reports issued by MiBACT, which use the year of receipt of funding as their main indexing criterion.

10 "Cultural interest" projects are evaluated based on a form divided into three macro-sections: "Quality of the story and script"; "Quality of the technical and technological components"; and "Quality, comprehensiveness and feasibility of the project plan." Each of the three is broken down into a range of micro-indicators that contribute toward the final points score.

11 As mentioned, the analysis of cast and crew took into account: 459 FEFs (40 by women, 419 by men); 547 DF/SFs (79 by women, 465 by men, 3 by mixed teams); and 264 shorts (48 by women, 210 by men, 6 by mixed teams).

12 The aforementioned CENTRIC software collects data on a film's cast and crew on the basis of its title, year, and director, leveraging six online databases. The system guessed the gender of subjects based on first names in 17 languages; around 5% of names could not be processed, and their gender was assigned manually, after consulting their biographies. The label "Ambiguous" was assigned to names which could not be conclusively assigned a gender. The final database included 18,994 professionals and around 1,000 public and private companies and institutions, and it was used to generate networks of professionals, wherein linked subjects worked on the same film.

13 There is another conspicuous absence in these representations of creative networks: actors and actresses. We excluded them for practical reasons (they are so numerous they would render the clusters unreadable) but also methodological ones. The way in which the databases consulted by CENTRIC catalogue actors and actresses does not necessarily reflect whether they are main or secondary actors in the films. Different databases also have longer or shorter cast lists, which would skew the database and require a manual intervention of homogenization that was not possible for this article.

14 Density is used to measure the relationship between the totality of nodes (in our case, the total number of professionals in our census) and the number of nodes that connect with each other.

15 The need to reclaim media (and social) representations of women is introduced in film and media studies in a systematic way in the 1960s, during the Second Wave of feminism and the development of feminist film criticism. More recently, the question of representation has been further developed through the debates on intersectionality, which suggests that interpreting and redressing gender inequality in media (and social) discourses need to take into account the interweaving of differences and forms of subalternity, in terms of class, race, colonialism, imperialism, ability, age, and so on.

References

Barca, F. (2018). Le diseguaglianze di genere nella società dello spettacolo. *Economia della cultura*, XXVIII(1–2), 163–172.

Bellour, R. (2012). *La Querelle des dispositifs: Cinéma—installations, expositions*. Paris: P.O.L.

Bruno, G., & Nadotti, M. (1988). *Off screen women and film in Italy.* London and New York: Routledge.

Butler, A. (2019). *Displacements. Reading space and time in moving image installations.* London: Palgrave Macmillan.

Casetti, F. (2015). *The Lumière Galaxy. Seven key words for the cinema to come.* New York: Columbia University Press.

Casetti, F., & Fanchi, M. (Eds.). (2006). *Terre incognite. Le spettatore intaliano e le nuove forme dell'esperienza di visione del film.* Rome: Carocci.

Cattani, G., & Ferriani, S. (2008). A core/periphery perspective on individual creative performance. Social networks and cinematic achievements in the Hollywood film industry. *Organization Science, 19*(6), 824–844.

Centre national du cinéma et de l'image animée. (2019). *La place des femmes dans l'industrie cinématographique et audiovisuelle.* Retrieved 31 January 2020 from https://www.cnc.fr/professionnels/etudes-et-rapports/etudes-prospectives/la-place-des-femmes-dans-lindustrie-cinematographique-et-audiovisuelle_951200

Cucco, M., & Manzoli, G. (Eds.). (2017). *Il cinema di Stato. Finanziamento pubblico ed economia simbolica nel cinema italiano contemporaneo.* Bologna: Il Mulino.

De Rosa, M. (2013). *Cinema e postmedia. I territori del filmico nel contemporaneo.* Milano: Postmedia.

DL 28/2004. *Riforma della disciplina in materia di attività cinematografiche.* Retrieved 31 January 2020 from https://www.camera.it/parlam/leggi/deleghe/04028dl.htm

European Audiovisual Observatory. (2019). *Gender imbalances in the audiovisual industries.* Retrieved 31 January 2020 from https://search.coe.int/observatory/Pages/result_details.aspx?ObjectId=0900001680946134

EWA. (2016). *Where are the women directors in European films? Gender equality report on female directors (2006–2013).* Retrieved 31 January 2020 from https://www.ewawomen.com/research/

EWA: European Women's Audiovisual Network. *Facts and figures across Europe.* Retrieved 31 January 2020 from https://www.ewawomen.com/resources/

Fanchi, M. (2020). *Equality illusions. Finanziamento pubblico del cinema e politiche di "genere."* In D. Missero & D. Holdaway (Eds.), *Il sistema dell'impegno nel cinema Italiano.* Milan: Mimesis.

Freeman, M. (2016). *Industrial approaches to media: A methodological gateway to industry studies.* London: Palgrave Macmillan.

Friedberg, A. (2000). The end of cinema. Multimedia and technological change. In Ch. Gledhill & L. Williams (Eds.), *Reinventing film studies* (pp. 438–452). New York: Arnold.

Gaudreault, A., & Marion, Ph. (2015). *The end of cinema? A medium in crisis in the digital age.* New York: Columbia University Press.

Gledhill, Ch., & Knight, J. (Eds.). (2015). *Doing women's film history: Reframing cinemas, past and future,* Champaign: University of Illinois Press.

Greco, M. (2002). *Il digitale nel cinema italiano. Estetica, produzione, linguaggio.* Turin: Lindau.

Hansen, M. (2012). Max Ophuls and instant messaging. Reframing cinema and publicness. In G. Koch, V., Patenburg, & S., Rothöhler (Eds.), *Screen dynamics. Mapping the borders of cinema* (pp. 22–29). Wien: Synema.

Hartley, J. et al. (2013). *Key Concepts in Creative Industries.* London: Sage.

Hartley, J., Wen, W., & Li, H. S. (2015). *Creative economy and culture. Challenges, changes, and futures for the creative industries.* London: Sage.

Holdaway, D. (2017). La rete sociale del cinema di interesse culturale. In M. Cucco & G. Manzoli (Eds.), *Il cinema di Stato* (pp. 127–169). Bologna: Il Mulino.

Iordanova, D., & Cunningham, S. (Eds.). (2012) *Digital disruption. Cinema moves on line.* St. Andrews University of St. Andrews Press.

Italian Research Council. (2020). *DEA. Donne e Audiovisivo.* Retrieved 31 January 2020 from https://www.cnr.it/it/focus/068-21/dea-donne-e-audiovisivo

Jedlowski, A. (2015). *Nollywood: l'industria video nigeriana e le sue diramazioni transnazionali.* Napoli: Liguori.

Ji-Hoon, K. (2009). The post-medium condition and the explosion of cinema. *Screen, 50*(1), 114–123. https://doi.org/10.1093/screen/hjn081

Lobato, R. (2012). *Shadow economies of cinema: Mapping informal film distribution.* London: BFI.

Lobato, R. (2019). *Netflix nations: The geography of digital distribution.* New York: New York University Press.

Lobato, R., & Thomas, J. (2015). *The informal media economy.* London: Palgrave Macmillan.

Mascherini, E. (2009). *Glass Ceiling. Oltre il soffitto di vetro. Professionalità femminili nel cinema italiano.* Città di Castello: Edimond.

MEDIASalles. (2019). European cinema yearbook. Retrieved 31 January 2020 from http://www.mediasalles.it/ybk2019/index.html

Montanari, F. (2018). *Ecosistema creativo. Organizzazione della creatività in una prospettiva di network.* Milano: Franco Angeli.

Morandini, M. Sr., & Morandini, M. Jr. (2010). *I Morandini delle donne. 60 anni di cinema italiano al femminile.* Roma: Iacobelli Edizioni.

Ofcom (2019). *Diversity and equal opportunities in television.* Retrieved 31 January 2020 from https://www.ofcom.org.uk/__data/assets/pdf_file/0028/166807/Diversity-in-TV-2019.pdf

Paterson, C., Lee D., Saha, A., & Zoellner A. (Eds.). (2015). *Advancing media production research: Shifting sites, methods, and politics.* London: Palgrave Macmillan.

Rodowick, D. N. (2007). *The virtual life of film.* Cambridge, MA: Harvard University Press.

Simone, P. (Ed.). (2019). *Female directors in European cinema. Key figures.* European Audiovisual Observatory. Retrieved 31 January 2020 from https://rm.coe.int/female-directors-in-european-cinema-key-figures-2019/16809842b9

Smith, M., & Telang, R. (2016). *Streaming, sharing, stealing. Big data and the future of entertainment.* Cambridge, MA: MIT Press.

Sossi, T. (2000). *Dizionario delle registe. L'altra metà del cinema.* Rome: Gremese.

Tryon, C. (2009). *Reinventing cinema: Movies in the age of media convergence.* New Brunswick: Rutgers University Press.

Tryon, C. (2013). *On-demand culture: digital delivery and the future of movies.* New Brunswick and London: Rutgers University Press.

Università Cattolica del Sacro Cuore, CLAS. *Valutazione di impatto della Legge Cinema e Audiovisivo: Anni 2017–2018.* Retrieved 31 January 2020 from http://www.cinema.beniculturali.it/direzionegenerale/148/valutazione-di-impatto/

Women Film Pioneers Project. Retrieved 31 January 2020 from https://wfpp.columbia.edu/

11 Heritage, luxury fashion brands and digital storytelling

A content analysis on the web communication of the top 30 luxury fashion holdings

Giada Mainolfi

Introduction

As companies currently face the challenge of keeping up with rapid environmental and technological changes, the brand has become one of the few resources providing long-term competitive advantage (Hakala et al., 2011). In this context, consumers become less confident in the future, seeking reassurance from brands and products they buy. The digital transformation is defining new standards of service and experience requiring brands capable of shaping and implementing contextualized, consumer-centric propositions. Legacy businesses with analogue processes are judged by these new standards that can label them as obsolete and outdated. Fashion industry is one of the most challenging sectors highly impacted by global economic uncertainty and the rise of technology. Many fashion brands are still wondering how to win the digital challenge. Any digital manifestation of the brand should be aligned with the new needs of customers without eroding the value of the brand heritage and identity. Therefore, this implies two main conditions. First, becoming a digitally savvy brand can no longer be considered a separate business. Second, heritage is still a precious source of long-term competitive advantage for companies and a sense of security into consumers. Heritage brands may provide comfort in the past in order to be ready for the future. Aware of this issue, fashion companies must (re) start from their own heritage with the aim of defining a holistic approach to digital transformation (Lay, 2018). Brand heritage can be interpreted as the dimension of brand identity, which is based on the longevity and history of the company. Brand heritage is, in fact, the result of a consolidated relationship with the market resulting from a process of sedimentation of trusty and authentic relationships with its users. Authenticity and heritage (Beverland, 2005a, b) are tightly linked as they both relate to the enhancement of the brand, providing an excellent and top-quality experience (DeFanti et al., 2013). The most common characteristics associated with brands include heritage, craftsmanship, rarity, hedonic value and social value. In the light of this, heritage constitutes a crucial aspect of a brand bonding together history and tradition of the firm. However, history can be seen as the

exploration of an "opaque past" whereas heritage is a way to make history relevant for both present and future (Urde et al., 2007). Therefore, brand heritage embraces all timeframes, from the past to the present, transferring the most important values – coming from past times – into a contemporary space that even extends to the future (Wiedmann et al., 2011). It is interesting to note that the productive sectors traditionally most devoted to the enhancement of heritage – for example the luxury industry – are rethinking their heritage strategies with a clear downsizing of the weight of legacy, while, instead, traditional manufacturing sectors, such as the food sector, are investing more and more in the history of the company that acquires a more relevant role within the value proposition. With reference to this last aspect, the motivation can be traced back to the bursting affirmation of two emerging phenomena, namely the masstige phenomenon and the rise of the Millennial segment. "Masstige" (Mass Prestige) marketing can be defined as a contemporary market penetration strategy in which premium/high-value products are perceived as luxurious and targeted to a wide range of customers known as the "mass affluent" (Silverstein & Fiske, 2003). Therefore, the ability to communicate effectively with a younger audience – increasingly fascinated by the appeal of luxury – is becoming increasingly decisive. This condition becomes particularly challenging, especially when you have to tell the roots and the past of a brand. In such a scenario, it is clear that companies feel the need to manage their inheritance with greater care, since they have to find new and innovative communication codes that are respectful and consistent with the past. Therefore, the understanding of the constitutive dimensions of brand heritage becomes a basic phase for the identification of a correct heritage management strategy. From an academic point of view, even though marketing scholars recognize the importance of heritage as a distinctive and irreproducible asset of brand identity (Aaker, 1996; Urde et al., 2007; Hudson, 2011) – for example Urde et al. (2007) define the brand heritage as "a dimension of a brand's identity found in its track record, longevity, core values, use of symbols and particularly in an organizational belief that history is important" (pp. 4–5) – at present there are no contributions that have proposed an operationalization of the construct of brand heritage.

Based on a thorough literature review on brand heritage it has been possible to identify only two studies specifically focusing on the categorization of heritage components. However, these proposals entail a prevalently inductive approach and do not seem to be capable of completely recovering the theoretical domain of the construct. The first study can be found in Hakala et al. (2011), where, starting from the certainty that "definitions of brand heritage don't explain how to measure brand heritage per se" (p. 449), the authors propose a measurement model based on history, consistency and continuity of core values, product brands and use of symbols. The second is in a recent study by Wuestefeld et al. (2012), in which the authors outline a measurement instrument based of formative indicators, obtained

through exploratory interviews. Fifteen items emerged from their analysis: continuity, success images, bonding, orientation, cultural value, cultural meaning, imagination, familiarity, myth, credibility, knowledge, identity value, identity meaning, differentiation and prestige. Looking at the items, the extreme heterogeneity and – at the same time – overlapping of factors do not help to stigmatize the phenomenon of brand heritage. To address the aforementioned gap within the existing literature, the present study aims at developing an initial systematization of the brand heritage image, understood as a system of beliefs, opinions and images evoked by the heritage assets of a brand.

Specifically, through an explorative content analysis conducted on the web communication of luxury brands owned by the top 30 luxury corporations, the study tries to stigmatize the thematic structure of the communication adopted to promote the brand heritage. The decision to investigate the digital communication of luxury brands stems from three main motivations. First, the luxury sector – through its production of high symbolic value – represents an ideal investigative space for observing the process whereby a heritage is created. Second, the luxury sector has definitely abandoned the original digital scepticism towards the adoption of digital channels to enter a phase in which digital channels dictate the rhythms of corporate strategies. Third, the heritage of luxury brands is put to a difficult test as it has to appear both "perfectly modern to the society of the day and at the same time laden with history" (Wiedmann et al., 2012, p. 566).

Despite the complexity and limitations arising from the breadth of the construct, results provide a sufficiently clear and consistent picture of main conceptual categories that synthesize the image of the brand heritage. On the basis of this study findings, a series of implications of potential interest have been highlighted with the aim of supporting the integration between brand heritage literature and luxury marketing studies through the proposal of an initial categorization of brand heritage suitable for representing the system of beliefs evoked by the heritage of a luxury brand. The study has also made it possible to identify some useful implications for a correct approach of heritage management strategies.

The present chapter is divided into four main sections. In the first section an overview of luxury brand heritage is presented to underline its significance as a relevant research domain. In the next section, the research objectives and methods have been described. Thereafter, the third section is devoted to the analysis of the content and discussion of the findings. Final discussion and managerial implications are proposed in the last section.

Luxury brand heritage: towards a definition

Brand heritage, especially in the field of luxury, helps to enhance the value of the brand itself, allowing a company to sell the products at very high prices with high profit margins. Those companies operating in the luxury

industry are not simply selling clothes or accessories; they are selling quality, expertise and a mythical story. If it is true that heritage refers to a specific brand's past, it is also true that this aspect is able to confer credibility and durability to the brand itself. In the context described above, the brand heritage acquires great importance. Brand heritage is defined by Urde et al. (2007) as "a dimension of a brand's identity found in its track record, longevity, core values, use of symbols and particularly in an organizational belief that its history is important" (p. 5). All brands have a history, but only some of them have a heritage and "having a heritage does not in itself create value, only the opportunity to do so" (Urde et al., 2007, p. 13). The brand heritage can be interpreted as a dimension of brand identity representing the traceability of the brand in the collective memory, its longevity and its own symbols proper of the brand system. Brand heritage recalls brand's origins and incorporates the evolution of values, symbols and meanings associated with the brand, thus delivering authenticity and differentiation (Aaker, 2004; Merchant & Rose, 2013; Boccardi et al., 2016).

A threat could be seen in the possibility of remaining stuck in the past, forgetting that one of the fundamental tasks of a luxury brand is to remain relevant to contemporary consumers. One of the most important things, and even one of the trickiest, is to find a balance between an authenticity linked to the tradition and an innovation-oriented motivation. A brand that owns and values its heritage can reassure consumers: its established market presence over the years is a guarantee that it will continue to honour the promises made to consumers and to transmit the set of values, which has been delivered in the past. This aspect provides the brand an aura of splendour that makes it a real myth in the present days. Scholars confirmed that heritage is a significant value source for luxury brands (e.g., Ardelet et al. 2015; Dion & Mazzalovo, 2016, Halwani, 2019) to be preserved by linking the past, present, and future (Schultz & Hernes, 2012). However, as also maintained by Halwani (2019), a dynamic assessment of potential associations between heritage and luxury brands across the generations is absent. This condition does not help luxury companies to understand the proper heritage management strategy at a time where something is changing in terms of customer profiles. If generation Y and Z represent the new frontier of luxury consumption, brand heritage management cannot neglect the changes brought about these communities. Grown up in an overabundance of logos, the Millennial segment has developed a healthy resistance to the pressures of branding by favouring neutral and almost invisible brands. Following this perspective, the process aimed at recovering traditions and historical memories in order to highlight the brand's authenticity is still valuable but needs a rethinking. This recovery should not be static; the traditions are in fact meant to be re-interpreted in a dynamic perspective to be able to make them contemporary and accessible without losing the original emotions that they aroused in the past. A heritage brand is a brand that has chosen to present its own history in an emphatic manner and to

be given a precise positioning and a reliable identity: having a heritage does not mean to be vintage or having a nostalgic attitude but, on the contrary, to constantly seek a balance with modernity (Lucci & Sacchi, 2014). The heritage attribute is a strategic intangible component for products with a high symbolic value since it cannot be imitated by competitors. Therefore, companies operating in the world of luxury may exploit the strategic value of heritage to "mark" their presence in the marketplace (Mosca, 2017). However, many luxury brands heritage brands operate based on the wrong idea that heritage and history are interchangeable. Moreover, quality and high prices are not sufficient to sustain the luxury brand positioning. They must be accompanied by a story that gives the offer intrinsic as well as extrinsic values. A story can help to define the boundaries of heritage within the brand identity, thus guiding the perceptions owned by identity makers in terms of both brand image and brand satisfaction (Pecot et al., 2018). If these two outcomes positively satisfy expectations over time, they may generate feelings of trust towards the brand (*brand trust*), a deep commitment to reiterative purchases of the same brand (*brand loyalty* and *buying intention*) and, finally, a potential long-term affection which may lead to brand advocacy (Figure 11.1).

Consumers, even the youngest, seek trusty links with a brand's legacy. Until now it was clear that luxury consumers were ready to become brand ambassadors when the story being told was perceived as authentic and presented as a "digital" tale. This is still true but no longer sufficient. The storytelling strategy called to support brand heritage must identify innovative communicational codes respectful of the past but able to follow the metamorphosis of luxury meanings on the part of audiences. In this framework, the definition of heritage for luxury brands does not rely on tangible elements neither on the level of uniqueness enabled through the past.

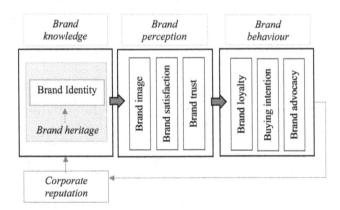

Figure 11.1 Management framework of brand heritage.
Source: Adapted by Schmidt et al. (2015) and Mainolfi (2018).

The differentiating factor lies in the ability to transfer sociocultural and symbolic values by moving the dialogue with consumers from consumerism to cultural exchange where authenticity merges with the identification of users' new needs (Bertola et al., 2017).

It is therefore clear that a wise, profitable and dynamic management of brand heritage must be supported by a theoretical framework encompassing valuable and well-discriminated components at the basis of the heritage creation process (Hakala et al., 2011).

Objectives and methodology of the study

Starting from the above considerations, the aim of the study is to carry out an empirical in-depth analysis on the digital communication of the brands belonging to the 30 most important luxury holdings in the world (Table 11.1). The aim is to compare the conceptual categories of the brand heritage with the communicative codes used by luxury fashion companies to express and transfer the symbolic value of their heritage. The content analysis was conducted on a total of 88 official websites of brands owned by the top 30 luxury corporations based on the annual report published by Deloitte, *The Global Power of Luxury Goods Companies, 2017.*

Data collection

The identification of the units of analysis was done through the selection of the official documents published by luxury companies on their brand websites. The selected documents were the ones describing the history, legacy, tradition and heritage of those companies. For reasons of clarity and in order to ensure linguistic consistency of the results, texts have been selected and downloaded exclusively in English. Based on a careful assessment of brand heritage literature (Urde et al., 2007; Rindell, 2010; Wiedmann et al., 2013), web sections were identified on the basis of the following keywords: "heritage", "brand heritage", "history", "tradition", "identity" and "inspiration".

Analysis of the corpus

Selected documents have been processed using the software Nvivo 12. The textual analysis consisted of three main steps (Bolasco, 2005). The first step of the analysis consisted in the *pre-treatment* of the data and was carried out through the normalization of the texts. In order to obtain a standardization of the orthographic variations, the software uniformed the textual forms thanks to the so-called *parsing procedure*. During this process, conjunctions and adverbs were added to the *stop word* list, and they were excluded from the analysis. The result of this phase is a list of all words present in the text. The list includes approximately 5,061 word-types

Table 11.1 Top 30 luxury goods companies

FY 2015 luxury goods sales ranking	Company name	Selection of luxury brands	Country of origin
1	LVMH Moët Hennessy-Louis Vuitton SE	Louis Vuitton, Fendi, Bulgari, Loro Piana, Emilio Pucci, Acqua di Parma, Donna Karan, Loewe, Marc Jacobs, TAG Heuer, Benefit Cosmetics	France
2	Compagnie Financière Richemont SA	Cartier, Van Cleef & Arpels, Montblanc, Jaeger-LeCoultre, Vacheron Constantin, IWC, Piaget, Chloé, Officine Panerai	Switzerland
3	The Estée Lauder Companies Inc.	Estée Lauder, M.A.C., Aramis, Clinique, Aveda, Jo Malone, Licensed fragrance brands	US
4	Luxottica Group SpA	Ray-Ban, Oakley, Vogue Eyewear, Persol, Oliver Peoples	Italy
5	Kering SA	Gucci, Bottega Veneta, Saint Laurent, Balenciaga, Brioni, Sergio Rossi, Pomellato, Girard-Perregaux, Ulysse Nardin	France
6	The Swatch Group Ltd.	Omega, Longines, Breguet, Harry Winston, Rado, Blancpain; Licensed watch brands	Switzerland
7	L'Oréal Luxe	Lancôme, Biotherm, Helena Rubinstein, Urban Decay, Kiehl's; Licensed brands	France
8	Ralph Lauren	Ralph Lauren, Polo Ralph Lauren, Purple Label, Double RL, Club Monaco	US
9	Chow Tai Fook Jewellery Group Limited	Chow Tai Fook, Hearts on Fire	Hong Kong
10	PVH Corp.	Calvin Klein, Tommy Hilfiger	US
11	Rolex SA	Rolex, Tudor	Switzerland
12	Hermès International SCA	Hermès, John Lobb	France
13	Lao Feng Xiao Co., Ltd.	Lao Feng Xiang	China
14	Michael Kors Holdings Limited	Michael Kors, MICHAEL Michael Kors	UK
15	Coach, Inc.	Coach, Stuart Weitzman	US
16	Tiffany & Co.	Tiffany & Co., Tiffany	US
17	Prada Group	Prada, Miu Miu, Church's, Car Shoe	Italy

(Continued)

FY 2015 luxury goods sales ranking	Company name	Selection of luxury brands	Country of origin
18	Burberry Group plc	Burberry	UK
19	Hugo Boss AG	BOSS, HUGO, BOSS Green, BOSS Orange	Germany
20	Fossil Group, Inc.	Fossil, Michele, Relic, Skagen, Zodiac, Mis t Licensed brands	US
21	Giorgio Armani SpA	Giorgio Armani, Emporio Armani, Armani, AIX Armani Exchange	Italy
22	Swarovski Crystal Business	Swarovski	Austria
23	Coty Inc.	Philosophy, JOOP!, Lancaster, Calvin Klein fragrance; Licensed fragrance brands: Marc Jacobs, Chloé, DAVIDOFF	US
24	Pandora A/S	Pandora	Denmark
25	Chow Sang Sang Holdings International Limited	Chow Sang Sang	Hong Kong
26	Christian Dior Couture SA	Christian Dior	France
27	Puig S.L.	Carolina Herrera, Nina Ricci, Paco Rabanne, Jean Paul Gaultier, Penhaligon's	Spain
28	Luk Fook Holdings (International) Limited	Luk Fook	Hong Kong
29	OTB SpA	Diesel, Maison Margiela, Viktor&Rolf, Marni	Italy
30	Gitanjali Gems Ltd.	Gili, Nakshatra, Sangini, Asmi, Passion Store	India

Source: Deloitte (2017).

with 28,499-word token. Words useful to interpret the content were selected from the list. The data were decomposed by using a process of open coding. The most recurrent words included: "brand" (275 times), "design" (236 times), "world" (222 times), "watch" (196 times), "first" (192 times), "new" (188 times), "products" (176 times), "innovative" (154 times) and "years" (132 times). The result of the text analysis is a word cloud offering a simple and effective graphic representation of the most frequent words associated with heritage communication (Figure 11.2).

Meaningful insights emerged from the comparison of the top five theme words across the corporations under investigation (Table 11.2). For example, with respect to the five most recurrent words of only the top ten holdings in the ranking, some similarities may be found. For example, with respect to the hard luxury product category, the Swatch Group and Kering SA have a similar discursive communication focused on theme words such as "brand", "world" and "innovation". The words "design" and "world" are present in four out of ten holdings. These two words highlight the importance of the global position for luxury brands that can be supported by a strong tension to design and creativity. Moreover, three corporations show the presence of both "design" and "world" in the top five words. The word "first" appears two times (2nd rank for both Compagnie Financière

Figure 11.2 Word cloud of the most recurring words.
Source: Author's elaboration.

Table 11.2 Top 5 most frequent words list considering the top 10 luxury fashion holdings

Companies	1	2	3	4	5
LVMH Moët Hennessy-Louis Vuitton SE	Design	House	New	World	Brand
Compagnie Financière Richemont SA	Watch	First	Watch-making	Movement	Manufacture
The Estée Lauder Companies Inc.	Make-Up	World	Fragrance	Create	Fashion
Luxottica Group SpA	Brand	Design	Eyewear	World	Style
Kering SA	Brand	Tailor	House	World	Innovation
The Swatch Group Ltd.	Watch	Watch-making	Brand	Innovation	World
L'Oréal Luxe	Beauty	First	Brand	Women	Skin
Ralph Lauren Corporation	Products	Brand	Design	Marketing	Accessories
Chow Tai Fook Jewellery Group Limited	Diamond	Perfect	Cut	World	Group
PVH Corp.	Brand	Design	Global	Collection	Women

Source: Author's elaboration.

Richemont and L'Oréal luxe). In these cases, it could be hypothesised that brands highlight their roles of innovators, confirming the dynamic nature of the heritage that can project the identity of the company into the future.

Analysis of the content and discussion of the findings

To comprehend the wider thematic structure of the different conceptual categories linked to heritage, for each selected brand, texts were codified and analysed for words and phrases alongside the highest-frequency words. This step identified the fundamental elements of the heritage and fragmented the text as a system of conceptual nodes. The nodes are a collection of references (i.e., words, phrases, paragraphs) about a specific topic. The detection of nodes brought out five main conceptual themes representing the corpus (Table 11.3): fascination, pioneerism, product features, longevity and roots.

Brand heritage as a fascinating world

The most important theme considering the total number of references is fascination. It includes all the categories directly referring to the canons which nurture the world of luxury in order to increase its aura of splendour and exert its charm on consumers. The identified nodes are "brand", "world", "design", "icon" and "uniqueness".

Table 11.3 Main conceptual themes

Themes	Nodes	N. of sources	References	Total n. of references
Fascination	Brand	85	275	862
	World	77	222	
	Design	75	236	
	Icon	41	69	
	Uniqueness	46	60	
Pioneerism	First	54	192	534
	New	66	188	
	Innovative	66	154	
Product features	Manufacture	27	90	323
	Style	42	86	
	Elegance	35	56	
	Quality	45	91	
Longevity	Time	44	112	278
	History	37	55	
	Company	38	111	
Roots	Name	32	64	273
	Tradition	38	92	
	Heritage	45	71	
	Family	24	46	

Source: Author's elaboration.

With respect to the word "brand", companies use it to explain the main features that enable them to be different from the competitors; this word is used to transfer the values to both loyal and potential customers:

> Impeccably crafted, Pomellato pieces have led the brand to embody a modern yet unconventional beauty, immediately recognisable per the Maison's signature style.
>
> (Pomellato)

> The brand is renowned for cutting-edge technologies and state-of-the-art materials, including silicium.
>
> (Ulysse Nardin)

> The brand is one of the most recognizable names in footwear; its award-winning shoes are worn by stylish women around the globe and by celebrities both on and off the red carpet.
>
> (Stuart Weitzman)

The high frequency of "world" means that each company highlights the idea of creating a true world with its products and expertise:

> the House welcomes its clients into a world that reflects its founding values and that is sold exclusively in Louis Vuitton boutiques.
>
> (Louis Vuitton)

all of which are elements that seamlessly translate in the world of Bottega Veneta.

(Bottega Veneta)

The world of TAG Heuer is intimately linked to motor racing and the division of time into infinitely small units, but its aura extends well beyond this arena.

(Tag Heuer)

However, "world" is also used to emphasise the aspect of having a global presence and a leading position all over the world:

Under the new vision of creative director Alessandro Michele, the House has redefined luxury for the 21st century, further reinforcing its position as one of the world's most desirable fashion houses.

(Gucci)

All over the world, the House welcomes its clients into a world that reflects its founding values and that is sold exclusively in Louis Vuitton boutiques.

(Louis Vuitton)

Reflecting a distinctive American perspective, we have been an innovator in aspirational lifestyle branding and believe that, under the direction of internationally renowned designer Ralph Lauren, we have had a considerable influence on the way people dress and the way that fashion is advertised and celebrated throughout the world.

(Ralph Lauren)

With reference to the word "design", it is used to refer to the role of the designer who gives a remarkable signature to the brand and the products, making them inimitable and aesthetically unique:

Emilio Pucci designs are instantly recognizable and embody a playful femininity that breaks with convention and looks at fashion in a new light.

(Emilio Pucci)

Miu Miu is a workshop of new design expressions that play with the kaleidoscopic nature of fashion, where experimentation is the expressive playground for spontaneous creativity.

(Miu Miu)

"Design" also refers to the functional characteristics of the products:

Distinctive soles and comfortable design embody the essence of Car Shoe, while quality materials, shape and precision of artisanal technique are the added value.

(Car Shoe)

Founded in 1967, Maison Pomellato has come to represent masterful Italian craftsmanship, profound goldsmith savoir-faire, and jubilantly distinctive designs.

(Pomellato)

Finally, "icon" and "uniqueness" are also used by luxury companies to create the myth surrounding the brand. In the difficult search for a balance between rarity and accessibility, luxury companies need to incessantly fuel the perception of uniqueness that distinguishes their products and makes them real icons. In particular, an "icon" is a representative symbol and can be constituted by either a product or a collection or the brand itself can be perceived as iconic. This is something related also to the mythical part of luxury goods and the aura built around them:

Founded by Spanish-born Cristóbal Balenciaga in 1917 and established in Paris in 1937, the iconic French fashion house defined the concept of modernity and elegance through the mastery of techniques and the use of innovative fabrics.

(Balenciaga)

Launched in 2003 as a premium service for the Selleria collection, a line made entirely by hand, the Fendi made-to-order service is now available for a selection of leather goods such as the iconic Baguette and Peekaboo bags.

(Fendi)

Its iconic collections, such as the Reverso which was born of the Art Déco movement in 1931, the Master, with classic and refined masculine lines, or even the Atmos, the pendulum, watch with almost perpetual movement, form the foundation for the Manufacturer's pride and the satisfaction of their loyal clients.

(Jaeger Le Coultre)

The pioneering vision of the luxury brand

The second theme, pioneerism, is characterized by the words: "first", "new" and "innovative". Undoubtedly, these three nodes highlight the pioneering tension of a brand. Being the first to have experienced or created a new product ensures an added value to the company and gives the consumer a greater guarantee that the product will be in line with expectations. To be a pioneer means to have experienced a new market or developed a new product or technology before competitors. This is strictly related to a long experience gained in a particular sector that enable the company to differentiate itself from others. The experience gained by a company in a certain field guarantees the satisfaction of consumer needs and distinguishes the

company from the others. Here are some examples emerging from the textual analysis:

> It is a reputation that even went beyond the borders of the Earth when Fendi put on a fashion show atop the Great Wall of China on October 19, 2007, making this breath-taking event the first show visible from the Moon!
>
> (Fendi)

> It was the first time that such pulsing geometric patterns had been incorporated into clothing and the effect was highly original, so much so that the international fashion press, smitten by his bold, radical approach, crowned him "The Prince of Prints.
>
> (Emilio Pucci)

Product features

The third theme identified is product features. Luxury companies could strengthen their competitive and superior position over time because their products have superior features capable of providing excellent performances and distinctive advantages. "Manufacture" is used to emphasize the deep-rooted artisanal tradition.

> Setting up his atelier in the Pucci family's grand palazzo in the heart of Florence, Emilio began working closely with expert fabric manufacturers in Italy to pioneer and patent revolutionary stretch fabrics that eschewed the heavy, rigid fabrications largely in circulation at that time.
>
> (Emilio Pucci)

> Founded in 1755, Vacheron Constantin is the oldest watchmaking manufacture in the world. At no time in its 260-year history has it ever stopped creating, enhancing and reinventing itself. Backed by a strong heritage of passing watchmaking excellence and stylistic ingenuity down generations of master craftsmen, the company's creations embody the exacting standards of Fine Watchmaking.
>
> (Vacheron Constantin)

"Style" is used to identify the distinctive presence of a brand as well as its core inspiration. It refers to the style and the brand identity but also to a personal style that the possession of a luxury product may confer:

> Each object is intended to enhance — not define — one's personal style and doesn't need to showcase any logo or initials that may hide its owner's ones. Wearing Bottega Veneta allows to reveal the inner strength

and confidence. Each detail is of essence, be it the strength of a seam, the size of a pocket, or the versatility of a garment.

(Bottega Veneta)

A byword for the Mediterranean basin and its evanescent beauty, Bulgari is driven by this inexhaustible source of inspiration. In all its creations, the House is distinguished by a personal style, which is daring yet sophisticated.

(Bulgari)

Elegance and quality, instead, are the core characteristics of luxury products. Elegance is associated with the aesthetic features of the product, whereas quality is mainly associated with the "pinnacle" value of a luxury brand:

Establishing a globally-recognized image, Carolina Herrera has resided at the helm of her eponymous label for over three and a half decades, proving with each new season that effortless elegance paired with modern refinement is always relevant.

(Carolina Herrera)

Eclectic, contemporary, romantic—Gucci products represent the pinnacle of Italian craftsmanship and are unsurpassed for their quality and attention to detail.

(Gucci)

Heritage: a timeless story

The fourth theme is longevity, developed by the words "time", "history" and "company", which together underline the presence of the brand over the years.

The history of the company is used like a framework for the entire narrative process as it gives common starting points. "Time" refers to the fact that luxury products retain their value over the years and therefore are timeless:

The integrity of Church's, both as a brand and as a product, lies in its timelessness and its ability to transcend time, age and generations.

(Church's)

Going beyond the Italian border and transcending time and fashion, Colonia became the exclusive perfume of high society, an unmistakable symbol of Italian elegance.

(Acqua di Parma)

"History" is a proof of longevity and success, testifying that a brand has been capable to adapt to the market and to leave its own mark:

> Few jewellery brands have such an illustrious history as the House of Harry Winston.
>
> (Harry Winston)

> This legendary history built around travel continues to place the House at the forefront of creation.
>
> (Louis Vuitton)

> Longines helped shape the history of the sporting world by introducing the first timing mechanism automatically triggered by an electric wire.
>
> (Longines)

"Company" is associated to the longevity of the brand and to its evolution through time.

> The company draws on both time-honored traditions and state of the art technology to offer its discerning customers products that are renowned for their peerless quality.
>
> (Loro Piana)

> The devotion to innovation coupled with TAG Heuer's heritage is propelling the company forward into the next millennium.
>
> (Tag Heuer)

The roots of the brand

The last theme is about the roots of a brand. It is the theme which assesses more in-depth the origins of the brand and includes the following conceptual nodes: "Name", "tradition", "heritage" and "family". "Name" is generally used to introduce the founder or designer, thereby enhancing his creativity and great impact on the company:

> Each print was like a work of art born upon a silk canvas, framed with a decorative border and signed in the artist's name – Emilio.
>
> (Emilio Pucci)

> Nicknamed the five fingers of the hand, it was they who, in 1965, invited a young German designer to join the House. His name: Karl Lagerfeld! After revolutionizing how to wear fur by fully reinterpreting it, transforming it into a fashionable, soft, light item of clothing, he launched the House's ready-to-wear collection in 1977.
>
> (Fendi)

"Tradition" is associated with craftsmanship and artisanal skills which are handed down over time within the enterprise and are an invaluable asset:

> Founded in 1848, the brand Lao Feng Xiang is a leader of innovation and expansion representing quality, culture, and a rich tradition within the luxury jewellery industry.
>
> (Lao Feng Xiang)

> Over the centuries, the company has shrewdly intertwined tradition with innovation to acquire the technical, aesthetic, artistic and human capital that shapes its vision of time.
>
> (Vacheron Constantin)

"Heritage" has a lower frequency than expectations. The majority of the brands tend to use it simply as a thematic section in their websites. They focus, instead, on the text it contains, aimed at enhancing all the aspects that are part of it. When "heritage" is present directly in the texts it expresses the link between past, present and future:

> It is imbued with the belief that a meaningful future comes from the transmission of a deep-rooted heritage.
>
> (Brioni)

> Bulgari's extraordinary success stems from this unquenchable desire to preserve its heritage while also looking energetically to the future.
>
> (Bulgari)

> The success of the Group and its iconic brand is rooted in innovation, craftsmanship and heritage.
>
> (Chow Tai Fook)

Finally, the references to "family" indicate that the brands were initially family businesses and that the values of families have shaped the identity of the brand:

> Since it was founded in 1895, five generations of the Swarovski family have reinforced the company's commitment to philanthropy and charitable giving.
>
> (Swarovski)

> Adele and Edoardo Fendi opened a small and medium leather goods shop and set up what was then a secret fur workshop. Success came quickly and was confirmed when their five daughters, Paola, Anna, Franca, Carla and Alda, decided to get involved in the family business bringing new energy and ideas.
>
> (Fendi)

Conclusion and managerial implications

The digital revolution has moved the competition into a new space where the management of luxury fashion businesses depends on the digital strategy. Consequently, the problem is no longer the integration between offline and online, but the creation of a prestigious atmosphere where offline and online merge together to create a unique brand experience (Gautam & Sharma, 2017). In response to this new digital wave, many fashion brands and retailers are obliged to innovate while at the same time being cost-conscious. Brands have started to improve their time delivery to market, as well as automate their core product design, manufacturing and supply chain process. However, in this context, the real challenge is – first and foremost – that of preserving the value of the brand. Firms need strategic guidelines to support a digital metamorphosis of the brand identity able to build sturdy relationships with their customers – that are getting younger and younger – in highly competitive business environment. Inevitably, therefore, brand heritage management also requires a strategic rethinking aimed at identifying new (digital) communication codes that interpret – in a contemporary spirit – the roots, the values and the symbols of the brand legacy. Therefore, managers today face the challenge of marketing a brand's heritage in a way that brings out its historical reliability but does not make it appear outdated. Brands representing stability, familiarity and trust can appeal to people in uncertain periods, helping to create an image of authenticity and integrity. Heritage is now acknowledged as a key organizational resource providing long-lasting strategic value: heritage makes companies unique and is the basis for superior performances leading consumers to be loyal and accepting higher prices.

However, the marketing literature has surprisingly underestimated the role of heritage as a component of a company's identity, devoting limited attention to the development of measurement scales representing the heritage components, and to the analysis of its effects on consumers' perceptions. Currently, due to the digital challenges, this knowledge gap appears particularly critical.

Based on these reflections, the study has adopted an inductive research approach with the aim of providing a seminal contribution to the understanding of the constitutive dimensions of the brand heritage domain in a digital context. The results of a content analysis of the discursive categories adopted in the web communications of 30 luxury fashion corporations, listed at the top of the Deloitte ranking of the largest luxury corporations, include a wide range of components that shape the heritage treasure and, at the same time, offer significant insights into digital storytelling strategies carried out by fashion companies.

Specifically, five themes have emerged from the textual analysis: Fascination, Pioneerism, Product Features, Longevity, Roots. While brand heritage dimensions included in past studies are characterized by overlapping

components that do not discriminate, for example, between history, longevity and identity, this study indicated that it is possible to trace a process underlying the emersion of the brand heritage on the part of a luxury brand. The pillars related to roots, longevity and product features describe the inner side of heritage based on craftsmanship, creativity, quality and values that the company has been able to transfer over time. Fascination and pioneerism, instead – called to enhance the heritage and the importance of "being the first" – are those components that can carry the brand into an omni-temporal dimension. The creation of a fascinating world surrounding the brand may increase the chance to comply with the cultural needs of new luxury consumers. The ability of the luxury company to convey potential customers into a symbolic scenario can increase the chance of transforming clients into "well-educated" brand ambassadors. This goal represents a huge opportunity to enter the top-of-mind luxury brands. Moreover, in terms of managerial implications, the practice of using heritage as a marketing tool is growing in importance among luxury brands. At a time when the "masstige" trap may erode the attractive power of the traditional qualities and features associated with luxury, the nourishment of the brand heritage can create a valuable protection for luxury brands. If the aim is to push the luxury consumer toward the apex of the pyramid (exclusive luxury), then success will derive from the ability to offer a unique emotional experience starting from the inimitable history of the brand. To do so, luxury brands should observe and metabolize the evolution in customer relationship management thanks to digital technologies.

The comparison between the communicative codes used by the brands belonging to the top 30 luxury holdings highlighted the aspects that they emphasize to express and transfer the symbolic values of brand heritage. Although exploratory in its approach, the present study contributes to the theories supporting the integration between brand heritage literature and luxury marketing studies through the proposal of an initial categorization of the conceptual categories representing the heritage of a luxury brand. The research shows that heritage is an element of great significance for luxury companies: it provides a unique competitive advantage and it can act as a barrier for companies belonging to the *masstige* category, which can hardly imitate it. The heritage is the distinctive and characteristic trait of the luxury companies, and it forms the basis for an effective storytelling. Results show that luxury fashion companies are using digital storytelling to protect and promote brand heritage. However, the proposal of a shared interpretative framework could facilitate brand heritage management giving the opportunity to organizations of shaping their constellation of elements across digital channels to allow their audience to draw from them, capture the truth about the brand and understand the corporate values, and, most importantly, digital storytelling is about evoking wonder and surprise.

The analysis gave empirical evidence to the theoretical construct of the heritage, interpreted as a dynamic timeframe between past, present and

future. In fact, if a brand wants to gain a competitive advantage using the heritage, it must create a dynamic storytelling: the focus should not be on the past, which is a static element, but the past should be considered a root from which drawing to actualize the dimensions and the core values of the brand.

Starting from the above considerations, strategic guidelines to successfully manage brand heritage may be stigmatized into three key activities: 1. categorizing the components that characterize the five dimensions of the brand heritage; 2. defining and implementing the most coherent heritage traits to be included into the heritage communication mix (off- and online); 3. ensuring consistency and authenticity between legacy, innovation and fascination.

Moreover, luxury fashion companies should also pay attention to the fact that the imaginary world recalled by the brand heritage can help the achievement of an effective communication towards new emerging markets. The ability of the luxury fashion company to convey potential customers into a symbolic scenario can increase the chance to transform clients into "well-educated" brand ambassadors. This goal represents a huge opportunity to enter into the top-of-mind luxury fashion brands.

References

Aaker, D. A. (1996). *Building strong brands*. New York: Free Press.

Aaker, D. A. (2004). Leveraging the corporate brand. *California Management Review*, 46(3), 6–18.

Ardelet, C., Slavich, B., & de Kerviler, G. (2015). Self-referencing narratives to predict consumers' preferences in the luxury industry: A longitudinal study. *Journal of Business Research*, 68(9), 2037–2044.

Bertola, P., Colombi, C., & Vacca, F. (2017). Managing the creative process. In E. Rigaud-Lacresse & F. M. Pini (Eds.), *New luxury management* (pp. 159–188). Cham: Palgrave Macmillan.

Beverland, M. (2005a). Brand management and the challenge of authenticity. *Journal of Product & Brand Management*, 14(7), 460–461.

Beverland, M. (2005b). Crafting brand authenticity: The case of luxury wines. *Journal of Management Studies*, 42(5), 1003–1029.

Boccardi, A., Ciappei, C., Zollo, L., & Laudano, M. C. (2016). The role of heritage and authenticity in the value creation of fashion brand. *International Business Research*, 9(7), 135–143.

Bolasco, S. (2005). Statistica testuale e Text-Mining: alcuni paradigmi applicativi. *Quaderni di Statistica*, 7, 17–53.

DeFanti M., Bird, D., & Caldwell, H. (2013). Forever now: Gucci's use of a partially borrowed heritage to establish a global luxury brand. In *CHARM proceedings*, 14–23.

Deloitte. (2017). *Global powers of luxury goods 2017. The new luxury consumer*. Retrieved 20 March 2019 from http://www2.deloitte.com

Dion, D., & Mazzalovo, G. (2016). Reviving sleeping beauty brands by rearticulating brand heritage. *Journal of Business Research*, 69(12), 5894–5900.

Gautam, V., & Sharma, V. (2017). The mediating role of customer relationship on the social media marketing and purchase intention relationship with special reference to luxury fashion brands. *Journal of Promotion Management, 23*(6), 1–7.

Hakala, U., Lätti S., & Sandberg B. (2011). Operationalising brand heritage and cultural heritage. *Journal of Product & Brand Management, 20*(6), 447–456.

Halwani, L. (2019). Making sense of heritage luxury brands: Consumer perceptions across different age group. *Qualitative Marketing Research, 22*(3), 301–324.

Hudson, B. T. (2011). Brand heritage and the renaissance of Cunard. *European Journal of Marketing, 45*(9/10), 1538–1566.

Lay, R. (2018). *Digital transformation. The ultimate challenge for the fashion industry.* Retrieved 5 January 2020 from http://www2.deloitte.com

Lucci, P., & Sacchi, S. (2014). *Brand jamming. Heritage marketing, co-branding, brand extension: l'evoluzione del branding.* Milano: Franco Angeli.

Mainolfi, G. (2018). *Luxury in a global and digital age.* Roma: Aracne Editrice.

Merchant, A., & Rose, G. M. (2013). Effects of advertising-evoked vicarious nostalgia on brand heritage. *Journal of Business Research, 66*(12), 2619–2625.

Mosca, F. (2017). *Strategie nei mercati del lusso.* Milano: Egea.

Pecot, F., Merchant, A., Valette-Florence, P., & de Barnier, V. (2018). Cognitive outcomes of brand heritage: A signalling perspective. *Journal of Business Research, 85*, 304–316.

Rindell, A., & Strandvik, T. (2010). Corporate brand evolution: Corporate brand images evolving in consumers' everyday life. *European Business Review, 22*(3), 276–286.

Schmidt, S., Hennings, N., & Wuestefeld, T., Langner, S., & Wiedmann, K. P. (2015). Brand heritage as key success factor in corporate marketing management: a review and synthesis of recent empirical studies. In *CHARM Conference*, 104–111.

Schultz, M., & Hernes, T. (2012). A temporal perspective on organizational identity. *Organization Science, 24*(1), 1–21.

Urde, M., Greyser, S. A., & Balmer, J. M. T. (2007). Corporate brands with heritage. *Journal of Brand Management, 15*(1), 4–19.

Wiedmann, K. P., Hennings, N., Schmidt, S., & Wustefeld, T. (2012). The perceived value of brand heritage and brand luxury. In A. Diamantopoulos, W. Fritz, & L. Hildebrandt (Eds.), *Quantitative marketing and marketing management* (pp. 563–583). Wiesbaden: Gabler Verlag.

Wuestefeld, T., Hennings, N., Schmidt, S., & Wiedmann, K. P. (2012). The impact of brand heritage on customer perceived value. *Der Markt, 51*(2/3), 51–61.

Webography

http://en.piaget.com/
http://eu.louisvuitton.com/
http://eu.tommy.com/
http://www.acquadiparma.com/
http://www.aveda.com/
http://www.balenciaga.com/
http://www.biotherm.com/
http://www.blancpain.com/
http://www.bottegaveneta.com/

http://www.breguet.com/
http://www.brioni.com/
http://www.bulgari.com/
http://www.carshoe.com/
http://www.cartier.com/
http://www.chowtaifook.com/
http://www.clinique.com/
http://www.clubmonaco.com
http://www.donnakaran.com/
http://www.emiliopucci.com/
http://www.esteelauder.com/
http://www.fendi.com/
http://www.girard-perregaux.com/
http://www.harrywinston.com/
http://www.heartsonfire.com/
http://www.helenarubinstein.com/
http://www.iwc.com/
http://www.jaeger-lecoultre.com/
http://www.jomalone.com/
http://www.kiehls.com
http://www.lancome.com/
http://www.laofengxiang.com/
http://www.loewe.com/
http://www.maccosmetics.com/
http://www.michele.com/
http://www.montblanc.com/
http://www.oakley.com/
http://www.panerai.com/
http://www.passionstone.com/
http://www.persol.com/
http://www.pomellato.com/
http://www.rado.com/
http://www.ralphlauren.com/
http://www.ray-ban.com/
http://www.relicbrand.com/
http://www.tagheuer.com/
http://www.ulysse-nardin.com/
http://www.urbandecay.com/
http://www.vacheron-constantin.com/
http://www.vancleefarpels.com/
http://www.viktor-rolf.com/
http://www.vogue-eyewear.com/
http://www.ysl.com/
https://asmishop.in/
https://eu.stuartweitzman.com/it/home/
https://it.calvinklein.com/
https://joop-fragrances.com/
https://misfit.com/
https://oliverpeoples.com/

https://uk.diesel.com/
https://uk.pandora.net/
https://www.armani.com/
https://www.benefitcosmetics.com
https://www.burberry.com
https://www.calvinklein.com/
https://www.carolinaherrera.com/
https://www.chloe.com/
https://www.chowsangsang.com/
https://www.church-footwear.com/
https://www.coach.com/shop/women-handbags
https://www.dior.com/
https://www.fossil.com/
https://www.gucci.com/
https://www.hermes.com
https://www.hugoboss.com/
https://www.jeanpaulgaultier.com/
https://www.johnlobb.com/
https://www.lancaster-beauty.com/
https://www.longines.com/
https://www.loropiana.com/
https://www.lukfook.com/
https://www.maisonmargiela.com/
https://www.marcjacobs.com/
https://www.marni.com/
https://www.michaelkors.com/
https://www.miumiu.com/
https://www.ninaricci.com/
https://www.omegawatches.com/
https://www.pacorabanne.com/
https://www.penhaligons.com/
https://www.philosophy.com/
https://www.prada.com/
https://www.rolex.com/
https://www.sergiorossi.com
https://www.skagen.com/
https://www.swarovski.com/
https://www.tiffany.com/
https://www.tudorwatch.com/
https://www.zodiacwatches.com/

Part IV

Digital tools for the arts

12 Cultural heritage on social media

The case of the National Museum of Science and Technology Leonardo da Vinci in Milan

Lala Hu and Mirko Olivieri

Introduction

Digital media have penetrated many aspects of daily practices; indeed, they are already so embedded in people's lives that users rely on them for several purposes, including searching for product information, writing reviews and recommendations about their experiences (Kapoor et al., 2018).

In the context of art and culture organizations, social media have created new possibilities for museums to exploit their assets and provide customer value in new ways (Gerrard et al., 2017). Through the web, museums can break their traditional value chain thanks to innovation: before digital transformation, the transmission of knowledge and also of the artistic heritage mainly took place in a top-down logic, while now social media users can contribute to the dissemination of this knowledge (Zott et al., 2010; Padilla-Meléndez & del Águila-Obra, 2013).

As regards the world of art and culture, according to Taylor and Gibson (2017) digital technologies have made heritage less dependent on experts. In fact, thanks to social media, everyone can express comments and opinions even if he/she is not an expert and his/her opinion can reach a vast number of people (Kaplan & Haenlein, 2010). However, heritage organizations also find difficult to adopt digital technologies. Main reasons are related to administrative and financial constraints (for example, a limited budget) or a lack of necessary skills to develop a digital strategy (Gombault et al., 2016).

Hence, the objective of this study is to understand the role of digital technologies and social media in the communication between museums and visitors. We conducted a systematic review to understand the most important dimensions of the relationship between visitors and museums on social media, and the opportunities provided by these touchpoints to interact with their target. In the empirical part, we adopted the case study methodology in order to analyze the digital communications strategy of the National Museum of Science and Technology Leonardo da Vinci, based in Milan. We carried out an in-depth interview with the museum's Head of Digital activities, who was the appropriate key informant for our research.

The remainder of this chapter is structured as follows: first, we provide a literature review on digital transformation, focusing on the art and culture context. Second, we present the case of the Museum of Science and Technology, focusing on their digital strategy and social media engagement activities. Last, discussion and managerial implications conclude.

Digitization and social media in the arts

Nowadays, digital and social media represent relevant touchpoints for firms and organizations to connect and engage with their targets (Lemon & Verhoef, 2016). As compared to traditional media, social media can enact more direct conversations with users thanks to the creation of user-generated content (Kaplan & Haenlein, 2010). Social media can be defined as a range of activities born from the integration among technology, interaction, and production of contents (Iasimone & Solla, 2013). Alternatively, they can also be defined

> as Web-based services that allow individuals to (1) construct a public or semi-public profile within a bounded system, (2) articulate a list of other users with whom they share a connection, and (3) view and traverse their list of connections and those made by others within the system. The nature and nomenclature of these connections may vary from site to site.
>
> (Boyd & Ellison, 2007, p. 211)

While their technological characteristics are fairly consistent, the cultures and communities that emerge around social media are varied. According to Boyd and Ellison (2007), some social media target a diverse audience, while others attract people based on a common language or racial, sexual, gender, religious, or nationality-based identity. Social media also vary to the extent that they incorporate new information and communication tools, such as mobile connectivity, blogs, and photo or video sharing.

As regards the world of culture, the digital transformation has meant that the art is now transferred from a physical to a virtual space. According to Royakkers et al. (2018), the world of art and culture has been deeply affected by digitization. This rapid progress and technological inventions have also impacted art: if the computer can be considered primarily a simple technological tool, for others it is like a resource in itself creative. Computer technology has provided artists with various tools for work and interaction; indeed, some artists have used technologies only as assistance methods, others as real creative resources. Initially, artists used the computer to obtain simple images, but with the development of digital technologies, we have moved quickly from simple images to three-dimensional images (Batur, 2012).

The recent literature points out that the sector of art and culture has been strongly affected by the impact of new technologies. Digital technology in

museums enhances an active engagement with art, thereby fostering art education, which yet increases the importance and difficulty of content management (Enhuber, 2015). According to several scholars (Padilla-Meléndez & del Águila-Obra, 2013; Taylor & Gibson, 2017), due to the advent of digital technology, the digital transformation of cultural heritage represents a challenge to make cultural heritage accessible to everyone. The initiatives for the digital transformation of cultural heritage have already progressed significantly and the advantages of international access to cultural artefacts are evident.

Furthermore, greater access to digital devices in art collections would have an important democratizing effect, especially if they allowed them to be seen outside their spaces (Besser, 1997). As for museums, Henning (2006) pointed out the attraction of digital transformation and new media in terms of the promise of democratization. Furthermore, expectations on the democratizing impact of digital platforms and social media on cultural heritage have already been discussed (Missikoff, 2006). All these new searches and formatting in the field of art have led people to very different orientations exposed in the lived environment and age. The most important reason for this is that technology continues to evolve and is growing rapidly, which is why the effect of technology on art is always greater. Moreover, the contribution of technology to contemporary art is important: for some contemporary artists, who use digital technologies as a tool of creativity, the main purpose is undoubtedly inclusion to the viewer in their own works of art (Batur, 2012). In this sense, the public becomes an important part of the work: these artistic works showcase the interaction between viewers and artworks.

The advent of social media in artistic organizations has been analyzed in a study by Padilla-Meléndez and del Águila-Obra (2013), who focused on the online performance of different artistic organizations based on both their use and use of users on social media. However, in this area the literature has focused mainly on the relationship between social media and museums (Gerrard et al., 2017). Multimedia information systems, based on the use of the Web and social media, have allowed museums to redesign traditional products and promote new cultural experiences that involve a huge network of potential visitors, that now will be able to take part in the production of the cultural service even from a distance. As a result, a correct understanding of how museum visitors use social media in their daily life is necessary for the success of museums in the age of new technologies (Marty, 2008).

Several studies on the impact of the Internet on the development of museum policies have shown that using the Internet is useful for their business activities (Padilla-Meléndez & del Águila-Obra, 2013). Other research (Marty, 2008) has focused on the need for museum professionals to think critically to their websites and their virtual pages to ensure that the information provided for visitors is correct. In fact, visitors to online and

in-house museums are not considered separate entities, but it is important for museum professionals to understand how the needs of museum visitors change over time to develop a complementary and supportive relationship between physical museums and the online presence of museums.

In sum, there is a scarce presence of interaction on museum websites and there are significant differences in the use of technological tools between countries and categories (López et al., 2010). The use of social media by museums has been classified into three organizational structures (Kidd, 2011): marketing (which promotes the face of an institution), inclusiveness (which develops a real and online community around the museum), and collaborative (which goes beyond communication and promotes collaboration with your audience). Indeed, social media support and facilitate viral marketing, which helps to stimulate word-of-mouth among customers. For example, a suggestion given by a Facebook user can reach an unlimited number of people and influence it. Therefore, an update of the museum's profile in social media and a regular stimulation of its community are to be considered necessary (Hausmann, 2012).

Thus, social media have created new possibilities for museums to exploit their cultural assets, allowing them to provide customer value in new ways. Bautista (2014) argues that technology is a tool for museums to achieve certain goals and support the experiential infrastructure. More recent studies (Light et al., 2018) have shown that social media have gained a significant role in the museum business, radically changing visitors' museum experiences. In particular, the role of social media has been to increase the involvement and connection of visitors with the exhibited works, modifying their meaning and interpretation. Therefore, social media have an important impact on a fundamental aspect of museums, which is to connect a diversity of visitors: in fact, new technologies represent an enabling element in this sense (Bautista, 2014). The web, by definition, facilitated the culture of participation (Jenkins, 2008): in this sense, connection and participation are fundamental for the dissemination of culture. At the base, there is the idea that museum is a place of formal and informal learning, that is, a form of "educational free time" (Hanquinet & Savage, 2012).

Nowadays, the museum user is no longer satisfied with limited access to information on museum collections, and many visitors want 24-hour access to data, regardless of where this data is located or how data is organized. The ability to manage information resources has long been an important skill for museum professionals, who try to meet these changing expectations: with the advent of social media, the challenge for culture professionals is to intercept and satisfy the visitor who is always connected to the virtual world, without losing the quality of information and guaranteeing the originality of their dissemination. In fact, access to digital devices has offered to users new ways to interact with each other and with museums.

Museum professionals must find ways to meet changing needs keeping pace with the times and with the evolution of new technologies. For this reason, museum professionals can no longer use a single data source for internal and external use, but they feel the need to share information on the Internet (Marty, 2008). Several online exhibitions have now become interactive and provide online visitors with immediate access to information resources which represent the latest knowledge on works of art. In fact, the diffusion of Web 2.0 technologies and social media, since the early 2000s, prompted museums to be present on digital platforms in order to bring social traffic through Facebook, Twitter and other social networks to stay up to date (Badell, 2015). Hence, this transformation has radically changed the process and the communication strategy in arts field: museums have moved from providing only a source for reference – that is, official website – to a variety of possibilities for interaction with users and among users themselves.

To establish this relationship through social media, museums need to understand the deep motivations and implications of their online visitors (Badell, 2015). In the past, social media adoption has often been viewed negatively by museums. For some, platforms like Facebook were considered "not serious communication channels" as they negatively influenced the museum's professional perception (Vogelsang & Minder, 2011). However, social media have transformed our society since most information now is delivered through the Internet. Digital platforms, indeed, represent an important channel through which to interact with visitors; this is also possible through blogs and wikis, multimedia archives such as YouTube, or via exchange platforms such as Facebook.

As previous studies have analyzed (Kelly, 2014; Enhuber, 2015; Taylor & Gibson, 2017), the impact of digital platforms has been relevant to the world of museums. It should be noted from the above literature review, however, that limited studies on social media are available in the museum field and this motivated the present study.

A case study: the National Museum of Science and Technology Leonardo da Vinci in Milan

Research question and methodology

The aim of this study is to understand the role of digital technologies and social media in the marketing and communications activities of museums. Our main research question is the following: *How do museums leverage on digital technologies and social media to communicate and engage with their target?*

As our objective is explorative, the appropriate methodology is the case study (Yin, 2009). We analyzed the digital strategy of National Museum of Science and Technology Leonardo da Vinci (Museo Nazionale della Scienza e della Tecnologia Leonardo da Vinci di Milano in Italian, hereafter,

Table 12.1 Descriptive data of the case study NMST

Name of the museum	National Museum of Science and Technology Leonardo da Vinci
Year of foundation	1953
Main collections	• The "Library of the sea" is a collection of about 3,600 volumes on the marine world in all its aspects; the Notebooks of NMST (i.e., workshop proceedings dedicated to telecommunications, scientific instrumentation, industrial heritage, naval collections, etc.); • The Scientific Records Documentary, consisting of over 2,850 thematic folders divided by topics and authors, preserves the preparatory documentation for Italy's participation in the 1933 Universal Exposition of Chicago a Century of Progress; • 16,000 technical-scientific and artistic products collected from the 1930s onward are part of the Museum's collections.
No. of employees	150
Website	www.museoscienza.org/english/

Source: Author based on corporate website.

NMST) in Milan by conducting an interview with the museum's Head of Digital activities, who has worked for the organization for 20 years; therefore, he is the appropriate key informant to provide an overview of the digital activities and strategies of the museum. The in-depth semi-structured interview was conducted in October 2019 and lasted over one hour. Upon the interviewee's consent, the interview was recorded and fully transcribed. We triangulated the primary data with secondary data, including the museum's webpages, social media accounts, and news articles regarding the museum. Researchers also carried out a participant observation in the NMST in December 2019. Table 12.1 contains the descriptive data of the case study.

Overview of the case study

The NMST was founded by the famous engineer Guido Uccelli (1885–1964) in 1953 to create an innovative museum in the center of Milan dedicated to industry and trade. Currently, its cultural heritage consists of the main collections (16,000 technical-scientific and artistic assets), an archive (paper and photographic), and a library (50,000 volumes and magazines), which showcase the history of science, technology, and industry from the 19th century to the present day. The NMST is the biggest museum of science and technology in Italy, and one of the most important museums of this kind in Europe. Their mission is to be a leader in informal education in Europe.

Regarding the digital team of the museum, four people are employed. Until a few years ago all activities were managed internally, today, due to

the specificities of digital technologies, the necessary skills and specializations have expanded so that some activities are outsourced. However, the key informant pointed out that it is important to keep the management of the digital strategy internally, although a lot of museums cannot afford it because of budget constraints.

Target description

Based on the collected data, the target audience of the NMST has evolved over time. Historically, the museum has two very clear and easily identifiable targets: one is represented by schools and the other is families. Since the 1980s, the museum has heavily invested in educational activities and developed a relationship with the scholastic world, so many visitors are composed of large groups of schools. At the same time, the other important target is the world of families, that is, the parents who bring their children to the museum mainly to participate at the workshop activities, which have greatly strengthened the relationship with families and above all have strongly structured the having an audience returning to visit the museum.

An important aspect emerged from the analysis of the case study is that in the last six years, after the museum greatly strengthened its offer, it has finally reached a new audience made of adults without children. As the key informant pointed out:

> Forty-year-old people have started to visit the museum as a place of culture without the need to visit it as a family unit. We see this phenomenon in the numbers, increase and at the same time, both thanks to the museum and the city of Milan, even foreign visitors are increasing: Milan has become a much more international city and this has also had following effects on museum visitors.

Hence, the target's expansion is evident because the museum begins to become a place of culture not only for schools and families, but also for adults without children. However, the great "black hole" of the young people who do not attend school remains, but probably, to reach this 20-year-old target, there is still a long way to go because this is an audience very difficult to reach for a science and technology museum. Some results on this audience can be achieved, for example, with activities about augmented reality or digital experiments, but it is still difficult to reach and engage them.

The museum digital strategy

The digital transformation, which gradually developed and led to the entry of digital languages into the museum, was described as "a long and complicated journey." As far as the NMST is concerned, the top management has

led to the creation of an internal digital team with professionals dedicated exclusively to online communication activities. Indeed, social media are a part of a broader framework which covers the whole enhancement of the museum's activities and which started before the birth and spread of the social media. The interviewed manager declared:

> In early years, it was difficult to integrate these languages and digital tools into the life of the museum and even the relationship with the other teams of the museum was not easy: gradually these instruments were integrated in the organization. Digital is now a connective tissue of our society and even the museum has made the digital strongly pervasive in all its daily actions: this is what the digital office generally tries to do. The digital world, in fact, has pulled down that wall of distance between institution and public and then continued has always strengthened the approach between these two worlds.

Social media have been fundamental in achieving the goal of approaching the museum target and making sure that the institution is perceived at the center of society. As the number of available digital tools are increasing, it is necessary to develop an integrated digital strategy. The platforms that the museum uses most frequently are Facebook and Instagram; Twitter is also active but used less than the first two social media. The museum is also present on YouTube, which, however, is used as a repository of unscheduled content. On this platform, audio-visual materials related to the museum's activities and events are collected: YouTube is mainly a visual showcase of what happens in the museum, but without a defined editorial calendar. Table 12.2 presents the results from the social media audit of NMST.

According to the key informant, for a museum the most important thing is to have a clear social media positioning with a recognizable identity. Therefore, it is necessary to create a flow of stories that can be diversified, but that must be homogeneous toward the public with an

Table 12.2 Social media audit of the National Museum of Science and Technology Leonardo da Vinci (as of 27 November 2019)

Social network	No. of followers or likes	No. of published content
Facebook	77,574 likes	n.a.
Instagram	11,100 followers	537 posts
Twitter	36,465 followers	5,840 tweets
YouTube	1,740 followers	182 videos

Source: Authors based on NMST social media's data.

identifiable tone of voice. This is important to gradually succeed in having a fan base that follows the museum with interest:

> The audience realizes and captures this authenticity through communication because our audience loves museums and is strongly judgmental towards this. The publics' love for museums is so strong that they claim to love this museum even more than those who work there, so they judge you based on that.

In the development of the digital strategy, it is necessary to monitor the electronic word-of-mouth (e-WOM): platforms such as TripAdvisor where users write reviews and express opinions are to be considered as a primary touch point.

Finally, influencers and brand ambassadors must be considered as important elements for a social strategy: at times the NMST has collaborated with experts or influencers of the sector. For example, when a celebrity, a famous singer, or a Youtuber was involved in activities in the museum, they were asked to share a promotional message (such as a video, a photo, or a post) on their own social media channels. Often, it happens that the location of the museum is booked by celebrities to shoot a video, and on that occasion the museum takes advantage of their presence, spreading the news on social media.

Engagement on social media

The interaction between an institution and its followers on social platforms is complicated, and it is achieved with hard and long work and dedication. From our research, it emerged that in order to establish a profitable relationship there is a need to focus on a series of elements, first of all the tone of voice:

> What we always try to keep very strong is a homogeneous tone of voice, which brings to the user a form of recognizability of the institution, of not having the feeling of finding a different communication tone of voice.

Although social media are spaces where haters could be easily present, the company must maintain a tone of voice appropriate to its role. Nevertheless, it was noted that in the museum field, the criticisms on the virtual pages are overall constructive as the public is passionate about culture. However, in terms of replies, social media managers should not contradict users but rather transmit the values that represent the identity of the museum.

In general, the interaction with museum visitors is positive because, as already mentioned, the target is very passionate ; therefore, they are curious to know the news of the museum and try new activities. As the manager pointed out:

> The synergy that is created with our users is very good because the public is very fond of us: even in the criticism and confrontation of a problem,

it happens that we interact with people fond of the museum and who hardly have a destructive spirit.

This is positive for the museum as it creates a strong relationship also thanks to the memory of past experiences shared together. For example, in August 2005 the Museum organized the shipment of the submarine *Enrico Toti* throughout the city of Milan until the museum building. This event was attended by thousands of people at night, creating a common memory around the event. Indeed, lots of Milan citizens still refer to the NMST as "the museum of Leonardo Da Vinci and Toti submarine." Moreover, this event is still exploited by the museum today as it has had a significant impact on people's memories and on the identity of the museum. Although the *Toti* delivery event happened in a period when social media did not exist yet, it is exploited by the NMST to create engagement on the museum's social media, leveraging on the fact that the event is remembered by the community with pleasure.

Therefore, to ensure that all these elements and contents relevant to generate engagement constantly dialogue on the different platforms, the NMST opted for a customer relationship management (CRM) logic by using a CRM software (i.e., Salesforce). The CRM tool communicates with all the catalogue record tickets and distributes the contents on an application. It is a centralized management of digital content, where the starting point is a list of contacts useful, for example, for the newsletter delivery. Among the museum's future challenges, there is the expansion of CRM tool also for the social management, which is still not automated:

> We are working with Salesforce to expand CRM also on social media management. Currently, we are the first reality in Italy with whom Salesforce has decided to work for free in order to use us as a case study and enrichment.

The sponsored posts are also part of the social media engagement strategy because of the limits of Facebook algorithms to reach organic users. NMST does not have a very large budget dedicated to sponsored content, but in some previous campaigns, they have noticed that even medium-sized investments can yield good results. Moreover, especially in the strategy phase definition, sponsorships should be planned on the basis of each individual objective: for example, if the goal is to increase the number of visitors and the recognition of the museum, it is important to focus on the museum's cultural offer and its values. According to the interviewed museum manager, these elements can help building a strong brand identity, recognizable by the public and stakeholders.

Discussion of findings and conclusion

The purpose of this chapter was to investigate the role of digital technologies and social media in the marketing communications strategies of museums, as well as the type of interaction between visitors and museums on digital platforms. We focused on the understanding of the characteristics that a museum's digital strategy should involve in order to engage visitors.

Based on our findings, the present study provides some suggestions for the social media management concerning the development and implementation of an effective digital strategy in the museum sector. For museums, digital technology is confirmed to enhance visitors' engagement (Enhuber, 2015). In accordance with Bautista (2014), specifically, social media have created new opportunities for museums to exploit their cultural assets: digital technologies are used as a tool to support the experiential infrastructure in the museums, but they can also develop a conversation with users before, during, and after the visit thanks to online platforms and e-WOM.

Nowadays, social media have increased their importance of a museum's digital strategy because of the change in visitors' experience (Light et al., 2018). Our findings highlight the importance of social networks to build positive interactions with visitors: museums should develop a clear and coherent social media strategy with a recognizable identity. This is fundamental to achieve the goal of approaching the target and make sure the represented institution can be perceived as an active part of society. From this study, it has emerged that, in order to establish a durable relationship with visitors, museums' communications should deliver a homogeneous tone of voice and originality in their content contents, and develop an integrated conversation with visitors on a variety of platforms. The combination of these elements within a long-term digital strategy will contribute to effective results in terms of visitors' engagement in the museum sector.

In future research, further investigations on the use of social media in museums could use an experimental approach to evaluate the effects of social media brand awareness and quantify their impact on museums' performance.

References

Badell, J. (2015). Museums and social media: Catalonia as a case study. *Museum Management and Curatorship*, 30(3), 244–263.

Batur, M. (2012). Space changing in the art with the digitalization. *Procedia-Social and Behavioral Sciences*, 51, 1035–1038.

Bautista, S. (2014). *Museums in the digital age: Changing meanings of place, community and culture.* New York: Rowman & Littlefield.

Besser, H. (1997). *The changing role of photographic collections with the advent of digitization.* In K. Jones-Garmil (Ed.). *The wired museum: Emerging technology and changing paradigms* (pp. 115–128). Washington, DC: American Association of Museums.

Boyd, D. M., & Ellison, N. B. (2007). Social network sites: Definition, history, and scholarship. *Journal of Computer Mediated Communication, 13*(1), 210–230.

Enhuber, M. (2015). Art, space and technology: how the digitisation and digitalisation of art space affect the consumption of art—A critical approach. *Digital Creativity, 26*(2), 121–137.

Gerrard, D., Sykora, M., & Jackson, T. (2017). Social media analytics in museums: Extracting expressions of inspiration. *Museum Management and Curatorship, 32*(3), 232–250.

Gombault, A., Allal-Chérif, O., & Décamps, A. (2016). ICT adoption in heritage organizations: Crossing the chasm. *Journal of Business Research, 69*(11), 5135–5140.

Hanquinet, L., & Savage, M. (2012). Educative leisure and the contemporary museum: Belgian case studies. *Museum and Society, 20*(1), 42–59.

Hausmann, A. (2012). The importance of word of mouth for museums: An analytical framework. *International Journal of Arts Management, 14*(3), 32–69.

Henning, M. (2006). New media. In S. Macdonald (Ed.). *A companion to museum studies* (pp. 302–318). Malden, MA: Blackwell.

Iasimone, A., & Solla, L. (2013). Sm-art (social media of art) for the Renaissance of culture on Web. *Procedia Chemistry, 8*, 302–306.

Jenkins, H. (2008). *Convergence culture: Where old and new media collide.* New York: New York University Press.

Kaplan, A. M., & Haenlein, M. (2010). Users of the world, unite! The challenges and opportunities of social media. *Business Horizons, 53*(1), 59–68.

Kapoor, K. K., Tamilmani, K., Rana, N. P., Patil, P., Dwivedi, Y. K., & Nerur, S. (2018). Advances in social media research: Past, present and future. *Information Systems Frontiers, 20*(3), 531–558.

Kelly, L. (2014). *The connected museum in the world of social media.* In K. Drotner & K. C. Schroder, (Eds.), *Museum communication and social media. The connected Museum* (pp. 64–82). New York: Routledge.

Kidd, J. (2011). Enacting engagement online: Framing social media use for the museum. *Information Technology and People, 24*(1), 64–77.

Lagrosen, S. (2003). Online services marketing and delivery: The case of Swedish museums. *Information Technology and People, 16*(2), 132–156.

Light, B., Bagnall, G., Crawford, G., & Gosling, V. (2018). The material role of digital media in connecting with, within and beyond museums. *The International Journal of Research into New Media Technologies, 24*(4), 407–423.

López, X., Margapoti, I., Maragliano, R., & Bove, G. (2010). The presence of Web 2.0 tools on museum websites: a comparative study between England, France, Spain, Italy, and the USA. *Museum Management and Curatorship, 25*(2), 235–249.

Marty, P. F. (2008). Museum websites and museum visitors: digital museum resources and their use. *Museum Management and Curatorship, 23*(1), 81–99.

Missikoff, O. (2006). *Assessing the role of digital technologies for the development of cultural resources as socio-economic assets.* In I. Russell (Eds.), *Images, representations and heritage* (pp. 139–159). New York: Springer.

Moro Sundjaja, A. (2015). An adoption of social media for marketing and education tools at museum industry. *Advanced Science Letters, 21*(4), 1028–1030.

Padilla-Meléndez, A., & del Águila-Obra, A. R. (2013). Web and social media usage by museums: Online value creation. *International Journal of Information Management, 33*(5), 892–898.

Royakkers, L., Timmer, J., Kool, L., & van Est, R. (2018). Societal and ethical issues of digitization. *Ethics and Information Technology, 20*(2), 127–142.

Taylor, J., & Gibson, L. K. (2017). Digitisation, digital interaction and social media: Embedded barriers to democratic heritage. *International Journal of Heritage Studies, 23*(5), 408–420.

Yin, R. K. (2009). *Case study research, design and methods.* Thousand Oaks, CA: Sage.

Zott, C., Amit, R., & Massa, L. (2010). The business model: Theoretical roots, recent developments, and future research. *IESE Business School Working Paper WP-862.* University of Navarra, 1–43.

13 Digital workers, well-being and networking

The case of transformational festivals and the importance of co-creation

Grant Hall, Raman Voranau and Ruth Rentschler

Introduction

The personal and professional benefits that one can access through engagement with arts activities are well documented (e.g., McCarthy, Ondaatje, Zakaras, & Brooks, 2001), including transformational festivals (TFs). Our research indicates that digitization has impacted TFs in relation to production and consumption in three key ways. First, digitization enables participants to begin the co-creation of their festival experiences in advance of the formal start of the event (through the use of online communication platforms to plan and self-organize). Second, digitization provides an array of technologies that TF participants incorporate into to art they co-create for TFs they attend. Third, digitization provides TF attendees with the tools they need to stay connected and collaborate on future projects. At TFs like Burning Man (BM), participants produce the arts experiences on offer whilst also consuming them in a process called *prosumption* (Chen, 2012). In this chapter, we examine digitization in TFs in regard to digital workers who use digital skills in their work as professionals, and the interplay of those skills with their engagement at BM. BM is a multi-day event popular with digital workers which has been classified as a *transformational festival* (Hall, 2019, p. 197). Academics have become increasingly focussed on the event to *explore how and why the culture is so inspirational and productive for so many of its participants* (Radziwill & Benton, 2013, p. 8).

Research indicates that digital innovation can be aided by "an investment of another kind, taking place upstream and independently of the production of a given project" (Salvador, Simon & Benghozi, 2019, p. 33), yet the spillovers from arts activities to digitality are underdeveloped compared with numerous studies on ICT impact on artistic creation. Accordingly, this paper is focussed on those who stand behind the development of new technologies – digital workers – with the objective of our research being to examine how engagement with arts activities at TFs can transform the way digital workers operate, and how their digital expertise is incorporated into

their TF experiences. TFs are relevant to this study due to the nature of the experience that participants engage in during the week-long anti-event that is called Burning Man.

The rest of this chapter is structured as follows. First, we undertake a literature review, examining digital workers, subjective well-being and networking. Next, we outline briefly the approach taken in this study. Then we present the findings on digital workers at TFs, i.e. BM, before the discussion and conclusion of the chapter.

Literature review

The research streams examined in the literature review entail digital workers, TFs, subjective well-being and networking. They are important to the case analysis because of the interlocking nature of digital workers engaging at a TF that may enhance their subjective well-being as they engage through networking. They are related to the core focus of this study, digital workers, as digital workers attended the event, BM, at which they found subjective well-being and networking to be core elements as part of the transformational experiences they underwent.

Defining digital worker

There is no universally accepted definition of digital work, and today it is hard to find a worker avoiding digital tools in everyday activities (Webster & Randle, 2016). Scholars have tried to capture the new nature of the work significantly altered by the emergence of information and communication technologies (ICT) using various terms since the 1970s. Whilst there is consensus in the literature about digital work being a diverse phenomenon, there is no consensus about definition.

In this study use the term *digital worker* rather than other terms, such as *virtual worker* or *digital labourer* (see, e.g., Fuchs, 2014; Webster & Randle, 2016; Huws, 2017), as ours is a management study. As Fumagalli, Lucarelli, Musolino and Rocchi (2018) notice *digital labour* is often provided in the studies emphasizing the violation of the workers' rights by means of ICT that is out of our focus. Also, *digital labour* is used within studies with an industrial (Fuchs & Sandoval, 2014) or corporate (Bukht & Heeks, 2017) focus, while we focus on occupational and individual data. The term *virtual* is put aside as it is still considerably associated with physically disembedded processes (Bukht & Heeks, 2017; Holts, 2018) and we do not consider characteristics of dislocation crucial in the focus of our research. In our study, we follow definitions of Huws (2017) and Durward, Blohm and Leimeister (2016) highlighting the role of product – digital content – and digital tools, used for production. Although activities within digital work can be paid or unpaid, in this study, we examine professionals who are remunerated for their work.

Digital technologies are permanently influencing artistic activities. They became a source of inspiration and main media for a growing number of creators shaping new curatorial directions in museums and art centres (Marchese, 2011). Digital technologies transformed the culture circle consisted of creation, production, dissemination, exhibition/reception/transmission, consumption/participation into culture network that merges different functions within online platforms (UNESCO, 2009) (see the notice about *prosumption* in the Introduction of this book chapter). Digital workers are the key figures for developing digital tools and services, enabling the growth of innovations (Brunow, Birkeneder & Rodríguez-Pose, 2018) and the success of digital economies worldwide (Dahlman, Mealy & Wermelinger, 2016). Digital workers are also active in cultural consumption (Campbell, O'Brien & Taylor, 2019). Despite the growing role of digital workers in artistic development, cultural consumption and the global economy, the benefits they search for and obtain from cultural consumption are still unclear.

BM has been selected as the case study because of its popularity with digital workers (Turner, 2009; Radziwill & Benton 2013) and the profound influence it has had on high-tech business communities (Turner, 2009; Radziwill & Benton, 2013; Bowles, 2014; Buhr, 2014; Trevena, 2017). Digitization is important to the experience at BM, from the use of credit cards for ticket purchase (while apologizing for its commerciality as an anti-event) (Kozinets, 2002), to the nature of the hi-tech activities in which participants engage, such as the creation of artworks and other experiences that incorporate digital technologies, such as computer-driven projections, interactive LED lighting and robotics.

Transformational festivals

Whilst BM has been classified within the academic literature as a *transformational festival* BM's organizers explain on their website that BM is *not a festival*, but rather something resembling a cultural movement (Hall, 2019, p. 197). BM was conceived by its organizers as an experimental event that temporarily created an experience that is meant to transform participants (there are no spectators) *whose economic and technological dynamic attrits and intrudes upon the integrity of the cultural process* (Harvey, 1997; Kozinets 2002). Hence, digitization has become central to BM experiences, as participants use digital technologies to communicate with others in advance of BM to organize their participation in the event (such as organizing transport, food, shelter and other co-created initiatives they may be involved with), mount arts installations onsite that incorporate digital technologies and keep in touch with the BM community following their participation with the event.

Subjective well-being

Subjective well-being has been deemed beneficial for individual arts festival participants, with studies finding that the event experience positively

influences self-identity, a sense of belonging, emotions and psychological fulfilment (Kitchen & Filep, 2019). The relationship between festivals and attendees' well-being is poorly documented (Kitchen & Filep, 2019) despite practitioners examining festivals as a growing aspect of well-being in tourism (Hjalager & Flagestad, 2012, p. 737).

Findings in the literature show a range of factors within festivals that contribute to the better well-being outcomes. The study by Packer and Ballantyne (2011) demonstrated how music festivals provide young people with a common ground to facilitate networking, feel a joint action, disconnect from everyday routine and *experience personal growth and self-discovery* (p. 178). Better well-being was associated with a balanced frequency of attendance (p. 177) and variety of experiences (Ballantyne, Ballantyne & Packer, 2013) with social facets being the best predictor of the well-being effects. Among the Australian population, participation in music events with active engagement demonstrated significantly higher well-being scores compared to passive music events (Weinberg & Joseph, 2017). However, none of these studies examined well-being for festival participants who are digital workers.

The contribution of an art event to subjective well-being depends on personality and can be diverse for different groups. Attendees of the film festival in Turkey from the local community perceived the event as a provider of social benefits contributing to their well-being (Yolal, Gursoy, Uysal, Kim, & Karacaoğlu, 2016). On the contrary, Liburd and Derkzen (2009) showed how international festivals in Denmark produced positive effects for participating artists from the local area but left most visitors from the local community feeling alienated and without sensing improvements in spiritual well-being. Lee, Hwang and Shim (2019) identified five attributes of the festival space that contribute to festivalgoers' experience: Escape, Playfulness, Togetherness, Sacredness and Placeness. They concluded that festival managers could enhance experiences in different ways for different audiences.

The findings within tourism management concur with studies about the relationship between cultural participation and well-being. Social interaction (Brown, MacDonald & Mitchell, 2015; Ferilli, Grossi, Sacco, & Tavano Blessi, 2017), moderate physical activities (Brown et al., 2015; Weinberg & Joseph 2017), environment (Grossi, Tavano Blessi & Sacco, 2019), diversity (Fujiwara, Lawton & Mourato, 2015) and quality (Wheatley & Bickerton, 2017) of engagements are critical factors within cultural activities contributing to the subjective well-being rather than artistic characteristics of the cultural participation.

Networking

There is a consensus that networking is essential for workers in the information age (Tymon & Stumpf, 2003). Digital workers are highly concerned with social networking, visibility and self-promotion, which they associate

with career and income opportunities. Networking plays a significant role in obtaining employment in the digital sector as it is precarious (Gandini 2016).

In the theory of networking, festivals are placed among the vital mechanisms that facilitate social interaction (Gilchrist, 2000). Nevertheless, the literature on the links between festivals and networking from the perspective of attendees is scarce. There is a strong demand for networking from festival attendees who are interested in an environment that fosters social interaction (Luonila & Kinnunen, 2019), as they are interested in co-creating the experience (Gyimóthy & Larson, 2015).

Social interaction within spectator-oriented festivals can be enhanced by design elements (Nordvall, Pettersson, Svensson, & Brown, 2014). Events produced around active participation rely on pre-existing personal, physical and situational factors (Andersson, Armbrecht & Lundberg, 2019), such as festival location and its non-commercial character (Larsen & Bærenholdt, 2019).

Method

Study setting

BM provides the context for this study. Considered a week-long, annual anti-market event in a remote, harsh desert setting (Kozinets, 2002), BM encourages discourses that disparage the market while nonetheless resulting in market products and services through participation in extreme activities, some of which use digitization as the means to solve challenges. As BM was conceived as an experimental project, with real and virtual activities which seek to alter participant practice, it is understandable that some activities are digitized. Furthermore, it is argued by Kozinets (2002), that is may be impossible to *escape the market* as BM seeks to do, given the results of participation that feed into business ventures. The Man is the central effigy for the event; it is burnt at the end of the week during wild night-long celebrations (Kozinets, 2002). BM originated in San Francisco in 1986, and now takes place in the desert in the US state of Nevada (Hall, 2019). Within the literature BM is variously described as bohemian, counter-cultural, party-like and drug infused, including "anarchists, drifters, and mystics in its community alongside the artists, engineers and academics" (Radziwill & Benton, 2013, p. 8). With annual attendances approaching 70,000, an ephemeral city called *Black Rock City* is established, which is dedicated to "community art", "self-expression and self-reliance" (Radziwill & Benton, 2013, p. 8; Hall, 2019, p. 196). The festival is symbolized by the ritualistic burning of a giant male effigy, the "burning man" (Hall, 2019, p. 196). In 2004, BM's Founder Larry Harvey laid out the "10 Principles of Burning Man" (Hoover, 2008, p. 5) which continue to act "as an informal social contract for the participants [...] providing a guide for how to relate to one another" (Radziwill & Benton, 2013, p. 8). These principles render BM a decommodified environment where financial exchanges are discouraged in

favour of a gift-based economy, and where participants are required to be self-reliant – which requires them to bring all of their supplies with them and leave without a trace upon departing. According to Turner (2009) for many Burners (people who have attended BM) "these principles have taken on a spiritual cast" (p. 84), and, when combined with the harsh desert location, this creates a highly unique event environment for participants.

Limbach (2014) explained that Burning Man is best known for its abundant art, including large-scale installations that protrude from the monotone earth like surreal trees in an unruly forest. Digital technology is often incorporated into the art (Brill, 2003), often through co-operation with digital workers. As Brill (2003) observed, "many of the artworks are site specific, and some are temporary, burned at the end of the event, leaving only a memory" (p. 342). The way the art is both produced and consumed at BM represents a point of difference from more conventional arts festivals. With an emphasis on participation and co-creation, and "no spectators" being a festival slogan (Chen, 2012, p. 571), burners are encouraged to engage with artistic and other creative activities such as "elaborate costuming, designing and decorating a campsite, constructing and driving an art car, performing dance or music, engaging in performance art and other collective activities at theme camps" (Chen, 2012, p. 581; Hall, 2019, p. 196). Hence, BM is perceived as transformational, using innovative processes to engage participants in creative activities.

Approach

We undertook a qualitative study in order to explore digital workers in the broader creative industries. Hence, the study took an interpretive approach using a constructionist paradigm. The constructionist paradigm lauds subjectivity, suggesting a stance of equality between researcher and researched. Thirteen semi-structured interviews with digital workers were used to collect data, an approach that is widely used in situations where the researcher seeks to develop theory. Following Bryman (2001, p. 351) an interview guide was prepared for this study which allowed the researcher "to glean the ways in which research participants view their social world whilst ensuring flexibility in the conduct of the interviews" (p. 317). The interview guide and the interview questions were informed by reading the relevant literature, informally discussing the questions with scholars, exploring existing interview questions from within the literature, such as Mackellar (2004) and Park, Oh and Park (2010), and through piloting the interview questions and protocols. Interviewees were drawn from high-tech communities using a snowball technique, where one interviewee led to the recruitment of another (Chadwick, Bahr, & Albrecht, 1984). The interviews were conducted between November 2018 and March 2019. Interviewees were asked in-depth questions about their work lives and their Burning Man experiences. In undertaking the semi-structured interviews, the researcher

analysed the recounted experiences of adults who have attended at least one BM event, as a means of unpacking how their BM experiences affected their professional lives. Interviews containing over 76,000 words combined were digitally recorded and analysed thematically using NVivo 11. Themes were devised using first-order and second-order coding, in a two-stage process.

Participant profiles

Participant profiles are illustrated in Table 13.1 which shows that the 13 interviewees are well educated, with all except one holding a university degree, three holding a bachelor's degree and the remaining nine holding graduate degrees. They are in their middle to mature years and have professional careers in innovation, as entrepreneurs or consultants, in technology, communications or marketing industries. The data are skewed with ten males and three females; ten people citing their ethno-racial background as Caucasian, one as Asian and one as Latino. Eight participants had attended BM multiple times, whilst five had been only once. Four participants reside in Australia, five are in North America, two are in Europe and two are in Asia. Table 13.1 summarizes the key demographics of the interviewees. Among the interviewees, all were digital workers with the majority being either entrepreneurs or being people who worked in roles where they need to employ entrepreneurial approaches or had entrepreneurial side-projects (some of which, such as a restaurant side-project, were not technology-focussed). Many of them were solo-entrepreneurs, or a founder or CEO of their own company. All of the interviewees held senior roles where they were responsible for leading the innovation processes of the workplaces or entrepreneurial projects they were involved with. Notably, most of them (8) hold multiple job roles, sometimes in diverse industries. Of the 13 interviewees, 11 had to fly vast distances in order to attend BM, whilst the remaining two interviewees resided in a state neighbouring Nevada and did not have to travel as far and could travel by land.

Findings

This section presents the findings that emerged from the data. The two key findings presented are well-being and networking. These two key themes are linked to the transformational nature of BM and the role played by digital workers. A particular note is paid to the workplace benefits that digital workers introduce as a result of being a BM participant.

Well-being

Physical well-being

The interviewees linked digital worker BM attendance to improvements to their subjective well-being. Such improvements ranged from physical fitness

Table 13.1 Interviewee profiles

Interviewee profiles

	Name	Current gender	Age range	Number of times attended BM	Ethno-racial background	Education	Employment description	Location and residency
1	AD	Female	30–39	5	White/Caucasian (non-Hispanic)	Bachelor's degree	Provides coaching services for tech founders and is a personal branding consultant.	From a western state of the United States. Self-identified digital nomad, mostly based in South East Asia.
2	FI	Male	40–49	3 (2012, 2014 and 2016)	White/Caucasian (non-Hispanic)	Graduate Degree	Provides guidance to entrepreneurs and holds a leadership role within a co-working association. Former start-up employee.	Australian, residing in Australia.
3	RJ	Male	50–59	More than 10	White/Caucasian (non-Hispanic)	Graduate Degree	Founder of two communications companies. Conference organiser. Author.	Resides in a western state of the United States.
4	RI	Male	30–39	3 (2008, 2009 and 2010)	White/Caucasian (non-Hispanic)	Graduate Degree	Senior innovation role within a wine industry start-up.	Australian, residing in Australia.
5	SC	Male	40–49	1 (2011)	White/Caucasian (non-Hispanic)	Graduate degree	IP lawyer and engineer within a tech company/Founder of a regional transformational festival	Australian, residing in Australia.
6	HI	Male	60–69	4 (2014, 2015, 2016, 2017)	White/Caucasian (non-Hispanic)	Graduate degree	Self-employed. Founder of maker spaces. Software developer.	Resides in a western state of the United States.

(Continued)

Interviewee profiles

	Name	Current gender	Age range	Number of times attended BM	Ethno-racial background	Education	Employment description	Location and residency
7	BZ	Male	40–49	8 (since 2009)	White/Caucasian (non-Hispanic)	Graduate degree	Former start-up founder. Writer and public speaker about start-up strategy.	Resides in an eastern state of Canada.
8	FC	Male	30–39	1 (2018)	Hispanic/Latino	Graduate degree	Start-up conference manager. Founder & CEO of two tech start-ups	From South America but residing in a western state of the United States.
9	RQ	Male	50–59	1 (2011)	White/Caucasian (non-Hispanic)	Bachelor's degree	CEO of a software company/restaurateur	Resides in a western state of the United States.
10	GC	Male	50–51	1 (2013)	White/Caucasian (non-Hispanic)	High school	Self-employed TV Producer	Australian, residing in Australia
11	GK	Female	30–39	1 (2018)	Asian	Bachelor's degree	Manager of a digital product-based company.	US citizen, self-identified digital nomad. Mostly based in South East Asia in recent years.
12	GI	Male	30–39	4	White/Caucasian (non-Hispanic)	Graduate degree	Academic and entrepreneur in the events industry (e.g.: academic and start-up events).	Resides in a Northern European country.
13	JD	Female	30–39	2 (2016, 2017)	White/Caucasian (non-Hispanic)	Graduate degree	Has just finished a senior role within a branding agency and is now the Chief Marketing Officer of a tech start-up.	Resides in a Northern European country.

through to improved emotional well-being, which resulted in increased levels of self-confidence, motivation and creativity, among other benefits. Attending BM is a physically and emotionally demanding experience, as participants seek to survive and thrive in a harsh desert environment. Interviewees relished the challenge of testing themselves in such conditions.

Amid the interviews were numerous stories of how participants were made stronger by their BM experiences – as AD, a consultant to tech start-up founders (among other roles) described, "BM is this powder keg compression chamber where you get put in, and it's only the strong who survive". The physical demands of BM were recounted by interviewees as they described attending yoga workshops, walking or riding bikes all day, dancing at parties and putting themselves into physical danger to construct art installations. Constructing art installations was a recurring theme that linked creativity with transformative learning in an extreme environment. For example, BZ, TL and JK each recounted working on the development of large-scale art installations that incorporated digital elements (such as LED lighting, projections or robotics), and the risks they took in creating these artworks (such as working on high scaffolding, the destruction of artworks due to extreme weather conditions and the dangers associated with working with fire based art works). The physical challenges helped SC, an intellectual property lawyer working in an environmental start-up who is also the chair of a regional festival based on the BM concept, in "terms of figuring out what I could physically achieve and realising that I probably wasn't as fit as I thought I was", whilst for FI, who leads a government agency to develop a regional start-up ecosystem, his BM experiences led him to make healthy improvements to his lifestyle – "I started to take care of myself better – I did a yoga teacher training course for a year".

Emotional well-being

Just as FI's BM experiences led him to make changes to the way he took care of himself, other interviewees recounted how their BM experiences precipitated profound personal changes in relation to their emotional well-being. AD, who, amongst other work roles, is developing a new personal development framework, explained the role of emotional well-being being a healing process at BM:

> There's a lot of healing around sexuality that happens at Burning Man... A lot of people have so much shame, and construction and rules around sexuality. Burning Man is like a place where they feel like they can drop that and express themselves in ways that they thought were off limits to them or that really reveals deep seated trauma or discomfort.

Other interviewees also spoke of emotional power of healing that can occur at a TF like BM. RJ, who has founded two successful communication

agencies, and who has been to BM over a dozen times since the 1990s, recounted a powerful personal story about how he was encouraged to go to BM in search of healing:

> My wife and I back then had had a rough experience in terms of a premature delivery of twins that we lost. It was a rough time for us. One day when I came back to work following that experience, a friend had put a candle on my desk that had a picture of the Man from Burning Man. Then it just had this beautiful quote on it about touching the flame. His suggestion was that what my wife and I needed was a healing journey by going to Burning Man. I felt it, and we did go ... and it was an incredible healing journey.

Others found the extreme conditions at BM not healing but exhilarating. As BZ, a successful tech-entrepreneur-turned-educator, author and conference organizer, recounted, "there are fewer and fewer chances to experience a place where it says on the ticket, you may die". In other words, BZ was responding to the thrill of being immersed in an extreme event in the desert, where emotional limits were tested as much as physical ones.

As demonstrated in these quotes, people experience emotional well-being in different ways in relation to their BM experiences. AD provided some insights about why people are likely to experience well-being at BM that transforms them, stating that

> when you're at Burning Man, you're like, cracked open to a degree that you wouldn't be in normal life - people are just so much more interested in trying new things at Burning Man, and pushing their boundaries and accepting that they can grow and change when they're in the container of Burning Man.

Subjective well-being reflects a change process known as transformative learning, which Mezirow (1997, p. 5) defined as "the process of effecting change in a frame of reference, whereby, frames of reference refer to the coherent body of experience which adults have". In other words, the *associations, concepts, values, feelings, conditioned responses* which are seen to *define their life world* (p. 5). Transformative learning processes have been characterized as having positive outcomes for the learner, and Moore (2005) provided a list of such outcomes which reflected improvements to well-being. Examples include improved self-confidence in new roles and relationships, a greater sense of personal power and spiritual growth, deeper compassion for others, new connections with other people, and increased creativity (p. 86). Within the interviews for this study, all of these outcomes were evident.

Almost all interviewees reported deriving an increased level of self-confidence in relation to their BM experiences, as AD reported, "the way

that I envision myself after Burning Man is far more as a doer and a giver and a leader whilst for GC (TV producer), it's inspired me to do more and bigger things". An increased feeling of connectedness was also predominant, as interviewees recounted becoming more community-minded and connected to others. As JD, a Chief Marketing Officer at a tech start-up, recounted, "people have an idea of what BM is, and then you go there, then it's actually so much more about the stuff that you don't see, like the emotions and relationships and connections". For SC, his newfound community-mindedness led him to starting and managing an innovative festival based on the BM concept:

> The way Burning Man has changed me is that it's made me more interested in community. It led me to get involved in founding our regional burn and running it. When I came back, I started looking for like-minded people, and a lot of the people I ended up bumping into had been to Burning Man. Because of that we had a common language, a common idea of like, let's see if we can start something.

SC then reiterated how he was changed by his BM experiences, explaining that "before I went I wasn't involved in community, I was just doing the everyday worker bee thing" and how "I've really changed a lot, becoming more involved in getting this community group up and running and trying to build a group of people whose common interests are developing art, making music and being creative". *Developing art* through co-creation at BM recurred a lot in the narratives of the interviewees, becoming a leitmotif in conversations with burners about their experiences at BM. AD provided an explanation about the role that such experiences at BM play in leading people to experience profound personal change:

> Burning Man takes you out of this transactional mindset where it's like: "I'm only going to give and participate and help if I can see a direct line to how it helps me." So that's the way our world has taught us to think, especially if we're talking and thinking business, but it's not how we think at Burning Man.

For regular burners, BM provides an opportunity for ongoing personal development. But businesses that employ burners also benefit from the improved well-being of their staff, such as their increased levels of self-motivation – as AD explained:

> There is a freshness to Burning Man. To me every burn is the beginning of the New Year, like the man burning is a much bigger New Year celebration for me than January 1. It's a marker to check in and see how far I've come and how much I've developed. And then also, it allows me to really come back to my work with a renewed sense of optimism, and

a strong feeling that one, I am the kind of person who can create ripple effects in the world [...] The way that I envision myself after Burning Man is like, far more as a doer and a giver and a leader and a participator than maybe what I feel when I'm coming into it.

AD's comments were reflected by other interviewees who recounted bringing the positive well-being effects that stemmed from their BM experiences into their workplaces, such as increased self-confidence and creativity. One such interviewee was RJ, who provided an example of how BM

gave me a different setting in my consciousness around what is really possible, and how Burning Man impacted how we came together not just as a company [...] because we became such a tribe and family beyond just the idea of a workplace [...] we were known as an IT company that brought a lot of technology and creativity together, something that I retro engineer that back to our experience at Burning Man and seeing how the latest technologies could also come together with creativity and make really cool things.

Creativity and *making cool things* are part of artistic experiences, illustrating the role of thinking outside the square had on transformative experiences.

Most interviewees discussed the well-being benefits they gained through their BM experiences. However, two interviewees cautioned that the use of narcotics by burners can have negative effects on their well-being. BZ pointed out, "there are tons of people who go there and develop horrible addictions or hook up with the wrong people or get really sick". Hence, experiences are not all positive. In other words, not everyone benefits from the physical and emotional well-being environment created by BM. Some participants ruin their mental and physical health.

In sum, BM catalyses profound personal changes (transformative learning) in relation to well-being. Such personal changes result in people feeling more confident, motivated, connected and creative, positive changes which they bring to their workplaces, and from which their employers' benefit. But not everyone as some destroy themselves by drug taking.

Networking

Digital workers demonstrated that they benefit from BM experiences in relation to networks burners access in relation to their BM participation. This finding may seem surprising as BM has a reputation for anti-corporate themes (Turner 2009) and takes place in a decommodified environment, yet the style of networking that stems from BM experiences differs from conventional corporate networking. As BZ explained, "it's almost frowned upon to be doing a LinkedIn style meeting at BM", whilst FC, founder of

two tech start-ups, pointed out that at BM, "you're in the desert; you don't have a business card".

Rather, burners build networks by doing things together and forging deep personal connections by doing so. The types of activities that interviewees recounted doing with others included: planning to go to BM, planning and building art installations, travelling to BM, setting up camp at BM, working on on-site projects, camping together, preparing food, consuming narcotics, exploring the site, partying and sharing other experiences. Of course, some of these networking behaviours, as we saw, contributed to either negative or positive social capital building, such as consuming narcotics versus planning art installations. Engaging with art was central to these experiences, as burners created art, took art-based workshops or explored and interacted with the art on offer. Through doing these things, burners developed networks that stem from their BM experiences, and subsequently collaborated with people in that network on professional projects in the default world. At the start of their BM journey, the networks burners were part of are typically loose affiliations; however, through their BM experiences, they subsequently develop established networks which they access in their professional lives. For example, BZ calculated that "there's probably ten people who I have had as speakers at conferences" whom he met at BM, whilst software developer HI explained how through his BM experiences, he has gained "a lot of great contacts throughout the industry - those who have helped serve my career since", and AD has gained clients in relation to her BM experiences.

Interviewees explained how such networks evolved. Conversations at BM typically were not focussed on work-related themes initially but could evolve into discussions about work. For example, in his interview, BZ explained that he developed good network contacts through his BM experiences, but when asked how he met such contacts, he explained, "I didn't actually talk to them about tech, like on the last day, I was like, 'oh, what do you do?', 'Oh, cool. Me too!'". FC, who met people at BM who later invested in his start-up company, also explained how such contacts were made at BM:

> I did meet other people that are collaborating on the project today from an engineer who works at [famous tech company] to investors - some of the investors that have invested in the company also went to Burning Man, and they love the idea that part of the conception of the project happened there. So yeah, there's definitely a network that starts to develop... After coming back, you try to keep in touch with the people you meet, the ones that you got to know. Many or most of my conversations were with people that I don't have any contact details for, but the few that you get the contacts for, they definitely become part of the network afterwards.

In discussing the evolution of networks that grew out of BM experiences, interviewees described the high degree of trust that exists amongst burners

as being a contributing factor that helps to bind burners together within such networks. For example, BZ explained how BM "helps people build trust in a really significant way, because you can trust that every burner around you is there giving and has got your back". As BZ described further, "if you have people who have been up that scaffolding with you, or had this preposterous idea they need made real, or you did something remarkable, it's almost like an induction ceremony". For BZ, being a burner was akin to being welcomed into an exclusive *club* that had a religiosity about it (the *secret handshake*) which was transformative and had an artistic element to it. To illustrate this emotion, he recounted an important meeting he had at a leading tech firm:

> I went into an office, and there was a gigantic picture of the playa [Burning Man site]..., like a panoramic shot on the wall behind the desk. And the person I was meeting said, "hey, how ya doin'?, Good to meet you — do you know what that is?" I looked at it and said, "yeah, that's the playa". He said, "okay", and that was like a secret handshake.

As such, the networks that burners form with other burners did not necessitate that they actually met at BM. As BZ explained, "there's the sense of, we have a shared experience, you have validated yourself, and somehow, we can be more candid". Such networks can provide burners with increased career opportunities, as indicated by the following story recounted by JD, where she describes how creative and artistic experiences at BM and outside it can be life-changing. It is sharing the arts experiences at BM that is part of the transformative experience:

> So many people have gone far from their life because this project has shown them what they can do – and now they can do so much more. For instance, a friend of mine was telling me how he's been collaborating with these Scandinavian artists and how he's just came back from Milan where he was building stuff for Fashion Week, and now he's going to Venice to work on the Biennale stuff. He's a carpenter and he's been able to realise so many things that he couldn't even imagine. And I think that's it ... It's about the relationships that have emerged from that, and now we're able to go and realise amazing things.

In sum, BM provides opportunities for participants to gain access to new, high-trust networks which they can exploit for personal, professional or commercial gain. Their networks and transformations are facilitated by arts experiences that range from art installations they created or experienced at BM to arts experiences that they can discuss that occurred somewhere else, such as the Venice Biennale. Networks evolve from loose affiliations through to established networks, through doing things together, or the acknowledgement of shared experiences, artistic, digital and networked.

Discussion and conclusion

The study responds to calls by Kitchen and Filep (2019) and Andersson et al. (2019) to improve understanding of well-being outcomes of events offering diverse experiences, in non-sport contexts and that require active participatory roles of visitors. Participation in BM, which is a transformational, art-focussed event with a high level of engagement, was shown to exhibit clear improvements in physical and emotional well-being, facilitated by co-created arts experiences, digital learning and networking, and enabled by digitization. The findings align with the literature highlighting the importance of physical activity during arts-related experiences (Brown et al., 2015; Weinberg & Joseph 2017). This study reveals that long-term physically demanding experiences can bring long-continued effects for well-being: re-assessment of the personal physical and psychological conditions and systematic improvements to lifestyle, brought about by participation in digital activities that are of benefit to introducing innovations in the workplace.

The prevailing view on art events is that they are positive contributors to the psychological well-being (Packer & Ballantyne, 2011; Ballantyne et al., 2013). Similar to other events, BM provides participants with feelings of increased self-confidence and motivation, personal growth and belonging to a community, facilitated by the arts experiences. The extreme emotional experiences create conditions for healing around sensitive matters such as sexuality and personal tragedies that are rarely documented in the other festivals. The effects we have identified of BM on well-being are helpful for digital workers. Beneficial effects of arts experiences can counteract some of the known negative characteristics associated with digital work – social isolation, uncertainty, poor work-life balance, lack of physical activities and limited time for learning (Gandini, 2016; Avdikos & Kalogeresis, 2017). The scope for future research includes projects on well-being effects of different types of art events or those provided in less extreme environments. BM is a special destination for ICT workers from high-tech communities (Turner, 2009, p. 74; Radziwill & Benton, 2013), where BM participation is sometimes considered a "sanctioned form of professional development that often appears on resumes" (Radziwill & Benton, 2013, p. 8). The further question still to be answered is whether digital workers can obtain similar effects by participating in other artistic events.

BM is an "extreme example of a participation event" (Andersson et al., 2019, p. 108); however, literature on event design that facilitates social interactions and networking does not fully explain the case of BM. BM is co-created by participants who are highly motivated before the event and who perceive themselves as a part of a *club*. The findings confirm the importance of pre-event activities and repetitive visiting for better networking (Wilks, 2011; Hawkins & Ryan, 2013), with the impact of the arts on transforming lives. In addition, the co-creational aspect needs to be emphasized, as it is

facilitated by digital technologies at each stage of one's BM experience. Digital workers participating in BM do not demonstrate a preoccupation with their professional networking and self-promotion during the event. However, the study exposes the effectiveness of participation in providing high-quality networking opportunities that derive from face-to-face communication rather than online resumes and business cards. Managerial implications relate to the well-being and networking benefits that digital workers can potentially gain through BM participation, and the increased productivity to which their employers will subsequently also benefit from. Further enquiries may concern identifying other competencies of digital workers that can be fostered by the participation in artistic activities. Creativity, adaptability, team work, focussed thinking, motivation and social intelligence will be essential for the digital workers of the future (Colbert, Yee & George, 2016; Lent, 2018), and as such, future investigations should focus on the professional benefits of engagement with arts activities.

BM shows one of the models that can be grown from the "classic" discussion about artists and engineers (Mellor, 2015). Artistic practices within BM go further than a creative collaboration between digital workers and artists and further than measurable spill-overs from technologies to arts and vice versa. The hyper-community and centrality of creativity to BM facilitates digital workers' artistic self-expression based on their deep expertise in digitality. The transformation from a digital worker to a digital artist brings positive effects that are known from the literature on active cultural participation, including better subjective well-being and growing networking (e.g., see: Packer & Ballantyne, 2011; Wheatley & Bickerton, 2017). The deeper level of engagement caused by the nature of *transformative* festivals enhances these effects significantly, as evidenced through the examples of well-being and networking. Digital workers/artists transfer the experience to their digital products in ways that can be realized not only in a code or a new lighting technology but in processes that can be consequently integrated into artists' practices.

The case of Burning Man reminds us that while thinking about spaces where arts meet digital, we should not narrow digitality to the particular high-tech products and internet services designed and coded by digital workers. The participants in our study mostly represent "managerial" workers in creative, non-routine positions resistant to mechanization. Further development of AI and robotics will make their roles in digitality even more critical. The impact of artistic events to the digital world can be compared with other spaces and events that are physical but making an impact on digitality, such as creative hubs or hackathons. The main value of creative hubs is in the connectivity of pro-active and creative participants. The decommodified and radically artistic nature, coupled with the well-being effects that BM brings about, reimagines the festival from a "creative hub" to "creative rehab" but with a huge role for the development of the digital.

References

Andersson, T. D., Armbrecht, J., & Lundberg, E. (2019). Participant events and the active event consumer. In J. Armbrecht, E. Lundberg, & T. D. Andersson (Eds.), *A research agenda for event management* (pp. 107–124). Cheltenham: Edward Elgar Publishing.

Avdikos, V., & Kalogeresis, A. (2017). Socio-economic profile and working conditions of freelancers in co-working spaces and work collectives: Evidence from the design sector in Greece. *Area, 49*(1), 35–42.

Ballantyne, J., Ballantyne, R., & Packer, J. (2013). Designing and managing music festival experiences to enhance attendees' psychological and social benefits. *Musicae Scientiae, 18*(1), 65–83.

Bowles, N. (2014, August 25). Ideate this: I'm Living at burning man's tech innovation camp. *Recode.* https://www.recode.net/2014/8/26/11630290/ideate-this-im-living-at-burning-mans-tech-innovation-camp

Brill, L. M. (2003). Introduction: Desert weirdness introduces a new era of art. *Leonardo, 36*(5), 341–342.

Brown, J. L., MacDonald, R., & Mitchell, R. (2015). Are people who participate in cultural activities more satisfied with life? *Social Indicators Research, 122*(1), 135–146.

Brunow, S., Birkeneder, A., & Rodríguez-Pose, A. (2018). Creative and science-oriented employees and firm-level innovation. *Cities, 78*, 27–38.

Bryman, A. (2001). *Social research methods.* Oxford: Oxford University Press.

Buhr, S. (2014, September 4). Elon Musk is right, burning man is silicon valley. *Techcrunch.* https://techcrunch.com/2014/09/04/elon-musk-is-right-burning-man-is-silicon-valley/

Bukht, R., & Heeks, R. (2017). Defining, conceptualising and measuring the digital economy. *Development Informatics Working Paper, 68.*

Campbell, P., O'Brien, D., & Taylor, M. (2019). Cultural engagement and the economic performance of the cultural and creative industries: An occupational critique. *Sociology, 53*(2), 347–367.

Chadwick, B. A., Bahr, H. M., & Albrecht, S. L. (1984). *Social science research methods.* Englewood Cliffs, NJ: Prentice-Hall.

Chen, K. K. (2012). Artistic prosumption: Cocreative destruction at Burning Man. *American Behavioral Scientist, 56*(4), 570–595.

Colbert, A., Yee, N., & George, G. (2016). The digital workforce and the workplace of the future. *Academy of Management Journal, 59*(3), 731–739.

Dahlman, C., Mealy, S., & Wermelinger, M. (2016). Harnessing the digital economy for developing countries. *OECD Development Centre Working Papers.*

Durward, D., Blohm, I., & Leimeister, J. M. (2016). Crowd work. *Business & Information Systems Engineering, 58*(4), 281–286.

Ferilli, G., Grossi, E., Sacco, P. L., & Tavano Blessi, G. (2017). Museum environments, visitors' behaviour, and well-being: Beyond the conventional wisdom. *Museum Management and Curatorship, 32*(1), 80–102.

Fuchs, C. (2014). *Digital labour and Karl Marx.* London: Routledge.

Fuchs, C., & Sandoval, M. (2014). Digital workers of the world unite! A framework for critically theorising and analysing digital labour. *tripleC: Communication, Capitalism & Critique, 12*(2), 486–563.

Fujiwara, D., Lawton, R., & Mourato, S. (2015). *The health and wellbeing benefits of public libraries.* Arts Council England, Simetrica. https://www.artscouncil.org.uk/health-and-wellbeing-benefits-public-libraries

Fumagalli, A., Lucarelli, S., Musolino, E., & Rocchi, G. (2018). Digital labour in the platform economy: The case of Facebook. *Sustainability*, *10*(6), 1–16.

Gandini, A. (2016). Digital work: Self-branding and social capital in the freelance knowledge economy. *Marketing Theory*, *16*(1), 123–141.

Gilchrist, A. (2000). The well-connected community: Networking to the edge of chaos. *Community Development Journal*, *35*(3), 264–275.

Grossi, E., Tavano Blessi, G., & Sacco, P. L. (2019). Magic moments: Determinants of stress relief and subjective wellbeing from visiting a cultural heritage site. *Culture, Medicine, and Psychiatry*, *43*(1), 4–24.

Gyimóthy, S., & Larson, M. (2015). Social media cocreation strategies: The 3Cs. *Event Management*, *19*(3), 331–348.

Hall, G. (2019). Transformations at burning man. In G. Brown (Ed.), *Eventscapes: Transforming place, space and experiences* (pp. 195–197). Abingdon, OX: Routledge.

Hawkins, C., & Ryan, L.-A. (2013). Festival spaces as third places. *Journal of Place Management and Development*, *6*(3), 192–202.

Hjalager, A.-M., & Flagestad, A. (2012). Innovations in well-being tourism in the Nordic countries. *Current Issues in Tourism*, *15*(8), 725–740.

Holts, K. (2018). *Understanding virtual work. Prospects for Estonia in the digital economy*. Tallinn: Foresight Centre at the Parliament of Estonia.

Hoover, J. D. (2008). Realizing the artful in management education and development: Smoldering examples from the Burning Man Project. *Journal of Management & Organization*, *14*(5), 535–547.

Huws, U. (2017). Where did online platforms come from? The virtualization of work organization and the new policy challenges it raises. In P. Meil & V. Kirov (Eds.), *Policy implications of virtual work* (pp. 29–48). Cham: Springer International Publishing AG.

Kitchen, E., & Filep, S. (2019). Rethinking the value of events for event attendees: Emerging themes from psychology. In J. Armbrecht, E. Lundberg, & T. D. Andersson (Eds.), *A research agenda for event management* (pp. 67–78). Cheltenham: Edward Elgar Publishing.

Kozinets, R. V. (2002). Can consumers escape the market? Emancipatory illuminations from burning man. *Journal of Consumer Research*, *29*(1), 20–38.

Larsen, J., & Bærenholdt, J. O. (2019). Running together: The social capitals of a tourism running event. *Annals of Tourism Research*, *79*, 102788.

Lee, H., Hwang, H., & Shim, C. (2019). Experiential festival attributes, perceived value, satisfaction, and behavioral intention for Korean festivalgoers. *Tourism and Hospitality Research*, *19*(2), 199–212.

Lent, R. W. (2018). Future of work in the digital world: Preparing for instability and opportunity. *The Career Development Quarterly*, *66*(3), 205–219.

Liburd, J. J., & Derkzen, P. (2009). Emic perspectives on quality of life: The case of the Danish Wadden sea festival. *Tourism and Hospitality Research*, *9*(2), 132–146.

Limbach, E. (2014, August 18). The wonderful, weird economy of burning man. *The Atlantic*. https://www.theatlantic.com/business/archive/2014/08/the-wonderful-weird-economics-of-burning-man/376108/

Luonila, M., & Kinnunen, M. (2019). Future of the arts festivals: Do the views of managers and attendees match? *International Journal of Event and Festival Management*, *11*(1), 105–126.

Mackellar, J. (2004). *How networks foster innovation—A case study of a regional festival* (Master's thesis, Southern Cross University). Lismore, New South Wales. https://epubs.scu.edu.au/cgi/viewcontent.cgi?article=1620&context=theses

Marchese, F. T. (2011). Conserving digital art for deep time. *Leonardo*, 44(4), 302–308.

McCarthy, K. F., Ondaatje, E. H., Zakaras, L., & Brooks, A. (2001). *Gifts of the muse: Reframing the debate about the benefits of the arts.* Santa Monica, CA: Rand Corporation.

Mellor, D. H. (2015). Artists and engineers. *Philosophy*, 90(3), 393–402.

Mezirow, J. (1997). Transformative learning: Theory to practice. *New directions for adult and Continuing Education*, 74, 5–12.

Moore, J. (2005). Is higher education ready for transformative learning? A question explored in the study of sustainability. *Journal of Transformative Education*, 3(1), 76–91.

Nordvall, A., Pettersson, R., Svensson, B., & Brown, S. (2014). Designing events for social interaction. *Event Management*, 18(2), 127–140.

Packer, J., & Ballantyne, J. (2011). The impact of music festival attendance on young people's psychological and social well-being. *Psychology of Music*, 39(2), 164–181.

Park, M., Oh, H., & Park, J. (2010). Measuring the experience economy of film festival participants. *International Journal of Tourism Sciences*, 10(2), 35–54.

Radziwill, N. M., & Benton, M. C. (2013). Burning man: Quality and innovation in the spirit of Deming. *The Journal for Quality and Participation*, 36(1), 7–11.

Salvador, E., Simon, J.-P., & Benghozi, P.-J. (2019). Facing disruption: The cinema value chain in the digital age. *International Journal of Arts Management*, 22(1), 25–40.

Trevena, B. (2017, 9 June). There's a city in my mind… *The Conversation.* https://theconversation.com/theres-a-city-in-my-mind-78337

Turner, F. (2009). Burning man at Google: A cultural infrastructure for new media production. *New Media & Society*, 11(1–2), 73–94.

Tymon, W. G., & Stumpf, S. A. (2003). Social capital in the success of knowledge workers. *Career Development International*, 8(1), 12–20.

UNESCO. (2009). *The 2009 UNESCO framework for cultural statistics.* UNESCO Institute for Statistics. https://unesdoc.unesco.org/ark:/48223/pf0000191061

Webster, J., & Randle, K. (2016). Positioning virtual workers within space, time, and social dynamics. In J. Webster & K. Randle (Eds.), *Virtual workers and the global labour market* (pp. 3–34). London: Palgrave Macmillan.

Weinberg, M. K., & Joseph, D. (2017). If you're happy and you know it: Music engagement and subjective wellbeing. *Psychology of Music*, 45(2), 257–267.

Wheatley, D., & Bickerton, C. (2017). Subjective well-being and engagement in arts, culture and sport. *Journal of Cultural Economics*, 41(1), 23–45.

Wilks, L. (2011). Bridging and bonding: Social capital at music festivals. *Journal of Policy Research in Tourism, Leisure and Events*, 3(3), 281–297.

Yolal, M., Gursoy, D., Uysal, M., Kim, H. L., & Karacaoğlu, S. (2016). Impacts of festivals and events on residents' well-being. *Annals of Tourism Research*, 61, 1–18.

14 The impact of digital transformation on fundraising for the arts

Alex Turrini, B. Kathleen Gallagher, and Marta Massi

Introduction

Arts organizations typically follow three golden fundraising principles in their everyday practice that third-sector organizations adopt across domains (Hopkins & Friedman, 1997; Byrnes & Martin, 2009; DeVeraux, 2015).

The very first principle is known as the "people" rule. Based on this principle, one of the key successful factors in fundraising is building relationships because, according to the well-known adage, "People give to People for other People" (Rosso, 1991). The arts are no exception to this rule. In fact, socialites who enjoy fundraising events and give because it is a major part of their social life and standing (Prince et al., 1994) are a significant part of the donors' bases of arts organizations. Socialites typically rely on their social networks to increase support for their preferred organizations, a treasure that fundraising units in the arts organizations nurture and renew very often. The importance of relationship building in arts fundraising is evident, in some ways, if we look at another important segment of prospective donors in the arts: dynasties (Prince et al., 1994). The value and importance of philanthropy and giving are instilled in this type of donor beginning in childhood. They typically support organizations that are important to family traditions. However, they are also driven to increase their reputation among peers, which motivates donations, involvement, and engagement in the social fabric of arts organization.

The second principle that arts organizations typically adopt in raising funds is the so-called "constituency" rule (Worth, 2016; Tempel et al., 2016). Based on this principle, stakeholders who are closer to the organization set the pace of giving. As a matter of fact, arts organizations in the United States have hybrid funding formulas mixing features of "beneficiary builders" and "member motivators" type of organizations (Landes Foster et al., 2009). On one side, a large proportion of arts institutions' revenues comes from the "price" (i.e., the ticket) paid by the beneficiaries of the service (i.e., the audience). Admissions or ticket sales do not cover the cost of the service delivered (Baumol & Bowen, 1966), and arts institutions engage

in development strategies that typically begin by "upgrading" ticket buyers to members and donors. On the other side, theater and museums increase contact with members (and donors) with a program of educational opportunities and social gatherings that fulfill members' social needs and further drive donations.

The third fundamental principle in arts fundraising is what might be labelled as the "mission" rule (Hopkins & Friedman, 1997; Byrnes & Martin, 2009; Weinstein, 2017): arts organizations typically rely on their mission to attract and retain donors interested in the arts. Leveraging the overall mission of the organization may open new territories of philanthropic endeavors for arts organizations. This implies a change in the "transactional" relationship with ticketholders and subscribers; a focus on the social outcomes achieved by the organizations outside the artistic production; an exploration of new segments of donors less interested in the arts *per se* and more interested in the philanthropic engagement of the arts organization in the community; and the development of projects that "use" the arts to achieve other social impacts like social justice, improved well-being and healthcare, and community inclusion (Radbourne & Watkins, 2015; Turrini et al., 2020).

As it will be clear in the following, digital technologies offer complementary tools that substantially support arts organizations' offline fundraising strategies revolving around these three main principles. Social media such as Instagram, Twitter and Facebook might be more used with more sophistication to enhance social interactions between nonprofit organizations and prosocial donors or ticketholders. Fundraising platforms such as *peer-to-peer* fundraising might satisfy arts patrons in their search for reputation from peers. Digital donor management systems and artificial intelligence (on one side) and e-newsletters or digital interactive reports (on the other side) might help cultivate and turn ticketholders or free visitors into novel donors and might help in strengthening the relationship with *constituents* such as major leadership gift donors. Virtual walls might be forms of gift recognition resulting in higher donor retention rates; and, finally, e-appeals, *crowdfunding* or mobile technologies might attract the interest and facilitate gifts of online donors who are not part of the arts' folks but might be sensitive to the outcomes arts institutions aim at achieving inscribed in their overall social mission.

On these grounds, the aim of this chapter is to describe how new technologies might support arts organizations in developing strategies that rely on the above-mentioned key principles to achieve success in fundraising in the arts. After a brief overview of the state of the art in the adoption of new technologies in fundraising by arts organizations, this chapter describes how new technologies might improve the efforts of arts organizations in attracting new donors, transforming ticket-holders into first-time donors and cultivating existing donors and members. The chapter then outlines which digital tools might be implemented to increase the visibility of arts

organizations in the virtual space and to drive traffic to the arts organization giving page. It suggests how new communication technologies might support the retention and upgrading of existing donors, especially when developing graded recognition programs, such as membership programs and giving societies in the arts. The last two sections focus on *arts crowdfunding campaigns* (which recently received a growing attention in the field) and the application of new technologies and *Artificial Intelligence* (AI) on arts institutions' donor management systems, which play a fundamental role in understanding arts constituents' needs, and providing opportunities that fit new and old donors' wants. The chapter concludes with a reflection about how arts organizations should change in the future to fully exploit the potential of new digital and communication technologies in order to achieve success in fundraising.

Trends in online fundraising for the arts

Online fundraising is becoming increasingly important for arts organizations in the United States and abroad. According to the Blackbaud Institute (2020), online giving in the arts has grown annually more than other fields in the last five years: arts institutions have shown an average increase of 11.0% in online giving, compared to average growth in other fields of 7.4%, with about 20% of the total online transaction occurs contributed in December (see Figure 14.1).

The average online donations to the arts seem much lower than what is donated to other sectors online (arts and culture nonprofits receive an average gift of $75 compared to $148 in other sectors). Giving through the Internet is increasingly important for arts institutions: in the last ten years,

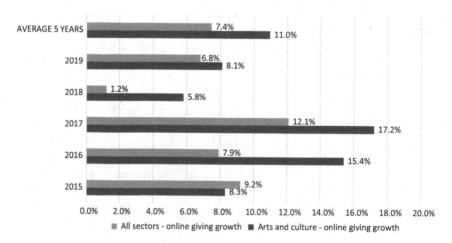

Figure 14.1 Year over year online giving growth in the arts (2015–2019)
Source: our elaboration on Blackbaud annual charitable giving reports 2015–2019.

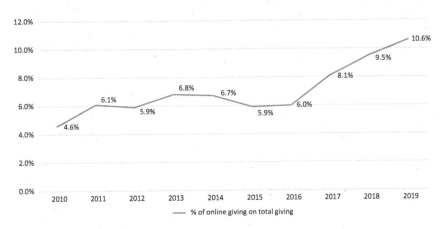

Figure 14.2 Share of online giving on total giving in the arts (2010–2019).
Source: our elaboration on Blackbaud annual charitable giving reports 2010–2019.

the share of online giving in the arts has more than doubled, increasing from 4.6% of the total contributions in 2010 to 10.6% of total fundraising in 2019 (Blackbaud Institute, 2020), as shown in Figure 14.2.

Unfortunately, the comparison of performances of arts and cultural organizations with other nonprofit sectors casts some shadows on the ability of the arts sector to exploit new fundraising opportunities coming from technological development. Table 14.1 illustrates some of the findings that the *2018 M+R Benchmarks Study* has recently highlighted, showing the relatively low performances achieved by cultural organizations included in the sample (M+R, 2019).

Arts organizations underperform in online donor retention (–11% retention rate of multi-year online only donors, –11% of first-year, online-only donors, and –13% overall online donors retention rate), in terms of one-time online average gifts ($80 average gift compared to an average of $106), and in terms of % of website main donation conversion rate (–5% in comparison to the average) (M+R, 2019).

Arts organizations' lack of preparation to adopt new technologies and social media to increase visibility and raise funds is confirmed by the 2013 survey of more than 1,000 US arts organizations that received grants from the National Endowment for the Arts (NEA). This study—one of the first in this domain—documents extensive use of technology in the arts to sell tickets, educate and engage the audience, and even market and deliver performance through the Internet. It highlighted the fact that the majority of these organizations have their own website and share content through it; have a social media presence on Facebook, Twitter, YouTube, Flickr, or other platforms; post updates daily; accept donations online; and sell tickets online (Thomson et al., 2013). However, fewer arts organizations

Table 14.1 Online giving: selected indexes on fundraising online

	Arts and culture	Overall sample	Difference
Online donor retention (2017–2018)			
New donors	14%	25%	–11%
Prior donors	48%	59%	–11%
Overall	24%	37%	–13%
Digital advertising investment/Total online revenue (2018)	3 cents	10 cents	(7 cents)
Average online gift (2018)			
Monthly	$24.00	$23.00	$1.00
One time	$80.00	$106.00	$(26.00)
Email Revenue × 1,000 Fundraising emails (2018)	$70.00	$45.00	$25.00
Fundraising Email Message Rate (2018)			
Open rate	19%	14%	5.00%
Clickthrough rate	0.51%	0.44%	0.07%
Response rate	0.05%	0.06%	–0.01%
Unsubscribe rate	0.16%	0.16%	=
Websites (2018)			
% website visitors that make a donation	0.50%	1%	–1%
% website main donation conversion rate	12%	17%	–5%
Facebook (2018)			
FB clap score	0.11%	0.16%	0.05%
FB Fundraiser average gift	$28.00	$31.00	$(3.00)

reported use of blogging, online sale of merchandise, podcasting, webinars, or apps to providing audience content—technologies that could help to cultivate revenue (Thomson et al., 2013). The *2019 Digital Outlook Report* further highlights this in a quite involuted framework: almost half of the nonprofit surveyed do not engage in *peer-to-peer* fundraising and do not have a strategy for the generation of leads, the majority of the organizations do not have metrics for assessing results of social media advertising, nor do they intend to budget an in-house developer who could support their technological development (Heynes, 2019).

The failure of most arts institutions to keep pace with the digital revolution appears problematic if we consider data concerning the demographic

and psychographic profiles and motivation of rising generation of philanthropists: as Davis and Herrell (2012) put it: "Philanthropy's Next Generation survey respondents (28.9 percent) shared what they learned about the nonprofit organizations to which they donate through some type of social media platform. Social networks are to Millennials what television was to Boomers. Nonprofits need to go where the next generation is - online!" (Davis & Herrell, 2012, p. 117).

As a consequence, nonprofit organizations should swiftly reconsider and upgrade the basic actions recommended for successful online giving strategies (i.e., an attractive and comprehensive website, a presence on social media, and an e-mail list segmented according to different categories) (Klein, 2016).

In the following section, we will, therefore, describe how investment in online fundraising technology and competencies might represent an opportunity for arts organization and their attempt to attract new donors or to cultivate existing ones.

How to use new technologies to cultivate donors in the arts

New technologies might be fundamental tools to support cultivation strategies arts organizations put in place toward their donors. Figure 14.3 represents the summary of digital tools that might be more appropriate to support the achievement of different goals of the annual fundraising campaign. In the following, we discuss how digital transformation offers innovative ways to connect with new and existing donors. We then offer a discussion of crowdfunding and digital tools that might support donor management systems. New technologies have opened endless opportunities to attract

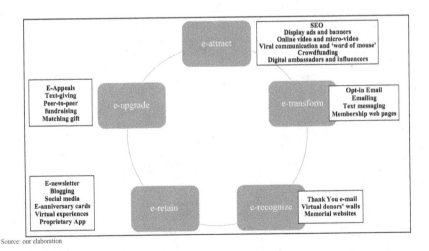

Source: our elaboration

Figure 14.3 Digital tools in annual fundraising campaign for arts organization.
Source: Our elaboration.

new online donors (*e-attract*), who might not even be even interested in the arts but are interested in supporting some social or community projects that an arts institution is carrying forward. Driving traffic to the arts institution donation webpage and increasing online visibility of arts institution is the main step to attract new donors. Different actions and tools might be adopted to increase organizations' visibility and facilitate the introductory donation online, namely:

- **Search Engine Optimization** (SEO). Arts institutions might utilize SEO in order to ensure that the name of the organization comes out earlier in results from users' relevant keyword searches. Sites that have a higher keyword density will generally obtain a higher ranking but Sargeant and Shang (2017) notice that a Google algorithm will weigh quality and *Pay Per Click* Google Ads[1] more in the future. Arts organizations should, therefore, not only care about traditional tactics (i.e., encouraging inbound links, clever choice of domain names, use of meta-tags, etc.) but must also adopt proactive actions like periodically reviewing and refreshing the content of their website and donation pages and engaging online users (eventually influencers or social media champions) with news and updates that are worthy of a link-retweet (Ahmed, 2012; Sargeant & Shang, 2017).

- **Banners and Display Ads.** Banners and ads that are placed in third-party sites resemble offline advertising. In this perspective, ads should be catchy and invite viewers to act: banner animation is frequently used to achieve this scope (Yoo et al., 2004).

- **Online Video and Micro Video.** This tool is one of the fastest-growing strategies being adopted by nonprofit organizations according to Mc Nutt et al. (2018). In fact, video allows dynamic and effective storytelling about the organization, its causes, and its activities. With the advent of smartphones and improvements in audio and video production equipment, the production cost of videos is extremely low, making this tool increasingly attractive for arts institutions.

- **Viral communication and "word of mouse" spread.** Arts organizations might encourage their constituents to share promotional emails, tweets, or a text messages (i.e., the "viral agent" to friends and acquaintances). The content of the communication (i.e., news, stories, exclusive event, videos, and music) should be compelling and worthy to be spread in the web. This often happens if the material becomes *social currency* (Klein, 2016): the recipient of the communication perceives the exclusivity of the communication he/she has (it should be nearly a secret) and might use it as a way to create social bonds or eventually—just because it's secret!—spread it to friends. At times the message explicitly urges the recipient to take action and pass it to a friend or relative. In many cases, viral campaigns aim to drive traffic without explicitly asking for a gift (Sargeant & Shang, 2017).

- **Digital Ambassadors and Influencers.** Putting aside arts celebrities (who might be eventually recruited for a fundraising campaign online and offline), nonprofit organizations might choose a person or a group of people within the organization that can perform the role of ambassador by offering digital testimonials and motivation behind their donations to the organization. Arts organizations might involve influencers to attract new donors that are removed from the arts. In particular, if we look at the *artification* process that is occurring in the fashion and design industry (Massi & Turrini, 2020), the rising number of bloggers and influencers represents a great opportunity for cause-related fundraising/ marketing initiatives that might increase the reputation and visibility of both the influencer and the arts institution.

 The use of digital ambassadors and influencers represents the digital realization of the principle that the likelihood of a donation increases when someone you know recommends you to give to a particular organization. For this reason, the choice of the ambassadors and the influencers who might attract new gifts should be aligned with the organization: he/she has to represent the values and the "personality" of the organization, and at the same time, he/she should be able to be attractive new categories of donors.

As mentioned before, new technologies might enable achievement of other goals of the annual fundraising campaign like *transforming* ticketholders or subscribers into donors, *retaining or upgrading* donors, and *recognizing* the gift of donors.

Offline, graded recognition programs, like giving clubs, giving societies, or membership programs, are meant to cultivate donors according to the amount of their annual gifts (Burk, 2003). The best membership programs offer donors multiple options—different levels, different benefits, and different ways to get involved—without being overly complicated. Above all, the very best arts membership program should sustain the transition from the typical, transaction-oriented relationship of a ticketholder or a subscriber with the organization to a long-lasting, philanthropic relationship. As Wiepking and Bekkers (2011) suggest, membership programs are not only about bringing tangible benefits to members. Graded recognition programs in the arts should rather offer involvement opportunities, updated information about the outcome of the organization and the benefits that the arts create in the community, an increased sense of belonging and a stronger connection with the group of constituents and leaders of the arts institution.

Program directors of arts membership have additional e-transform tools that might be helpful in achieving this task. Solicitation to become members begins by asking the audience for permission to send informative or fundraising *emails or text messages*. This might happen at the ticket counter or highlighting *opt-in email* request in the website or in the online ticketing webpage. In general terms, the use of emails and text messages should be strictly controlled by the organization in order to avoid the recipient

unsubscribing from the arts institutions mailing lists. As we will see in the following section, a shared and accurate CRM information system is fundamental to coordinating the overall quantity and periodicity of promotional emails from the marketing and the development department.

Emails and text messages should, above all, aim to drive traffic to the *membership program website/webpages* which extensively explain the benefits members receive. As a matter of fact, based on the *2019 Global NGO Technology Report*, 86% of NGOs worldwide recognize that the website is the most effective communication tool for raising funds, which implies a very careful design of it (Nonprofit Tech for Good, 2019). Concisely, webpages regarding membership programs should respect common principles when designing a website by a nonprofit organization (Ahmed, 2012; Klein, 2016; Sargeant & Shang, 2017; Weinstein, 2017), namely:

1 Webpages should convey credibility, informing the possible prospects/ members about the organization, its mission, its activities, its constituents, and its financial viability. In particular, the organization should reassure about the security it grants in processing the payment by the member/donor.

2 Webpages should convey engagement, push prospect members to action, and try to establish some form of connection or relationship. This also means that the membership program webpage should include an eye-catching call to action such as the "Act/Donate now!" button" and the headline of the membership program should be compelling. Having a mobile-optimized membership website is fundamental nowadays as well as the use of powerful pictures and images.

3 Webpages should be also very informative describing in a concise way all the benefits the member can enjoy on the basis of the size of the gift.

4 Simple and straightforward navigation is important as well as an easy-to-process payment. A clear navigation map or breadcrumbs might help the user to see where they are on a site, and can help the decision to join as member, The "Join Now!" button should take user to a secure site where they can make a gift by credit card, PayPal, or the like.

As mentioned before, converting ticketholders into members represents one of the major challenges for arts institutions and should be the first step for donors' cultivation. However, new technologies support other fundamental tasks in individual fundraising, such as recognizing, retaining, and upgrading donors once they become members.

Fundraising practitioners know that a donor should be thanked immediately after the gift. A delay in acknowledgment might appear to the donor as a lack of care or efficiency and might be counterproductive. *E-recognizing* tools support the speed of communication with the possibility of sending *an email or text message of gratitude* shortly after processing the gift. Arts organizations might exploit other possible ways of *e-recognizing* donors

such as *virtual donors' walls* (a virtual space where the member's name is listed and his/her gift is acknowledged publicly) or donors' *memorial websites* (which are websites reserved to recognize and remember wealthy members who passed away and left a legacy to the organization).

Retaining existing and new members (and donors) might be very challenging: nonprofit organizations might experience almost 40% of annual retention rate and, and as we have seen before, even less online (Fundraising Effectiveness Project Annual Report, 2018; M+R, 2019). As a matter of fact, it is important not to forget donors after having received the gift or acknowledging it: retention is an ongoing activity that encompasses informing the donors about the activities of the organization, engaging and involving members, increasing their sense of belonging to the organization and its mission. The digital revolution has enabled arts organizations to fulfill these tasks through different type of *e-retaining* tools: *social media* (above all Facebook, Twitter and Instagram), *e-newsletters and blogs* (which might take the form of online journals or virtual spaces where arts organizations posts allow readers to comment on the posting), *e-anniversary cards* (to celebrate members' birthdays, weddings, births, or other important donor's life moments), *virtual experiences* (such as virtual visits to a museum collections, online lectures and tutorials, reserved accessed to virtual libraries, concert streaming online, etc.), and *proprietary apps* (which engage the members with enriched content about the arts organization or the type of arts proposed) (Sargeant & Shang, 2017). Even if all these tools can be utilized to appeal for funds, the focus should remain on the institution and its accomplishments. In other words, all these online tools are not meant to immediately get donations but to cultivate and steward existing donors.

Finally, new online actions might complement the offline efforts of arts organizations in upgrading donors either by proposing to advance from their current-level of membership to the next level or by increasing the total amount of money a member might give to the organization in a given year. In the first case, the fundraising staff of an arts institution ask explicitly for a larger gift. An explicit *upgrade e-mail* to the member/donor might be the effective if it describes the mission-related reasons why the donor should give more on a regular basis. Making the payment process easy, in this case, is fundamental and the email should highlight web links directing the recipient to the online giving page of the arts organization. In the second case, arts organizations might incentivize additional donations in different ways. *Matching gifts*, for example, are donations that leverage on the commitment of a sponsor or the institution itself: the member donates because his/her gift will be doubled or tripled by a third party. *Peer-to-peer fundraising campaigns* rely on social pressure of other online users or members and trigger also imitative behavior. *E-appeals or text-to-give campaigns* exploit the sense of urgency and the ease of giving. In particular, with text-to-give campaigns the donor is invited to text the arts organization to make a donation, typically of small size and for an urgent matter. The act of texting

directly triggers a donation that is billed to the mobile phone account so the single member/donor concretely pays when he/she receives the bill from his/her phone carrier (Heyman, 2017; McNutt et al., 2018).

The use of crowdfunding to attract new arts patrons

Digital transformation has brought about new opportunities for democratization. This is especially true in the context of the arts, a field traditionally characterized by elitism and separation between production and consumption (Massi et al., 2020). In particular, the digital environment has provided cultural producers with new chances to engage with donors and backers (Booth, 2015). The most disruptive process being introduced in this context has probably been crowdfunding, a process aimed at raising "external financing from a large audience (the 'crowd') [...] instead of soliciting a small group of sophisticated investors" (Belleflamme et al., 2014, p. 585). In particular, digital crowdfunding is increasingly becoming a common practice within the arts and culture sector, making it possible for organizations, such as museums and theaters, as well as artists and other creatives to sustain their business through support derived from digital platforms. Despite the growing debate on new forms of art funding, only a few empirical studies on crowdfunding have emerged to date in the arts field (Boeuf et al., 2014; De Filippi, 2015).

Crowdfunding might function as a more inclusive form of art consumption, leading to democratization of the fundraising process. Once artists and art projects were funded almost exclusively by monarchs, the aristocracy, and popes and cardinals. Now a fragmentation of the traditional patronage paradigm has occurred which is spread out to different patrons, that is, those who have a stake in the project (Brabham, 2017). As a "very democratic way to resource the arts," crowdfunding takes "the decision-making out of the hands of the gatekeepers" and places it "in the hands of the mob" (Creative Partnerships Australia, 2017).

As stated in the mission of Indiegogo, one of the first established crowdfunding platforms, crowdfunding allows for democratization of fundraising and empowers everyone across the world to fund their passions. Crowdfunding, therefore, seems to encourage people, opening up new spaces for value co-creation. Individuals can be extremely motivated to support an organization or a project because they share the values or mission of the organization or because they are simply motivated by the need to belong to a community. However, while several scholars (e.g., Mollick & Robb, 2016) have celebrated crowdfunding as a means of democratizing the arts funding process, others have criticized it, warning that "an uncritical embrace of an Internet trend may threaten public funding for the arts by aligning with neoliberal ideological language" (Brabham, 2017, p. 983). Crowdfunding platforms use two main funding models: "all-or-nothing," which allows the creator of the project to retain the amount collected only if he/she reaches

or exceeds the funding goal, and the "keep-it-all" that allows the creator to retain the crop regardless of the achievement of the funding goal. Massi et al. (2020) found that backers are more willing to support a project when they receive a reward for supporting the project.

Crowdfunding platforms can be classified based on their orientation (profit vs. nonprofit) and their focus (general vs. vertical). Generalist platforms, such as Kickstarter and Indiegogo, are dedicated to a variety of sectors. In contrast, platforms such as BeArt are dedicated to contemporary art and do a curatorial selection of projects. Art Basel crowdfunding (born from a partnership between Kickstarter and Art Basel fair) and Art Happens (crowdfunding platform of the Art Fund UK) are dedicated only to nonprofit projects.

The success of crowdfunding as a way to raise money to fund projects in the arts and culture highlights the importance of the introduction of innovative and backer-friendly ways of funding projects. Digital crowdfunding is increasingly becoming a common practice within the arts and culture, representing for art organizations and artists a new way for sustaining their business.

Technological resources for improved management of the fundraising unit

Baumol and Bowen (1966) detailed the problem of cost disease for arts organizations. Technology has produced increased labor productivity in many fields which supports increased wages. This applies upward pressure to salaries in other fields, even when technology cannot be leveraged for productivity advantages. Fundraising is an area within which new technology can be used to increase efficiency and productivity and deliver important organizational benefits. Technology has been leveraged for fundraising in a variety of nonprofit fields. The Salvation Army recruited significantly more donors, maintaining a high return on investment (ROI) after adding new media channels (Colling, 2011). Saxton and Wang (2014) report that fundraising success is not a product of an organization's financial capacity but its web capacity. Technology advances allow organizations to send and receive information and, more importantly, to connect with the public and prompt them to act (Saxton & Wang, 2014). Investment in the development of infrastructure, such as systems for information technology, financial management, and fundraising, indicate organizations that are more likely to survive economic recessions (Gregory & Howard, 2009). Despite numerous benefits, nonprofit arts organizations have lagged behind other nonprofit fields in their adoption of technology.

Nonprofit arts organizations often struggle with capacity issues. Expanding fundraising efforts and growing donor bases are major challenges (Schatterman, 2015). While nonprofit arts organizations acknowledge that technology increases efficiency, representatives report capacity issues

when it comes to adopting and using technology (Thompson et al., 2013; Schatterman, 2015). Upgrading hardware and software, creating, updating, and effective use of databases are common problems (Schatterman, 2015). Costs, funding, staffing, and time are cited as barriers to adopting new technologies in nonprofit arts organizations (Thompson et al., 2013). Limited external funding is available to help nonprofit arts organizations expand their technology tools (Thompson et al., 2013). Despite the promise of technology tools, arts organizations face numerous barriers to adoption of new technologies.

Nonprofit arts organizations experience lags in adopting new technologies. Despite awareness that digital technologies are very important for fundraising, less than 40% of nonprofit arts organizations report that they generally embrace new technology well and only half report that is "somewhat true" (Thompson et al., 2013). With an ever-growing array of digital tools, a dedicated digital manager is desirable but frequently it is not viable. Fewer than half of nonprofit arts organizations have a dedicated digital manager, more common among organizations with budgets over $10 million (M+R, 2019). Only 20% of nonprofit arts organizations feel they do not need outside help for their technology needs but only 16% report securing external tech support (Thompson et al., 2013). Nonprofit arts organizations face capacity issues and delays in adoption of new technology. Fundraising units derive significant benefits from technology-enhanced practices. This opportunity positions the fundraising unit to lead the adoption of the technological tools that support unit performance and management.

Technology offers direct response to specific needs of the fundraising department. Fundraising is highly competitive, stressful, and prone to high turnover and burnout. Technology can be deployed to enhance recruitment and increase retention of successful fundraisers. There are additional digital resources for managing teams. New modalities provide rich access to a variety of continuing education opportunities. Integration of new tools promises to generate benefits in both fundraising and managing the fundraising divisions.

Fundraising is identified as a growth area (Meisenbach et al., 2018). Furthermore, executive directors report an insufficient number of qualified candidates for director positions (Ernst, 2017). The vast majority of fundraisers (80%) report satisfaction with their jobs (Association of Fundraising Professionals, 2019). Two-thirds are satisfied that the technology provided supports their ability to do their jobs (Association of Fundraising Professionals, 2019). However, fundraising is marked by a turnover of 19% per year (Meisenbach et al., 2018). Half of fundraisers reported they would likely leave their position within two years, and 30% indicated they were likely to leave the profession altogether in that time (Association of Fundraising Professionals, 2019). The average tenure of a major gift officer is 1.5 to 2 years (Ernst, 2017). Nonprofit arts organizations must compete for

competent, qualified development personnel and technology provides an array of solutions that can be used to recruit and retain employees.

- **Organizational transparency before candidates are hired.** Organizational performance and reputation are essential to successful fundraising. Prospective employees have increased access to indicators of organizational health with transparency-driven websites such as Candid (formed by the merger of the Foundation Center and GuideStar) and Charity Navigator. Regular maintenance of the information on these sites contributes to assuring donors and job candidates.
- **Flexible work arrangements.** Teleconferencing, web-conferencing, and telecommuting have been around for many years and have always promised the opportunity for workers to connect and work from anywhere. A variety of platforms allow remote workers to participate in and contribute to meetings. This became common practice across industries during the COVID-19 pandemic. Tools were adapted for virtual fundraising and social events. Flexible work location is an important benefit. It can improve work-life balance and increase employee productivity, health, and happiness. In competitive fields, such as fundraising, jobs with greater flexibility become more competitive and attractive.
- **Networking, collaboration, and communication.** Remote workers need to collaborate and connect with others in the unit. New systems for sharing files, calendars, ideas, holding meetings, and instant messaging support team pursuit of shared goals (McNutt et al., 2018). Programs and apps can be found to meet all budgets—from purchasing a license to free access means that there is a solution for any budget.
- **E-supervision/cyber supervision.** The completion of work in multiple locations makes tracking progress more difficult unless digital tools are employed (McNutt et al., 2018). While employees value flexibility, remote work can feel isolating. Managers can use digital tools to check in and offer feedback and training.
- **Augmented reality (AR) and virtual reality (VR).** These new technologies allow users to interact with and explore simulated experiences (McNutt et al., 2018). They are a promising tool for attracting donors—by offering a meaningful examination of the organization's mission, services, and programs. They also have potential for preparing fundraising experts for a variety of scenarios.

Sustainability of arts nonprofits requires competent, efficient work on the part of the fundraising unit. Digital tools provide multiple resources to increase an organization's efficiency and efficacy in fundraising—from the funds raised to the behavior and performance of those working in the fundraising unit.

Being a fundraising professional today means more than just having the necessary fundraising knowledge and experience," said Geiger. "The

more leadership and management skills we have—the more we can lead up, down and sideways, educate our CEOs, boards and other staff, and help develop organizational cultures—the more effective we will be in our jobs" (Association of Fundraising Professionals, 2019, p. 1).

Conclusion

This chapter has focused on how the digital transformation, now occurring in many sectors, might support arts organizations in developing successful fundraising strategies. As emphasized, digital transformation can favor and enhance the application of the three golden tenets of fundraising, that is, the "people" rule, the "constituency rule," and the "mission rule." Digital transformation can provide arts managers with tools to complement arts organizations' offline fundraising strategies revolving around the three main principles. Each digital tool addressed in this chapter can be used to achieve a different purpose in the arts fundraising context. Social media such as Instagram, Twitter, and Facebook might be employed used to enhance social interactions between nonprofit organizations and their prosocial donors or ticketholders. Peer-to-peer fundraising platforms might satisfy arts patrons in their search for reputation from peers. Digital donor management systems and AI (on one side) and e-newsletters or digital interactive reports (on the other side) might help cultivate and turn ticketholders or free visitors into novel donors and might help in strengthening the relationship with *constituents* such as major leadership gift donors. Virtual walls might work as gift recognition resulting in higher donor retention rates. *Crowdfunding* might favor a greater level of backer engagement, thus making arts funding projects successful.

Arts managers can no longer ignore the call for introducing new digital tools in their everyday practice. They should develop a sense of "we-ness" with potential backers and donors, in order to let them feel as an active and important part of the project they are about to invest in (or to donate to). Digital transformation can play a crucial role in this process.

Note

1 Pay per click is an internet marketing formula according to which advertisers pay a fee each time their ad is clicked through. The fee might be fixed (which is typical for ads displayed in websites) or might be connected to a keyword bidding system that top search engines like Google or Yahoo design for online advertisers.

References

Ahmed, S. (2017). *Effective non-profit management: Context, concepts, and competencies.* Routledge.

Association of Fundraising Professionals. (2019). Fundraisers satisfied with many aspects of their jobs, but half likely to leave current position in two years.

Retrieved 7 June 2020 from Arlington, VA: https://afpglobal.org/fundraisers-satisfied-many-aspects-their-job-half-likely-leave-current-position-two-years

Baumol, W. J., & Bowen, W. G. (1993). *Performing arts-the economic dilemma: A study of problems common to theater, opera, music and dance*. Aldershot: Gregg Revivals.

Bekkers, R., & Wiepking, P. (2011). A literature review of empirical studies of philanthropy: Eight mechanisms that drive charitable giving. *Nonprofit and Voluntary Sector Quarterly, 40*(5), 924–973.

Belleflamme, P., Lambert, T., & Schwienbacher, A. (2014). Crowdfunding: Tapping the right crowd. *Journal of Business Venturing, 29*(5), 585–609.

Boeuf, B., Darveau, J., & Legoux, R. (2014). Financing creativity: Crowdfunding as a new approach for theatre projects. *International Journal of Arts Management, 16*(3), 33–44.

Booth, P. (2015). Crowdfunding: A Spimatic application of digital fandom. *New Media & Society, 17*(2), 149–166.

Brabham, D. C. (2017). How crowdfunding discourse threatens public arts. *New Media & Society, 19*(7), 983–999.

Burk, P. (2003). *Donor-centered fundraising: How to hold on to your donors and raise much more money*. Chicago, IL: Burk & Associates and Cygnus Applied Research.

Byrnes, W. J. (2009). *Management and the arts*. New York: Focal Press.

Colling, M. (2011). The Salvation Army: How to improve a best-of-breed donor recruitment campaign. *Journal of Direct, Data, and Digital Marketing Practice, 12*(4), 364–371.

Creative Partnership Australia. (2017). The low-down on crowdfunding. Retrieved 11 April 2012 from https://creativepartnershipsaustralia.org.au/for-artists-and-arts-organisations/resources/guides-and-factsheets/crowdfunding/

Davis, E. (2012). *Fundraising and the next generation, + website: Tools for engaging the next generation of philanthropists* (vol. 199). Hoboken, NJ: John Wiley & Sons.

De Filippi, P. (2015). Blockchain-based crowd-funding: what impact on artistic production and arts consumption? Retrieved 7 June 2020 from http://papers.ssrn.com/

DeVereaux, C. (2015). Fund-raising and grant-writing basics for arts managers. In M. Brindle & C. DeVereaux (Eds.), *The arts management handbook: New directions for students and practitioners: New directions for students and practitioners* (pp. 290–318). New York: Routledge.

Ernst, L. A. (2017). Attracting and retaining good fundraising talent. Retrieved from https://www.givinginstitute.org/news/356156/Attracting-and-Retaining-Good-Fundraising-Talent.htm

Fundraising Effectiveness Project Report. (2018). Fundraising effectiveness project report. Retrieved 7 June 2020 from https://bloomerang.co/retention on March 2nd, 2020

Gregory, A. G., & Howard, D. (2009). The nonprofit starvation cycle. *Stanford Social Innovation Review*. Retrieved 7 June 2020 from https://ssir.org/articles/entry/the_nonprofit_starvation_cycle#

Heyman, D. R. (2016). *Nonprofit fundraising 101: A practical guide to easy to implement ideas and tips from industry experts*. Hoboken, NJ: John Wiley & Sons.

260 *Alex Turrini et al.*

Hopkins, K. B., & Friedman, C. S. (1997). *Successful fundraising for arts and cultural organizations*. Phoenix: Oryx Press. .

Klein, K. (2016). *Fundraising for social change*. Hoboken, NJ: John Wiley & Sons.

Landes Foster, W., Kim, P., & Christiansen, B. (2009). Ten nonprofit funding models. *Stanford Social Innovation Review*, 7(2), 32–39.

Massi, M., Piancatelli, C., Romanazzi, S., & De Molli, F. (2020). Democratizing art consumption through digital crowdfunding: An investigation on the factors that affect the performance of arts projects. *Working paper.*

Massi, M., & Turrini, A. (Eds.). (2020). *The artification of luxury fashion brands: Synergies, contaminations, and hybridizations*. Cham: Palgrave.

Massi, M., Vecco, M., & Lin, Y. (2020). *Digital transformation in the cultural and creative industries. Production, consumption and entrepreneurship in the digital and sharing economy*. London: Routledge.

McNutt, J., Guo, C., Goldkind, L., & An, S. (2018). Technology in nonprofit organizations and voluntary action. *Voluntaristics Review*, 3(1), 1–63.

Meisenbach, R. J., Rick, J. M., & Brandhorst, J. K. (2019). Managing occupational identity threats and job turnover: How former and current fundraisers manage moments of stigmatized identities. *Nonprofit Management and Leadership*, 29(3), 383–399.

Mollick, E., & Robb, A. (2016). Democratizing innovation and capital access: The role of crowdfunding. *California Management Review*, 58(2), 72–87.

Nonprofit Tech for Good. (2019). Global NGO Technology Report. Retrieved 7 June 2020 from https://www.funraise.org/techreport/infographics on 02/28/2020.

Prince, A., Autor, R., & Maru File, K. (1994). *The seven faces of philanthropy. A new approach to cultivating major donors*. San Francisco, CA: Jossey-Bass Publishers.

Radbourne, J., & Watkins, K. (2015). *Philanthropy and the arts*. Melbourne: Melbourne University Publishing.

Rosso, H. (1991). *A achieving excellence in fund raising: A comprehensive guide to principles, strategies, and methods*. San Francisco, CA: JosseyBass Publishers.

Sargeant, A., & Shang, J. (2016). Outstanding fundraising practice: How do nonprofits substantively increase their income? *International Journal of Nonprofit and Voluntary Sector Marketing*, 21(1), 43–56.

Saxton, G., & Wang, L. (2014). The social network effect: The determinants of giving through social media. *Nonprofit and Voluntary Sector Quarterly*, 43(5), 850.

Schatterman, A. (2015). Capacity challenges of the arts. *Philanthropy Journal*. Retrieved from https://pj.news.chass.ncsu.edu/2015/08/31/capacity-challenges-of-the-arts/

Tanghetti, J. (2017). Interview, 18 May 2019.

Tempel, E. R., Seiler, T. L., & Burlingame, D. F. (2016). *Achieving excellence in fundraising*. San Francisco, CA: Jossey-Bass. Thompson, K., Purcell, K., & Rainie, L. (2013). Arts organizations and digital technologies. Retrieved from Washington, DC: https://www.pewcenterarts.org/sites/default/files/pip_artsandtechnology_pdf.pdf

Turrini, A., Canale, B., & Jillson, J. (2019). Exploring drivers for multi-categorical charitable giving in the arts. *Working paper SMU meadows school of the arts: Dallas.*

Weinstein, S., & Barden, P. (2017). *The complete guide to fundraising management*. New York: Wiley.

Worth, M. J. (2015). *Fundraising: Principles and practice*. Thousand Oaks, CA: Sage Publications.

Yoo, C. Y., Kim, K., & Stout, P. A. (2004). Assessing the effects of animation in online banner advertising: Hierarchy of effects model. *Journal of Interactive Advertising*, 4(2), 49–60.

Afterword

François Colbert

Back in the mid-1970s when I started my career, the faster ways to contact somebody were either by phone or by FAX. In the beginning of the 1990s, I remember having been puzzled when someone said to me, « just email me »; emails were not as widely used as they are today; it was a brand-new device that we all had to get familiar with. In 30 years, the Internet changed our lives and the lives of companies and organizations all over the world in all sectors of the economy.

With computers and the Internet, the market has faced tremendous changes, from the point of view not only of enterprises but also of consumers. Miniaturization and artificial intelligence are currently moving the issue one step further. Everyone has to adapt, in the arts as well as in any sector of the economy.

The cultural sector is affected in the production as well as in the distribution facet of operations. Books are available in digital format. Movies can be viewed on a tablet or any support. One can buy their favorite songs through streaming platforms. Stage managers have access to sophisticated software to control sound and lighting during a live performance. Museums and heritage sites are experimenting virtual reality.

Internet and digital transformation are great disruptors in the purchase and consumption of goods, but they can also become big friends for the artist and the consumer. A good example in the music sector is the easiness for musicians to record a song in their basement and make it available to everyone on the Web. Making available on the Net is also a good way to build an audience. A popular music band from Canada did exactly this. Analyzing their data from the songs they made available for free on the Net, they discovered that the largest group of fans was in Paris. So, they decided to organize a concert in Paris. It started their career.

Another example is the use of visual reality in the museum and the heritage sectors. The positive side of this new technology is that it is adding a new experience to consumers. This means offering the visitor a new « product ». However, contemplating a painting of a great artist in a museum by standing in front of the real work is not the same as using an audio-guide or wearing a mask of virtual reality. You can build your own art gallery

on your computer, but it is not the same experience as visiting a museum. You can watch an opera from the MET in a movie theatre, but the physical presence of the singers and musicians is missing. The benefits of the client are not the same.

The context of digital transformation poses a supplementary challenge to marketers. The question is what kind of experience visitors prefer. Some art lover does not use audio-guide, or any other devices, because they want the intimate contact with the work of art. Others are thrilled by the virtual reality experience. They enjoy being transported to another world. The art is important but more so is this enhanced experience. It impacts the production side and the consumption side as well as the product we are selling to potential clients.

Digital transformation is changing our lives and academic research is following the trend. Manuals and scientific articles are published. This book will be adding value to the conceptualization needed to pursue research in the area in an organized manner. It will also help managers and producers. It is a timely endeavor.

Index

Note: **Bold** page numbers refer to tables; *italic* page numbers refer to figures and page numbers followed by "n" denote endnotes.